VARIORUM COLLECTED STUDIES SERIES

Enamels, Crowns, Relics and Icons

Paul Hetherington

Paul Hetherington

Enamels, Crowns, Relics and Icons

Studies on Luxury Arts in Byzantium

ASHGATE
VARIORUM

Published in the Variorum Collected Studies Series by

Ashgate Publishing Limited
Wey Court East
Union Road
Farnham, Surrey
GU9 7PT
England

Ashgate Publishing Company
Suite 420
101 Cherry Street
Burlington, VT 05401–4405
USA

Ashgate website: http://www.ashgate.com

ISBN 978–0–7546–5950–1

British Library Cataloguing-in-Publication Data
Hetherington, Paul
 Enamels, crowns, relics and icons : studies on luxury arts in Byzantium.
 – (Variorum collected studies series)
 1. Enamel and enamelling, Byzantine 2. Art objects, Byzantine
 I. Title
 738.4'09495'0902

 ISBN 978–0–7546–5950–1

US Library of Congress Cataloging-in-Publication Data
Hetherington, Paul.
 Enamels, crowns, relics, and icons : studies on luxury arts in Byzantium / by Paul Hetherington.
 p. cm. – (Variorum collected studies series)
 Single contribution in French.
 Includes index.
 ISBN 978–0–7546–5950–1 (hardback : alk. paper)
 1. Cloisonné, Byzantine. 2. Enamel and enameling, Byzantine. 3. Art objects, Byzantine.
 I. Title.

NK5013.H48 2008 2008008220
738.409495–dc22

Printed and bound in Great Britain by TJ International Ltd, Padstow, Cornwall

VARIORUM COLLECTED STUDIES SERIES CS908

CONTENTS

CONTENTS

This volume contains xii + 314 pages

PUBLISHER'S NOTE

The articles in this volume, as in all others in the Variorum Collected Studies Series, have not been given a new, continuous pagination. In order to avoid confusion, and to facilitate their use where these same studies have been referred to elsewhere, the original pagination has been maintained wherever possible.

Each article has been given a Roman number in order of appearance, as listed in the Contents. This number is repeated on each page and is quoted in the index entries.

PREFACE

The studies collected here appeared over a period of some thirty years and, with a few exceptions, concern works involving Byzantine enamel. The final two relate to other art forms, five more involve questions of contemporary or later views and reception of the medium, but the rest are devoted to the study of ensembles of this colourful and brilliant art form, for which the artists of Byzantium were rightly famous in their age.

A word might be said about the choice of the subjects presented here. The researcher in this field is faced with an exceptional range of problems which, in spite of its manifest beauty and delicacy, or indeed because of these qualities, are inherent to the study of Byzantine enamel. Foremost among them is the simple one of access. Although a huge majority of works in the medium would have been produced in Constantinople, virtually every single plaque has left the city. This means that the seeker after this art form has perforce to travel to many countries, visiting major and minor museums, ecclesiastical treasuries and collections of all kinds to see examples at first-hand. This widespread *diaspora* of works involving enamel has often prevented close comparison of one work with another – always an essential stage in trying to establish reliable developments and styles; only have exhibitions in recent years improved this to a limited extent. While photography can obviously be a huge assistance, minor inaccuracies in colour reproduction will give an inaccurate impression of the enamels that have been used in any one work. To minimise this problem accurate details of colours, using an internationally available system of colour terminology, are included in some of the studies, so that a more valid comparison can be made between works in different countries which would never normally be brought together. It is to be hoped that this practice will be extended, giving a broader base of data from which to work in the future.

Then there is the problem produced by the small proportion of examples which have survived; this is the starting point for the first of these studies. There has always been a huge and acknowledged loss of works in precious metal over the centuries, but with enamel this is compounded by the fragility of the medium. Enamel consists in essence just of small, thin areas of coloured glass which adhere to a metal base. This means that as soon as they become at all fractured or chipped they flake off from their original surface, and any inherent iconographic value is thereby lost. These plaques then tended to be useful only as scrap bullion, while the surviving enamels became available for re-use. This process explains why five

of the studies presented here (VI, X, XI, XV and XVI) all concern some form
of later re-use of plaques, while five others (VII, IX, XII, XIII and XIV) concern
ensembles that survive virtually in their complete and original form. One of the
fascinations of the arts of Byzantium rests often in how little, in any profound
sense, we really know about them or their makers. When so little is provided for
the modern enquirer into works in gold and enamel, very often the only docu-
ment available becomes the work itself. The examination of just a single ensemble
can thus be used to help us to gain a greater understanding of what lay behind
the production and development of this art form. This consideration lies behind
ten of the studies included here; it is often only by taking the examination of one
individual object further than has been done previously, and disregarding most of
the 'given' generalisations, that we have been able to build up a broader picture of
the circumstances of its production; in this way may it becomes possible to shed
further light on the uses and treatment of the medium in general. Even where some
of the most prestigious works are concerned, our knowledge of the background
against which they were created remains extremely obscure. If, for example, the
scribe of the manuscript of which the cover is examined in Study X had not written
of the journey he took from Rus' to Constantinople to acquire the enamels which
adorn it, we would never have known what lay behind its current appearance. In
the same way Study XII exemplifies how enamels might be used to stress liturgical
and dynastic developments, while it is suggested in Study XI that enamels now in
Stockholm could offer a glimpse into the virtually unknown territory of what art
might have been produced in the capital during its occupation by the Latin rulers
of the Fourth Crusade.

Throughout much of the medieval period it was widely known that the essence
of enamel was glass; when coloured with a variety of different metallic oxides, this
could be heated until it fused with the metal base on which it was placed. This
technique was widely practised, but it was the great heights of refinement which
Byzantine artists in enamel achieved that made their work so highly valued. In
particular, the extraordinary delicacy of the *cloisons*, or enclosures formed to hold
the different enamel colours, must have been particularly admired. Even in the
Byzantine period the products of the enamel workshops of the capital were treas-
ured in western Europe, presumably because they were regarded as impossible to
emulate. This accounts for their appearance in the works examined in Studies VI,
XV and XVI. The value of other assemblages, such as that discussed in Study VII,
led to records which make this the best documented collection of such works that
we have. While the well-head discussed in Study XVIII may seem something of
an intruder in a book devoted to the luxury arts, it is shown how this monolithic,
recently-carved piece of marble may have been such a rarity in the Byzantine world
that it seemed correct to include it in this collection.

Another notable feature of works in the luxury medium of enamel, which might be mentioned here, is how their prestige could continue to reflect fame and importance on the possessor beyond the period with which these studies are concerned. Some works even continued to represent such political significance that their location had in recent times to be changed or kept secret; this applied in the modern age to the famous Hungarian crown in Study IV, and to a lesser extent the cross reliquary found in Study XVI. Both these works were removed from their natural homes during the middle decades of the twentieth century to more secure locations.

I would like to close by offering a general expression of thanks to all those who have in their care the valuable works which I needed to study. They are held in various cathedral, church, monastic or hospital treasuries, in museums, in libraries, and in one case in private ownership, and I was invariably given access with the fullest consideration and help. Without such individuals in positions of custodianship, the study of much of the work published here would not have been possible. I also wish to express my gratitude to John Smedley, Celia Barlow and the editorial staff of Ashgate for their careful help.

PAUL HETHERINGTON

London
September 2007

A note on the illustrations: except where otherwise indicated all photographs are by the author.

ACKNOWLEDGEMENTS

Grateful acknowledgement is made to the following persons, institutions and publishers for their kind permission to reproduce the studies included in this volume: P. Yannopoulous on behalf of *Byzantion* (for study I); Walter de Gruyter GmbH & Co. KG, Berlin (II, III, V, XVIII); *Acta Historiae Artium*, Budapest (IV); *Cahiers archéologiques*, Paris (VI, XIV, XV); Istituto di Storia dell'Arte, Fondazione Giorgio Cini, Venice (VII); Istituto nazionale di Studi sul Rinascimento, Florence (VIII); David Brown, Oxbow Books, Oxford (IX); *Zeitschrift für Kunstgeschichte*, Basel (X, XII); David Buckton and Michael Hall, Editor, *Apollo*, London (XIII); Dimitris Arvanitakis, Head of Publications, Benaki Museum, Athens (XVI); Richard Shone, Editor, *The Burlington Magazine*, London and the Cathedral Museum, Mdina, Malta (XVII).

I

BYZANTINE *CLOISONNÉ* ENAMEL :
PRODUCTION, SURVIVAL AND LOSS (*)

Introduction

The modern world has always accepted that, over the centuries, a large proportion of works of medieval art have been lost. In the field of works in precious metal this loss will have been proportionally even larger, due to the inherent bullion value of the metal involved. What has often been too readily overlooked, however, is how easily these losses can distort the modern view of the development of a particular art form from the past, which has had to be based only on what has survived into the modern age. The question should always be asked when comparisons are made : is the basis on which a discussion of a work of medieval art is conducted sufficiently broadly based to validate a given conclusion ?

This paper has two main aims : one is to arrive at a considered basis for the level of loss that the field of Byzantine *cloisonné* enamel has suffered over the centuries ; this has not been attempted before, although it has always been assumed that losses would have been substantial. The second is to offer some thoughts on how the literature of the subject, often

(*) The author would like to express his thanks to Dr Christopher Walter for his helpful advice on various aspects of the content of this article.

To reduce the need for multiple bibliographical data for each individual work of art, references to publications of them have, where appropriate, been confined to entries in one of the four major exhibition catalogues of the last twelve years where the work has most recently been displayed ; these both provide references to earlier literature and offer the best reproductions but are not of course primary references. Those referred to are : *Byzance : L'art byzantin dans les collections publiques françaises* (J. DURAND *et al.*, Eds.) Paris, 1992 ; *Byzantium : Treasures of Byzantine Art and Culture from British Collections* (D. BUCKTON, Ed.) London, 1994 ; *The Glory of Byzantium : Art and Culture of the Middle Byzantine Era, A.D.843-1261* (H. C. EVANS and W. D. WIXOM, Eds.) New York, 1997 ; and *Byzantium, Faith and Power (1261-1557)* (H. C. EVANS, Ed.) New York, 2004.

due to an absence of secure data of other kinds, has had to rely extensively on the concept of a normality of enamel production and development to be able to arrive at many of its currently accepted conclusions (¹). This has already been questioned by David Buckton in the field of "early" Byzantine enamel (²), consisting as it did when he began of less than five objects, and which he may well have reduced to zero. He showed how some previously accepted conclusions were based on a perceived norm that had in turn been derived from too limited a surviving sample.

The medium of Byzantine *cloisonné* enamel is exceptional among the art forms in precious metal in that it is possible to claim that virtually the entire surviving field has been identified, and in various forms has even been published (³). Although further works in the medium may well come to light, it must surely be most unlikely that they would impose some radical change in how the medium is generally regarded. Chance excavations, such as those in 1928 of a plaque of St Procopius in the Forum of Theodosius in Istanbul (⁴), and in 1962 of a fragmentary inscribed frame and broken plaque in the Pantocrator monastery (⁵), are of individual interest and could well recur ; however, the relative completeness of our knowledge of surviving examples of the medium makes it unlikely that an isolated find would impose any radical changes on our current perceptions. Isolated pieces will also no doubt continue occasionally to appear, and may pass through the art market, but when this has occurred the generally accepted picture has not needed alteration.

An essential feature that governed the production of Byzantine enamel was that plaques were constricted by two significant technical factors. One concerned the physical size to which plaques were limited due to the need to retain a uniform rate of cooling after the firing process (⁶), and the

(1) See e.g. the entry by K. WESSEL in *RBK,* t. 2, Stuttgart, 1971, col. 105-106 where he cites ten dated plaques ; the same sequence is cited by W. F. VOLBACH in H. R. HAHNLOSER and R. POLACCO, eds., *La Pala d'Oro,* Venice, 1994, p. 44.

(2) See D. BUCKTON, *Byzantine Enamel and the West,* in J. D. HOWARD-JOHNSTON ed., *Byzantium and the West 850-1200,* Amsterdam, 1988, pp. 235-244.

(3) See n. 21-100 for references to the list assembled here.

(4) *Second Report upon the Excavations Carried Out In and Near the Hippodrome of Constantinople in 1928,* London, 1929, p. 44-45, Fig. 52.

(5) A. H. S. MEGAW, *Notes on Recent Work of the Byzantine Institute in Istanbul,* in *DOP,* 17 (1963), pp. 348-349 and Figs. 16 (mispr. as 61), 18 and 19.

(6) The description of the enamelling process given by the 12ᵗʰ c. artist Theophilus in ch. 54 of his *De Diversis Artibus,* emphasises how the vessel in

second was that, once completed and polished, the plaque could not be fully re-heated as this would destroy the enamel it contained. The result of these limitations was that the construction of an object such as a reliquary, a chalice or a book-cover that was intended to receive ornament in enamel would first have to be completed from other materials (usually either metal or wood) before being embellished by the plaques of enamel without the use of heat. To overcome this further technical restriction, the union of the plaques with their intended home would (on the evidence of a huge majority of surviving works) have been achieved either by their being pierced and then secured to their intended location by passing nails or rivets through the holes, or by being held by means of a narrow bezel or flange that was firmly attached to the object to be decorated, and which was burnished over the edge of the plaque ; in either method the use of heat was avoided. This process of production and attachment means that individual plaques could quite readily become detached from the object for which they were originally made. There is even good evidence that, during the medieval period, individual plaques could become the subject of re-use, and even re-sale ([7]). Certainly, modern museums now display in isolation individual plaques of Byzantine enamel which have become detached, and it tends to be this class of individual, isolated plaques which can now be found in private hands.

A gold base was used for the great majority of surviving middle Byzantine enamel plaques, and this presence of precious metal would always have represented a certain risk. But this would be increased substantially by the extremely fragile nature of the glass medium (whether opaque or translucent enamel) that the plaques contained. Once a plaque had suffered any significant damage to its enamel both its iconographic message could be lost and its decorative value reduced, and, when chipping and fragmentation of the glass held in the *cloisons* had continued and exposed any major areas of the base plate, its bullion value would be all that remained. Such damage could of course occur at any time, and a

which the enamels have been fired should only be cooled very slowly ; see ed. of C. R. DODWELL, London, 1961, pp. 105-106.

(7) A colophon written by the Russian scribe Naslav makes it clear that, while in Constantinople *c.* 1125 ordering enamels for a book-cover, he also acquired some earlier plaques as well ; see P. HETHERINGTON, *Byzantine Enamels for a Russian Prince : The Book-cover of the Gospels of Mstislav*, in *Zeitschrift für Kunstgeschichte*, 59 (1996), pp. 309-324. (Here Study X).

common solution (apart from leaving empty the frame holding the plaque) was either to create a new plaque in colours and a style which would not relate to those remaining on the object, or to find another Byzantine plaque with which to replace it. The regulation of gold and silver bullion was a matter of the greatest importance to the authorities in Constantinople, and the ninth/tenth-century *Book of the Eparch* indicates that severe penalties were reserved for goldsmiths and money-lenders who were found to have transgressed the sequence of regulations that governed transactions and trade in this medium ([8]). It must be of interest to our subject that while "gold, silver, gems and pearls" in various forms are specified in this text as being closely monitored and controlled, there is no mention at all of enamel. The most likely explanation for this is that it would only be the gold content of enamel plaques that would be of any importance or value ; fragments of glass enamel in damaged plaques would be of no financial interest.

Any discussion of general questions of the production of Byzantine enamel clearly needs to start from a basis that provides a broad total of surviving works, and to achieve this a compilation is presented below that brings together all the major known examples. So that the varieties of scale between small and large ensembles do not invalidate possible conclusions, this compilation includes the numbers of plaques found in each ensemble ; it can be seen that these vary greatly. The assemblage given below will permit a calculation to be made as to the total number of plaques that survive from the period of Byzantine art during which the production of enamel was current, which is independent of the scale or number of the objects on which they are found. What follows is therefore a listing, given necessarily in the briefest possible form, of all the main known surviving works of *cloisonné* enamel, with the number of individual plaques that have been used and with an indication of any of exceptional size. It will be seen that a few works such as the image of St Demetrius from the Guelph treasure now in Berlin ([9]), the enamel icon

(8) Although the punishment of having the hand cut off appears to be only retained for goldsmiths who abuse the coinage of precious metal, and for bankers involved in comparable practices ; see I. Dujčev Ed., *To Eparkhikon Biblion*, London (Variorum), 1970, Chs. 2 and 3.

(9) Most recently discussed by D. Buckton, *The Gold Icon of St Demetrios*, in J. Ehlers and D. Kötzsche, Eds., *Der Welfenschatz und sein Umkreis*, Mainz, 1998, pp. 277-286.

of St Theodore in St Petersburg ([10]) and the reliefs in the frame of the *Sacro Volto* in Genoa ([11]), have not been mentioned. Their omission is due to the fact that they do not conform to an accepted *cloisonné* technique, and so they present such an untypical usage of Byzantine enamel that their inclusion could be deemed to distort conclusions based on a recognised technique of *cloisonné* enamel production. For different reasons the uncertainties surrounding such works as the ewer at St Maurice d'Agaune ([12]), the plaque of a dancer in the V & A Museum, London ([13]), the enamels on the mitre from Linköping Cathedral now in Stockholm ([14]), on the gloves at Brixen ([15]) and on the staurotheke at Cosenza ([16]), have precluded their mention here. Problems also surround enamels with Georgian inscriptions and other characteristics, as these may well have been made outside the metropolitan Byzantine sphere ; for these reasons a number of such works in Tibilisi as well as those from Kievan Rus' ([17]) have also been omitted, as have the few enamels on such late artefacts as

(10) See C. WALTER, *St Theodore and the Dragon*, in C. ENTWISTLE, Ed., *Through a Glass Brightly*, Oxford, 2003, pp. 95-106.

(11) See G. WOLF *et al*, *Mandylion, Intorno al* Sacro Volto*, da Bisanzio a Genova*, Milan, 2004 (Exhibition catalogue), also P. HETHERINGTON, *The Frame of the* Sacro Volto *Icon in S. Bartolomeo degli Armeni, Genoa : the Reliefs and the Artist*, in *CA*, 50 (2002), pp. 175-184.

(12) For this and opinions on it, see P. LASKO, *Ars Sacra 800-1200*, Harmondsworth, 1972, pp. 23-24.

(13) See M. BÁRÁNY-OBERSCHALL, *The Crown of the Emperor Constantine Monomachos*, Budapest, 1937, p. 86-89.

(14) Most recently discussed by Å. NISBETH and I. ESTHAM, *Linköpings domkyrka, inredning och inventarier*, Linköping, 2001, pp. 110-113, fig. 69, *a-f*, with references to earlier literature ; I am currently revising the persisting assumption that these were made in Venice.

(15) For the roundels now on liturgical gloves in the Diocesan Museum, Brixen, see J. DEÉR, *Die byzantinierenden Zellenschmelze der Linköping-Mitra und ihr Denkmalkreis*, in *Tortulae*, Rome-Freiburg-Vienna, 1966, pl. 16 b and d.

(16) For the *staurotheke* at Cosenza, see DEÉR, *Zellenschmelze*, pl. 17 d, e, f, 18 a, and WESSEL, *Enamels*, pp. 176-181.

(17) For numerous examples see e.g. S. AMIRANASHVILI, *Medieval Georgian Enamels of Russia*, New York, n.d. ; one of the works most readily accepted as Byzantine is included here at n. 67. Discussion on the origins of the enamelled items of jewellery found in the 'Preslav Treasure' in 1978 does not appear conclusive.

the reliquary of Cardinal Bessarion ([18]), which are hard to see as part of an ongoing tradition. No attempt is made to distinguish different 'centres' of enamel production within the Byzantine world, such as has occasionally been attempted for Thessaloniki ([19]). Also, for this exercise niello ([20]) is not regarded as enamel, and finger rings with enamel have been excluded.

Some points should be made about the designations given below. *Number of plaques* indicates the totals of enamel plaques that survive attached to the object concerned, or in detached state. Plaques with non-figural and decorative designs are included, as to omit these would have presented an unbalanced overall picture, so they have usually been assessed as part of an ensemble, but plaques of separate individual small *tituli* are mostly omitted as being too diminutive to be added to a total production figure. Where enamel plaques have become detached from the objects for which they were originally made but survive reassembled on another object, or as an isolated group, they are indicated by *. For these, any date referring to a later location can for this reason only be a *terminus ante* unless they have internal evidence. Further, ** indicates that plaques have been securely dated either by internal evidence, such as an inscription, or by external circumstances (but not by stylistic argument). Detailed discussion of the chronology of individual works is not, in any case, an objective of this paper. *** has been introduced on six items to indicate that at least one plaque at the location referred to is of exceptional size, with one dimension exceeding 25 cm ; this provides a way of separating plaques of major scale from the less individually prominent examples.

(18) For basic data on this late and complex *staurotheke* see A. FROLOW, *La relique de la Vraie Croix*, Paris, 1961, n° 872, pp. 563-565, but the essay by J. B. SCHIOPPALALBA, *In perantiquam sacram Tabulam*, Venice, 1767, remains essential reading; final agreement on many of its aspects has not been reached, but wherever its enamel elements were made it does not appear possible to link them to an ongoing Byzantine tradition.

(19) See e.g. M. C. Ross, *Catalogue of the Byzantine and Early Medieval Antiquities in the Dumbarton Oaks Collection*, Vol. 2, Washington D.C., 1965, pp. 109-110.

(20) Niello is a black substance formed from silver mixed with sulphur and other metal, and has a lower melting-point than enamel; its medieval production is described by Theophilus in *De Diversis Artibus*, chs. 18-19, pp. 80-82.

Listing of surviving enamels

Ensembles or individual enamel plaques,
with current locations *Number of plaques*

Berlin, Kunstgewerbemuseum : detached plaques ([21]) 5
Budapest, National Museum : plaques possibly for a crown ([22])*/** 9
Budapest, Parliament : *corona graeca* of St Stephen's crown ([23])*/** 18
Cleveland, Ohio : enkolpion ([24]) 2
Copenhagen, National Museum : cross of Queen Dagmar ([25]) 2
Esztergom, Cathedral Treasury : staurotheke ([26])*** 1
Freising, Cathedral Museum : icon revetment ([27]) 20
Halberstadt, Cathedral treasury : St Demetrius reliquary enkolpion ([28]) 1
Jerusalem, Museum of Greek Patriarchate :
 'The King of Glory', icon revetment ([29])**/*** 28
Limburg, Diocesan Museum : staurotheke of the
 Proedros Basil ([30])** 60
London, British Museum : St Demetrius reliquary enkolpion ([31]) 2
 Cross enkolpion ([32]) 1

(21) St Demetrius : *Glory of Byzantium*, p. 107 ; Presentation plaques : K. WESSEL, *Byzantine Enamels from the 5th to the 13th century*, Shannon, 1969, p. 172-175.

(22) *Glory of Byzantium*, pp. 210-212.

(23) É. KOVÁCS and Z. LOVAG, *The Hungarian Crown and other Regalia*, Budapest, 1980.

(24) *Glory of Byzantium*, p. 164.

(25) *Idem*, pp. 498-9.

(26) P. HETHERINGTON, *Studying the Byzantine staurothèque at Esztergom*, in *Through a Glass Brightly*, C. ENTWISTLE ed., Oxford, 2003, pp. 82-94 ; see also *Glory of Byzantium*, p. 81.

(27) WESSEL, *Enamels*, pp. 195-6, with lit.

(28) *Glory of Byzantium*, pp. 161-162.

(29) See P. HETHERINGTON, *Who is this King of Glory ? The Byzantine Enamels of an Icon frame and Revetment in Jerusalem*, in *Zeitschrift für Kunstgeschichte*, 54 (1990), pp. 25-38. (Here Study XII).

(30) Recently discussed by Nancy P. ŠEVČENKO, *The Limburg Staurothek and its Relics*, in *Thymiama ste mneme tes Laskarina Mpouras*, Athens, 1994, I, pp. 289-294, with references to recent literature. See also n. 103, below.

(31) *Glory of Byzantium*, pp. 167-168.

(32) *Idem*, pp. 170-171.

(33) *Byzantium*, pp. 186-187.

(34) The 'Beresford Hope Cross' ; *Byzantium*, p. 132

(35) E. SPEEL, *Dictionary of Enamelling,* Aldershot, 1998, p. 30 ; a diminutive roundel of Christ in the same Museum is probably of Georgian origin.

(36) *Glory of Byzantium*, pp. 165-166.

(37) *Idem*, pp. 162-163.

(38) HETHERINGTON, *Enamels for a Russian Prince*, pp. 309-322.

(39) *Glory of Byzantium,* pp. 166-167.

(40) *Idem*, pp. 171-172.

(41) A. GRABAR, *Les revêtements en or et en argent des icônes byzantines du moyen âge*, Venice, 1975, pp. 62-63, with lit.

(42) WESSEL, *Enamels,* pp. 80-85.

(43) *Idem*, pp. 167-168.

(44) P. HETHERINGTON, *The Byzantine Enamels on a Staurothèque from the Treasury of the Prieuré d'Oignies, now at Namur,* in CA, 48 (2000), pp. 59-69.

(45) *Glory of Byzantium*, pp. 346-347.

(46) *Idem*, pp. 74-75.

(47) *Idem,* pp. 348-349 for five fragments ; the sixth from this group is in the Louvre ; see *Byzance*, pp. 328-329.

Decorative halo from an icon ([48])	1
Ornamental 'temple pendant' ([49])	2
Enkolpion ([50])	2
Tip of a pointer (formerly Stoclet Collection) ([51])	1
The Stavelot triptych ([52])	18
Orleans, Cathedral treasury : roundels ([53])*	2
Paris, Cluny Museum : roundel from Djumati icon ([54])	1
Paris, Louvre : paten (formerly Stoclet Collection) ([55])	4
Patmos, Monastery of St John : decorative halo on icon of St John ([56])*	1
Poitiers, Abbaye de Ste Croix, Saint-Benoit : surround of staurotheke ([57])	1
Richmond, Va., Museum : quatrefoil enkolpion ([58])	2
St Petersburg, Hermitage Museum : icon / reliquary (?) ([59])*	6
Siena, Biblioteca degli Intronati : book-cover ([60])*	54
Siena, Ospedale della Scala : enkolpion ([61])	5
Plaque ([62])	1
Sofia, formerly Ecclesiastical Museum : icon frame ([63])	1

(48) N. KONDAKOV, *Histoire et monuments des émaux byzantins*, Frankfurt, 1892, p. 294 and pl. 16.

(49) *Glory of Byzantium*, pp. 246-247.

(50) *Idem*, p. 165.

(51) *Idem*, p. 249.

(52) *Idem*, pp. 461-463.

(53) *Byzance*, p. 340, although a south Italian origin has been suggested.

(54) *Idem* p. 324 ; for the other nine roundels in this group, see n. 45, above.

(55) *Adolphe Stoclet Collection*, Fwd. by D. LION-GOLDSCHMIDT, Brussels, 1956, pp. 144-149. See n. 47, above, for a halo fragment also in the Louvre.

(56) A. D. KOMINIS *et al.*, *Patmos, Treasures of the Monastery*, Athens, 1988, pp. 107-108, 131 ; the plaques from the book held by the saint have not been included.

(57) *Byzance*, p. 326-328.

(58) *Glory of Byzantium*, p. 162.

(59) GRABAR, *Revêtements*, pp. 75-76.

(60) *Faith and Power*, pp. 509-511 ; two plaques from the spine appear now to be detached since 1978.

(61) L. BELLOSI (ed.), *L'Oro di Siena, Il Tesoro di Santa Maria della Scala*, Milan, 1996, p. 107-110.

(62) *Idem*, p. 105-106.

(63) *Glory of Byzantium*, p. 332-333.

(64) *Idem*, p. 243-244.

(65) Most accessible in S. AMIRANASHVILI, *Medieval Georgian Enamels of Russia*, New York, n.d., pp.93-123, but also in IDEM, *The Khakhuli Triptych*, Tbilisi, 1972.

(66) *Glory of Byzantium*, p. 342, although a possible Georgian origin is suggested.

(67) AMIRANASHVILI, *Georgian Enamels*, p. 90-91.

(68) H. R. HAHNLOSER (ed.), *Il Tesoro di San Marco, Il Tesoro e il Museo*, Florence, 1971, pp. 48-49.

(69) *Idem*, pp. 47-48.

(70) *Idem*, pp. 49-50.

(71) *Idem*, pp. 50-52.

(72) *Idem*, p. 63 ; "Inv." is used as a short form of "Inventario Tesoro" for all the items held in the Treasury, with only the final two held on the "Inventario Santuario".

(73) *Idem*, pp. 59-60.

(74) *Idem*, pp. 63-64.

(75) *Idem*, pp. 58-59.

(76) *Idem*, pp. 60-61.

(77) *Idem*, p. 64.

(78) *Idem*, p. 61.

(79) *Idem*, pp. 62-63.

(80) *Idem*, p. 62.

Chalice of green glass decorated with hares (Inv. 76) [81] 1
Chalice of onyx-agate (Inv. 94) [82] 4
Chalice of silver-gilt (Inv. 96) [83] 3
Crown of Leo VI (Inv. 116) [84]** 7
Detached plaques (Inv. 100, 146,147) [85] 16
Icon of St Michael (full-length, Inv. 6) [86]*** 55
Icon of St Michael (half-length, Inv. 46) [87]* 44
Icon of the Virgin Nikopoia [88]* 24
Pala d'Oro, principal plaques in lower part [89]*/**/*** 76
Pala d'Oro, principal plaques in upper part [90]*/*** 7
Pala d'Oro, minor plaques in surrounds and frames
of both parts [91]* 96
Paten (Inv. 49) [92] 1
Staurotheke (Inv. Sant. 75) [93] 7
Staurotheke of empress Irene Doukas (Inv. Sant. 57) [94]** 4
Vyšši Brod, monastery : cross of Záviš [95]* 11
Washington, Dumbarton Oaks : icon frame [96] 8
Detached plaques [97] 2

(81) *Idem*, pp. 103-104.

(82) *Idem*, pp. 61-62.

(83) *Idem*, pp. 65-66, although the lithograph by Osterreith after Girogio Canella in A. Pasini, *Il Tesoro di San Marco in Venezia*, Venice, 1885, pl. 38 shows several more plaques in place.

(84) Hahnloser, *Tesoro*, pp. 81-82.

(85) *Idem*, pp. 82-86.

(86) *Idem*, pp. 23-25.

(87) *Idem*, pp. 25-27.

(88) *Idem*, pp. 22-23.

(89) H. R. Hahnloser and R. Polacco, *La Pala d'Oro*, Venice, 1994, pp. 5-38.

(90) *Idem* pp. 39-43.

(91) *Idem*, pp. 44-70 ; the number includes the 17 purely ornamental plaques, but not the five of accepted 14th c. western production.

(92) *Idem*, p. 72.

(93) *Idem*, pp. 34-35.

(94) *Idem*, pp. 35-37.

(95) P. Hetherington, *The Cross of Záviš and its Byzantine Enamels* : *A Contribution to its History,* in *Thymiama* I, Athens, 1994, pp. 119-122.

(96) Ross, *Catalogue*, vol. 2, pp. 105-106.

(97) *Idem*, pp. 100-105.

Pectoral reliquary cross ([98])	1
Pear-shaped pendant ([99])	1
Reliquary enkolpion ([100])	2
Total	1.065

Period of production

As mentioned above, a few works of continuing controversial origin, authenticity or date have not been included, but while minor anomalies of inclusion or omission may be identified, this listing must represent a largely complete record of plaques of Byzantine *cloisonné* enamel that have indubitably survived into the modern age.

So if, to facilitate discussion and making allowance for some minor and easily repeated decorative plaques, we can use a round figure of 1000 as representing the total production of Byzantine cloisonné enamel plaques to have survived, a further step is to attempt to establish a period of time during which they must have been produced. Here the well-known paucity of dateable plaques that would provide an assured frame of reference has always been a problem, but as the purpose of this paper is not to discuss in detail the dating of individual works but to present an overall coverage, only 'outside' parameters of dates have been given here. A consensus has been reached that the great majority were produced from some time in the 9th c., when the image of Leo VI (886-912), on a crown in Venice, is the earliest securely dated plaque ([101]), and the later 12th century. This is supported by the named portraits or inscriptions on enamels from the reigns of the two 10th century emperors Romanos (920-944 and 959-963), where the name is found on two chalices also in Venice ([102]), by the reliquary in Limburg from the years 963-985 of which the inscription mentions the Proedros Basil ([103]), by those of Constantine Monomakhos

(98) *Glory of Byzantium*, p. 174.
(99) *Idem*, pp. 212-213.
(100) Ross, *Catalogue*, vol. 2, pp. 111-113.
(101) See n. 84, above.
(102) See n. 73 and 76, above ; it is usual now to acknowledge that Romanos II is the emperor referred to in both these inscriptions.
(103) See n. 30, above ; while the names of the emperors Constantine Porphyrogenitus and his son Romanos appear on the cross, that of the Proedros Basil is given on the box which contains it, and so he must be seen as initiating the creation of the enamels.

(1042-1055) whose image is found in Budapest ([104]), and those of the reign of King Géza I of Hungary (1074-1077) from St Stephen's crown and the emperor Michael Doukas (1071-1078) ([105]) ; his imperial portrait was also given a new home on the Khakhuli triptych, the large assemblage of enamels made by the Georgian king Dimitri I (1125-1146) ([106]). While the entire astonishing ensemble of the Pala d'Oro was only given the form in which it is now seen in Venice in 1343-1345 ([107]), the first commission for the plaques that now form the majority of the lower part was also of the 12th c., having an accepted and recorded date of 1105 during the dogeate of Ordelaffo Falier (1102-1118) ; the major plaques of the upper part, long accepted as booty from the Fourth Crusade, were installed in 1209 under the Doge Pietro Ziani (1205-1229) ([108]).

As in other fields, the Fourth Crusade and the occupation of Constantinople by western powers have usually been credited with having brought an end to the production of Byzantine *cloisonné* enamel, and this may well have been largely the case. While little evidence has so far been produced for the requisite skills and resources having survived and being practised through the 13th c., it can actually be shown that by the late 14th c. the previously used word for the medium of enamel, χευμυτής or ἔργα χυμευτά, was no longer even known to the writers of an inventory of the treasury of Hagia Sophia ([109]), and was apparently not available to be used by Sylvester Syropoulos when he accompanied the Greek patriarch to view the Pala d'Oro when he visited San Marco while in Venice in 1438 ([110]).

(104) See n. 22, above.

(105) See n. 23, above.

(106) See n. 65, above, pp. 100-101.

(107) See n. 89, above, pp. 39-43.

(108) HAHNLOSER / POLACCO, *Pala d'Oro*, pp. 129-131.

(109) See P. HETHERINGTON, *Byzantine and Russian Enamels in the Treasury of Hagia Sophia in the late 14th century*, in *BZ*, 93 (2000), pp. 133-137.

(110) In the account by Sylvester SYROPOULOS, *Les "Mémoires" du Grand Ecclésiarque de l'Église de Constantinople*, V. LAURENT ed., Paris, 1971, pp. 222-224, he refers to the Pala d'Oro as "an *eikon* formed from many others", with no mention of the medium ; he then, when disagreeing with what the group had been told by the Venetians (that the images in the Pala d'Oro had come from the templon of Hagia Sophia), even mentions the "brilliance of the material" (λαμπρότητι τῆς ὕλης) without using the word for enamel.

So the conventional view that the period of something over three centuries from the later 9th c. to 1204, or shortly after, must have seen the overwhelming majority of enamel production in the Byzantine world has usually been accepted, and may in all probability be broadly correct. In the case of enamels made during the reign of Leo VI, it must be assumed that the ability to create them must have been developing prior to his reign, and so the period of some 350 years from *c.* 850 to *c.* 1200 must, in broad terms, represent the time during which the overwhelming majority of the enamels listed above will have been created.

Survivals and losses

Simple arithmetic thus provides us with the basic fact that the surviving output of all Byzantine enamellers working in the *cloisonné* technique, suggested here as some 1,000 plaques, amounted to a tiny average production rate of only some 2.8 plaques per year. On this basis the reliquary of the Proedros Basil would have taken over 21 years to complete, and even the armlets in Thessaloniki over 14 years – with no other enamels being produced at the same time. If the period of 350 years was expanded to, say, 400 years to accommodate an earlier start or later ending, the rate of production would fall to just 2.5 plaques per year, or five plaques every two years. This finding clearly requires critical evaluation.

While the simple process that has provided us with these figures, although no doubt open to minor adjustment, must be substantially correct, the finding still raises many problems. First among these must be the extent to which the above listing represents a proportion of the total output of the medium. When dealing with works in any medium, the starting point for a secure solution to the problem of losses that may have accrued over the centuries would be provided if a possibility existed of placing them against a known total production. While this will never be possible in the field of Byzantine enamel, some steps can nevertheless be taken which will provide a basis for arriving at a putative figure for losses.

A first such step would be the simple one of observing the number of empty mountings in surviving ensembles where it is completely clear that plaques have simply become detached from their former home and disappeared, leaving either an empty frame or an evidently later replacement. Just as we know that one plaque in the Limburg reliquary is a

modern replacement ([111]), as eight in the Khakhuli triptych must be 19th c. ([112]), so too among the many enamel ensembles preserved in Venice empty mountings that must once have held enamel plaques can readily be found. From the frame of the spectacular icon of the standing St Michael where three roundels have clearly been lost, to the crown of Leo VI (seven), the book-covers of Lat. I, 101 (seven), Lat III, 111 (four later replacements) and the chalices at Inv. nos. 68 (four), 70 (three), 71 (thirteen), 72 (two) and 96 (eighteen) ([113]) all show evidence of discernible and countable loss. However, this exercise, even in the case of the uniquely well documented collection in Venice, only allows us to suggest a figure of some 67 plaques that can be demonstrated as having been lost from ensembles which have otherwise survived. At some 6% of just the existing known total this cannot be seen as more than a small step forward, and would only be significant if it was known that there had never been any other losses at all.

A second line of enquiry, which is inevitably more extensive, involves examining ensembles of surviving enamels which have been formed from plaques that have been re-used and re-located on other objects. (Individual plaques that survive in detached isolation will be discussed later.) It is not of course possible here even to summarise the many problems that still surround the enamels of the Pala d'Oro, but while the principal plaques of the lower part were indeed re-mounted in a new setting in 1343-1345, there is no secure basis for suggesting that there were significant losses from the early 12th c. commission. However, the 96 plaques from the entire frame can all be regarded as having been collected from a wide range of other origins, and the main plaques from the upper part were certainly re-located in Venice from their original home ([114]). They will be discussed below.

(111) It was made by the goldsmith D. Wilm during restoration ; see J. RAUCH, *Die Limburger Staurothek*, in *Das Münster*, 7/8 (1955), pp. 222-223, fig. 25.

(112) For these later plaques see AMIRANASHVILI, *Khakahuli Triptych*, pl. 53, 55, 64, 65, 66, 72, 74 and 80.

(113) For these, see above at n. 84, 69, 70, 74, 76, 77, 78 and 83.

(114) They are said by Volbach to have formed "decorazione di icone, di legature o di croce", and that "la maggior parte dei pezzi appartiene a serie incomplete". See HAHNLOSER / POLACCO, *Pala*, p. 44.

The listing above shows that of the 14 ensembles which contain plaques that were re-located from their original homes, 268 plaques (approximately 75%) are found in the three major ensembles of the Siena book-cover (54), the Khakhuli triptych (118) and the framing of the Pala d'Oro in Venice (96). The majority of the plaques that have been re-used in these three locations form in each case a random assemblage, in contrast with the programmatic character of plaques that remain in their original locations. While exceptions have to be made in such cases as St Stephen's crown, examination of smaller ensembles such as the book-covers in Moscow and Munich, the crosses at Namur and Vyšši Brod and the Nikopoia icon in Venice would confirm, but not add significantly to, findings based on these three major ensembles.

To take the book-cover now in Siena as the first of these major assemblages, it is clear that we are dealing with a collection of 54 Byzantine enamels brought together for later artists to use in the adornment of a liturgical object. I have previously suggested that these were Venetians who would have been charged with the creation of the book-cover using the random range of Byzantine plaques that were the product of the looters of the Fourth Crusade ([115]). Whether the artists were Venetians or Greeks is immaterial here, and while I have not found any reason to revise the characteristics of the eight groups formed by 25 of its 54 enamel plaques that I proposed in 1978, I was not then, of course, concerned with arriving at a possible survival rate that these groups might represent. Assessing them again now it can be seen that they are formed from survivals from a *dodecaorton,* a chalice ensemble, a 'deesis' group, and four other different but unquantifiable ensembles. It becomes clear that a conservative figure for the various ensembles from which these 54 plaques emerged would have to start from a total of around 150, and that a figure of more than double this number could be sustained.

With the triptych from Khakhul, now in Tbilisi, we confront the most numerous assemblage of Byzantine enamel plaques created during the medieval period ([116]). The 118 plaques that are now installed on the

(115) See P. HETHERINGTON, *Byzantine Enamels on a Venetian Book-cover,* in *CA,* 27 (1978), pp. 117-142. (Here Study VI).

(116) For basic data see AMIRANASHVILI, *Khakhuli Triptych* ; much of the information in this discussion on the triptych is based on personal observation by the author.

Khakhuli triptych could have had no commissioned origin comparable with the lower part of the Pala d'Oro, and their collective existence is recorded in a Georgian inscription running along the bottom edge of the outer wings. Here king Dimitri I (1125-1155) acknowledges that the triptych displays some enamels originally created for his father, king David III (the Builder), who died in 1125 ([117]). Of the original central subject, the half-length figures of the Virgin, stolen in 1859, only the face and hands are now present, having been returned from the Botkine Collection in 1923.

There was never any basic iconographic programme which controlled the detailed positioning of this extensive assemblage, and even a brief examination of the plaques underlines the essentially chance and random nature of their origins. A prominent feature of the wings, for example, is provided by the three crosses (one large and two smaller) which dominate the design of each. However, all six crosses are made up in different ways, with enamels only being used in three of the smaller ones (gems are used in the others), and one of them being formed from four decorative enamel strips that could derive from any decorative framing, with only two having figural content, itself of varied type. As with other ensembles our purpose here has to be confined to assessing the nature and extent of the groups of plaques from which those now present are the survivors, and so allow us to suggest a figure for the ultimate losses that are implied by those that have survived here.

Space does not allow a detailed examination of all the groups which contributed to this unique display, but an example is provided by two sequences of tall rectangular plaques in each of which a pair of standing saints is portrayed. Of these two groups that with the six smaller plaques, now located to either side of the central image, offers a series of the twelve apostles and so should be regarded as complete. That with the

(117) The inscription chased in the silver-gilt panels along the base of the triptych runs : "Thanks to God the Father, you the Queen make the things of your holy church to flourish on all sides; enrich the things of your holy church that David, the successor to David, has presented to you, the Virgin, with his own body and soul, and his family. Dimitri, a new Solomon rich with talents, and like the sun in the heavens, made your church bright at this time for your pleasure, holy Virgin, and for Christ our king". I would like to thank Dr Marina Kenia for providing me with this translation of a text which is insufficiently well known; the original Georgian text is in AMIRANASHVILI, *Khakhuli Triptych,* pl. 104-107.

larger plaques is confined to just two which are located at the base of the central panel ; now attached by flanges burnished over, these still display the empty nail-holes which secured them to their first home. So a basic presumption can be made that these are just two survivors of an original group of six plaques, which would have portrayed a series of the twelve apostles.

The complexity of the problem is illustrated by 36 further plaques which portray individual saints in isolation, none of which are seen in more than bust or half-length format ; of these ten are rectangular and 26 are roundels. Not only do shapes and dimensions vary extensively, but there is also much duplication, with four plaques of varied format portraying St John Theologos, four St Matthew, three St Luke and two St Mark. These 36 plaques must be the survivors of a minimum of 84, and probably from more than 120.

Of the 26 circular plaques, 14 are approximately 56-60 mm. diameter, and portray mainly apostles and evangelists ; the fact that among these plaques SS. Simon and Matthew appear twice strongly suggests that in all probability there were a minimum of two groups providing at least 24 plaques of which these are the survivors. Nine circular plaques of approximately 38 mm. diameter portray a wider range of saints, with the four evangelists accompanied by five warrior saints ; however two of these (SS. George and Theodore) are on roundels of 40 mm. diameter, with the other three including a second plaque of St Theodore. In more complete surviving ensembles warrior saints in pairs accompany, as guardians, apostles and evangelists ; this suggests that this assemblage of roundels will be the survivor of at least two, if not three, ensembles and so implies that these 26 are probably the survivors of up to 36 circular plaques.

When dealing with most of the remaining 74 plaques it is not possible to make use of the concept of established ensembles of saints. There are, for example at least 27 plaques of purely decorative enamel from which it is not possible to make deductions of any original complex.

There are also three plaques in *vollschmelz* ([118]), which must be the survivors of at least one larger ensemble in that they portray the Virgin and

(118) The term is used to designate enamel that covers the entire base of the plaque, leaving no gold showing, and is usually regarded as the earliest form of Byzantine enamel.

St Theodore in roundels and the crucifixion in a four-lobed plaque ; their technique makes them almost certainly the oldest enamels of the entire triptych. Among the larger rectangular plaques are three taller ones representing a conventional "deesis" group, but a single square one of Christ Pantocrator is unlikely to have been intended to be alone in its first home.

So in assessing the 118 medieval plaques now found on the Khakhuli triptych, and which were therefore available for the goldsmiths of king Dimitri I when the assemblage of plaques was completed in 1146 or slightly earlier, it appears that a conservative estimate would suggest that these were the survivors of a number of groups which would have totalled not less than 196. While this represents a theoretical minimum loss of some 40% we cannot now, of course, compute a reliable upper figure. However, one can surmise from the visually well-balanced arrangement of the plaques which were available to the creators of the triptych, that had a range of plaques that was more iconographically coherent been fully available the artists would have made use of them. As it is, their use of what had come to hand gives a widely disparate and imbalanced result ; for example, no less than eight representations of St John Theologos can be found, six of St Matthew and four of St Mark, with seven of Christ (other than in the two crucifixion scenes) and ten of the Virgin (two of these with the Christ child). The conclusion appears strongly that the 118 plaques that were used must have been all that could be found in 1146. There certainly does not appear to have been a policy of rejection of less suitable plaques, but rather one of maximum inclusion. In view of this, the upper figure of losses from the groups now represented may not have been very much higher than the 40% that has been argued above ; even if they had originally been accompanied by up to 50% that had been lost by 1146, this would give us a figure of 236 plaques that had been originally present at some anterior date attached to a range of objects, and of which 118 had remained available for re-use.

In the matchless riches in this field held in Venice, admiration for the medium had been long established even before the loot of the Fourth Crusade multiplied the huge range of Byzantine enamel held in San Marco. Leaving aside for the present the smaller ensembles such as the half-length icon of St Michael, where the 22 roundels and, probably, the two rectangular plaques portraying the archangels Oriel and Gabriel, will all have been re-located in the relatively recent main frame – perhaps as late as the 19th c. when the frame was renovated. The Nikopoia icon, too,

received its rather theatrical surround in 1617, and a conservative analysis would indicate that some 30 plaques were lost to provide the 16 that we see today, and this number could well be considerably greater.

But it is on the incomparable ensemble of enamels still to be found in its original home in Venice, and known as the Pala d'Oro, that attention must now be focussed ([119]). As the entire assemblage that we now see was given its present form in 1343-1345, its enamels have to be regarded as a huge enterprise of re-location, but, as indicated above, the principal groups of plaques in the lower part (the central cartouche, 6 deacons, 12 archangels, 12 prophets and 12 apostles, with 10 scenes of St Mark's legend and 11 scenes of feasts and of Christ's passion) will not here be regarded as having sustained any significant losses. The only question that could be raised would centre on the mixed nature of the subject-matter of the 11 feast and Christ scenes, but the relatively stable and uniquely public history of the entire ensemble does not encourage suggestions of any significant losses here.

Assessing the seven large plaques of the upper part we would agree with the most recent major treatment of the Pala, and regard them (six feast scenes and a single archangel) as representing just half of an original ensemble of the *dodecaorton* with one further accompanying archangel. Whether or not they originated in the monastery of the Pantocrator in Constantinople need not detain us here ; the group should be seen as the survivors of a 50% loss.

Much more problematic for our theme of survivals and losses are the major groupings of the 71 small figural plaques distributed over the surrounds and frames of both parts, which form the majority of the 96 plaques that would have been installed here in the course of the reconstruction of 1343-1345. As it is not possible to discuss in terms of losses either the 17 purely ornamental plaques, or the five roundels of secular or decorative content, these, with the five plaques accepted as being of western origin, have been omitted from this exercise. The remaining 71 plaques present a completely different range of problems

(119) While this is today without parallel, it is possible that it may have been inspired by comparable displays of gold and precious stones in Constantinople ; Robert of Clari briefly described that to be seen in Hagia Sophia on the high altar in 1204 : "...car le tavle, qui seur l'autel estoit, ert d'or et de pierres precieuses esquartelees et molues..." (Robert De Clari, *La Conquête de Constantinople,* P. Lauer ed., Paris, 1924, p. 84.)

from the two main parts ; it is for this reason that they are listed separately above. It has always been accepted that the varied format, dimensions, styles and identities of these plaques can only be explained by their having originated in a range of different periods and contexts, and in this respect are comparable with those on the Khakhuli triptych ; the main difference in these circumstances would be that the Venetian assemblage was given its present form some 200 years later. In the most recent major monograph their distribution has been described as "pienamente casuale" ([120]). As in the Khakhuli assemblage, the approach was clearly to include as many as were available, even adding the five western 'gothic' plaques, rather than to select from a larger number those that were most appropriate. A distinct difference from the saints portrayed in the work in Tbilisi, however, is that a large majority of those in Venice are not of major saints from such more common groupings as that of the apostles, but are of much less familiar subjects, some of them unique in the field of enamel.

In assessing these various groups in terms of survival and loss one could begin with what must have been the only sequence of roundels of similar size which included some of the apostles, where SS. Peter, Andrew, Bartholomew, Philip, Paul and John (Theologos ?) are joined by John the Baptist and SS. George and Demetrius ([121]) ; it would be a defensible assumption here that roundels showing six further apostles, now absent, would have been joined by roundels of the Virgin and Christ to form an original group of 15, of which eight are now lost. In another sequence of twelve plaques which share the same square format and size, and with each plaque bearing the same uncommon corner ornaments ([122]), it is possible with some safety to propose that they all started life attached to the same object. The fact that six of them are quite familiar warrior

(120) See HAHNLOSER / POLACCO, *Pala*, p. 44 : "Anche la loro disposizione sulla Pala attuale è pienamente casuale ed alcune figure, come il Pantocrator e diversi Santi, sono ripetute due volte". It is also very likely that no-one concerned with the design and disposition of the enamels in the frame could read the Greek inscriptions on the plaques ; this was certainly the case in 1359, when Byzantine relics were brought from Venice to Siena and sold with incorrect labelling ; see P. HETHERINGTON, *A Purchase of Byzantine Relics and Reliquaries in Fourteenth-century Venice*, in *Arte Veneta*, 37 (1983), pp. 9-30.

(121) HAHNLOSER / POLACCO, *Pala*, pp. 51-54 and pl. 52-53.

(122) *Idem*, pp. 57-61 and pl. 54-55.

saints, while the other six depict relatively minor martyrs, such as SS. Probos, Akyndinos and Eustratios, would suggest that this had probably been a reliquary containing relics of these martyrs, but it leaves no clue as to possible losses. A further group of eight roundels portraying minor male saints, all of the same size and strongly unified in style, should also be seen as having originally come from a comparable original object ([123]) ; however, the identities and functions of the saints are more varied than the former series, and do not conform to any established grouping. Among the remaining 42 plaques of this major assemblage of 71 the similarities between more than two or three make any further such grouping unsustainable. It is clear that their distribution and location on the Pala was guided solely by visual criteria, and that their identities were of no importance. Thus, for example, down the left-hand end of the upper part small and large plaques alternate, two roundels of the Virgin *orans* are separated by roundels of SS. Elizabeth, Demetrius, Sisinnios and Bartholomew. Isolated plaques from what must have been more spectacular ensembles, such as an imposing roundel of St George Tropaiophoros and a large, slightly oval plaque of Christ Antiphonetes (rare in other media and unique among surviving enamels), all suggest the varied origins from which the Pala d'Oro plaques derived. While any number suggested has to remain hypothetical, it is hard to see how the 71 figural plaques could be the survivors of original ensembles totalling less than 400 in their original locations and this, giving a survival of under 18%, is almost certainly a considerable underestimate.

To summarise this selection of the three major works in which plaques were re-used on a wholesale basis, it is suggested that the total of 265 plaques which they display, adapted from earlier ensembles, are the survivors of not less than 786, while a higher figure of over 900 could well be justified. This could be expressed as a perceived minimum loss of between 65% and 77%. While it is only secondary to our discussion, it could be mentioned that some of this loss of over 500 plaques had already occurred by the 12th c. and more by the 14th, when the two major collections in Tbilisi and Venice had been assembled.

(123) *Idem*, pp. 67-69 and pl. 58 ; the possibility of origin on a reliquary should have been included by Volbach (see n. 114, above.)

Detached and isolated plaques

A third line of enquiry should be mentioned, which is offered by plaques which still survive, but now unattached to any larger object and kept in isolation, usually in museums. One such group is the sequence of ten circular plaques of great refinement, now divided between New York and Paris, that originated on an icon of the archangel Gabriel at Djumati, in Georgia ; although the icon no longer exists, a 19th c. engraving indicates that there may have been eleven, suggesting a loss of just one plaque here ([124]). Other small collections in Berlin and London are also too slight to be made the basis of any productive discussion here. In reality, the only such group which is sufficiently numerous to be used as a basis for any further analysis is that in the treasury on San Marco, Venice. Here 15 plaques have been assembled, and it could be mentioned that they have most probably only found a home here after the Pala d'Oro had been completed in 1345 ([125]) ; if they had been available at that point it would seem, following the discussion above, that they would have been absorbed into that major enterprise. As it is, their minor individual status appears to have resulted in their arrival in San Marco to have been unrecorded in any of the long sequence of inventories, and they were only been reproduced for the first time in 1971 with the laconic note 'di provenienza diversa' ([126]). The duplications, with varieties in scale, and including the empress Zoe and the less familiar martyr saints Probos and Tarakhos, mean that these must again have come from a range of different contexts, and these 15 plaques could well be the survivors of at least 12 original groupings. A conservative figure for the total of these could therefore be put at 100. We will return to this theme below.

(124) For the engraving of the complete icon see KONDAKOV, *Histoire,* p. 254, fig. 91 ; for the roundels see n. 45 and 54, above.

(125) HAHNLOSER, *Tesoro,* pp. 82-86 ; this collection (see Pl. LXXVII, 13) even included one plaque that had originally been part of the decoration of a chalice also in San Marco itself (Tesoro 72), but was later re-attached in its original home.

(126) *Idem,* p. 82, and suggests no form of origin ; the entire assemblage was omitted from the first full illustrated publication in 1885 of the Tesoro by PASINI, *Il Tesoro di San Marco.*

Further uses of enamels

Up to this point we have been concerned with ensembles of enamels that have survived, even if only partially. It can be seen that we have had to consider plaques that overwhelmingly come from what must be seen as quite a narrow context : that of the decoration of objects with broadly liturgical functions. As with much of medieval art, the factors that control the accidents of survival are heavily weighted towards the survival of art forms with religious uses. Attention should briefly be drawn to a small range of enamels that have survived, but which would have had uses which did not offer the kind of protection that came automatically with liturgical use. To take the single survival of the pair of enamel armlets found in Thessaloniki in 1956 : it is very probable that this pair of secular arm ornaments is the sole surviving representative of a whole class of production. By chance we know of one aristocratic lady of the 11th c., Kale Basilakaina, who was both the daughter and the wife of high palace officials, and became a nun, and who in her will bequeathed "my wide golden enamel bracelet" to her sister Maria the Proedrissa ([127]). There must have been numerous such luxury items of adornment to be found among the ladies of the Byzantine court. What is now impossible to assert is any rationally argued figure that would represent those that are lost. Were there ever just ten such pairs of comparable ornaments ? – Or twenty ? – Or fifty ? We will never know, but a possible hypothetical figure will be ventured below.

It is rare for secular enamels to have been incorporated into the decoration of objects for religious use, as in the cross of Záviš, where two halves of a decorative pendant (originally used, it has been suggested, to hold scented cloth) were allied with religious plaques to form a single decorative entity ([128]). A few other such ornaments have survived, but their numbers and scale would again suggest that only a tiny proportion of a total production has survived into modern times. These enamels have been seen as related to a small number of objects, also of probably secular use, of which the decoration is of such exquisite delicacy that it has been suggested that they may derive from a single common workshop

(127) Her will is held at Iviron, Mount Athos ; see P. HETHERINGTON, *Enamels in the Byzantine World : Ownership and Distribution,* in *BZ,* 81 (1988), p. 34.
(128) See HETHERINGTON, n. 95, above, II, pl. 61.

serving an aristocratic level of patronage. Among this production is the pendant (perhaps from a *loros*) in Dumbarton Oaks, and the tip of a sceptre formerly in the Stoclet collection and now in New York. These isolated survivals are the only extant evidence of what must have been a much more numerous original output, and again a figure for the numbers lost will be offered.

Another location for the use of enamels was in the embellishment of icons. A few have survived which still demonstrate this custom; besides the two icons of St Michael in San Marco made from enamel throughout, the frames of those in Freising, Jerusalem (fig. 1) and the Great Lavra, Mount Athos (to name the more prominent) all display enamel plaques. We have textual evidence of a sufficient number of others to suggest that the survival rate of these may too be quite low; there is even a reference to an icon of the Virgin in Constantinople that is referred to as "the enamelled one" ([129]), implying that an entire image was made from enamel plaques. The inventory of the treasury of Agia Sophia made in 1396 also enumerates several items adorned with enamels, including an icon ([130]) ; these must have survived the looting of the city in 1204, but not the sack of 1453.

From these groups which must have sustained substantial losses, we should move now to the area where the losses have to be given as 100% simply because the existence of the enamels is known only from written sources; enamels with a particular class of use have been recorded as being present, but have since disappeared without leaving any other physical trace. Without the textual references we would not have known that even the particular application had occurred.

We could start here with one usage that may have absorbed quite a substantial output of Byzantine enamels, but of which our only source is literary : it is that of enamels used on the harness and saddles of horses or other animals. The mention of this practice is important partly because it would seem that not a single example has survived into the modern world, and we only know of it from chance mention in texts. While our knowledge of all aspects of the text of the (probably) 12th c. epic poem

(129) G. et M. Soteriou, *Icones du Mont Sinaï*, Athens, 1958, pp. 125-128 and pl. 146-149, where the upper part of the icon's frame bears five images of the Virgin, one of which is inscribed as ή Xυμευτή ; this is the only known reference to this designation of an image of the Virgin.

(130) MM, II, pp. 566-567 ; see also Hetherington, n.109, above.

Digenes Akritas may still not be complete, it must be important for our subject that it contains four references to enamels being used in this way : one is in conjunction with gold and pearls, two to an episode in which twelve women's saddles were decorated with gold, and two of these were specially adorned with enamels and pearls, and a fourth in which the harness and saddles of twelve selected mules were decorated with silver and enamels ([131]). We know also from the *De cerimoniis* that the harness of the emperor's horse was also adorned with enamels ([132]). Yet not a single plaque has survived of which it could be claimed with certainty that it was created for the intended use of this kind. So it would appear that an entire output of decorative or figural enamel plaques has here been lost without physical trace.

A further use of enamel must have occurred in the context of diplomatic gifts. Sometimes the use of enamel can be surmised but not proved, but an Arabic text by Ibnu Hayyam quoted by Ibn Mohammad al Makkari recounts the presence of enamel in just such a prestige diplomatic gift. In 949 Constantine VII sent a letter to the Caliph of Cordoba contained in a silver casket with a portrait of the emperor on the lid "made in coloured glass of extraordinary workmanship" ([133]). More specifically, we know that the *De cerimoniis* mentions how in the imperial palace enamel was made to serve diplomatic ends simply by creating an atmosphere of overwhelming richness and luxury; plates and other vessels were displayed solely to impress visiting dignitaries ([134]). What would these enamel ensembles been like ? Unless such magnificent items as the icons of St Michael in Venice are implied here, we will never know ; the losses that are implied by this 10th c. reference may well be 100%.

It is not far from enamel used on horse harness to enamel used on garments worn by dignitaries, and while only Digenes Akritas mentions this, his allusion to a garment worn by a man of which the hem was ornamented with enamels and pearls must be allowed to speak for other such examples ([135]). This is unlikely to have been a completely isolated

(131) *Digenes Akrites*, ed. and transl. J. MAVROGORDATO, Oxford, 1963, pp. 80, 122 and 128.

(132) *De cerimoniis aulae byzantinae*, E. REISKE ed., Bonn, 1829 (*CSHB*), I, p. 99 (bk.I, ch. 17) ; see HETHERINGTON, n. 127, above.

(133) For the sources of this episode see HETHERINGTON, n.127, above, p. 33.

(134) *De cerimoniis*, I, 640 (bk. II, ch. 40).

(135) *Digenes Akritas*, p. 80.

case, but again, none have survived. Interestingly, there is no evidence that the crowns, worn by members of the imperial family, ever bore enamel ornament ([136]).

Finally, nothing has so far been said of the known practice of installing enamel plaques on architectural or sculptural ensembles, which were for this reason in a static and non-portable form. A 10th c. text, the *Vita Basilii*, ascribed to Constantine VII, describes how Basil I built and embellished a church in the Great Palace of which the *templon* was adorned by images of "God in the form of man, represented several times in enamel" ([137]). It has also, for example, long been claimed that the plaques now located on the upper part of the Pala d'Oro in Venice originally adorned the *templon* of the monastic church of the Pantocrator in Constantinople, and whether or not this was the case the fact that the association was first proposed in 1438 by the Greek patriarch must suggest that the practice was not unknown to him ([138]). From a textual source we also know that the emperor John I Tzimiskes had his own sarcophagus made and had it decorated with gold and adorned with enamels ([139]). Again, as not a single example of this usage of enamel has survived in its original location, we can only guess at the frequency with which it could once be found.

Conclusions

What conclusions can be drawn from this assemblage of works of Byzantine enamel, in some cases still surviving in whole or in part, in others re-used by later artists of both east and west, and in others again lost and known to us only from written sources ? While it has always been recognised that losses would have been substantial, this study has made it possible to quantify the level of loss with greater assurance. We have assessed five categories of works in which Byzantine *cloisonné* enamel was displayed :

(136) P. HETHERINGTON, *The Jewels from the Crown : Symbol and Substance in the Later Byzantine Imperial Regalia*, in *BZ*, 96 (2003), pp. 157-168 ; the Hungarian crown was of course for a client ruler, not for the emperor.

(137) *Theophanes Continuatus*, J. BEKKER, ed., Bonn, 1838 (*CSHB*), pp. 330-331.

(138) See Sylvester SYROPOULOS, *Mémoires*, pp. 222-224.

(139) C. MANGO, *The Brazen House*, Copenhagen, 1959, p. 152.

1. Objects which retain in full the plaques with which they were originally adorned ;

2. Objects which retain some of their original plaques, but from which some have clearly been lost ;

3. Objects that have been created specifically to be adorned with plaques that were originally located on other works ;

4. Plaques that have been separated from their original locations but retained in isolation ;

5. Texts which demonstrate uses of enamel but of which no examples have demonstrably survived.

It should be emphasised that these five headings have been dictated by the evidence associated with the medium, either physical or textual, and that the first three provided the basis for the minimal figure of 65% loss that has been suggested. A figure of 80% loss could be easily defended on the basis of what has been discussed.

The problem should now be approached from another viewpoint. Taking all the various categories and applications of enamel that have been reviewed, and bearing in mind the factors of the fragility and bullion value of damaged plaques, and that some entire categories of production have vanished completely, it is suggested (taking the higher figure just mentioned) that we have today just 20% of a total production. However, applying this figure in another way will make even this seem much too high. If our total of 1,000 surviving plaques really represented 20% of a total production over 350 years, it would mean that there would have been a total of some 5,000 plaques produced ; yet even this total would mean that fewer than 15 plaques were created in any one year. A survival rate of 10% would increase this annual production to just under 30, implying that there had been a production of 10,500 plaques over the period. It is at this point that we can begin to approach a more convincing annual figure by applying the process to one work of, admittedly, outstanding scale. For we can be fairly sure that the 76 plaques of the new Pala d'Oro, some of exceptional size and complexity, that were commissioned by Doge Ordelaffo Falier who was elected in 1102, were installed in Venice in 1105. If the average of some 25 plaques per year that this implies is accepted (and it could hardly be less), we can begin to visualise a production that would have to be sustained while the workshops of Constantinople were continuing to deal with the normal and current range of 12th c. commissions. If the enamellers producing the plaques of the

Pala d'Oro were satisfying only half the commissions of those years, we can arrive at a modest annual total output of 50 plaques. While this may still be too low (and there are several plaques of exceptional size), it does mean that over a period of 350 years we can envisage the potential production of something over 17,500 plaques. Such a projection naturally implies an even rate of production, which is most unlikely to have existed, but given increases and decreases over this period this begins to approach a more realistic level of output. If this is anywhere near the case, it means that for each one of the 1,000 plaques that our listing shows did survive, there may well have been 16 to 18 more that have not survived into the modern world. To express this in another way, these figures indicate a rate of survival from the total output, over the whole period involved, of between only 1% and 2%.

Throughout this discussion we have tended at every point to minimise the likely level of lost enamels, and to propose a figure of even 3% survival could therefore still represent an overestimate. There may one day be evidence to confirm an overall survival rate of only 1% or 2%, but for the present this figure does explain the total absence of survival among such groups as enamels on harness or clothing, mentioned above, and the isolated survival of such works as the pair of armlets in Thessaloniki. It would indeed be within bounds of credibility to imagine that over a period of three centuries at least a hundred armlets of this kind might have been created to adorn the aristocratic or rich women of Byzantium, some being passed down from one generation to another, as was done by Kale Basilakaina.

What conclusions should be drawn from this to guide future research ? Firstly, and as mentioned at the beginning of this article, it would seem that the concept of an identifiable "normality" of production should only be used with great caution, and for much discussion should be largely abandoned. Any argument based on what enamels have survived should be qualified by the realisation that for every single surviving plaque under discussion there could be at least 16 (and very possibly more) that are lost. The lost examples might well have forced some qualification upon, or even disproved, conclusions based on the lonely survivors.

Secondly, it should always be born in mind that some categories of production would have been more subject to loss than others, and that enamels on liturgical vessels, for example, would very probably have a higher survival rate than most examples in secular use.

Thirdly, it is perhaps unexpected, but certainly of interest, that even by the 1140's it can be shown that substantial losses had already occurred even in enamels of Christian subject-matter. This is illustrated by, for example, the plaques of the Khakhuli triptych which were being assembled for the Georgian king, who could not bring together anything approaching an iconographically coherent programme, so that any plaques that could be found were being installed. Even so, in the discussion above those that were used had survived with a 40% level of loss even by the 1140's. So while the familiar picture of the sack of 1204 being the cause of the greatest loss of luxury objects, much had apparently already disappeared sixty years earlier.

Fourthly, while comparisons of one work with another may still be perfectly valid, any conclusion that is drawn should make allowance for a large and unseen majority of lost enamels that cannot be produced and compared for confirmation. Certainly, any claim that a work produced with particular enamel characteristics could have been unique, should only be made conditionally. What today can with justification be called unique, such as the armlets in Thessaloniki, might well in the 12th c. have existed in some numbers.

In conclusion, therefore, it could be suggested that while the concept of normality as applied to the broad chronology of Byzantine *cloisonné* enamel can be retained, when isolated survivals (either individually or as groups) are examined they should always be seen in a much larger context than is usually allowed. Space does not allow for a widespread discussion of how this approach could be applied, but there is one group of seven plaques which exemplifies the importance of constantly retaining in mind the fact that we have access to such a small proportion of a total production of enamels. It is the group that includes a portrait of the emperor Constantine Monomachos, which was bought by the National Museum in Budapest in the 1860's, and has been assumed to be a crown for over a century, and even displayed in this form ([140]). Whether or not this was their function, the fact remains that the technique as well as the subject-matter of these plaques can, under current conditions of knowledge, be justifiably regarded as a unique survival. Even the authenticity

(140) See n. 22, above ; already by 1884 it had been decided that the plaques formed a crown, as in C. PULSKY, E. RADISICS et É. MOLINIER, *Chefs-d'œuvre d'orfèvrerie ayant figuré à l'Exposition de Budapest*, Paris / Budapest [1884], p. 83.

of the plaques has recently been questioned ([141]). But what has not so far been possible to acknowledge is that (if they are genuine) this study suggests that there could at one time have been some 15 or more collections of comparable plaques with similar characteristics, and that even just a few of these might have offered, or even imposed, a range of conclusions that were more securely based than any current discussion allows. They could well have been part of the output of a particular workshop which would have produced many other enamels of the same technique and character over a generation or more. The same comments could be made on the small group of works mentioned earlier, which were excluded from this discussion precisely because their technique was matched in so few other surviving works, or none, such as the enamel icon of St Theodore and the dragon in the Hermitage ([142]).

A second question which should be raised here concerns works bearing enamels that have consistently been assigned to geographical centres other than Constantinople ; they have sometimes been referred to as "Byzantinising" ([143]), but an origin in the capital itself has not been thought possible. The presumption that workshops could have been active in the capital, but producing enamels of what are now qualified as lower artistic quality, has been almost universally applied, but without any persistent argument to support it. The norm has been to ascribe only what the modern eye regards as the highest quality works to the capital, and so allocate works of "lower" quality to an origin somewhere else in the Mediterranean world. This approach would seem now to be due for revision, as it can involve using the selected features of one plaque to argue a general stylistic trend for an unknown number of others.

(141) N. Oikonomides, *La couronne dite de Constantin Monomaque*, in *TM*, 12 (1994), pp. 241-262.

(142) See n. 10, above.

(143) As e.g. Deér, *Zellenschmelze*, n. 15, above.

II

ENAMELS IN THE BYZANTINE WORLD: OWNERSHIP AND DISTRIBUTION

Among the earlier scholars to write on the subject of Byzantine enamel a tendency can be found to assume that the medium was associated exclusively with the highest echelons of the imperial court, or of the church leadership in Constantinople[1]. There were certainly good reasons for this view of the subject to have become established; enamel was a medium *de grand luxe* and of spectacularly rich appearance, in which highly skilled workmanship was deployed in a labour-intensive form; it also involved using the most expensive materials, as the great majority of surviving enamels were made on gold. When compared with icons, or even with more modest manuscripts, for example, it could certainly be expected that ownership and use would be found to be far more narrowly distributed.

The view was also based on two further factors. One of these was the presence of imperial portraits in enamel on some objects still in existence, which certainly gives emphasis to this aspect of the subject; indeed, the only enamel portraits of living people that have survived are imperial portraits. If this is taken, when it occurs, to imply possession and exclusive use, then certainly a good basis for this view always existed. Also, as we shall see, it was supported by a number of textual sources, all of which gave emphasis to these associations. (It was also doubtless the rarity and value of individual enamel plaques that accounts for the relatively high incidence of re-use; we shall return to this question later.) The other factor was the texts in which reference is made to enamel objects, in which very often they are mentioned as highly prestigious items. This paper will seek to broaden the base of evidence so far used, and so extend our knowledge of the range of who would seem tho have owned and used, during the Byzantine period, items which incorporated this most luxurious of art forms.

When a wider range of sources is assembled it can be seen that the question of the Byzantine possessors of enamels is more complex, and subject to greater change, than has usually been suggested. No doubt, as more information becomes available, the picture that emerges will need modification, but it is hoped that in the meantime this discussion will contribute something to our knowledge of how objects displaying enamels were distributed in the Byzantine world.

There are two main forms of evidence available to us: works containing enamel which have survived into modern times, and textual and documentary sources which contain references to the medium. As it is the enamels themselves which have received most attention in the literature, we may start by briefly summarising those surviving works which contain internal evidence of previous or original Byzantine owners. Due mainly to technical aspects of production, Byzantine enamels were usually produced in the form of plaques measuring no more than a few centimetres in any dimension, and so (as is well known) they were most frequently found mounted in assemblies, sometimes of a considerable number, on objects of larger scale such as reliquaries or book-covers. The internal

[1] See F. Bock, Die byzantinischen Zellenschmelze der Sammlung Dr. Alex. von Swenigorodskoi (Aachen 1896) 43–49; J. Labarte, Recherches sur la Peinture en Email dans l'Antiquité et au Moyen Age (Paris 1856) 106ff; and *idem,* Histoire des Arts Industriels au Moyen Age et à l'Epoque de la Renaissance, 2nd ed. (Paris 1872–5) III, 70: «les empereurs s'étaient réservé sans doute le droit exclusif de fabriquer les émaux».

evidence needed to establish Byzantine ownership is normally therefore either in the area of the enamel itself (usually a portrait with an inscription), or in an inscription also found on the object to which the enamels were originally attached. The following grouping will cover the various surviving examples which offer this information.

Firstly there is the well-known group of enamels with named imperial portraits:
– The votive crown of the Emperor Leo VI (Venice, San Marco)[2]
– The Holy Crown of Hungary (Budapest)[3]
– The crown of Constantine Monomachos (Budapest)[4]
– Roundel medallion of the Empress Zoe (Venice, San Marco)[5]
(It is not proposed to include in this discussion the enamels of the Pala d'Oro in Venice, or those on the Khakhuli Triptych icon, now in Tbilissi. Although these uniquely magnificent works constitute by far the two greatest concentrations of Byzantine enamels, and both contain named imperial portraits, they are both in different ways assemblages, and so their use as secure evidence of any original Byzantine ownership would not be appropriate here.[6])

Secondly there is a group of enamels of which the mounting has an inscription indicating ownership or associations:
– The reliquary of the Proedros Basil (Limburg, Minster)[7]
– Two chalices of an emperor Romanos (Venice, San Marco)[8]
– The ring of Admiral Stryphnos (Washington, D. C., Dumbarton Oaks)[9]
– The icon frame of Michael Disypatos (Freising, Cathedral)[10]

Thirdly, there is a small category which should be included here which concerns objects which contain enamels, and although having no inscription or portrait, have some other means of identification with a Byzantine owner; this would include:
– The frame of the icon of the "Sacro Volto" (Genoa, S. Bartolommeo degli Armeni). Although an early tradition that it was presented by John V Palaiologos some time before 1388 is unconfirmed, the object is of such a character and status that previous ownership of this class is clearly far more probable that not.[11]

[2] H. R. Hahnloser (Ed.), Il Tesoro di San Marco; Il Tesoro e il Museo (Florence 1971) Cat. No. 92, pp. 81–82. (Hereafter, Tesoro).

[3] J. P. Kelleher, The Holy Crown of Hungary, (Papers and Monographs of the American Academy in Rome, XIII) (Rome 1951) with lit.; and now E. Kovács and Z. Lonag, The Hungarian Crown and Other Regalia (Budapest 1980) with updated bibliography.

[4] M. v. Barany-Oberschall, The Crown of the Emperor Constantine Monomachos. Archaeologia Hungarica, Acta Archaeologica Musei Nationalis Hungarici XXII (Budapest 1937).

[5] Hahnloser, Tesoro, Cat. No. 100, p. 84.

[6] For the Pala d'Oro see H. R. Hahnloser (Ed.), Il Tesoro di San Marco: La Pala d'Oro (Florence 1965); for the Khakhuli Triptych see Sh. Amiranashvili, The Khakhuli Triptych (Tbilisi 1972). The latter work particularly, is largely a collection of enamels of different periods made by the Georgian king David the Builder; I hope before long to publish a study of these enamels.

[7] J. Rauch and J. Wilm, Die Staurothek von Limburg. Das Münster 8 (1955) 201–240; also M. C. Ross, Basil the Proedros, Patron of the Arts. Archaeology 11 (1958) 271–275. The distinction should be maintained between the relic itself, which carries the name of an emperor Romanos, and the containing box which Basil the Proedros made for ist.

[8] Hahnloser, Tesoro, Cat. Nos. 41 and 42, pp. 59–61.

[9] M. C. Ross, Catalogue of the Byzantine and Early Mediaeval Antiquities in the Dumbarton Oaks Collection, Vol. 2, Jewelry, Enamels, and Art of the Migration Period (Washington, D.C. 1965) No. 158, pp. 108–109.

[10] A. Grabar, Les Revêtements en Or et en Argent des Icones Byzantines du Moyen Age (Venice 1975) No. 16, pp. 41–43, with lit.

[11] C. Dufour Bozzo, Il "Sacro Volto" di Genova (Rome 1974) 28–30. The particular technique of the scenes on the frame, involving a combination of repoussé forms and simplified enamel application in parallel strips of only three colours, suggests a later 14th century date.

– The enkolpion reliquary of the Holy Blood (Siena, Ospedale della Scala), documented as being sold from the imperial collection by the empress Helena Kantakouzenos, wife of John V Palaiologos, in 1356/7.[12]

There are other works which might be included here, such as the cover of the Gospels of Mstislav (Moscow, Historical Museum), or that of the pericope of Henry II (Munich, Staatsbibliothek). The latter has the best claim to containing enamels which all were once the property of a Byzantine owner (the princess Theophano, who married Otto II in 972) but their owner in their present form was certainly Western,[13] while the problematic assemblage of enamels on the Moscow book-cover date from the 10th through to the 16th century, and so constitute an assemblage indicating yet again the esteem in which all Byzantine enamels were held.[14]

In general, therefore, it can be seen that the early view of Byzantine enamels being found only among the highest echelons of the court and clergy does indeed have a real basis in the surviving works; where an owner is known at all, he or she would seem fairly certainly to have been a member of some form of aristocracy. While it may not always be clear precisely what is to be understood by the expression "ownership", it is probably true that works bearing imperial insignia were associated overwhelmingly with the entourage of the emperor or his family. Whether the chalices with the name of the emperor Romanos were used exclusively by him, or were presented by him for use by others, is probably unimportant; they must be assumed to have had pre-eminently an association with him, in the same way that the Zoe medallion (which must have originally been attached, with other enamels, to a larger object) can be regarded as a survivor from an object associated with her. Even the works mentioned in Siena and Genoa can trace a direct imperial provenance. Where enamelled objects were in the possession of major ecclesiastical institutions the question of personal ownership is harder to determine, and it may be on this account that no inscription survives which explicitly suggests this kind of use. All inscriptions refer to individuals, not places.

Three factors should now here be emphasised. The first concerns the approximate proportion of total surviving works that the above group represents when related to the known and broadly accepted canon. While no *corpus* of Byzantine enamels yet exists, it is probable that (always omitting the completely exceptional cases of the enamels of the Pala d'Oro and of the Khakhuli Triptych) we have noted above only some 15–20% of surviving objects into which Byzantine enamels are in some way incorporated.[15] The second is that even among these nine works, there are two (the ring of Admiral Stryphnos and the icon mount dedicated by Michael Disypatos) which have no claims to imperial ownership at all. So it can be seen that the view that the owners of enamels must neccessarily have been of exalted status can only be based on no more than a fifth of even what has survived. Thirdly, there is the obvious consideration that we are dealing with an art form in which there must have been a very high overall rate of loss. The areas of glass in any cloisonné enamel fracture and fall away very easily, and once this process has begun the work is very disfigured, and the gold becomes very liable to be melted down for bullion and subsequently re-used. It is of course impossible to know with what

[12] P. Hetherington, A Purchase of Byzantine Relics and Reliquaries in Fourteenth-century Venice. Arte Veneta 37 (1983) 9–30. During the sale negotiations two Western bishops visited the empress to obtain her personal affirmation as to its origin in the imperial possession.

[13] P. E. Schramm, Ein byzantinisches Stemma aus dem Besitz Heinrichs II. (Theophanus?), Herrschaftszeichen und Staatssymbolik II (Stuttgart 1955) 638–642.

[14] N. Kondakov, Les Emaux byzantins Collection A. W. Zwenigorodskoi (Frankfurt 1886) 185–186.

[15] The most recent survey of the subject is that of K. Wessel, Byzantine Enamels from the 5th to the 13th century (Shannon 1969) in which 66 works are listed; the great majority of surviving works are enumerated here, although there ist no claim to inclusiveness.

proportion we are now dealing, but it could well be 1% or even less of what was in existence during the 14th century, when production of the medium largely ceased.[16] It is therefore essential that any valid conclusions on this subject should involve the use of further evidence in the form of written sources.

The nature of much Byzantine literature – historiography, theological commentary, homilies and sermons, lives of holy men and women, pilgrim's and travellers' accounts, poetry, etc. – is not one in which precise reference to any artistic medium can be expected to appear with any great frequency. Nevertheless (to take this field first) a small number of texts can be assembled which contain specific references to the existence of possession of enamel objects; although making no claims to completeness, these must at least be representative of this kind of source, and are given here in approximately chronological sequence.[17]

– *Narratio de structura templi S. Sophiae*: an 8th/9th century account of the building of Hagia Sophia. It is characteristically poetic in its approach, being neither objective nor technically very informative, but it contains this unequivocal reference to the use of enamel. "...[Having cast the top of the main altar table, Justinian] set it up, and underneath it he placed columns of pure gold with precious stones and enamels; ..."[18] This was probably the object that Nicetas Choniates described as having been broken into pieces in 1204 so that it could be divided among the soldiers of the Fourth Crusade.[19]

– *De cerimoniis aulae byzantinae*: compiled by Constantine VII, the detailed descriptions of the official life of the imperial palace contained in the famous 10th century "Book of Ceremonies" may fairly be regarded as contributing substantially to the "aristocratic" or "exclusive" view of the ownership of the medium. The imperial palace clearly housed great resources of works containing enamel: plates and other vessels,[20] objects simply exhibited for display to dignitaries,[21] more than once, simply "enamelled works",[22] and even the harness on the emperor's horse[23] – all are referred to as being decorated with enamel. A further interesting mention occurs in the ceremonies of the eve of Palm Sunday, when (it is written) "... the emperor stands in the Church of Saint Demetrius before the enamel icon of the Theotokos."[24] This is the only textual reference that we have to this image, but it is possible that its appearance can now be established.[25]

– *Vita Basilii*, being Book V of *Theophanes Continuatus*: written in the 10th century, and ascribed to Constantine VII. Telling of the buildings with which Basil I embellished the Great Palace, the text describes the screen that was built separating the choir from the

[16] There is general agreement that no surviving work in enamel can be dated to later than c. 1400, or even considerably earlier. See Wessel, op. cit., 30–31 and 195–200.

[17] For the etymology of χυμευτή, or ἔργα χυμευτά see Kondakov, op. cit., 84–85.

[18] Th. Preger (Ed.), Scriptores Originum Constantinopolitanarum (Leipzig 1901) 95 (In: Narratio de structura templi S. Sophiae).

[19] I. Bekker (Ed.) Nicetas Choniates, Historia (Bonn 1835) (CSHB) 758.

[20] E. Reiske (Ed.), De cerimoniis aulae byzantinae (Bonn 1829) (CSHB) I, 597 (Bk. II, ch. 15): ... [on a small gold table were set] δούλκιον διὰ χειμευτῶν καὶ διαλίθων σκουτελλίων, ...

[21] Ibid, I, 640 (Bk. II, ch. 40): σκοῦτον χρυσοῦν χειμευτόν ...

[22] Ibid, I, 581 (Bk. II, ch. 15): ... ἰστέον, ὅτι τὰ στέμματα καὶ τὰ χειμευτά ἔργα ἕν παρ' ἕν ἐκρέμαντο, ἤγουν μέσον στέμμα καὶ ἔνθεν κἀκεῖθεν ἔργα χειμευτά.

[23] Ibid, I, 99 (Bk. I, Ch. 17): ... ὁ βασιλεὺς ἐφ' ἵππου ἐστρωμένου ἀπὸ σελοχαλίνου χρυσοῦ διαλίθου χειμευτοῦ, ...

[24] Ibid, I, 170, (Bk. I, ch. 31): ... πρὸ τῆς χειμευτῆς εἰκόνος τῆς Θεοτόκου ...

[25] G. et M. Soteriou, Icônes du Mont Sinai (Athenes 1958) text vol. 125–128, pl. 146–147, shows an icon with four images of different types of the Virgin, one of them being titled ἡ χυμευτή "the enamelled one"; this type is also similar to the enamel image on the enkolpion now in the church of St Mary, Maastricht (Wessel, op, cit., pl. 39), and it is probable that they both reflect the lost enamels icon in the Church of St Demetrius (Wessel, op. cit., 119–120.)

nave in one of the most sumptuous of the churches that he initiated: "its columns and lower part are made entirely of silver, while the beam that is laid on top of the capitals is of pure gold. ... The image of our Lord, God in the form of man, is represented several times in enamel upon this beam."[26] While this has of course not survived, its general appearance can be surmised from the evidence of other screens or *templa*.[27]

– An Arabic text by *Ibnu Hayyam* quoted by Ibn Mohammad al Makkari: a history of the Mahomedan dynasties of Spain, it recounts an episode in which enamel appears to have been used as a prestige diplomatic gift. In 949 Constantine Porphyrogenitus sent gifts to the Caliph of Cordoba, Abd-al-Rahman; his ambassadors gave the Caliph a letter in a silver casket on the lid of which there was a portrait of the emperor "made in coloured glass of extraordinary workmanship".[28]

– *Patria Constantinopolitanae*: a late 10th-century text recording *inter alia* the activities of the emperor John Tzimiskes. He is said, shortly before his death, to have had his own sarcophagus constructed from decorated gold inlaid with enamel. It was sited in the narthex of the church that Tzimiskes had reconstructed in a raised part of the Chalke complex, and on his death in 976 he was buried in it.[29] This reference, with the first and third above, are of interest in that they represent what was most probably a rarer usage of enamel in a fixed or static context.

– *Digenes Akrites*: the 10th/11th century epic poem concerning the exploits of "the borderer" represents life in the remoter regions of Asia Minor, rather than amid the wealth and relative security of the capital. Although poetic invention must lie behind much of its imagery, the text contains altogether six references to the decorative use of enamels. Four of them refer (as in the *De cerimoniis*) to the application of enamels to harness: one in conjunction with gold and pearls; two to an episode in which twelve women's saddles were prepared, of which ten were decorated with gold, while two special ones were adorned with enamels and pearls; and another to a lavish present among which were twelve selected mules of which the saddles and harness were decorated with silver and enamels.[30] Also in a purely decorative context, enamels and pearls are described as ornamenting the hem of a red tunic worn by a man.[31] Finally, and nearer to more familiar use of the medium, among the presents which included the mules were "two enamel icons of the Saints Theodore."[32]

To these sources, of which the character is to some degree literary, and even rhetorical, some more can be added which represent the field generally known as brevia: wills and inventories of the possessions of individuals and of religious institutions. These are of the utmost importance for our purpose, as any future user of the listing would have been expected to be able to identify any item that was mentioned, and they therefore represent some of the most secure information we have on works of this kind. The nature of this

[26] Theophanes continuatus (Ed. J. Bekker), CSHB (Bonn 1838) 330–331: ἐν ᾗ κατὰ πολλὰ μέρη καὶ ἡ θεανδρικὴ τοῦ κυρίου μορφὴ μετὰ χυμεύσεως ἐκτετύπωται.

[27] See Hahnloser, Tesoro, 95 and pl. LXX.

[28] See Labarte, Peinture, 112, where the MS source is given as Bibl. imp., MS arabe, anc. fonds No. 704, fol. 9. v.

[29] Preger, Scriptores (1907) 283, n. 2 (Patria Constantinopolitanae); this is discussed in C. Mango, The Brazen House; a Study of the Vestibule of the Imperial Palace of Constantinople (Copenhagen 1959) 149–152; and in Labarte, Peinture, 114–115.

[30] Digenes Akrites (ed. & transl. J. Mavrogordato) (Oxford 1963) 80, 122 and 128; I do not accept Mavrogordato's translations of χυμευτά as variously "fused", "handicraft", "jewelly", etc.

[31] Idem, 80: τὰ ὅλα ἔργα χυμευτὰ μετὰ μαργαριτάρων, and 128: ... μετὰ σελλοχαλίνων ἀργυρῶν τε καὶ χυμευτῶν, ἔργων ἀξιεπαίνων·

[32] Idem, 128: εἰκόνας δύο χυμευτὰς ἁγίων Θεοδώρων ...

evidence also does more than anything else to redress the imbalance that is inevitably produced by the texts given above.

– *Will of the Protospatharios Eustathios Boilas*: an almost unique document for its date (1059), this will includes an inventory of the possessions of a major landowner in the eastern provinces of the empire, who had previously been an official of the highest importance in the capital.[33] After a number of major dispositions, the will goes on to make two references to enamels, their mention here contrasting with the more poetic context in which they occur in *Digenes Akrites*. Eustathios had some time previously built a church which he had endowed with a number of objects of liturgical use, and he took this opportunity to confirm the donation. Mentioned first among them is "the venerable cross with gold and enamel images in six plaques."[34] This most probably refers to a cross that was large enough to have the core (probably made of wood) covered with gold sheet, and to which six enamels (probably roundels) were fixed.[35] The second mention of enamels is more obscure, and comes first among a considerable number of books, also given to the church already founded by Eustathios: "My treasure, most highly honoured beyond all honour, the sacred and holy Gospel, written throughout in gold [letters], and having golden images of the four evangelists with enamel decoration."[36] The precise form of the enamels mentioned here is not clear, but the object referred to must be a *de luxe* evangelistary; the cover was ornamented with enamels, although the evangelist portraits mentioned were probably painted miniatures found inside at the head of each gospel. Certainly no evangelistary has survived with just four evangelist portraits in enamel on the cover, feast scenes being apparently *de rigeur* from the 11th century onwards.

– *Will of the nun Maria*, who (as Kale Basilakaina) was the wife of the Kouropalates Symbatios Pakourianos and daughter of the Kouropalates Basilakios. This late eleventh-century will in the monastery of Iviron, Mount Athos,[38] is of considerable interest, as the objects itemised in it must be presumed to represent the property of an aristocratic lady of the Byzantine court. After a number of other bequests, some items of personal adornment are listed as being bequeathed "to my sister Maria the Proedrissa"; among them are a garment decorated with pearls, a girdle, and then "my wide golden enamel bracelet" is mentioned.[39] Coming where it does in the sequence of objects would imply that it was not regarded as the most valuable of the possessions being bequeathed, but it is of interest in that (with the partially comparable ring bearing the name of Admiral Stryphnos) it is the only reference to personal jewellery that we have.[40]

[33] Text published by V. Beneshevich, Zavieschanîe vizantîiskago boiarina XI vieka. Zhurnal ministerstva narodnago prosvieshchenia (St Petersburg May 1907) 219–231; translation and discussion by S. Vryonis Jr., The Will of a Provincial Magnate, Eusthathius Boilas (1059). Dumbarton Oaks Papers 11 (1957) 263–277.

[34] Beneshevich, 226: ἤγουν ὁ τίμιος σταυρὸς διάχρυσος χυμευτὰς ἔχων εἰκόνας, βλεμία ἕξ ...

[35] Possibly comparable with the cross reliquary now in the Cathedral, Cosenza (Wessel, op. cit., pl. 56).

[36] Beneshevich, 226: ... ἅγιον εὐαγγέλιον, χρυσόγραφον διόλου, χρυσᾶς ἱστορίας ἔχον τοὺς τέσσαρας εὐαγγελιστὰς μετὰ χυμευτῶν ἐξεμπλίων, ...

[37] See Tania Velmans, La couverture de l'Evangile dit de Morozov et l'évolution de la reliure byzantine. Cahiers Archéologiques 28 (1979) 115–136. The tradition of feast scenes evolved from that of standing figures of Christ and the Virgin, and evangelists only appear in this context in the 13th–14th centuries.

[38] Joachim Iverites, Ἐκ τοῦ Ἀρχείου τῆς ἐν Ἁγίῳ Ὄρει ἱερᾶς Μονῆς τῶν Ἰβήρων. Ὀρθοδοξία 5 (1930) 613–618 and 6 (1931) 364–371. See also F. Dölger, Aus den Schatzkammern des heiligen Berges (Munich 1948) 180–184, where an isokodikon (dated 1098) referring to these parties is published as no. 65.

[39] Iverites (1931) 366: Τὰ βραχιόνιά μου τὰ χρυσᾶ τὰ χειμευτὰ τὰ πλατέα. ...

[40] The two armlets in Salonika (Wessel, op. cit., pl. 14) although probably more substantial, may well be the only comparable objects to have survived into modern times.

– *Inventory of the treasury and library of the Monastery of St John the Evangelist, Patmos.* Written in 1201, this inventory gives a valuable insight into the holdings of a major ecclesiastical foundation, which had prospered since its foundation in 1088.[41] The inventory opens with a list of the icons held, which include: "A large holy icon of [St John] Theologos with silver-gilt surround, and the halo and gospelbook [held by the saint] both [decorated with] enamels on gold, and silver[42] ... another rounded [image – ?enkolpion] of the Virgin and child both in silver-gilt and enamel... [in the cell of the abbot] an enkolpion of the Virgin and child, decorated all over with silver and enamels... a [?]processional cross with images in enamel."[43] The next section concerns relics, and opens: "Three holy relics of wood [?of the cross] having silver mountings[?], enamelled and gilded."[44] It should be noted that in both sections here a strict sequence was used which began with the most valuable of the objects in any one category, and that those with enamels were placed first. (The inventory ends by listing the books held, and although this is by far the longest section, there are no enamel bindings mentioned.)

– *Inventory of the monastery of the Virgin Eleousa near Strumica, Macedonia.* This was an eleventh-century imperial foundation, and the earliest surviving inventory of its possessions dates from 1449.[45] The first section deals with the holdings of books, listing almost seventy, but without mentioning any bindings of value. There follows a substantial list of icons, with the first seven being grouped as "adorned"; the fifth among these is described as: "A large icon of the most holy Virgin and child, speaking sweetly, and having two haloes, both silver-gilt and with enamels."[46] If significance is to be attached to the position of this item in the inventory (and in general it is clear that care was taken over the arrangement) it would indicate that other factors, probably concerning size, meant that some icons were here more highly valued than the one with enamel decoration.

* * *

The nature of much Byzantine literature would make it likely that the only sources which might mention enamel would be those having associations with the court or with the highest ecclesiastical authority; in this way the first seven of the texts cited above tend to confirm the "aristocratic" view of the ownership of enamels. Indeed, it is only when the second category of documentary sources is assembled that any notable change begins to emerge. Some brief general points could be made first.

It is notable that so many of the references are to enamel decoration on harness – clearly a vulnerable form of use for this fragile medium. It could also be mentioned in connection with the references in *Digenes Akrites* that, although the work has no pretensions to accuracy, it must be of interest that even in this poetic context it was not

[41] Ch. Diehl, Le Trésor et la bibliothèque de Patmos au commencement du 13e siècle, B.Z. 1 (1892) 488–525.

[42] Idem, 511, under heading of "holy icons": Εἰκὼν ἁγία μεγάλη ὁ Θεολόγος ... καὶ στεφάνου καὶ εὐαγγελίου τῶν ἀμφοτέρων χρυσοχειμευτῶν ... Some separate haloes of this type have survived; see Kondakov, op. cit., pls. 16 and 20.

[43] Idem, 512: ἕτερον στρογγύλον Θεοτόκος μετὰ βρέφους, τὰ ἀμφότερα ἀργυρᾶ διάχρυσα χειμευ-τά. ... ἐγκόλπιον ὁλοκόσμητον ἡ ἁγία Θεοτόκος ἀργυροχειμευτὸν μετὰ βρέφους. ... ἕτερος σταυρὸς σίγνον ἔχων εἰκονίσματα χειμευτά. For the use of σίγνον in this sense, see C. Mango, The Art of the Byzantine Empire 312–1453 (Sources & Documents in the History of Art, New Jersey 1972) 238. n. 289.

[44] Idem, 512, under heading of "τῶν τιμίων ξύλων καὶ ἁγίων λειψάνων: Τίμια ξύλα τρία ὦν τὸ ἐν ἀργυροτζάπωτον χειμευτὸν καὶ διάχρυσον."

[45] L. Petit, Le Monastère de Notre Dame de Pitié en Macédoine. Izviestiia russkago arkheologicheskago instituto v Konstantinopolie, VI (1900) 114–152.

[46] Idem, 118–119: Εἰκὼν μεγάλη στασίδιον ἡ ὑπεραγία Θεοτόκος μετὰ βρέφους ἐγκάρδιον εὐλαλᾶ-τον ἔχουσα φέγγη δύο χυμευτὰ ἀργυρᾶ διάχρυσα.

incongruous that a border chieftain might have possessed icons in enamel, which in this case formed prestigious gifts. Thirdly, it is interesting that the enamel bracelet of the nun Maria (the only mention we have of an item of personal jewellery) does not appear to have been among her most valued possessions. This may perhaps suggest that in some cases it was the associations of the medium which gave it its significance.

A summary of these documentary sources adds the following objects to the previously accepted body of works containing enamels:

- A cross that was of sufficient size to support six plaques;
- Another cross with enamel imagery;
- A Gospelbook with enamels on the cover;
- Two icons with enamel attachments that would certainly have been nonfigural in character – decorative haloes and the book held by St John;
- Either two or three enkolpia with images of the crucifixion and of the Virgin and child;
- Three reliquaries, probably all quite small, and of which the enamel decoration (as no subject is mentioned) may have been non-figural.

Even given the random and fragmentary nature of these sources, they do provide the basis for some tentative conclusions on the question of ownership.

Firstly, it is notable that there does not appear to have been an automatic distinction, with objects incorporating enamels, between institutional and private ownership. It would be wrong to place too much emphasis on the chance survival of the will of Eustathios Boilas, a major provincial landowner, but the two most significant items in the brief list above – the cross and the book-cover – had been given "long ago" to the church that he had built. They were clearly seen as objects for public use and there was evidently no thought of their remaining in his own or his family's immediate possession, although he had two surviving daughters and sons-in-law. Boilas' political position was, of course, that of an exile, and precious movable objects could be regarded as being more safely protected from expropriation in the possession of a church, rather than remaining in private hands.[47] A comparison with Boilas' will is provided by the inventory contained in the 11th century *Diataxis* of Michael Attaleiates, where no enamelled objects appear in the substantial list of items made in precious metal.[48]

It must, however, clearly have been possible for circumstances similar to Boilas' to have arisen without the owner going into exile. The concentration of luxury objects in the institutions of Constantinople must have been due in part to the general feeling that they were better protected there than in private ownership. The chance of alteration of the materials to another form of use may well also have been thought to be less likely under these circumstances – or, if it did take place, that a sacred function was still maintained. The question of the scale of individual objects is also clearly of importance here. The cross in Boilas' will may well have been of sufficient size for it to be inappropriate to retain it for private devotional use, and lavish bindings seem largely to have been confined to evangelistaries and lectionaries, indicating a public use in churches, where they were carried in procession. Of the few major items listed above, it is very probable that the exceptionally large reliquary of the Proedros Basil passed into the possession of some form of institution on his death (in all likelihood a very exalted one, given his background) rather than that of a private individual, although this did not save it from the looters of the Fourth Crusade. (The inscription on the relic that it contains indicates that it had originally belonged to emperors called Constantine and Romanos; this must have

[47] There are, of course, similarities in the geographical background to the epic of Digenes Akrites and the foundations of Boilas.

[48] K. N. Sathas, Μεσαιωνικὴ Βιβλιοθήκη, I (Venice 1872) 4–69, particularly 47–48.

been a peronal gift to Basil, who created the reliquary for it.[49] Otherwise, from the point of sheer quantity, it would seem that the imperial palace may well indeed have had the largest single holding of such works.

In this context it could hardly be expected that enkolpia, which are essentially small objects for personal use, being worn on a cord or chain round the neck[50], should be found in the treasury of any institution such as a monastery. As in the case of Boilas, one must surmise that they were given or bequeathed by wealthy members of the monastic community concerned, or by lay individuals, in preference to members of the former owners' families. Again, it would seem that institutional, rather than private, ownership, was seen as being preferable even for intimate objects of this kind. The same would no doubt be said of the three enamelled reliquaries in the Patmos inventory, although several other items there (including enkolpia) are listed as being in the abbot's cell there.

This tendency must presumably have been a one-way traffic; it is hard to imagine that institutions would readily have returned into private ownership objects of which they had assumed possession. This practice, repeated over many years, and involving many different institutions, would have had the effect of accumulating the great majority of these precious works in the monasteries, convents and churches of Constantinople. It is probable that even in such places as hospitals, as well as in the hundreds of smaller churches of the city, there could also be found enamelled objects bequeathed by their founders or by later benefactors. It must be regretted that documents of the character of inventories appear to be so rare, and that none have so far come to light that concern an institution in the capital. In this respect the will of Eustathios Boilas, although his position as an exile was untypical, may represent an interesting, and typical, situation: although when he wrote it he was a provincial landowner he had spent a number of years in high office in the capital, and it was no doubt then that he had acquired the precious objects and books with which he endowed his foundations. It surely could not have been usual for a small and remote foundation to possess the kind of library or objects of liturgical use that Boilas had given to his church. He was clearly trying to impart to a provincial setting something of the riches that a comparable foundation in the capital might have been expected to hold.

Also to be lamented is the fact that surviving *typika* do not contain any detailed inventories of the holdings of the foundations to which they refer, as it must have been to the more richly endowed monasteries and convents that *de luxe* objects such as enamels would have passed at an early date, if not at their original dedication. This category of text, although existing in considerable variety, is unfortunately not one that is concerned with information of this kind.[51]

As it is, we are left with one very clear indication of the value and esteem in which enamel was held, and this is the readiness with which individual plaques seem to have been re-used. As mentioned above, plaques were usually first attached to larger objects, and so could be detached and re-used in another context quite easily. The epilogue on the Gospels of Mstislav specifies that one Naslav "took the manuscript to Constantinople and bought the enamel plaques there ready made."[52] There would have been a wide variety of different reasons why this was done, and the practice needs no further explana-

[49] The inscriptions on both objects are given in F. X. Kraus, Die Altchristlichen Inschriften der Rheinlande, Pt II (Freiburg i.B. 1890) 312–314.

[50] For *enkolpion* see the entry in Wessel, Reallexikon zur byzant. Kunst II (Stuttgart 1967) 152.

[51] For a recent discussion of this category of text, see Catia Galatariotou, Byzantine Ktetorika Typika: A Comparative Study. Revue des Etudes Byzantines 45 (1987) 77–138. I would like to thank the author for her help on this point.

[52] Kondakov, op. cit., 185–186.

tion when found in the West, where original manufacture of this kind of enamel was not possible.[53] But when it can be suggested that quite substantial works, such as the staurothèque, or even the indisputably major icon of the standing Saint Michael, both now in Venice[54], were assembled in Constantinople from enamels of different origins, it is clear that even ownership of just individual plaques must have been a matter of importance and personal prestige. (This icon might well have been one of the "enamelled objects" referred to in the Book of Ceremonies, quoted above.) While this is not central to our theme, it must be seen as an indication of the apparent scarcity of enamels, and of craftsmen to produce them; this shortage must have presented acute difficulties, particularly when a major work was being created. Re-use of prized enamels, it would seem, could either be preferable to new plaques being specially made, or was perhaps the only way that a desired result could be achieved.

So in conclusion it could first be emphasised that the texts collected above clearly confirm the uniqueness and value attached in the Byzantine world to the medium of enamel. Secondly, this discussion indicates that the ownership and use of Byzantine enamels may (outside the confines of the imperial palace) have been more widely distributed than has often been suggested. Further, even when individual ownership can be established, this may well have only applied to a limited extent and for a limited period. There does seem to have been a strong tendency for objects of this level of value (unless they were used, like the casket with the enamel portrait of Constantine Porphyrogenitus, as prestige diplomatic gifts for despatch abroad) to pass quite readily into the ownership of institutions, where, until catastrophe struck, they would have stayed. In this context it must be significant that Diehl, in his publication of the Patmos inventory, noted that the last five icons in the relevant section (four of which had metal revetments) had been added in the margin of the manuscript, strongly suggesting that they were later acquisitions of the monastery.[55] As the centuries passed it must have been in institutional and ecclesiastical treasuries that the overwhelming majority of these works (at least in numerical terms) were eventually accumulated and housed. The poverty of the imperial court by the mid-fourteenth century is well known[56], and the treasuries of Western Europe, particularly that of San Marco in Venice, would by then have held the greater part of the most sumptuous of the remaining works in enamel. In probably a majority of cases these would have gravitated from the possession of their original, private owners to that of the public institutions which were looted in 1204.

[53] Two book-covers are evidence of this admiration; that in Munich (Staatsbibliothek, Clm. 4452, from Bamberg Cathedral Treasury, and that in the Bibliotheca degli Intronati in Siena; both are examples of the re-use of Byzantine enamels by Western artists. For the former see Wessel, op. cit., 80–85, and for the latter see P. Hetherington, Byzantine Enamels on a Venetian Book-cover. Cahiers Archéologiques 27 (1978) 117–145.

[54] For these works see Hahnloser, Tesoro, Cat. nos. 24 and 16. In the case of the staurothèque it is suggested (34) that the enamels are a 13th century imitation of 10th century style, but it would seem far more probable that a chance collection of plaques was re-used (Saint Panteleimon would never normally appear among the six other major saints). The enamels in the frame of the icon of Saint Michael, although of the same period, are also anomalous, with Saint Menas seemingly having no place with either St Peter or the eight warrior saints (see also Wessel, op. cit., 92–95).

[55] Diehl, loc. cit., 512, n. 4.

[56] Nicephorus Gregoras records that by 1347 none of the cups or bowls used at table in the imperial palace was of silver or gold, but were made of leather or pottery disguised as precious metal (Historia, Ch. 15, 2; Ed. L. Schopen, I. Bekker [Bonn 1830] 788.)

III

THE JEWELS FROM THE CROWN: SYMBOL AND SUBSTANCE IN THE LATER BYZANTINE IMPERIAL REGALIA

It has long been known that in April 1343 gems from the Byzantine imperial crown were pledged with the Venetians as collateral for a loan; the sum secured by this transaction was the substantial one of 30,000 ducats.[1] The action had been taken by the empress Anna of Savoy, who, after the death of her husband Andronikos III in 1341, had ensured that her young son, born in June 1332, was crowned by the patriarch in November of the same year as the emperor John V Palaiologos.[2] She negotiated the loan when desperately short of funds while acting as his regent during the ensuing civil war of 1341-1347; under the agreed terms the loan would be repaid at the rate of 10,000 ducats per year over three years, plus interest at 5%. The timescale of the agreement implies that she must have initially hoped that the jewels would be recovered for her emperor son, then only eleven years old, when he reached the age of fourteen.

In the event, the Venetians were never to recover their money, and the imperial jewels were never to be returned. Endless failures in repayment, extensions and variations in the terms of the loan, offers of arbitration over disputed terms of the interest owed, long and abortive negotiations for the sale of the island of Tenedos to the Republic as part quittance of the loan, all came to nothing.[3] In 1350 and 1373 the jewels had been brought back to Constantinople in the hope that negotiations could conclude the matter and that they could be restored to the emperor, and in 1362 the *jocalia* had reached Negroponte,

[1] 19th century scholars such as Hopf and Heyd were among the first to comment on this episode, and it has more recently been mentioned by Muratore, Hodgson, Ostrogorsky and Zakythenos; these references were assembled by F.Dölger, Regesten der Kaiserurkunden des Oströmischen Reiches, 5. Teil (Munich 1965) no. 2891 (mispr. as 2791), 9-10, who also gives details of many documents involved, some included by F.Miklosich and J.Müller, Acta et diplomata graeca medii aevi sacra et profana (Vienna 1860-90); further documents are in F.Thiriet, Régestes des déliberations du Sénat de Venise concernant la Romanie, I (Paris 1958). A recent discussion of the transaction is in Kenneth M. Setton, The Papacy and the Levant (Philadelphia 1976), I, 318-320, and the whole episode is carefully assessed by D.M.Nicol, Byzantium and Venice. A Study in Diplomatic and Cultural Relations (Cambridge 1994) 259-260 and 296-316. For the fullest analysis and documentation of the episode, see n. 4, below.

[2] See D.Nicol, The Byzantine Family of Kantakouzenos (Cantacuzenus) ca. 1100-1460 (Washington, D.C. 1968) 58-68; John V's reign has also recently been discussed in D. Nicol, The Last Centuries of Byzantium 1261-1453 (London 1972) 172-191.

[3] For the Venetian interest in Tenedos, see R.-J.Loernetz, John V Palaiologos and Venice (1370-1371), REB 16 (1958), 217-232; and F.Thiriet, Venise et l'occupation de Ténédos au XIVe siècle, Mélanges de l'Ecole Francaise de Rome, 65 (1953) 219-243. The ultimate fate of the jewels, still secured in the Treasury of San Marco in 1448, seems never to have been established; see Nicol, Byzantium and Venice, 316, refuting Thiriet's repeated claim that the jewels were returned to Constantinople in 1373. As they would presumably have in due course become the property of the Venetian bankers who provided the loan, they were probably eventually sold on the open market, and so lost their identity.

but each time they had been returned to Venice.[4] As time passed, full repayment could never have been a realistic possibility, and the finances of the empire never recovered sufficiently to allow it; even in January of 1453, over a century after the original pledge, and (if anyone had then known it) only four months before the fall of the city, Constantine XI was to be found increasing the imperial debt still further by pledging another balas-ruby with the Genoese as security for a loan of 9000 hyperpera (then equivalent to about 3000 ducats).[5]

The sequence of documents that relates this sad story has hitherto only been discussed in terms of their relevance to the historical and economic conditions that prevailed during the last century of Byzantium, with the fullest analysis of them being found in a contribution by Tommaso Bertelè to the six-volume *festschrift* of an Italian economic historian.[6] In spite of this interest, the documents have never been used to confirm or advance our knowledge of the physical characteristics at that period of the imperial crown from which they must have been extracted, and one purpose of this essay is to see how far they can help us in this endeavour.

There has never been any doubt that the crown was the prime symbol of the Byzantine imperial office, and that as such its physical appearance could have been expected to be of the greatest importance for the entire Byzantine world. However, the study of the appearance of crowns that were worn by the Byzantine emperors, the empresses, the imperial family and client rulers over the centuries has always presented particular difficulties. This is due to a range of problems which include paucity of first-hand evidence in the form of surviving regalia, imprecise textual sources, variations of terminology,[7] uncertainty over the accuracy of second-hand (i.e. illustrative) evidence, and realisation that the form taken by imperial crowns was in any case subject to change.

The evidence has usually been considered to have taken three main forms. In the first place we have the primary evidence of the few crowns of Byzantine origin that have survived into modern times, but even in this limited field agreement is not universal;[8]

[4] For the fullest discussion of this episode, with transcription of 36 documents, see T. Bertelè, I gioielli della corona bizantina dati in pegno alla repubblica veneta nel sec. XIV e Mastino della Scala, Studi in onore di Arminto Fanfani, II (Milan 1962) 91-177.

[5] This transaction, which involved a gem of unusual size, took place in the house of Loukas Notaras; see Bertelè, op. cit., 137-8, n. 64.

[6] See n. 4, above.

[7] The most frequently used terms are *stemma* and *stephanos*; they are used in the 14th century as if the terms are interchangeable by both John Kantakouzenos, Historiae, I, 41 (Ed. Schopen, CSHB, I, Bonn 1828, 197-198), and Pseudo-Codinus, Treatise on the Dignities and Offices, (Ed. Verpeaux), Paris 1966, 191 and 252-273.

[8] The authenticity of the "crown of Constantine Monomachus" in Budapest has most recently been called in question by N. Oikonomides, La couronne dite de Constantin Monomaque, TM 12 (1994) 241-262; even the Holy Crown of Hungary is accepted as a marriage of two pieces of widely differing enamel objects; see J.Deér, Die heilige Krone Ungarns (Vienna 1966) 185-270 where the possibility is also discussed of its Byzantine enamels having been re-used. Mention is made later of the only surviving headgear that may be a copy of the Byzantine imperial *kamelaukion* which was found in the sarcophagus of Constanza, wife of Frederick II Hohenstaufen (d. 1222); it is still in Palermo Cathedral, but there has to be an assumption that it was her husband's crown for it to be included in this discussion (see J.Deér, op. cit., and P.E.Schramm, Kaiser Friedrichs II Herrschaftszeichen (Göttingen 1955) 11-15.

much more plentiful is the considerable body of visual evidence for the appearance of the imperial regalia that can be drawn from coins, ivories, mosaics, paintings, manuscript illustrations, etc.; and thirdly, there are a number of textual references from various periods. The literature that has grown up around this problem is quite extensive but remains surprisingly inconclusive. For example, the textual reference to red and white crowns that can be worn by the emperor that appears in the 10th century *De Cerimoniis* (which should be regarded in this context as an impeccable source, at least for its period) finds no corresponding echo in any of the illustrative material or in the sparse surviving evidence of Byzantine crowns, and continues to baffle commentators.[9] It is the second of these forms - the illustrational sources - that will mainly have to be used for this exercise.

Given below, then, is a summary list of the Byzantine emperor's crown jewels pledged with the Venetians in 1343. It is based on two inventories in documents dated in August and October of that year that are still in the Venetian archives;[10] the jewels are usually referred to as *jocalia imperii*, or simply *jocalia*. Of prime importance to the individuals originally involved was the question of weight, and this was expressed in altogether four different scales: *saggi* and *charati* of both Constantinople and of Venice. The accurate interpretation of these is a matter for experts in historical metrology, but as this aspect is of secondary importance to this discussion I give here only the series of modern equivalents of the weights in grammes that were arrived at by Bertelè;[11] I have also retained the order of the items as it appears in the documents, but added my own index numbers for ease of reference:

1. One balas-ruby (57.77 gr.)
2. One balas-ruby (59.64 gr.)
3. One ruby, weighed *extra aurum* (53.42 gr.)[12]
4. One balas-ruby (70.4 gr.)
5. One balas-ruby (31.26 gr.)
6. One balas-ruby (61.5 gr.)
7. One balas-ruby (25.05 gr.)
8. One ruby (15.73 gr.)
9. One balas-ruby (22.98 gr.)
10. One *tabula* for a balas-ruby *montata in oro* (16.15 gr.)
11. One *castone* with 5 pearls, one ruby and 3 balas-rubies, weighed *cum toto auro* (62.12 gr.)
12. Two *castoni* with 10 sapphires and 8 pearls, which *simul ponderata cum auro*, weighed 132.94 gr.

This list presents a number of problems, the foremost perhaps being of terminology. A balas-ruby, which appears in the documents as *balascio*, *ballasium* or *balaxium*, is a stone with a colour of rose-red to pink, and has been regarded as commoner than the deep

[9] De Cerimoniis, I, ch. 37, CSHB, Ed. Reiske (Bonn 1829-30) 187-188.

[10] Bertelè, op. cit. in n. 4, documents 4 and 6, pp. 144-147 and 150-152.

[11] Bertelè, op. cit., 98.

[12] This phrase only appears in the inventory of October 1343; see Bertelè, op. cit., 151, document 6.

red ruby; this no doubt explains why there are more than twice as many balas-rubies as there are rubies in the collection. While there are earlier mentions in manuscript, the 16th-century treatise by the goldsmith Benvenuto Cellini is the earliest published source for several technical goldsmithing terms, and offers the definition: *balascio si è rubino di poco colore*.[13] Their value is indicated by the fact that two of the four largest stones that he incorporated in the spectacular morse that Cellini made for Pope Clement VII were balas-rubies.[14] The other gems mentioned in the inventory, sapphires and pearls, present no problems of interpretation, although their treatment will be referred to later.

Further questions of identity arise with the presence of items accompanying individual unmounted gems; the latter could be expected as forming the imperial "crown jewels", but the most immediately interesting for this discussion are items 10, 11 and 12: the *tabula di balascio* and the three *castoni*. To look first at the *castoni*, the most frequent meaning for this refers to the setting or bezel for a stone in a ring or other form of jewellery: *Quella cavità nell'annello, od in gioiello d'altra specie, dove é posta e legata la gemma*.[15] These are the only items which are designated in both inventories (other than the small quantity of gold given in one document at no. 3) which are stated as being weighed *cum toto auro* (no. 11) and *simul ponderata cum auro* (the two at no. 12), and the inference must be that here the gems, mounted or unmounted, were weighed together with their gold settings. This in turn must confirm that the other gems (except perhaps no. 3) were pawned without any setting at all. It is a reasonable assumption that the two *castoni* weighed together were an identical pair, each with five sapphires and four pearls, while the single one (no. 11) holding one of the three rubies in the collection, was one of the heaviest individual items in the inventory.

So we come to the *tabula* (no. 10), which, at 16.15 gr. is one of the two lightest objects in the inventory. It would seem that this must refer to a form of framed panel or mount made most probably from wood, and that the phrase *montata in oro* will in that case refer to the small amount of gold framing which must have been detached for the weighing process. It is clear that only one balas-ruby was involved here, and there was one such stone which seems to have been the outstanding item in the entire collection, as in three documents from much later in the episode (from the years 1375, 1376 and 1381) the phrase recurs: *De facto jocalium domini Imperatoris et balaxio suo*,[16] thus isolating one large balas-ruby from the group of all the other items forming the *jocalia*. It may therefore have been just this one pre-eminent jewel that was kept displayed on a

[13] B.Cellini, Trattati dell'Oreficeria e della Scultura, ed. of 1857, ch. 4. Although written in the mid-16th century, Cellini's treatise is the earliest published source to use technical terms of this kind, and he must have adopted existing terminology for describing them; his definition corresponds with that in the excellent modern study by G.Cantini Guidotti, Orafi in Toscana tra XV e XVIII secolo, 2 vols. (Florence 1994), I: Glossario, 85; Theophilus Presbyter does not mention them in the 12th century treatise De diversis artibus.

[14] For the morse of Clement VII, see Vita di Benvenuto Cellini, ed. G.G.Ferrero, (Torino 1959) I, ch. 51.

[15] Vocabolario degli Accademici della Crusca, 5th ed., Florence 1881, 653; this also corresponds with the definition of *alveolo* given in Cantini Guidotti, op. cit., I, 119.

[16] Bertelè, op. cit., documents 33-35, 176-177.

tabula, but was removed from it when mounted in the imperial crown; if this is correct, the *tabula* itself would therefore not itself have been part of the crown.[17]

Finally, it is clear that the term "crown jewels" meant precisely that: the jewels from the crown, without including any major or significant context. At no point is there any indication that they were still attached to the crown.

In order to establish what this documentary evidence may tell us about the appearance of the crowns worn by emperors in the mid-14th century, it should now be related to existing visual evidence. Fundamental to this discussion is the fact that for a long time it has been accepted that Byzantine empresses wore a crown of completely different type from that of the emperor; it is invariably shown as being "open" in form, and with the top displaying a sequence of pointed shapes giving a serrated effect. This is one of the few points on which agreement seems to be universal. The Venetian documents are in any case categorical that the jewels came from the emperor's crown, not that of the empress. Given the state of the imperial finances, the inference has to be drawn that the crown which Anna of Savoy pillaged in order to produce the gems and *castoni cum auro*, to secure the loan, was the one which her late husband, Andronikos III, had used at the time of his death.

It is known that emperors had more than one crown, and that the Byzantines did not adopt the concept of a unique crown which was transferred from emperor to emperor.[18] The circumstances that applied at this time would suggest that Anna took one of two courses: either the crown used by the young John for his coronation in November 1341 was the one that his father had used, and, if so, it would have needed to be adapted for his youthful head, or a smaller one could have been made and the jewels from the larger one could have been transferred to it. In either case, the prevailing conditions of imperial penury would certainly suggest that there was only one imperial crown in use at any one time. If this was the case, it would have been that from which the *jocalia* were extracted by Anna of Savoy in 1343; she would probably also have intended that the jewels would be replaced in a larger crown for her son when he reached years of maturity. It is possible that there was already a plurality of crowns available, and that another crown destined for the head of the nine-year-old prince had been created following the death of Andronikos; certainly, there were occasions when several members of the imperial family would have been present in public simultaneously each wearing some form of crown. However, given the state of the imperial finances, which were after all the cause of the entire episode, one would have to conclude that only one crown at any one time could hold the imperial "crown jewels".

[17] Du Cange, Glossarium mediae et infimae Latinitas (Ed. Graz 1954) VIII, 4-8 makes it clear that the *tabula* should be understood here as corresponding to some form of board or panel on which the gem was displayed, while the word could also be used to denote a means of displaying relics, corresponding to a form of staurothèque, as in the 12th century text: Quomodo portio vivificae crucis Werdeam pervenit (Monum. Germ. Hist. Scriptores, t. 15, pars 2, Hanover 1888) 768-770. I am most grateful to Professor Schreiner for clarifying this point for me, and for pointing out this reference.

[18] It is also known that individual crowns could be presented as offerings, although further uncertainty is produced by the fact that the votive crown of Leo VI in the Tesoro di San Marco, Venice, may be too small to have been worn by an adult.

What, then, might Andronikos III's crown have looked like before the jewels were taken from it? By this time the imperial crown is always represented as the *kamelaukion* type, with a closed and rounded top.[19] While any contemporary or near-contemporary representation of the emperor wearing a crown must be regarded with the usual caution over finer details, there are sufficient crowned imperial portraits of the period to provide a basis for some conclusions. Certainly, the emperor's headgear at this time is invariably depicted as being of a gold-coloured material.

Probably the best known collection is that in the manuscript of Zonaras now in Modena, Mutin. gr. 122, which contains in its unique sequence of 24 heads portraits (in monochrome, and so not indicating any colour) of both Andronikos III and of his son, John V.[20] They should be used with more than usual caution as evidence for our purposes as they were produced over a century after the period with which we are concerned; while the faces must be regarded as no more than generalised schemata, the accuracy of the depiction of the regalia can nevertheless be checked, and in the single leaf reproduced here (Fig. 1) the artist has certainly differentiated between the crown types of the later emperors and that of Constantine I. Coins of the 14th century are less useful as a source than in earlier periods,[21] but there are a number of other Palaiologue imperial portraits which collectively must be accepted as conveying the main forms of the crown worn by the emperor.[22] Of particular interest because of its clarity is a record, in the form of a 16th century woodcut by a western artist, of a full-length portrait that is almost certainly of either Andronikos II or Andronikos III; it was made from a mosaic in the church of St Mary Pammakaristos in Constantinople (Fig. 2).[23]

[19] This form of headgear, which had become standard for the imperial crown by the 14th century, is already mentioned in the *Liber Cerimoniis*, but with specific reference to military garb (perhaps best rendered as "helmet"), for which a *stephanos* was substituted for a coronation (CSHB, II, ch. 27, 628) For a discussion of textual sources, see T. Kolias, "Kamelaukion", 32-33 JÖB (1983) 493-502; also E.Piltz, Kamelaukion et mitra. Insignes byzantins impériaux et ecclésiastiques (Stockholm 1977) 19 and 74-76; and RBK, III (Stuttgart 1978) 373-398.

[20] See Io. Spatharakis, The Portrait in Byzantine Illuminated Manuscripts (Leiden 1976) 172-183.

[21] Coins of the Palaiologue period offer a less clear image than those of previous centuries; see P. Grierson, Catalogue of the Coins in the Dumbarton Oaks Collection and in the Whittemore Collection, Vol. 3 (Washington DC 1993) Pt 1, 127-130 and Table 13.

[22] Among examples of crowned Palaiologue imperial portraits could be cited those of Andronikos II on a chrysobull in the Byzantine Museum, Athens (ill. in A.Grabar, L'empereur dans l'art byzantin (Strasburg 1936) Pl. XXVI, 2); of Andronikos III in Würtembergische Landesbibliothek, Stuttgart, cod. hist. 2, 601, f. 2 (ill. in Spatharakis, op. cit., fig. 180); the two of John VI Kantakouzenos in Paris, B.N. cod. gr. 1242, ff. 5 and 123, of 1370-75 (Spatharakis, op. cit., figs. 86-88, and in colour in Catalogue, Byzance. L'art byzantin dans les collections publiques francaises (Paris 1992) 419 and 461); and that of Manuel II as author of the funeral oration on his brother in Paris, BN, Suppl. gr. 309, f. 6, of 1407-25 (Spatharakis, op. cit., fig. 175-6).

[23] Martin Crusius, Turcograecia (Basel 1584), unnumbered p., facing p.1, discussed in H. Belting, C.Mango, D.Mouriki, The Mosaics and Frescoes of St. Mary Pammakaristos (Fethiye Camii) at Istanbul (Washington D.C. 1978) 23-24. While there is doubt about whether the double portrait in mosaic was of Andronikos II or Andronikos III, both of whose empress consorts were named Anna, it is clear that this image is to be dated in the 14th century, and in any case before the death of Andronikos III in 1341.

When assembled, these examples represent a surprisingly consistent later tradition, and largely confirm the characteristics of the crowns in the Modena manuscript. There was always a band that fitted round the head, resting above the ears, and one feature invariably shown is a panel mounted centrally on this above the wearer's forehead, displaying a single large gem; this seems to have been one of the most persistent features in the long history of the imperial crown, as it appears in the diadem of Constantine I in the Modena Manuscript, and is still present in the representations of crowns of earlier type of the eleventh century.[24] Further gems decorated the band to either side, apparently spaced out on the head band. Above this rose the rounded upper element which enclosed the wearer's head, and which seems always to have been surmounted by a small cross or other decorative item; a further constant feature seems to have been a central strip running from the prominent mounted gem up to the apex, and itself holding a further mounted gem; on either side of this were more gems set in two identical groups. The other feature invariably included is that of the *perpendoulia:* chains or jewelled cords hanging down on either side of the head of the wearer, and ending in jewelled pendants.[25] (Anticipating a point that will be raised later, one medium that seems never to have been included, and certainly is unmentioned in the documents of this case, is that of enamel of either decorative or figural content.)

These generalised characteristics of the imperial crown should now be related to the items described in the inventories made in 1343. There is one jewel that is invariably given a place of prime importance on the front of the head band of all representations of the crown, and this may now be identified with the balas-ruby that appears in the inventory as associated with the *tabula.* This is the most consistent single feature of the crown over many centuries, and if there was a "hereditary" element in the imperial regalia, perhaps it was this individual stone, mentioned in the documents quoted above in isolation from all the other jewels as "...*domini Imperatoris [et] balaxio suo.*" The single *castone* (no. 11), with its gold mount was the second heaviest item in the inventory; this must have been the most spectacular single item in the collection, with a ruby, three balas-rubies and five pearls, all mounted in gold, and would surely have been given a prominent place. An explanation could be that it was fixed to the upper part of the *kamelaukion*, and located centrally above the pre-eminent balas-ruby; this is certainly a consistent feature in all representations at this period. This leaves the pair of *castoni* (no. 12); weighed with their ten sapphires and eight pearls it is possible that they formed the jewelled ends to the *perpendoulia*, hanging on either side of the crown, but the visual evidence does not support this. The other more likely rôle for these was that they formed a pair of ornamental plaques, resembling brooches, which can be seen in virtually all representations attached symmetrically to the upper part of the *kamelaukion* on either side of the central, vertical band.

In the Modena manuscript and in the woodcut of an emperor Andronikos the lower band of the crown appears as quite narrow, but displays a gem set centrally above the wearer's forehead. The three largest elements on the upper part could then be the single

[24] See the RBK, III, 373-398, and the mosaic portraits of Constantine IX and John II in the south gallery of Hagia Sophia in P.Underwood, The Mosaics of Haghia Sophia at Istanbul, Third Preliminary Report (Oxford / Boston 1942) pls. 10 and 26.

[25] For *perpendoulia* see Piltz, op. cit.

large *castone*, mounted centrally, with the two smaller *castoni* holding sapphires and pearls located to either side of it. It seems inherently more likely that the two identical *castoni* were elements of this kind than that they formed pendants of the *perpendoulia*; in both the imperial mosaic portraits (of an emperor Andronikos and of Constantine IX) it is clearly shown that these were made so that they ended in three jewels (possibly drilled and threaded gemstones) each attached at one end. The other gems in the inventory would then have been mounted elsewhere on the crown, probably round the main head-band; they could have been set either with a claw setting or (more probably) a bezel mount, from which they could be removed quite easily.

Most of what has just been said may be regarded as offering confirmation of existing evidence of another kind; the most controversial suggestion may be that by this period it was the jewels that were the constant feature, being switched from crown to crown as the need arose. But whether this proposed brief designation is accepted or not, a more controversial question should now be asked: of what material was the basic structure of the imperial crown made? It could not have been a single, integrated construction of metal, that was handed to the Venetians intact and in its entirety, as (apart from questions of weight) it is clear from the discussion above that the items of value could be (and were) removed from it. It would seem that the crown itself was to some extent an assemblage made up from different elements, the most valuable of which could be detached individually (and, it must have been hoped, re-attached), leaving an existing substructure. While the head-band of the *kamelaukion* may have been of metal, perhaps copper and, if so, gilded, it could not have been of solid gold, as the documents make clear that the only gold handed over was in quite small quantities.

However, it is here suggested that the rounded upper part, which would have been made from some lighter gold-coloured material, may not have been of metal at all, but made from nothing more valuable than gilded leather.

The evidence for this is supplied by a contemporary eye-witness, the chronicler, polymath and scholar, Nikephoros Gregoras. It is on his evidence that we know that by the mid-14th century items of imperial costume were decorated by glass imitations of real gems, and were actually made from gilded leather, as we have the good fortune to have access to his written record. He must have been present at celebrations which took place in the Blachernae palace on 21st May 1347, (even giving the time of day) and so almost four years after the crown jewels had gone to Venice.[26] The five thrones were occupied for this occasion by the two emperors, John V Palaiologos and John VI Kantakouzenos, and by Anna and Eirene Kantakouzenos and her daughter Helen. This is Gregoras' account of what he saw:

"At these festivities the imperial crowns [διαδήματα] [27] and robes [περιβλήματα] were for the most part only make-believe [φαντασίαν], pretending to be of gold and precious stones; in reality they were made of leather, gilded as leather-workers sometimes need

[26] Nikephoros Gregoras, Byzantina Historia, XI, 11, 2 CSHB, II (Bonn 1830) 788-789.

[27] A *diadema* seems to have retained its original meaning of "crown", applicable to both male and female wearers, although its form, when worn by a man, would have been that of a *kamelaukion*; see Codinus, Dignities and Offices, ed. cit., 199: ... ὅπερ καλεῖται νῦν στέμμα, ὠνομάζετο πάλαι διάδημα; also RBK, III, 373-398.

to, and [decorated with] pieces of glass [ὑέλων] of all colours; amongst this could be seen the glint of gems of genuine richness and the lustre of pearls, which did not deceive the eye.... To such an extent had the wealth and richness of the Roman empire fallen,... and it is not without shame that I now relate these matters."

By περιβλήματα Gregoras would have been referring to the element of the imperial robes that derived ultimately from the *loros*, and although developing different forms it would always have been adorned with mounted gems.[28] Incidentally, had Gregoras known that the gems from John V's crown had gone to Venice almost four years before, he might well have mentioned it here; it certainly would have suited the tone of his writing of this passage. As it is, the implication of his description is that (at least after 1343) some of the imperial robes and even the crown may have been made partly of leather which was gilded to resemble gold, and that the balas rubies and other gems would have been replaced mainly by fake glass and paste counterfeits. It is only pearls, with a very few real gems, that are mentioned as being genuine, and we do have corroboration of the relatively plentiful quantities of pearls still to be found in the city half a century later. The inventory of the treasury of Hagia Sophia made in 1396 contains, among the scores of precious items, numerous references to pearls used as decoration, but among the gems (*litharia*) mentioned as ornaments, the only ones named are said to be broken amethysts.[29]

It could be significant that the only surviving example of imperial headgear that we have, which approximates to the closed *kamelaukion* type, is made from richly decorated cloth. It was found in the sarcophagus of the empress Constance, wife of Frederick II, who died in 1222, and is now kept in the treasury of the Cathedral of Palermo.[30] Its design is completely different from women's crowns as depicted in numerous illustrative sources, and it has been suggested that it represents an attempt by Frederick II to emulate the Byzantine male imperial *kamelaukion*; if so, it would imply that even by that period it was known not to be made from metal of any kind.[31]

The fact that in 1343 Anna of Savoy was able to detach the gems and the three *castoni* from the crown itself indicates strongly that even before that date it was formed from some substance other than metal, and that the parts specified as being of gold which she pledged with Venice had been the few pieces of genuine gold left on the crown. It seems unlikely that significant amounts of gold, which would have increased the value of the loan, would have been left in place, and so the replacement of the genuine gems with glass imitations could have taken place without any major re-making. In any case

[28] See RBK, III, 437-444.

[29] Fr. Miklosich & Ios. Müller, Acta et Diplomata graeca medii aevi sacra et profana, II: Patriachatus constantinopolitanae MCCCXV-MCCCCII (Vienna 1862) 566-570, where (p. 567) three broken amethysts were mounted on a silver-gilt cross; no mention was made of rubies of any kind, but pearls are noted as decorating 18 of the approximately 180 items in the treasury; for a discussion of this text see P.Hetherington, Byzantine and Russian Enamels in the Treasury of Hagia Sophia in the late 14th century, BZ, 93 (2000) 133-137. (Here Study V).

[30] For sources, see above, n. 8.

[31] See J. Deér, The Dynastic Porphyry Tombs of the Norman Period in Sicily (Washington, D.C. 1959) 171.

it has to be concluded that after 1343, when the Palaiologue emperors appeared wearing a crown that had a superficial resemblance to gold enhanced by gems, it would most probably in reality have been made of some cheaper substance, and that most of the gems with which it was decorated were fake.

What, then, did Byzantine observers think that they saw when the emperor appeared in public clad in the imperial regalia in the mid-14th century and later? The question of the Byzantine perceptions of reality that this raises is too large a subject to be pursued very far here, but one observation can still be made.

This discussion indicates that the quite numerous imperial portraits of the 13th and 14th centuries (mainly in manuscripts) were surprisingly accurate in conveying the distribution of gems on the *kamelaukion*; given the frontal pose, there is generally close correspondence when the various elements of jewellery are compared. While it must always have been the case that depictions of the emperors wearing their regalia that appeared as illustrations in manuscripts or carved in ivory would only have been seen by a small and selected audience, this could not be the case with more public representations. It so happens that the only full-length portrait of John V Palaiologos of which we have a record was a highly public one; it was to be found in mosaic on the great east arch of Agia Sophia, where it was recorded in 1847-49 by Fossati.[32] For us it is regrettable that damage had removed the top of the emperor's crown before Fossati made his drawing, but even so it is worth observing that the mosaic image, made in 1355 or very soon after, and so some twelve years after the crown jewels had gone to Venice, must have been created to reproduce an impression of the crown worn by the emperor as he participated in the ceremonies of the Great Church enacted in full and public view below it. For the Byzantine eye, the superficial appearance of reality must have corresponded to a genuine condition; if gilded leather and coloured glass was a symbol that played the part of genuine gold and gems in the celebrations in the Blachernae Palace, could it not also do so under the dome of the Great Church?

A further conclusion can be drawn from this episode. It was remarked above that the medium of enamel does not appear to have figured in the makeup of the imperial crown; at no stage do we have any evidence - visual or literary - that this luxury medium was used in the Byzantine regalia. There is certainly no mention of it in the documents of our case, and no representations from earlier periods can be found that show plaques of either figural or decorative enamel to have been incorporated into the imperial crown. This forms a complete contrast with the few crowns that have survived that were worn by client rulers or Slav princesses, where we do have surviving examples. The most famous must be the Holy Crown of Hungary, and although this now has an "upper crown" with other enamels incorporated into it, the plaques of Byzantine enamel (that formed the *corona graeca*) must always have played a highly significant and integral part in its design.[33] They would have been arranged in a way that showed the two plaques with rounded

[32] C.Mango, Materials for the Study of the Mosaics of St. Sophia at Istanbul (Washington D.C., 1962) 74-76, Fig. 97 (Fossati Drawing no. 364.) Fossati's colour notes designate the *loros* as of gold, with red and green shaped ornaments, resembling large gems, applied to it; his drawing was intended to be an accurate record before the mosaic was covered again, and so should be regarded as extremely reliable.

[33] A good recent publication, with bibliography, is that of Éva Kovács and Zsuzsa Lovag, The Hungarian Crown and Other Regalia (Budapest 1980).

tops, portraying Christ and the Byzantine emperor Michael VII Doukas, as superior to the enamel portraits of the emperor's son, Constantine, and the Hungarian king, Géza I, who is the only un-nimbed figure. A further distinction could be made here; besides the surrounding string of drilled pearls, the stones now set in St Stephen's Crown have been identified as sapphires, almandine garnets and amethysts, and have been assessed as being of poor quality and little value; two have recently been identified as being of green glass.[34] While it is possible that they are substitutes from a later period, the sanctity with which the crown was endowed makes this unlikely, and most should probably be regarded as forming part of its original design.

The picture emerges of a distinct and deliberate difference operating on the materials used for a crown when it was bestowed on a client ruler like King Géza of Hungary, and when it was destined for an imperial head. This might have been predictable, but the differences are certainly of interest, and appear to fall into two fields - political and economic. The first of these concerns the apparent purpose which lay behind the gift of a rich and - now - uniquely impressive crown to the Hungarian ruler. Whatever the original arrangement of the enamels of the *corona graeca*, it has long been understood that they must have been intended to convey a political and diplomatic message: the subservient status of King Géza I to the Byzantine power. For this message to be clear, only some figural form such as enamel was appropriate.

But the comparison of the 11th century Holy Crown of Hungary with the 14th century imperial crown suggests a further dimension. To the modern observer the extraordinary brilliance and artistry of its enamels make it a work of matchless, if perhaps rather austere, beauty, and certainly of greater artistic interest than if (like the imperial crown) it had been decorated solely with gems. Throughout the long development of imperial Byzantine crowns, enamels never appear to have formed a significant part of their design. But for the eleventh-century Byzantine court the use of enamel may have been a solution that had another objective besides the political one just mentioned. The value of enamels as a pledge against cash would certainly have been very much lower than that of fine gems. Even the Doukas dynasty would have been conscious of the fact that while gems could have found their way into the bankers' vaults at any time that the Hungarian royal finances needed a further supply of funds, enamels with (or without) their clear political message would be far more likely to stay in their proper and intended place. Their value as a pledge would never have been as high, even if reduced to bullion. It could never have been in the interests of the Byzantine court to bestow the means for producing an independent source of revenue on the Hungarian king, and enamels provided a spectacularly brilliant, worthy and diplomatically significant alternative.

Given these considerations, a final point could be made here. It is of interest that when Helena, the wife of John V, had in 1356 to raise the huge sum of 100,000 *hyperpera* to pay the ransom for Halil, the son of the Ottoman sultan Orkhan, she had to sell a substantial collection of relics that were then still in the imperial possession, and which were to end

[34] See Patrick J. Kelleher, The Holy Crown of Hungary (Rome 1951, Papers and Monographs of the American Academy in Rome, XIII), 32-33, n. 44, where expert evidence is cited; the recent identification of green glass is given in E.Toth and K. Szelényi, The Holy Crown of Hungary (Budapest 1999) 19. For the diplomatic background to the crown, see R.Cormack, But is it art?, Byzantine Diplomacy, J.Shepard and S.Franklin, eds., (Aldershot 1992) 218-236.

up in the treasury of the Ospedale della Scala in Siena.[35] The priorities seem initially quite clear: for the pledge in 1343 the crown jewels were regarded as in some way more readily expendable than the relics, although the latter included an enkolpion mounted with a variety of gems, some of which were balas-rubies.[36] It was only 13 years later that the relics and reliquaries were put up for sale; pledging them as security for a loan does not seem to have been an option in this case.[37] Of the two empresses involved in these money-raising enterprises, Anna of Savoy was Italian-born, while Helena was proud of her Kantakouzene family descent. It may have been this distinction that lay behind the priorities that seem to have prevailed during these troubled decades: the Italian-born empress pledged the crown jewels rather than the holy relics, leaving the Byzantine empress to sell the remaining relics and reliquaries from the palace.[38]

[35] Paul Hetherington, A purchase of Byzantine Relics and Reliquaries in Fourteenth-century Venice, Arte Veneta, 37 (1983) 9-30. This study, with the documents it included, was apparently unknown to G.Derenzini, who partially re-published them in: Esame paleografico del codice X.IV.1 della Biblioteca Comunale degli Intronati e contributo documentale alla storia del "Tesoro" dello Spedale di Santa Maria della Scala, Annali della Facoltà di Lettere e Filosofia dell'Università di Siena, 8 (1987) 59-74.

[36] Siena, Ospedale della Scala, Reliquary A; see Hetherington, op. cit., 9-11.

[37] An outright sale was by then the only option; the Venetians must now have realised the impossibility of any loans being repaid from the Byzantine imperial finances; see Bertelè, op. cit., 136.

[38] Helena Kantakouzenos had sworn "with great sobbing" (*cum grandissimo singultu*) that by then there was nothing as valuable left in the palace (Hetherington, op. cit., 18.)

Fig. 1 Modena, Biblioteca Estense, MS grec. 122,
fol. 294v. The top row has portraits of Andronikos III
on the left and of John V Palaiologos an the right.

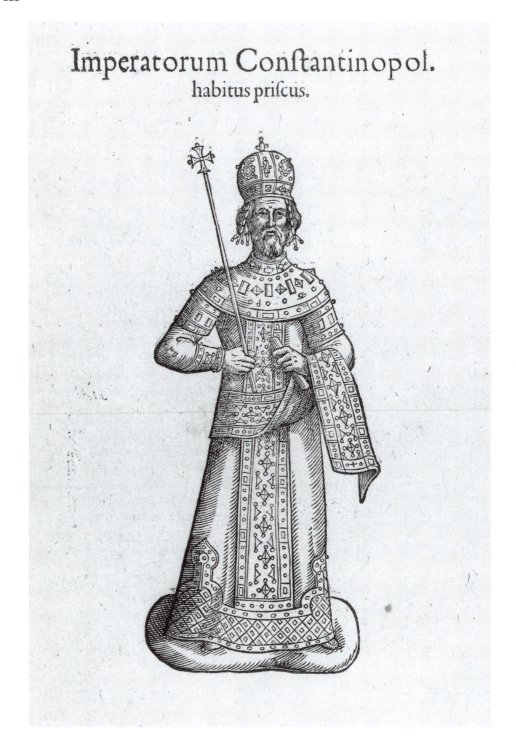

Fig. 2 Martin Crusius, Turcograecia (Basel 1584).
Woodcut facing p.1. (149.h.11 © British Library Board.
All Rights Reserved.)

LA COURONNE GRECQUE DE LA SAINTE COURONNE DE HONGRIE: LE CONTEXTE DE SES ÉMAUX ET DE SES BIJOUX[1]

The „corona graeca" of the Holy Crown of Hungary: the context of its enamels and jewels - This communication is concerned with the general circumstances under which the *corona graeca* of the Holy Crown of Hungary would have been produced in Constantinople. It is first considered in the context of „diplomatic gifts", and is compared with other enamels of the same period that are now in Tbilisi, although it is usually agreed that these are of lower artistic standard than those in Budapest. The point is made that the crown must be the result of the same technical restrictions as any other examples of Byzantine enamel, and that this aspect of production could have involved the re-use of individual plaques, such as that with a rounded top portraying Michael VII Doukas. The question of the locality in the city where the workshop in which the crown was made is discussed, and the minimal evidence for the existence of a „palace workshop" is noted. It is suggested that the modest value of the gems in the crown could be the result of diplomatic or economic considerations; for modern eyes the contrast between them and the perfection of the enamels demands some explanation of this kind. It is pointed out that all the evidence points to there never having been any enamels used in the crowns worn by Byzantine emperors.

Keywords: enamel, jewels, Tbilisi

J'ai pris pour mon point de départ pour cet essai l'idée qu'il n'y a pas un seul œuvre d'art qui est sorti d'un vide - soit qu'il est un œuvre du rang artistique de la sainte couronne de Hongrie soit qu'il est une oeuvre d'origine beaucoup moins élevée. Chaque œuvre est le résultat d'une ensemble de conditions, et ces conditions fournissent ce que j'apelle ici un contexte, ou une ambiance. Il y a des autres collègues qui vont délibérer sur quelques de ces éléments qui ont eu des influences sur la couronne, dans la forme en quelle elle existe aujourd'hui. Mais, en me limitant à la couronne grecque, c'est mon intention de vous proposer d'autres éléments que nous pourrons considérer comme formant une ambiance dans laquelle la couronne grecque fut produite.

On pourrait commencer par une considération de la place que la couronne grecque prendrait dans la tradition de « cadeaux diplomatiques ». Ceci est une tradition très fluide et assez peu connue, mais on pourrait suggérer une place prise par la sainte couronne dans ce domaine.[2] En outre des couronnes qui doivent avoir servi comme couronnes nuptiales, il y a deux couronnes qui existent encore que nous

devons considérer, quoiqu'elles ne font pas partie de la tradition des cadeaux ou des présentations diplomatiques comme la Sainte Couronne : une d'eux fut trouvée dans la tombe de la reine Constance d'Aragon, mort en 1222, et se trouve maintenant dans la cathédrale à Palerme.[3] On croit maintenant que cette couronne appartenait à son mari, Frédéric II, et c'est considérée comme la meilleure imitation contemporaine d'une couronne byzantine, quoiqu'elle fut fabriquée sans doute à Sicile. L'autre est la fameuse couronne dite de Constantin Monomaque,[4] maintenant encore à Budapest, aussi ne peut pas être classée avec certitude comme un tel cadeau. Mais ils existent encore des vestiges en émail qui se trouvent maintenant en Georgie, et qui presque certainement viennent d'un cadeau diplomatique : là, entre le grand nombre de plaques d'émail qui furent rassemblés par le roi de Georgie, Dimitri I (1125–1146) sur le triptych de Kakhuli, maintenant à Tbilisi,[5] se trouvent quelques émaux qui doivent avoir commencé leur existence sur quelque chose comme un cadeau, sinon diplomatique, un cadeau qui accompagait un mariage diplomatique. Le double portrait nous permet d'identifier préci-

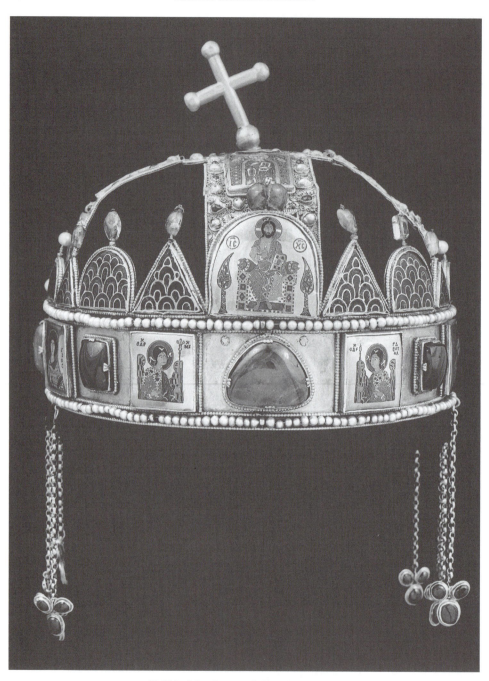

Fig 24 La Sainte Couronne de Hongrie, vue de front

sément le date et l'occasion du cadeau. Les deux personnes sont nommés comme Michel VII Doukas (1071-1078), et son épouse qui était la fille de l'empereur Géorgien Bagrat IV (1027-1072), et l'inscription montre qu'ils sont couronnés tous les deux par le dieu « avec ses propres mains ».[6] Par hasard, c'est ici le même empereur dont le portrait se trouve sur la Sainte Couronne.

Nous ne savons pas la forme de l'œuvre ou du cadeau où ces plaques furent originallement installés, mais il y a quelques indications. Les deux plaques qui représentent deux scènes du Dodekaorton bien connus ont été soumises à des altérations très intéressantes : une présente une Annonciation,[7] mais à la place de la vierge, on voit une princesse ; et une autre la Baptême par le Précurseur,[8] mais en place du Christ on voit encore une princesse – présumablement la même ; mais un troisième plaque dans ce collection montre deux princesses qui sont bénies par la Vierge qui se trouve entre les deux.[9] Il n'éxiste pas une explication complètement satisfaisante de cet ensemble d'émaux, pour lesquels il n'y a aucune parallèle, mais à mon avis on devrait penser à un coffret contenant peut-être des cadeaux de mariage, sur lequel ces émaux étaient originallement installés.

Pour notre thème du contexte de la couronne grecque de la Sainte Couronne, il faut dire que le qualité de travail des portraits impériaux à Tbilisi manque la perfection que tout le monde trouve dans les émaux de la couronne grecque. On doit chercher une explication de cette différence, parce que c'est le même empereur, Michel VII Doukas, qui est representé sur chaque pièce. Je vais revenir à ce problème plus tard, mais pour le moment il faut indiquer que le contexte impérial des deux ensembles – la Couronne et le putatif coffret – doit être superficiellement le même – c'est à dire le même empereur se trouve sur chaque œuvre. Mais dans cette comparaison limitée on devrait trouver que la Sainte Couronne serait complètement unique, pendant que l'autre œuvre de présentation pourrait être d'un dessein moins limité.

L'assemblement des émaux sur le triptych de Kakhuli constitue un exemple uniquement impressionnant de ce qui est arrivé souvent pendant l'histoire de Byzance, et dans les siècles post-byzantines ; c'est le résultat d'un élément

technique de la fabrication des émaux. Il faut comprendre que l'émail c'est simplement de verre de couleurs variés, qui est mis dans les cloisons sur le plaque d'or en forme de poudre.[10] Ensuite, le plaque doit être placé dans un four très chaud où ces poudres sont mis en fusion avec la base de métal. La matière dans les cloisons devient de verre pur et solide à ce moment, est c'est absolument essentiel que, quand la plaque commence à refroidir et ainsi contracter, le métal du base et l'émail contractent tous les deux ensemble et au même degré ; sinon, le verre de l'émail se relève de son base et l'émailleur doit recommencer son travail. C'est à cause de cela que chaque exemple de l'émail byzantin prend la forme d'une collection de petites plaques (la Sainte Couronne en a dix), qui sont fixés sur une base plus grande. Une plaque ne peut pas être réchauffée encore plus tard, ainsi le méthode de fixer les plaques à la Sainte Couronne, comme dans presque chaque autre cas, est par une biseau qui est bruni complètement froid.

Cet aspect de l'art de l'émailleur byzantin a eu le résultat que les plaques pourraient être détachés de leur demeure originale, et ainsi deviennent isolés ; dans ce cas ils pourraient être considérés un peu comme des bijoux. Ceci c'est un autre aspect du contexte du travail des artistes en émail. Nous savons qu'un atelier d'orfèvres à Constantinople pourrait maintenir un stock de plaques qui pourraient être rassemblés de quelques ensembles d'émaux qui ont été dispersés. Un exemple documenté de ce traitement se trouve dans le texte des Evangiles de Mstislav à Moscou, où le scribe du manuscrit qui s'appelait Naslav, du pays des Russes, a écrit dans le manuscrit que, vers 1130 il a porté son manuscrit à Constantinople (qu'il appelait Tsargrad) et qu'il a commandé là des émaux pour la reliure de son manuscrit.[11] En tout cas il me parait que les cinq émaux avec un profil gothique qui restent sur la reliure, et qui comprennent des portraits des princes russes Boris et Gleb, sont ceux que Naslav a commandés, et que les sept autres sont des époques antérieures, et qu'il les a achetés au même temps, et peut-être du même orfèvre qui a fabriqué les autres émaux. Pour le contexte de la Sainte Couronne, on peut suggérer que ce n'est pas nécéssaire que tous les dix émaux furent fabriqués à exacte-

ment le même date, et c'est possible que le portrait de l'empereur Michel VII Doukas était une addition, déjà en existence, à un ensemble qui fut autrement le résultat d'une commande impériale. C'est à cause de cela que ce plaque est le seul où se trouvent des trous;[12] la meilleure explication pour cela est que ce portrait avait une existence antérieure, et qu'il se trouve maintenant dans une demeure seconde où ultérieure.

On connaît d'autres collections d'émaux byzantins qui furent assemblés complètement en dehors d'aucune centre byzantine. À mon avis, la reliure splendide qui se trouve maintenant à Siena fut fabriquée à Venise vers 1359, et elle fut vendue cet année, avec environ quarante reliques venant du palais impériale à Constantinople, à la *Ospedale della Scala* à Siena.[13] Les orfèvres vénitiens se sont servis ici d'une collection de quarante-huit émaux byzantins qui peuvent être divisé en peut-être dix groupes. Je mentionne ceci comme illustration de ce phénomène de la séparation des plaques de leur demeure originale qui est si souvent arrivée. C'est un aspect, je trouve, du contexte général de l'émaillerie byzantine.

On pourrait continuer, en réfléchissant sur le contexte de la couronne, par une considération brève sur la question du localité où se trouvait en Constantinople l'atelier dans laquelle fut créé la couronne avec ses émaux. Ca vaut la peine de poser ce question, parce que pendant beaucoup d'années du siècle dernier il existait une présomption que dans le palais impérial lui-même ils existaient des ateliers, et même un scriptorium, où commissions d'une importance comparable avec la Sainte Couronne furent mises à exécution. Cette tradition fut dévelopée pour la plupart à cause du continuateur de l'historien Théophanes, qui dans la Chronographia de l'empereur Constantin Porphyrogenète, avait parlé de son talent pour une peinture «précise», et comment il avait «corrigé» les œuvres des sculpteurs, des maçons, des charpentiers, des doreurs, et des orfèvres.[14] C'est certainement possible que cet empereur du dixième siècle a véri-tablement produit des peintures lui-même dans le palais, mais j'ai toujours trouvé qu'il serait impossible pour un atelier d'orfèvres de fabriquer des œuvres d'une telle complexité que – par exemple – la fameuse staurothèque de Limbourg, avec provenance de la cour impéria-

le,[15] ou le calice des patriarches,[16] tous les deux avec des émaux du même siècle que le Constantin Porphyrogenète, sans avoir dans leur voisinage tout un ample assortiment d'autres spécialistes. Les restrictions de ce milieu devraient être trop limitées pour une telle variété de métiers. Dans chaque grande ville du moyen âge on aurait trouvé un quartier particulier où les orfèvres des différents spécialités travaillaient côte à côte : les négociants en or et en argent, qui pourraient être vraiment des banquiers, les fondeurs de métal précieux, les travailleurs à la filière, les fabriqueurs de filigrane, les marchands des bijoux et les polisseurs des bijoux, les gens qui percent les perles en perçant des trous pour les affixer, les orfèvres qui produisent des plaques d'or avec ses cloisons pour l'émail, souvent très minuscules, les émailleurs lui-mêmes, et, si l'oeuvre soit en argent, les doreurs. Avec une œuvre comme la staurothèque de Limbourg, il y avait peut-être une douzaine de spé-cialistes qui travaillaient ensemble sous l'autorité d'un maître. Ce question vaut plus de recherches, mais à mon avis il serait impossible de rassembler un tel équipe de spécialistes différents dans les confins du palais impérial, et il faut supposer un quartier de la cité où se trouvaient tous ces spécialismes variés, et où fut transmise la commission pour la Sainte Couronne.

Il y a un autre aspect du contexte de la Sainte Couronne que je veux contempler, et ceci concerne ses bijoux. Ils sont tous contemporains avec la couronne sauf un, qui est le safir à facettes qui se trouve au dessous du portrait de Michel VII, qui est un remplacement fait dans le dix-septième siècle;[17] les autres ont été identifiés comme une aigue-marine, deux comme almandines, deux comme safirs et deux de verre verte. Même si ces identités sont disputés, il faut dire que ces bijoux ne sont pas valables. En comparaison avec la perfection des émaux, les bijoux dans ce présentation diplomatique ne devraient pas être ou très rares ou très précieux. Je peux offrir une explication pratique pour cela.

Il faut reconnaître au commencement que aucune des couronnes impériaux des empereurs de Byzance portaient des émaux; ils ont tous, ou pour l'empereur, ou pour l'impératice ou pour les enfants de la famille impériale, portaient des couronnes ornées seulement de bijoux. Ces

bijoux étaient les « joyaux impériaux » des empe-
reurs à Byzance, et l'idée générale d'une couron-
ne impériale qui était passée d'un empereur à
son successeur n'éxistait pas. C'était seulement
les joyaux qui furent transmis. Je n'ai pas le
temps de développer ce thème avec assez de
détaille, mais je peux vous offrir un exemple de
l'importance que ce concepte pourrait détermi-
ner. Plus tard, en 1343, l'impératrice Anne de
Savoie, la veuve de l'empereur Andronikos III,
désespérée pour protéger les droits de son jeune
fils de dix ans, Jean, pour obtenir une avance de
30,000 ducats d'un syndicat de banquiers Véni-
tiens, a engagé tous les joyaux de la couronne
impériale, laissé par son mari qui venait de
mourir.[18] Dès ce date les joyaux qui devraient
orner la couronne d'empereurs successifs de
Byzance étaient fermés à clef dans le trésor de
San Marco à Venise. Il existe encore une longue
série de documents qui fournissent non seule-
ment l'identité précise de tous ces joyaux, avec
(aussi important) leurs poids, mais aussi mon-
trent que les Vénitiens chaque cinq années ont
demandé le retour des 30,000 ducats, avec
entérêt entendu, à fin que les joyaux pourraient
être rendus, et que chaque fois les Byzantins ont
plaidé qu'ils n'étaient pas dans un état écono-
mique où cela était possible. Entre parenthèses
il faut dire que cette situation signifie que
chaque fois que les empereurs se présentaient
en public portant leur couronne, de 1343
jusqu'à 1453, (ça fait cent-dix années) leur cou-
ronne fut ornée de joyaux faux – des morceaux
de verre coloré comme des vraies bijoux.[19] Il
existe, par exemple, un portrait dans un manu-
scrit de c.1403 au Louvre de Manuel II Palaio-
logue et Helena avec leurs trois fils qui doit

réfléchir un tel exemple,[20] et le manuscrit de
Zonaras contentant les portraits de tous les em-
pereurs qui se trouve maintenant à Modena, du
XV^ème siècle, même reconnaissant ses limita-
tions artistiques, devrait commander de respecte
pour son détaille.[21]

Quel rapport a cela pour la couronne
grecque de la Sainte Couronne de Hongrie? Ma
suggestion ici c'est que les Byzantins, même à
l'onzième siècle, savaient bien que les émaux,
quoiqu'ils étaient sur une base d'or, ne pour-
raient pas être engagés pour fournir quantités
considérables d'argent. On ne pourrait pas
attacher un grand valeur financier aux émaux,
surtout ceux qui portaient les portraits de per-
sonnages vivants; leur valeur étaient surtout de
prestige. Mais si les bijoux avaient été d'un
valeur comparable à ceux de la couronne impé-
riale (surtout les très grands rubis, et rubis
balais, qu'on trouve sur les portraits impériaux
et, plus tard, dans la liste des joyaux des ban-
quiers vénitiens),[22] les Byzantins pourraient com-
prendre que si la famille royale de Hongrie
avaient besoin de se procurer de l'argent en
temps d'adversité national, c'est possible que
quelques éléments de leur couronne pourraient
se trouver engagés chez des banquiers. En tout
cas, il me semble qu'une explication devrait être
trouvée pour la différence (pour les yeux moder-
nes) entre la perfection des émaux de la Cou-
ronne grecque et le pauvreté relatif des bijoux
qui les accompagnent.

J'espère que ces observations brèves sur quel-
ques aspects de l'ambiente de la Sainte Couronne
fourniront une mise en place pour d'autres con-
tributions sur les différents aspects de la Sainte
Couronne qui seront fournis à cette conférence.

NOTES

1. C'est avec grand plaisir que je présente mes remercie-
ments au Directeur de l'Institut Hongrois en Paris, M.Sándor
Cernus, à Mlle. Sághy, Chargée de mission, et à M. Etele Kiss
du Magyar Nemzeti Múzeum et M. Ernő Marosi du Művészet-
történeti Kutatóintézet à Budapest, pour mon invitation de
contribuer au Colloque sur la Sainte Couronne de Hongrie.
2. Voir par exemple Shepard, J. et Franklin, S. (éditeurs):
Byzantine Diplomacy, Aldershot 1992, particulière-ment p.
230–236 de la contribution de Cormack, R., « But is it art? »
3. Voir Deér, Josef: *The Dynastic Porphyry Tombs of the
Norman Period in Sicily*, (Dumbarton Oaks Studies 5)
Washington, D.C. 1959, 171.
4. L'étude fondamentale des ces plaques uniques est
celle de v. Bárány-Oberschall, Magda: The Crown of the Em-

peror Constantine Monomachos, *Archaeologia Hungarica*,
Acta Archaeologica Musei Nationalis Hungarici, XII, Buda-
pest 1937, mais a depuis dévelop-
pé.
5. Amiranashvili, Shalva: *The Khakhuli Triptych* (texte
en géorgien, russe et anglais), Tbilisi 1972.
6. Amiranashvili 1972, fig. 9: Στέφω Μιχαήλ σύν Μαρι-
άμ χερσί μου
7. Amiranashvili 1972, fig. 12.
8. Amiranashvili 1972, fig. 11.
9. Amiranashvili 1972. fig. 10; images meilleures se
trouvent en: *Medieval Cloisonné Enamels at Georgian State
Museum of Fine Arts*, Tbilisi 1984, figs. 68–70 [aucun nom
d'auteur].

10. Cet opération est décrit en ch. 44 du traité du XII^e siècle par Theophilus, *De Diversis Artibus*; voir l'édition par Dodwell, C.R., Londres 1961, p. 104-107.

11. Hetherington, Paul: Byzantine Enamels for a Russian Prince: The Book-cover of the Gospels of Mstislav, *Zeitschrift für Kunstgeschichte* 59 (1996) p. 25-38.

12. Tóth, Endre et Szelényi, Károly: *The Holy Crown of Hungary: Kings and Coronations*, Budapest 1996, p.27.

13. Hetherington, Paul: Byzantine Enamels on a Venetian Book-cover, *Cahiers archéologiques* 27 (1978) p. 117-142; et *idem:* A Purchase of Byzantine Relics and Reliquaries in Fourteenth-century Venice, *Arte Veneta* 37 (1983) p. 9-30.

14. Constantine Porphyrogenitus, *Theophanes Continuatus*, VI, 22, CSHB, éd. Bekker, Bonn 1838, p. 450; voir aussi Toynbee, Arnold: *Constantine Porphyrogenitus and his World*, London 1973, p. 5.

15. Une étude récente, avec bibliographie, est celle de Ševčencko, Nancy P.: The Limburg Staurothek and its Relics, *Thymiama ste mneme tes Laskarinas Boura*, Athens 1994, p. 289-294; le staurothèque porte une inscription avec les noms de deux empereurs et d'un proedros.

16. Hahnloser, H. R.: *Il Tesoro di San Marco. Il Tesoro e il Museo*, Venise 1971, cat. n. 40, p. 58-59 et tavv. 60-61.

17. Voir Tóth et Szelényi 1996 (voir note 12), p. 19, et Kelleher, Patrick J.: *The Holy Crown of Hungary*, Rome 1951, p. 32-33, où l'identification des pierres faite par Sándor Koch

est citée; quoique ces deux autorités ne correspondent pas exactement, c'est le dernier qui mentionne que la seule pierre à facettes est une addition du XVII^e siècle.

18. La longue série de documents relative à cet épisode fut publiée par Bertelè, Tomaso: I gioielli della corona bizantina date in pegno alla repubblica veneta nel sec. XIV e Mastino della Scala, *Studi in onore di Arminto Fanfani*, Milan 1962, II, 91-177; j'ai un article sous presse dans *Byzantinische Zeitschrift* qui s'occupe avec autres aspects de ces événements.

19. La description dans la *Byzantina Historia* de Nikephoros Gregoras, assez bien connue, de festivités dans le palais de Blachernae en 1347, où les robes de la famille impériale étaient décorées de pierres fausses, se trouve en ch. XI, 11, 2 (CSHB, II, Bonn 1830, s. 788-789).

20. MS Ivoires 100, f. 2r; voir Spatharakis, Iohannes: *The Portrait in Byzantine Illuminated Manuscripts*, Leiden 1976, Fig. 93; le voyageur et diplomate Ruy de Clavijo a décrit son réception par Manuel II, sa femme l'impératrice et ses trois jeunes fils, et ce rencontre de 1403 est contemporain avec ce manuscrit qui date de 1403-1405; voir Le Strange, Guy (éd.): *Clavijo Embassy to Tamerlane 1403-1406*, London 1928, p. 61.

21. Modena, Mutin. Gr. 122, ff. 293-294 (Spatharakis en note 20, Figs. 117-127).

22. Comme raconté par Bertelè; voir note 18.

BYZANTINE AND RUSSIAN ENAMELS IN THE TREASURY
OF HAGIA SOPHIA IN THE LATE 14TH CENTURY

The inventory of the treasury of Hagia Sophia that was drawn up in October 1396,[1] during the second patriarchate of Antony IV,[2] is remarkable in several different ways. Under some 108 headings it enumerates over 180 different objects, providing an authentic and revealing insight into several aspects of the ecclesiastical life of the Great Church, and so of Constantinople, in the later Palaiologue period. This paper will focus chiefly on the decoration of metal objects that are described as forming part of the treasury, and the suggested presence there of Byzantine and Russian enamels, but some general preliminary points should first be made.

The very existence of so much bullion accumulated in the Great Church at that date is itself worthy of comment; what is known of the imperial finances of earlier decades in the century confirms that the ecclesiastical authorities had been more successful than the imperial family in assembling or retaining precious objects in the decades since the expulsion of the Latin emperors. In 1343 the empress Anna of Savoy had had to pawn the jewels from the imperial crown to pay for immediate pressing expenses,[3] and in 1356 the empress Helena Kantakouzene had sold a large quantity of valuable relics and reliquaries from the imperial possessions to pay a huge ransom demand.[4] Yet just four decades later the Great Church was clearly still in possession of such substantial wealth that only a fraction of the objects held could have been in anything approaching continuous use.

Great value seems to have been placed on the three items that were said to be of ἴασπις—perhaps jasper, but quite possibly agate or onyx; these may well have had the most venerable associations, and one will be mentioned again below.[5] Although only three items (a chalice, a paten and a "star") are said to be of gold, the overwhelming majority of metal objects are described as "silver-gilt" (ἀργυροδιάχρυσος); these include sixteen ῥιπίδια and fourteen chalices[6]. The vestments and other textile materials consisted, *inter alia*, of seven σάχοι, six ἐπιτραχήλια, three ἐπιμάνικα and two ἐπιγονάτια, almost all richly decorated. A recurrent phrase used when describing many of

[1] F. Miklosich & I. Müller, Acta et diplomata graeca medii aevi sacra et profana, 6 vols. (Vienna 1860–90) II, Acta Patriarchatus Constantinoplitanae MCCCXV–MCCCCII, 566–570. (Hereafter, M.M.).

[2] V. Grumel, La Chronologie (Paris 1958) 437; Antony had previously been patriarch 1389–90.

[3] See F. Dölger, Regesten und Kaiserurkunden des Oströmischen Reiches, 5. Teil (München 1965) no. 2891 (mispr. as 2791), 9–10, where most references to this episode are assembled; it has been discussed more recently by K. M. Setton, The Papacy and the Levant (Philadelphia 1976) I, 318–320.

[4] For an account of this episode see P. Hetherington, A Purchase of Byzantine Relics and Reliquaries in fourteenth-century Venice, Arte Veneta, 37 (1983) 9–30.

[5] See n. 9, below.

[6] The two words used by the compilers of the inventory to designate a chalice are discussed in n. 9, below; one of the chalices is described as being broken.

134

these is to say that they are adorned with pearls (μετὰ μαργάρων, μετὰ μαργαριταρίων, ὁλομάργαρον, etc.) and it would certainly appear that this was one form of jewelled ornament which was not in short supply.

The number of liturgical books mentioned here is so small (four εὐαγγέλια, five κοντάκια and two τακτικὰ) that it must be assumed the bulk of the holdings of the Great Church would have been stored elsewhere (probably in a pastophory). Those that are noted may have been kept in the treasury on account of their precious bindings, which certainly existed in the case of the εὐαγγέλια and the τακτικά. Perhaps more surprisingly, only four icons are mentioned: one of Christ, one of the Virgin, one of [St John] Chrysostom and one of the Deposition; while a few items, such as an altar cloth and a censer, are noted as being "kept in the church", none of the icons are so described. While this might suggest that these may have been the only portable icons then to be found in Hagia Sophia, it is more likely that it was the ornament in precious metal that they are described as bearing which was the reason for their being enumerated as part of the treasury. The highly interesting entry describing the icons of Christ and the Virgin is the longest in the document, which suggests that unadorned icons were regarded as being of relatively less interest or value.

Among the relics three fragments of the true cross are mentioned, enclosed in different forms of reliquary, besides the skulls of St Stephen the Younger and of St Eustratios and the jaw-bone "of the great Paul"; seven other relics are noted, but it is interesting to realise that some could not be identified by the writers of the inventory.

Occasionally we find a qualitative judgement being introduced; of the five manuscripts of the gospels (εὐαγγέλια), that with the least decoration on its cover is said to be "everyday" (καθημερινά) and is "in the church". The same term is applied to one of the pairs of ἐπιμάνικα.

Another area of interest is raised by the designation of some of the treasury contents as having been dedicated or inscribed by known individuals. An ἐπιτραχήλιον is thus associated with "the most holy patriarch Kyr Neilos of blessed memory"—presumably Neilos Kerameus, patriarch 1380–1388,[7] who is also credited with the addition of a richly decorated σάκος. Another item was donated by the current patriarch, Antony, and the presence in the treasury of a chalice of jasper (ἴασπις) is due to "the holy lady, Kyra Hypomone"; this donor was in all probability none other than the former empress and patroness of the arts Helena Kantakouzene, who retired c. 1392 to the convent of Kyra Martha as the nun Hypomone. This is significant in two ways: it is a further indication that the treasury was actually expanding, with new additions being received during the later Palaiologue period; it also provides strong evidence that the inventory was completed before November 1396, the likely date of Helena's death.[8]

It is in the context of this substantial assemblage of precious objects that some of the vocabulary used by the compilers, and the terms describing the decoration of the Treasury contents, should be set. There seem, for example, to be two words used (κρατὴρ, of five objects, and ποτήριον, used of nine) that should both be rendered as

[7] Grumel, op. cit. in n. 2, 437.

[8] See D. M. Nicol, *The Byzantine Family of Kantakouzenos (Cantacuzenus)* ca. 1100–1460 (Washington, D.C., 1968) No. 30, 135–138, particularly n. 7. Helena died between October and December 1396, probably in November; the terms in which she is referred to in the inventory indicate strongly that she was still alive at the time of writing.

"chalice";[9] although it is hard to locate a distinction in how they are applied, it could be that the former is used where what may originally have been a bowl (in two cases of jasper, ἴασπις) was converted to use as a chalice, but this useage may not have been completely consistent.

In particular it is the meaning that should be given to how the word υἱελία (or ὑελία) is used that seems to be the most rewarding to pursue here. The term appears eleven times in the course of the inventory, describing the decoration of chalices (three times), covers of gospel-books (twice), crosses (twice) a gold paten (once), the embellishment of an icon (once) and applied to vestments (twice). The conventional rendering for the word would be "glass", and in some of these cases that may have been intended. Half a century earlier, in 1347, it was the word used by Nikephoros Gregoras to convey the pervasive poverty of the Blachernae palace when he described the imperial garb worn at festivities of that year as being of gilded leather decorated with coloured glass to give the appearance of real gems;[10] the entire sense of this passage must mean that in this instance Gregoras intended that the word should refer precisely to the coloured glass which had been substituted for genuine gems.

Yet in two cases in our inventory the word is used in conjunction with gems (λιθά-ρια υἱελία) which taken literally would mean "glass gems" or perhaps "glassy gems". However, both items appear to be of unusual richness; one of them is the first item in the inventory, and is a jasper chalice "with silver-gilt ornament, λιθάρια υἱελια and mother-of-pearl, …"[11]. The other instance is when the icon of the Virgin (mentioned above) is described as being with "silver-gilt decoration, λιθαρίων ὑελίων and pearls".[12] In both these cases it would seem highly improbable that cheap decoration had been used or substituted, and possibly "polished gems" might convey better what the writers intended, suggesting the usual medieval form of rounded polished stones, sometimes known as cabachons.[13] If this is the case, it would seem to continue the useage of the 11th century *Diataxis* of Michael Attaliates, where an icon frame is described as being ornamented with 25 ὑελίων, which Gautier rendered as "cabochons".[14]

However, on two other occasions the word is used on its own to describe the decoration of two on the only three items of solid gold in the treasury: a chalice "with ὑελίων and pearls, of which four are left", and of the only gold paten in the treasury: "with ὑελίων and fourteen large pearls". The same quality is conveyed in the descriptions of the bindings of two evangelistaries, one of which was clearly of exceptional richness: "… with gold letters and decorations likewise of gold and silver with ὑελίων and pearls … seventy-eight pearls are left, three settings and six ἔργα … four

[9] Both κρατὴρ and ποτήριον appear to be used to mean a chalice, or communion cup; use of the former seems most often to have implied that the chalice was made from a mineral or hardstone bowl with metal mountings, and of the latter that it was made from metal throughout, but complete consistency does not seem to have been practised here.

[10] Nikephoros Gregoras, Historia, XV, 2, (Bonn 1830) 788–789.

[11] M. M., 566; φάκτα, used in the text here, could indicate settings from which ornaments have been lost.

[12] M. M., 567.

[13] "Cabochon" denotes the convex shape produced by an uncut, but polished, stone, rather than any precise kind of gem.

[14] La Diataxis de Michel Attaliate, ed. P. Gautier (Paris 1981) 90–91.

136

clasps.[15"] Whatever the precise meaning of the terms used here, it is clear that the ὑελία would have been out of place as a cheap glass substitute for genuine gems, and the writers avoided the expression λιθάρια ὑελία.

Could it be that what the writers were describing when they used this word was the opaque, coloured and polished glass of Byzantine enamel, and that they had no other term by which to denote it? The production of enamel would have ceased by the period of the inventory, and so the accepted word for it, χειμευτής, could well have dropped out of use.[16] In this case a word that conveyed polished glass would have been an appropriate, if rather inaccurate, alternative.

Confirmation of this explanation is hard to find, partly due to the relative rarity of the medium. It must be significant, however, that when Sylvester Syropoulos described the visit made in 1438 by the Greek patriarch and his entourage to San Marco, Venice, where they were shown the Pala d'Oro with its huge and dazzling collection of enamels, he never used any term which might have conveyed that what they were admiring was an artefact in the medium of enamel. He simply had no word for it. Lacking any accepted vocabulary for the medium, he described it as having the form of "a very large icon (μιᾶς μεγίστης εἰκόνος) assembled from many others", and even his well-known reference to the "portraits of the Komnenoi" just uses the term στηλογραφίας.[17] If we did not know that the subject of this passage was an assemblage of gold plaques with coloured enamel, later commentators might be forgiven for assuming that it was made up of richly decorated paintings on gilded wooden panels.

But if, in evaluating the inventory of Hagia Sophia, we render ὑελία, when used on its own, as "enamels," an image of the treasury emerges that would be familiar to anyone who has studied the contents of the Tesoro di San Marco in Venice; here the great majority of Byzantine luxury objects surviving as loot from the sack of Constantinople in 1204 can now be seen, and in many cases Byzantine enamel forms an integral and prominent part of their decoration. Book-covers, icons, chalices with bowls made from onyx and agate and a paten formed from alabaster (ἴασπις in our inventory was no doubt used as a generic term to convey a range of minerals),[18] can all be found here, many items displaying plaques of Byzantine enamel. At least where objects in precious metal were concerned the two treasuries could have had much in common, and might indeed be described in very comparable terms. One could make a further observation and suggest that, if any precious objects incorporating Byzantine enamels had survived in the city into the late 14th century, the treasury of Hagia Sophia was one of the most probable resting places for them to have found.

As for textiles, with which the Venetian crusaders may not have been so concerned, it must be of relevance here that an ἐπιτραχήλιον is the only item in the treasury of Hagia Sophia that is designated as being "of Russian work" (ῥωσικὸν); it is said to be "covered in pearls" (ὀλομάργαρον) and, most significantly, it is also noted as display-

[15] M. M., 567.

[16] For the etymology of this word, see N. Kondakov, Histoire et Monuments des emaux byzantins (Frankfurt 1892) 85.

[17] Sylvester Syropoulos, Les "Mémoires" du Grand Ecclésiarche de l'Église de Constantinople sur le Concile de Florence (1438–1439), ed. V. Laurent (Paris 1971) 222–223. He earlier referred to the individual enamel plaques of the Pala as θείας εἰκονογραφίας, without any inference that they were formed from coloured enamel.

[18] U. T. Holmes, Medieval Gem Stones, Speculum 9 (1934), 198.

ing ὑελίων among its decoration.[19] A decorative system that integrated Russian en-
amel plaques with applied pearl encrustation as an ornament of textiles used for li-
turgical garments can be shown to have become a Russian speciality. For example,
the *sakkos* of Metropolitan Alexei (1354–1378),[20] richly decorated with small seed
pearls and enamels, can be found among the exhibits of the Kremlin Armoury Mu-
seum in Moscow; its decoration corresponds closely to the description of the vestment
in Constantinople, as well as to the date that the inventory was compiled. To read ὑε-
λίων as either "glass" or "cabochon stones" should surely in this case be questioned,
but if it is rendered as "enamels" the whole phrase becomes identifiable with an exist-
ing and known decorative system.

The scarcity of the luxury art of Byzantine enamel outside major centres means
that there are few parallel cases for comparison. Of the few inventories and *brevia*
surviving from the last two centuries of the Byzantine period, there seems to be only
one that mentions the presence of enamel, and for this the writer uses the conven-
tional word χυμευτὰ; this was in an inventory of 1449 of the monastery of the Virgin
Eleousa near Strumica, in Macedonia,[21] where the halo of an icon of the Virgin is
noted as having enamel decoration. An explanation for this could be that the writer
had specialist knowledge, or that he was repeating the term from an earlier inventory.
The fact that the word was unknown to Sylvester Syropoulos, writing ten years ear-
lier, suggests that the latter may well have been the case.

If it is accepted that this inventory is proof of enamels from an earlier age having
come to rest in Hagia Sophia, it is a further indication of the "one-way traffic" of
such *objets de grand luxe* from private to institutional, or at least more public, sur-
roundings.[22] It is impossible to know how many, of the 180 or so objects listed in the
inventory of 1396, might still have remained there at the taking of the city just under
57 years later. Some of the pieces made from precious metal could have been con-
tributed to the fund for the defence of the city in 1452, but some could well have re-
mained to be taken as loot by the victorious Turks the following year, and so might,
conceivably, have survived to be found in modern collections.

[19] M. M., 569.

[20] Well illustrated in D. Douglas Duncan, Great Treasures of the Kremlin (New York 1979) 41
and 131.

[21] L. Petit, Le Monastère de Notre Dame de Pitié en Macédoine, Izvestija russkogo archeologičes-
kogo instituto v Konstantinopolie, 6 (1900) 114–152, particularly 118–119.

[22] See P. Hetherington, Enamels in the Byzantine World: Ownership and Distribution, BZ 81
(1988), 29–38. (Here Study II).

BYZANTINE ENAMELS ON A VENETIAN BOOK-COVER

In the Biblioteca comunale degli Intronati in Siena there is a sumptuous Byzantine lectionary with an extremely precious and elaborate binding [1]. It can be seen (figs. 1-3) that this consists of sheets of silver-gilt on front and back, each with a beautifully executed repoussé design, and to each of which 24 enamels on solid gold have been attached ; there are six more small enamels still on the spine. Its known history is as follows : according to a reliable tradition the manuscript and its cover were sold, with a number of other objects, to Pietro di Giunta Torrigiani in Constantinople ; the sale took place in 1357 in the Venetian quarter of Pera, and was witnessed by four other Italians [2]. During the sale it was certified by reference to the Empress

Irene that the pieces that were the subject of the transaction had been in the possession of the Emperor John Cantacuzenus [3]. In 1770 a ' copia autentica ' of the deed of sale was still in existence, but a recent search for it was unsuccessful [4]. In 1359 the treasure was brought to Venice, and the same year it was transferred, under the auspices of Andrea di Grazia, a syndic of the Ospedale di Sta. Maria della Scala in Siena, to the possession of that hospital. In 1787 the manuscript and its cover passed to the Biblioteca comunale of Siena by order of the Grand Duke of Tuscany, where it has been kept ever since [5].

In this paper the character of the silver-gilt cover will be assessed, and a Venetian origin proposed for it ; and the enamels

1. The manuscript has always been referred to previously as a Gospels ; I would like to thank Professor Hugo Buchthal for pointing out that it is in fact a lectionary. For previous literature on the book-cover, see : J. Labarte, *Histoire des Arts industriels au Moyen Age et à l'Époque de la Renaissance*, 2nd ed., III, Paris, 1875, pp. 24 and 445-446 and Pl. LXI ; J. Schulz, *Der byzantinische Zellenschmelz*, Frankfurt, 1890, p. 50 ; G. Schlumberger, *Un empereur byzantin au dixième siècle Nicéphore Phocas*, Paris, 1890, p. 23 (the 2nd ed. of 1923 omitted the engraving of the book-cover) ; N. Kondakov, *Histoire et monuments des émaux byzantins*, Frankfurt, 1892, pp. 187-190 (hereafter, *émaux*) ; E. Molinier, *Histoire générale des Arts appliqués à l'Industrie... IV : l'orfèvrerie... du V^e à la fin du XV^e siècle*, Paris, 1900, p. 52 ; A. Venturi, *Storia dell'Arte italiana*, II, Milan, 1902, p. 648 ; A. Muñoz, *Byzantinische Kunstwerke in der " Mostra dell'anticha Arte senese "*, in *Byzantinische Zeitschrift*, XIII, 1904, pp. 705-708 (hereafter, " *Mostra* ") ; O. M. Dalton, *Byzantine Art and Archaeology*, Oxford, 1911, pp. 516-518 ; L. Dami, *L'Evangelario greco della Biblioteca di Siena*, in *Dedalo*, III, 1922-23, pp. 227-239 (hereafter, *Evangelario*) ; C. Diehl, *Manuel d'art byzantin*, 2nd ed., Paris, 1926, p. 693 ; H. R. Hahnloser (Ed.), *Il Tesoro di San Marco : La Pala d'Oro*, Florence, 1965, pp. 31, 48, 57 (hereafter, *Pala*) ; L. Mallé, *Cloisonnés bizantini*, Turin, 1967, pp. 163-164.

2. See G. D. Ristori, *Breve distinta Relazione dell'e sagre Reliquie e di un Evangelario greco manoscritto...*, Siena, 1770, p. 4 ; Dami, *Evangelario*, p. 227.

3. Ristori, *op. cit.*, pp. 4-5, relates that two of the Italian bishops concerned in the sale went to the Empress, wife of John VI Cantacuzenus (who by 1357 would have retired to Mount Athos), so that she might certify that the relics had been the Emperor's property ; she affirmed that " l'impero nulla aveva di piu prezioso ". It is of interest that this factor must have affected the price.

4. I would like to express my warmest thanks to the Director and staff of the Biblioteca comunale degli Intronati both for this information, and for their unfailing help and courtesy while I was studying the lectionary. The copy of the deed had apparently been seen both by Muñoz, " *Mostra* ", p. 707 and Dami, *Evangelario*, p. 227.

5. Dami, *Evangelario*, p. 227. The sum involved in this transaction, 3,000 gold florins, was thought by Dami to refer only to the manuscript, but by A. Frolow, *Les Reliquaires de la Vraie Croix*, Paris, 1965, p. 102, to a reliquary. It presumably in fact convered all the items in the deed of sale, which was dated 14 April, 1359 (see Ristori, *op. cit.*, p. 5).

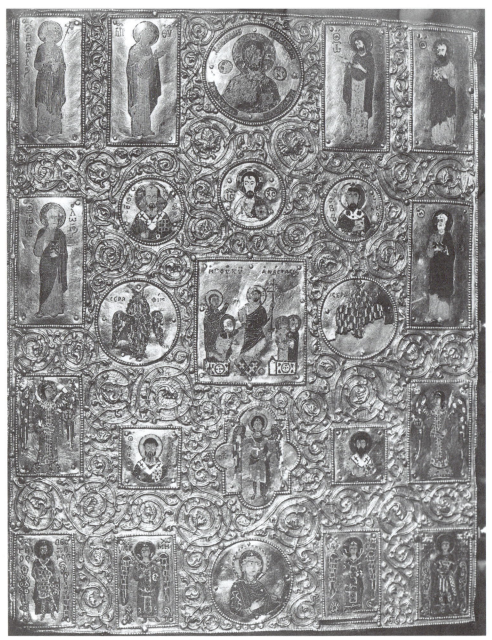

Fig. 1. — *Cover of Lectionary* (*Front*). Siena, Biblioteca Comunale degli Intronati.

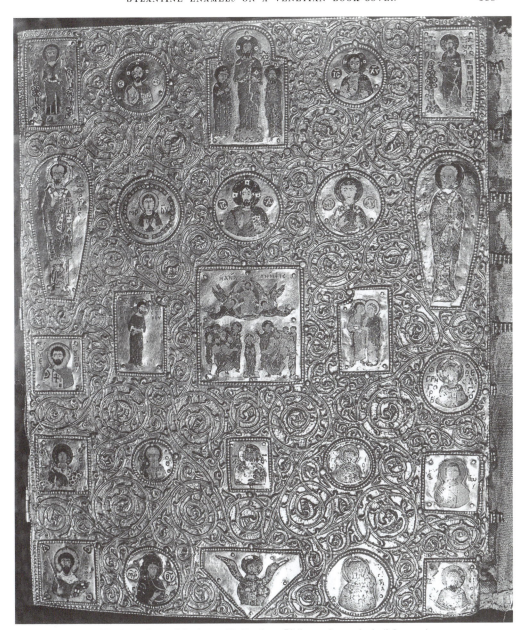

Fig. 2. — *Cover of Lectionary (Back)*. Siena, Biblioteca Comunale degli Intronati.

Fig. 3. — *Spine of Lectionary*. Siena, Biblioteca Comunale degli Intronati.

will be discussed and evaluated more fully than has been done in the past. Before looking at aspects of the book-cover in more detail a few general points should be made about it. Firstly, it is quite clear that the design of both the front and back covers was created around the enamels ; nothing has been added subsequently, and even later substitutions are most unlikely, as the frames created by the design of the silver backing fit the enamels extremely accurately. Secondly, it is also clear that the enamels are of pure Byzantine workmanship ; this has never been disputed. Thirdly, it is evident that as far as the enamels are concerned, the work is an assemblage, with the enamels displaying a considerable variety of styles, shapes, sizes and scale. This must account for a fourth point, which is that, by comparison with other book-covers embellished with Byzantine enamels, the design of this one is to a large extent unique [6]. Fifthly, and this has not been expressed in any previous discussion of the book-cover, it is soon evident to anyone familiar with the formal intricacies of Byzantine art and its iconographic programmes that, whoever it was who devised the arrangement of these enamels, it is scarcely credible that he could have been a Byzantine. Even allowing for the impositions that were made by what was probably a random collection of enamels at his disposal, it would surely have been unthinkable for a Byzantine artist to create, or a Byzantine patron to accept, the extraordinary series of juxtapositions that are found particularly on the back cover : a deesis, three versions of Christ as Pantocrator, and two of the Virgin Orans, with three

more versions of the Virgin below, all of different types ; the two military saints, Theodore and Nestor, are not placed symmetrically, but are balanced by a martyr and a bishop (St. John [7] and St. Basil), while St. John Theologos is paired with another warrior saint, St. George. The front cover is less heterogeneous, as the craftsman here used larger groups of enamels at his disposal, but the roundel of the Virgin at the bottom, for example, which must originally have formed part of a deesis, could have profitably been exchanged for any one of the more symmetrical representations.

The tradition of Byzantine book-cover design conforms to two overwhelmingly predominant themes : the front and back are dominated either by standing images of Christ and the Virgin, or else by feast scenes, usually of the Crucifixion and Anastasis [8]. In either case these central motifs are usually framed by images of saints [9]. It may well have just been a fortunate chance that of the two enamels with feast subjects that were available, one happened to be of the Anastasis. In other respects the Siena book-cover only bears a limited resemblance to the known and fairly stable tradition for book-cover design. It would seem fairly certain, therefore, that the very luxurious cover of this manuscript was created from a chance selection of enamels at some date after the latest of them had been made, and that the random nature of this selection dictated (at least in part) a design which only related in the most general way to the tradition of Byzantine enamelled book-covers as we know it.

6. Cf. e.g. those in the Marciana Library (Cod. lat. Cl. 1, no. 100), and in the Treasury of St. Mark's, Venice (Cat. nos. 35, 36, 37 and 38). See H. R. HAHNLOSER (Ed.), *Il Tesoro di San Marco : Il Tesoroe il Museo*, Florence, 1971, pp. 47-52 and Pls. XXXII XXXVIII (hereafter : *Tesoro*). For a survey of Byzantine book-cover design, see KONDAKOV, *op. cit.*, pp. 172-191.

7. DAMI, *Evangelario*, p. 239 names this figure as St. John the Evangelist, but this must be an error as he is holding a martyr's cross. There is unfortunately no secure basis for deciding which of the 15 martyr saints of this name in the *Synax. Eccl. Const.* is the one depicted in this roundel.

8. E.g.'s of the former type are Cat. nos. 36 and 37 in the Treasury of St. Mark's, and of the latter, Cat. nos. 38 and 39 (HAHNLOSER, *Tesoro*, pp. 48-54).

9. As in the case of icon-frames, these may well have been designed to conform to a litany ; cf. M. E. FRAZER, *The Djumati Enamels : A Twelfth-century Litany of Saints*, in *The Metropolitan Museum of Art Bulletin*, XXVIII (6), 1970, pp. 240-251 ; for the relevance of this concept to the field of ivories, see also E. KANTOROWITZ : *Ivories and Litanies*, in *The Journal of the Warburg and Courtauld Institutes*, V, 1942, pp. 56-81.

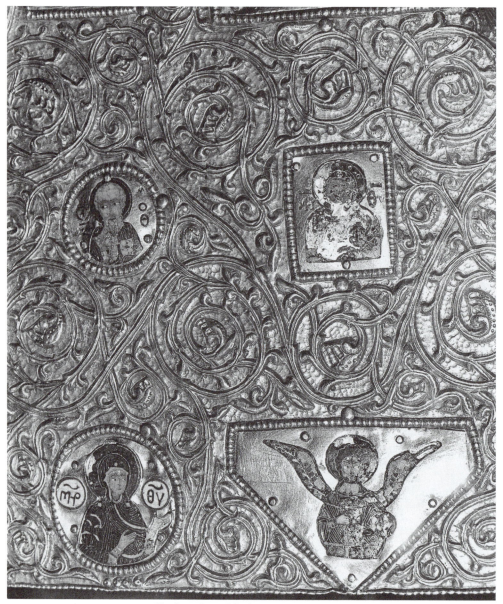

Fig. 4. — *Cover of Lectionary* (Détail of Fig. 2).

1. THE ORIGIN OF THE BOOK-COVER.

The design of the silver-gilt surround of the enamels has been carried out with great assurance and verve. The forms of the ornamental scrolls fill the awkwardly shaped, irregular areas between the enamels with an almost effortless precision that conceals a high degree of artistic skill. Whoever drew and executed this design was a virtuoso craftsman working in a rich and vigorous artistic tradition. This mastery is made perhaps even more notable by being achieved with relatively modest means, in that there appear to have been only about a dozen different punches used throughout the creation of this sumptuous work (fig. 4).

As Luigi Dami acknowledged [10], the vine-scroll motif on which the design is based is a very pervasive one, although the present writer would not agree that the stylistic parallels which he cited — the wooden door of the cathedral of Spalato (1214), the colonettes flanking the door of the cathedral of Traù (1240), or the sculpture of the font at Parma (c. 1270-80) — are sufficiently close to provide constructive analogies. He appears to accept that it is of Byzantine workmanship, although it is " un opera assai tarda e di gusto occidentalizzante ", and that " la rilegatura nel suo stato attuale non possa risalire molto oltre la seconda metà del sec. XIII. " The only other writer to comment critically on the character of the design, Nikodim Kondakov [11], also produced a rather equivocal response. In an apparent attempt to satisfy his unease about the style of the work he concluded that " La reliure... nous paraît donc être quelque chose comme une contrefaçon grecque ". His unease was understandable, as the character of

the book-cover, both in its overall design, and in its detail, is indeed virtually unique. When Byzantine craftsmen decorated sheet metal with a repoussé design, as was often the case with icon-frames and book-covers, they usually sub-divided the area of decoration into simple shapes such as squares, circles and rectangles ; these were then covered with a pattern of densely grouped, small motifs, repeated with mechanical precision, each unit being based usually on vegetable or vinescroll forms [12]. This treatment tended to impart a rather Islamic character to much Byzantine metal-work, and can indeed be found in other classes of object as well [13]. Kondakov, with his long experience of Byzantine metal-work, must have been perplexed as to how to explain the origins of this book-cover, of great richness and brilliance of execution, into which Byzantine enamels had been integrated, but which did not conform to any other type of metal-work that he knew.

The dates during which the cover was made must lie between 1357, when the work was sold, and from which its history is known, and the date of the latest of the enamels. In a later section in which the enamels are discussed, it is shown that none of them is dateable with certainty to later than the 12th century. The *prima facie* evidence afforded by these facts gives such a wide range of possible dates that a closer look should be taken at the particular forms of the decorative detail.

At the centre of the individual scrolls is an unusual kind of floral design, which might be characterised as a flower bud from which the petals are in many cases just emerging (figs. 4, 9 & 10). This rather indeterminate form, althought broadly comparable with some of the huge range of such motifs to be found in Romanesque and Gothic art, can actually

10. DAMI, *Evangelario*, p. 230.
11. KONDAKOV, *émaux*, pp. 187-190.
12. For this approach applied to the sheet metal revetments of icons, see A. GRABAR, *Les Revêtements en or et en argent des icônes byzantines du Moyen Age*, Venice, 1975, cat. nos. 13, 17, 18, 20, 25, 34, 36, etc.
13. Such as ivories and decorative illumination in

manuscripts ; for the former medium see e.g. the borders of panels when made into caskets, in : A. GOLDSCHMIDT and K. WEITZMANN, *Die byzantinischen Elfenbeinskulpturen, I : Kasten*, Berlin, 1930, *passim*; for the latter, see e.g. K. WEITZMANN, *Die byzantinischen Buchmalerei des 9. und 10. Jahrhunderts*, Berlin, 1935, Pls. XIX-XXI, XXXI, XXXVI, etc.

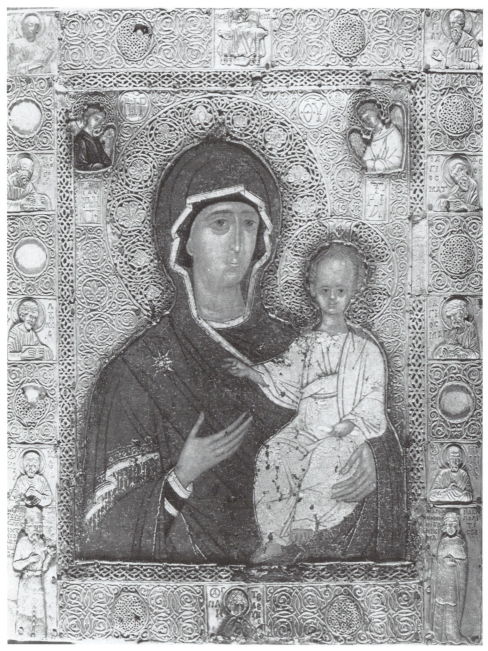

Fig. 5. — *Icon of the Virgin, with Donors.* Moscow, Tretyakov Gallery. (Photo : The Tretyakov Gallery).

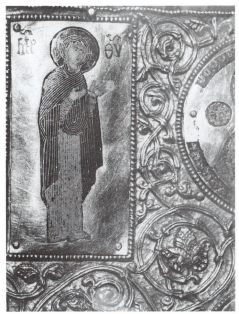
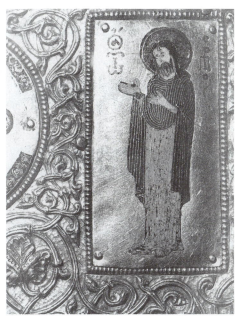

Fig. 6. — *The Virgin* (Detail of fig. 1). Fig. 7. — *St. John the Baptist* (Detail of fig. 1).

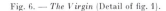

be related quite closely to the design of the silver revetment of Byzantine icon that is now in the Tretyakov Gallery in Moscow (fig. 5). This work is dateable by an inscription to the last half of the 13th century [14]. The four panels of repoussé decoration at top and bottom of the frame, in particular, contain rinceaux with a budlike form at their centre which is not only very rare [15], but is also quite comparable with the relevant shapes on the Siena lectionary. The level of workmanship is not so high, and the craftsman here lacked both the assurance and the inventiveness displayed on the book-cover, his design appearing rather cramped and repetitive beside the fluid drawing of the scrolls which surround the enamels.

At this point, however, attention should be drawn to an interesting detail of the Siena design. Despite the confidence with which the whole work is treated, there is

one instance at which the artist seems to have faltered : at the top of the front cover (fig. 1), just below the central enamel roundel of the Pantocrator, he placed in the centre of the scroll of just two of the rinceaux a leaf of very different character from any other on the book-cover (see figs. 6 and 7). It is a three-lobed leaf with slightly serrated, crimped edges which is quite unlike any other such motif in Byzantine metal-work that is known to the present writer, including the Moscow revetment. It is in fact much closer to the great range of such ornament that is found in Western, and particularly in Italian, art of the 13th and even the 14th centuries. It is as if the artist had begun to work in one manner, and, after making these initial leaf forms, had continued in another, possibly with reference to a piece of Byzantine metalwork such as that on the icon in Moscow. The shrewd

14. GRABAR, *Revêtements*, Cat. no. 18, pp. 45-46 and Pls. XXVII-XXVIII. The repoussé decoration depicts Constantine Acropolites, whose father lived 1220-1282, and this is the basis of the suggested date.

15. They do not conform, for instance, to any of the large number of such motifs categorised by A. FRANTZ, *Byzantine illuminated ornament*, in *The Art Bulletin*, XVI, 1934, pp. 43-76.

Fig. 8. — *Base of Chalice*. Modena, Cathedral Treasury. (Photo : Orlandini, Modena).

comment of Kondakov should now be recalled ; could it be that we are here dealing with a work that was made in a deliberately Byzantinising style by an artist for whom this was not a native tradition ? It has already been remarked how " un-Byzantine " the distribution of the enamels appears.

There is one centre where this kind of activity is known to have been taking place for a considerable period of time, and that of course is Venice [16]. While the most characteristic form of Venetian metalwork was the celebrated *opus venetum ad filum*, there was also a substantial amount of metalwork decorated in repoussé [17]. Among the many objects attributed to Venetian workshops of the

16. See P. Toesca, *Storia dell'Arte italiana : Il Medioevo*, Turin, 1927, pp. 1146-1147, n. 60 ; and Hahnloser, *Tesoro*, pp. 131-136.

17. Cf. H. R. Hahnloser, *Scola et Artes Cristellariorum de Veneciis 1284-1319, Opus venetum ad filum*, in *Venezia e l'Europa : Atti del XVIII Congresso internazionale di Storia dell'Arte, 1955*, Venice, 1956, pp. 157-165 ; also refs. in n. 16, above.

13th and 14th centuries there are several which display floral decoration in this technique which is close in character to the two isolated motifs on the book-cover. Among them are a reliquary of S. Crisogono now in Zara Cathedral and another reliquary in Chioggia, while the base of a chalice attributed to the " maestro della serpentina " now in Modena Cathedral (see fig. 8) is perhaps the most characteristic [18].

Whether or not this can be accepted, it must be agreed that Venice is by far the most probable Western centre for any Byzantinising work to be produced during the late Middle Ages [19]. It does therefore seem that the best explanation for the impressive but ambivalent character of the Siena book-cover is that it was the work of a craftsman active there at some date probably in the later 13th or early 14th centuries, who was attempting to give his creation a Byzantine flavour, perhaps to be in keeping with the enamels which he was incorporating into it. The small aberration just mentioned may have been the first essay in a detail that he later revised to be closer to a genuine Byzantine work. It is in any case certain that there were circulating in Venice for many years after the Fourth Crusade substantial numbers of genuine Byzantine artefacts, of which both enamels and manuscripts must have formed a significant proportion. While the principle ultimate destination of many of the enamels must have been the Pala d'Oro in St. Mark's, into which they were later incorporated, many others would have remained in private hands. It would have been quite natural for a Venetian who was sufficiently rich to have assembled some fifty Byzantine enamelled plaques and a de luxe manuscript to commission one of the workshops of the city to produce a silver-gilt cover for the manscript which would also contain the enamels ; his instructions might even have referred to the style to be adopted for its decoration. It is also possible that the lectionary already had an elaborate binding which its Western owner wanted to restore or improve upon, as it has recently been suggested that the only Byzantine service books to be given lavish and imposing covers were lectionaries, as they were the only one used solely for ceremonial purposes [20]. In any case the precise date at which the cover was produced cannot at present be established, but the historical situation would tend to suggest the first half of the 13th century ; the sparse stylistic data might suggest a later date than this [21], but there is such ambiguity and uncertainty surrounding this aspect of the work that accuracy of chronology cannot be expected.

The fortunes of the manuscript and its cover between its manufacture and its arrival in Siena in the mid-14th century will probably never be known. There is no reason why the reported sale of the book in Constantinople in 1357 should not be true ; it could well have found its way to Constantinople among the property of a Venetian some time before that date, and been in circulation in the city. The fact that it had apparently been in the Emperor's possession is of interest, but does not affect the basic argument ; indeed, the fact that it was the only book in a sale that was otherwise of jewels and preciously mounted relics implies that to a Byzantine it might have actually appeared to be a foreign work, if not actually — to use Kondakov's phrase — a " contrefaçon grecque. "

18. For the two reliquaries, see HAHNLOSER, *Tesoro*, Pl. CXLIV, 9 and Pl. CXLIV, 3-4, and for the chalice, Pl. CXLIX, which is here dated to the second quarter of the 14th century.

19. For this phenomenon as practised in the field of sculpture see O. DEMUS, *The Church of San Marco in Venice*. Washington, D.C., 1960, pp. 109-190.

20. See N. G. WILSON et al., *Byzantine Books and Bookmen* (Dumbarton Oaks Colloquium, 1971), Washington, D.C., 1975, p. 99.

21. A 14th century date was in fact suggested by MUÑOZ, " *Mostra* ", p. 707, but without any supporting argument. A technical examination which included a partial dismantling of the book-cover might well yield more secure evidence.

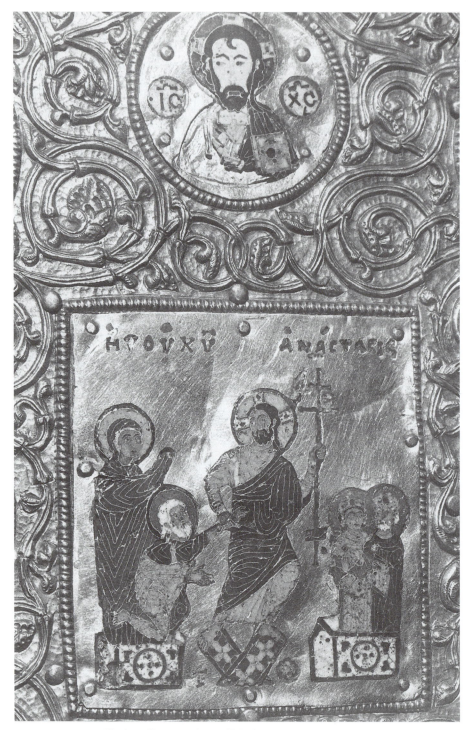

Fig. 9. — *The Anastasis, and Christ Pantocrator* (Detail of fig. 1).

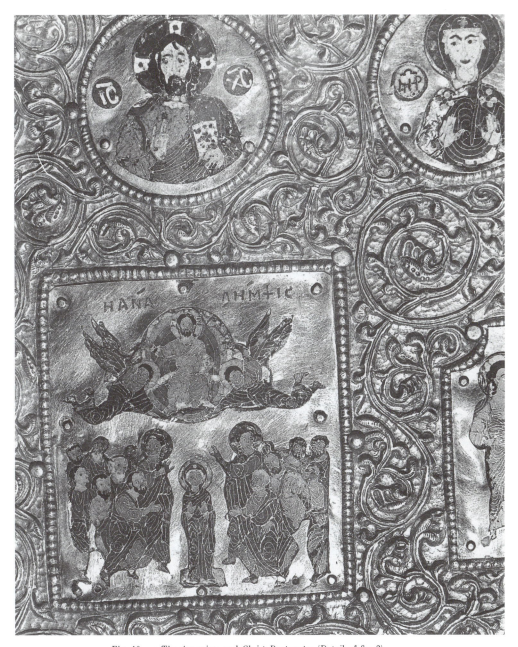

Fig. 10. — *The Ascension, and Christ Pantocrator* (Detail of fig. 2).

2. The enamels.

It was over 50 years ago that Luigi Dami made the most serious attempt to divide the collection of enamels into a series of groups, and found bases for forming eleven groups from 38 of the plaques. Prior to this Kondakov had begun by discussing the front cover in these terms but did not persist with the back cover, and Dami may well have been correct in his guess that the Russian scholar was working with only the coloured lithograph of the front cover from Molinier's book in front of him, although he had of course seen the whole work [22]. Mallé has recently expressed reservations about some of Dami's conclusions, but his discussion was too brief to allow alternative arguments [23].

For the purpose of this paper a fairly restrictive definition of a ' group ' will be used — that is that two or more enamels will only be regarded as forming a group if they are shown to have been created at the same time, as well as intended for attachment to the same object. This is necessary in view of the disparate nature of the collection of plaques with which we are concerned.

It would seem appropriate to start by examining the only two feast scenes on the cover (12 and 36, see figs. 18 and 19), which we will call Group I (figs. 9 and 10). Although not quite identical in size, there is clearly a good *prima facie* case for regarding them as having been made in the same workshop and for attachment to the same object. Other disparities include very slightly different colours used for flesh parts and haloes (two aspects of all enamels in which artists clearly felt least bound by iconographic limitations), and the competence with which the inscriptions are applied to the gold background in the two enamels; the ANACTACIS is awkwardly cramped at the end. However, they clearly must have started out together, although probably not on a bookcover : while the Anastasis is quite often found in this context, the Ascension would be unique among surviving bindings. It is probable that these two plaques formed part of a larger sequence, such as that of the Dodecaorton, and it is pure chance that one of the survivors was the Anastasis. In spite of the different number of figures in each of the enamels, the handling of the cloisons can be seen to be very comparable ; an interesting feature of this group is the apparent disparity in the skill with which the heads and features, particularly in the case of the depictions of Christ, are formed, when compared with the draperies. The occasional use of a rather crude spiral form — for the left knee of Adam in the Anastasis and the knees of Christ and left-hand flying angel in the Ascension — strongly suggests that while one hand was at work here, it was a different one from that which created the very delicate and precise cloisons of the faces, especially of Christ. This will be mentioned later. As it is, there would appear to be no surviving enamels that share characteristics of this group, both in the features that have been mentioned and in others such as the bright yellow of Christ's robe [24], sufficiently closely for their origin in a common workshop to be suggested.

Another sequence of plaques that would seem to have a clear basic coherence is that on the top of the front cover (1, 5, 15, 20, 2 and 21 in fig. 18), which we shall call Group II. Not only are their sizes virtually identical, but they employ the same three colours throughout for the areas of drapery, and all the haloes are of the same translucent green ; the inscriptions are also homogeneous. From the point of view of style as well as tech-

22. See Dami, *Evangelario*, pp. 227-8 and 236-240, and Kondakov, *émaux*, pp. 187-189 ; lack of precise knowledge about the back cover is implied by the latter's comment : " Le revers était autrefois orné d'une série de médaillons... dont il ne reste qu'un petit nombre ".

23. Mallé, *op. cit.*, pp. 163-164.
24. This feature was noted by Kondakov, *émaux*, pp. 188-189, as a " violation grossière des traditions de Byzance ".

nique, the most striking aspect of this series is the mathematical precision with which the gold cloisons form rigidly parallel lines (see figs. 6 and 7). This is such an obtrusive feature that it must be regarded as a mannerism of this particular artist or his atelier. A further aspect of the technique that is of interest is the treatment of those parts of the figures, such as the right foot of 1, and the extended hand of 5 and 15, where the detail is too fine to be formed by the relatively simple outline of the recess. In order to overcome this the forms of the fingers or toes are indicated by cloisons, but the space between these and the simpler outline of the recess is filled with a yellow enamel which is clearly intended to simulate the gold of the plaque itself. As a technical device this is not uncommon, but the infilling is (surprisingly) far more often found to be a dark blue colour. It can be seen also in yellow only (to the present writer's knowledge) in the famous series of roundels from Djumati [25], but further research might indicate that it was a more widespread practice than these isolated examples might suggest. A further refinement can be seen in this group which also seems to be a rare phenomenon, and that is the use of a paler tint of flesh colour for the Virgin in comparison with all the other five male figures; this must be a deliberate departure, and probably has a partly iconographical basis [26].

Another sequence of seven enamels (our Group III) can be formed around four at the bottom of the front cover (4, 9, 19 and 23 in fig. 18) and three at the top of the back cover (24, 34 and 44 in fig. 19). The strongest initial reason for regarding these as forming a group is a stylistic one, and is based particularly on the decorative vegetable forms flanking the single figures; even when reduced to little more than clumps (as in 9 and 19),

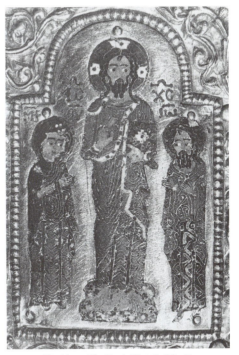

Fig. 11. — *The Deesis* (Detail of fig. 2).

they still have the same basic colours and forms. In addition, the haloes are all of identical colours — translucent green with a red border, and, except in the case of the Deesis, red dots set in it — and the sizes are consistent to within two millimetres; just the semicircle surmounting the Deesis plaque makes the overall height of this greater than the other enamels (fig. 11), but the height to the shoulder of this plaque is the same as those with single figures. The artist controlling the production of this group clearly had a liking for creating decorative patterns, either using several colours, as in the tree motifs, or using one colour, as in the cloaks of the military saints and the drapery of the figures in the Deesis. The extremely personal handling of the cloi-

25. Blue infilling can be seen, e.g., in the plaque of St. Demetrius in Berlin (formerly Swenigorskoi collection), the half-length figure of the Virgin in the Maastricht reliquary, and *passim* in the lower series of feast scenes and many standing figures in the Pala d'Oro (see WESSEL, *Byzantine Enamels*, Shannon, 1969, figs. 36

and 39 (hereafter, *Enamels*); and HAHNLOSER, *Pala*, Pls. XI-XV and XXVIII-XL). Yellow infilling can be seen in the Djumati roundels of the Virgin and John the Baptist (WESSEL, *Enamels*, figs. 40a and 40b).
26. This appears to be extremely rare; it does not occur in e.g. the Djumati enamels.

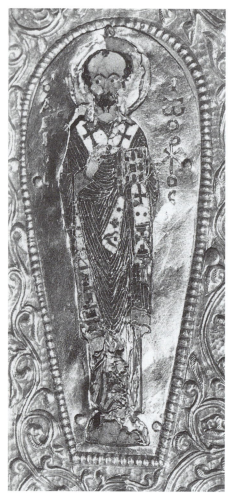

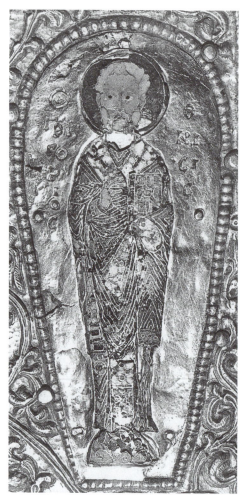

Fig. 12. — *St. John Chrysostom* (Detail of fig. 2).

Fig. 13. — *St. Gregory of Nyssa* (Detail of fig. 2).

sons suggests that the creator of this group was to some extent influenced by Islamic art, and, if other enamels by him still existed, they should be quite easy to identify. His personality is certainly quite distinct from that concerned with group II.

No other groups of corresponding size within the enamels on the Siena bookcover can be formed. The remainder fall into smaller entities or have to be left as single, isolated plaques. One pair of enamels (our Group IV) stands out as being of unusual shape and size : it is on the back, and its two plaques portray the bishops St. John Chrysostom and St. Gregory of Nyssa (25 and 45 ; figs. 12 and 13). Their shape — like that of an inverted pear — and unusual size, combined with a very comparable stylistic identity, make their origin in the same atelier virtually certain.

A further pair, in this case circular in shape, can also safely be regarded as a further small group (our Group V) ; this is the two roundels on the front cover with portrait busts of bishops — 6 and 16. These have in common, besides identical dimensions and very closely related

style (see fig. 1) a particularly brilliant and intense shade of blue in the haloes [27]. This is one of the features, it has been seen, where enamellers seem to have felt themselves to be free of most of the traditional iconographic conventions, and to be able to give their own personal colouristic emphasis to their work.

Another pair (Group VI) that clearly originated in the same context is that of the two Seraphim on the front (7 and 17, figs. 16 and 17). Their identical size and fairly unusual subject-matter make it fairly certain that they must have been originally mounted on the same object, and so made in the same workshop. In view of this it is of interest to see that the wings of the seraphs are in each case not only made with different colours, 7 having feathers of blue, white, red and green and 17 using blue of a slightly different hue, and yellow instead of white. The cloisons are also formed in different ways in the two plaques. These points will be referred to later.

Two further plaques must also in all probability have been made originally for the same object; these are the orthostatic enamels of archangels (3 and 22) which we will call Group VII (fig. 1). Despite minor differences in size and flesh colour, they have so many other features in common, such as style and basic colour range, that they must be regarded as complementary.

Yet another pair of enamels, this time on the back, must also be the sole survivors of a larger ensemble. They are the two rectangular plaques either side of the Ascension (31 and 41) which depict Christ brought to the crucifixion, and, although lacking an inscription of any kind, the other must be the Virgin with the grieving St. John (fig. 2). These will form our Group VIII. The identical size, shape, style and technique, together with complementary subject-matter makes their origin in the same ensemble virtually certain. This pair of enamels has two features, both of which are not only very rare, but are also to be associated with reliquaries of the true cross. Firstly, the subject of 31 is to be found in surviving enamels only on the Esztergom reliquary, where the figure of Christ is accompanied by a soldier and a priest. Secondly, the curious rounded indentation in the top inside corner of each plaque suggests that they were placed below and to either side of a major central motif; it should be noted that enamel plaques of precisely this shape (depicting archangels) are to be found flanking the recess occupied by the relic of the true cross in the Limburg staurothèque [28]. It is therefore possible that these two enamels originally formed part of the decoration of a reliquary of the cross, of which the other parts have disappeared. It may well be that the Deposition also (as on the Esztergom reliquary) was part of the original ensemble. A further striking feature of 41 is a particularly intense turquoise blue enamel used for the haloes; among the Siena collection this can be matched only with a roundel on the front, 11, in which Christ Pantocrator is shown wearing a garment beneath his cloak of just this colour [29]. This colour is seldom found in Byzantine enamels, but a further possibly unique aspect of this roundel is the deathly white of Christ's face; this is so striking that it must have an iconographical significance. If we are correct in relating plaques 31 and 41 to a reliquary of the cross (which by their siting on either side of the relic would imply the scene of the Crucifixion, without actually representing it), it is possible that this roundel also may have been part of the original ensemble, the rest of which has been lost.

We have seen how there are good grounds for forming at least 25 of the

27. On the Munsell system of colour notation they are 7.5 PB 3/10. This is a well-tried and internationally available system of colour terminology, scientifically based, and of great potential use in cases such as this where enamels that were originally in larger groups have become separated.

28. For the Esztergom reliquary, see WESSEL, *Enamels*, fig. 49, and for that at Limburg, fig. 22b. See also A. FROLOW, *Les Reliquaires de la Vraie Croix*, Paris, 1965, pp. 169 and 249, for the subject of 31; he was unaware of the Siena plaque.

29. Munsell 2.5 PB 5/4.

enamels on the two covers into eight distinct groups ; this still leaves 23 of the plaques (or 22 if number 11 is included in group VIII) that have no readily discernible characteristics in common, and so we are in effect dealing with the products of some different ateliers of enamel workers. This number is of course increased if the six diminutive plaques on the spine are included. It should also be realised that there is in all probability a time range of at least two centuries during which it is possible for these enamels to have been produced, and quite possibly more.

Before relating any of the groups that we have found to other enamels of which the date and provenance is known, a brief look should be taken at the conclusion reached by Dami some 50 years ago. Of his eleven groups, some inevitably coincide with those arrived at here : his Groups II, IV, V, VIII, IX and X are almost identical with our Groups II, III, VII, I, IV and VIII respectively. The differences that occur would appear to be the result of too great a readiness on Dami's part to associate plaques with only minimal features in common ; in other words, his definition of a ' group ' was too loose to produce a result that would survive a more rigorous examination. To take just one example, his Group VII has seven plaques in it [30] (in fact all those of square format, depicting male saints, that are on the book-cover) with the only reason for grouping them being that they are ' Smalti di fattura meno accurata dei precedenti ; le lamine sono assai distanziate e i colori spesso di non perfetta bellezza '. This definition on its own could apply to several other of the enamels, and cannot be regarded as giving a permanently valid result.

An essential first step in attempting to establish the probable date of a group of enamels is of course to see if there is

any internal evidence — in the form of inscriptions, for example — that establishes either a date of manufacture or a provenance. Unfortunately the Siena book-cover, like other assemblages of Byzantine enamels such as the Khakhuli triptych in Tiflis, is composed of plaques that are now divorced from their original context, and so any accompanying data that might have located them in either place or time is now lost. All that it is possible to do is relate the style and, in some cases, the iconography of our groups to other enamels of which the date or provenance is known. While comparisons with works in other media can and should be made, this should be done with care. While common stylistic and iconographic trends naturally permeated all the arts of Byzantium, the highly specialized technical character of works in enamels tends to differentiate them from works in other media. A painter, for example, could work on vellum, on wooden panels or in fresco on a wall, giving the same stylistic character to each of these media, but it is highly unlikely that a skilled worker in enamel would work in any other medium than (possibly) other forms of metal-work. Only in the field of iconography can comparisons be made with other media with any real assurance ; otherwise the general guidelines provided by the known phases of Byzantine art are all that the historian concerned with enamels has to rely on, at present [31].

It is fortunate that the Siena enamels contain two feast scenes (Group I) from which conclusions can be drawn on the basis of their iconography. In the case of the Ascension (fig. 10) it is possible to establish a distinct tendency during the 11th and 12th centuries to introduce a greater degree of movement and agitation into the way the groups of apostles

30. DAMI, *Evangelario*, p. 237 ; it has been assumed that his first mention of 28 is a mis-print for 27. The opinions of Labarte and Molinier are so manifestly oversimplified and out-dated that they have not been considered in detail.

31. There is an urgent need for a more secure framework of reference for dating Byzantine enamels than

exists at present ; of the dozen or so accurately dated or dateable pieces, almost all are the result of imperial or court patronage, and there is as yet no understanding of the way that work for humbler patrons related to the highest level of production.

are represented [32] ; while the basic elements of the scene were already established in the 6th century Rabbula Gospels [33], the rather static and formal character of the figures here gives way to a genuinely more *mouvementé* effect. In our enamel the two groups of apostles contain figures which appear to be almost rushing to meet each other, with only the rather doll-like appearance of the Virgin surviving from the more static tradition. This development can be followed in such works as the Kludoff Psalter of the 9th century [34], and a 10th century ivory in the Bargello [35], which maintain a relatively more formal character, to examples such as the Homilies of James Kokkinobaphos in Paris, dated 1101 [36], a 12th century icon at Sinai [37] and, on a larger scale, in the mosaics at Monreale [38]. While this is not a completely consistent tendency, in that relatively formal versions continue to appear in, for example, the miniatures of Queen Melisende's Psalter [39], there was certainly a stream of development in this subject which, as in our enamel, favoured a greater degree of movement and energy within the figures, more varied silhouettes for the two groups of apostles and readier use of gesture, giving a more excited and voluble character to the whole composition [40]. It should perhaps be noted that besides this feature, the Siena enamel has a characteristic not shared by the few other surviving versions in enamel of this subject : the group of apostles, particularly that on the right, looks rather unhappily

' cut off ' at the outer border. This would suggest that the composition was in this case derived not from other enamels such as the two versions on the Pala d'Oro [41], but from a framed miniature or icon. On all this evidence, therefore, we can conclude that this plaque was certainly not produced earlier than the 12th century, and possibly even later ; furthermore, it may well be that it was made in a context where reference to the finest enamels of metropolitan production was not possible. The conclusions of Kondakov and Dami, which were reached on rather subjective and empirical grounds, may well therefore in this case be correct [42].

We have already seen that the Anastasis enamel is closely linked to that of the Ascension on grounds of style, and so it would be expected that its iconography might confirm this dating ; this is indeed substantially the case. The two most common types of this subject show Christ either advancing towards Adam and taking him by the hand while facing him, or (as here) holding Adam's hand and striding away from him, almost dragging him up from Hell [43]. This latter version does not appear before the 11th century, but from that time becomes very popular [44]. The presence and position of the other figures, such as Eve and the prophets and kings of the Old Testament, provide no further criteria for dating. The suggestion of provinciality that was discernible in the Ascension plaque, means that in this case there is no problem raised if the Anastasis

32. See G. SCHILLER, *Ikonographie der christlichen Kunst*, III, Gutersloh, 1971, pp. 141-164 ; and the *Reallexikon der byzantinische Kunst*, II, Stuttgart, 1971, cols. 1224-1262.
33. SCHILLER, *Ikonographie*, fig. 459.
34. SCHILLER, *Ikonographie*, fig. 462.
35. GOLDSCHMIDT and WEITZMANN, *Elfenbeinskulpturen*, II, Berlin, 1934, No. 58.
36. J. BECKWITH, *Early Christian and Byzantine Art*, Harmondsworth, 1970, fig. 207.
37. G. and M. SOTERIOU, *Icônes du Mont Sinai*, Athens, 1956, No. 91.
38. SCHILLER, *Ikonographie*, fig. 466.
39. H. BUCHTHAL, *Miniature Painting in the Latin Kingdom of Jerusalem*, Oxford, 1957, Pl. 11a.
40. Byzantine versions of this subject usually include two angels, one on either side of the Virgin, as here, but this feature is no help in determining chronology ; see SCHILLER, *Ikonographie*, and E. de WALD, *The*

Iconography of the Ascension, in *American Journal of Archaeology*, XIX, 1915, pp. 277-319.
41. HAHNLOSER, *Pala*, Pls. XXXIII and XLVI, where both compositions show a more developed sense of relating the two groups of apostles to the plain gold background.
42. Cf. n. 24, above.
43. A third type, where Christ stands symmetrically between Adam and Eve, holding them by either hand, occurs rarely, and then usually in a liturgical context. Cf. R. MOREY, *East Christian Paintings in the Freer Collection*, Princeton, 1914, pp. 45-53 ; K. WEITZMANN, *Das Evangelion im Skevophylakion zu Lawra*, in *Seminarium Kondakovianum*, VIII, 1936, pp. 87-89 ; and the *Reallexikon*, I, Stuttgart, 1966, cols. 142-148.
44. See K. WEITZMANN, *Aristocratic Psalter and Lectionary*, in *Record of the Art Museum, Princeton University*, 19, 1962, pp. 98-107 ; see also MOREY, *art. cit.*

too is dated in the 12th century or later.

When we attempt to find dates for any other of our groups of enamels on the Siena lectionary, stylistic criteria are all that we have to go on ; none of the figures contain iconographical features that would indicate a date for any of them. The problem is made harder by the unfortunate fact that the development of styles in Byzantine enamel-work is a subject about which all too little secure information exists. An example of the fragility of any reasoning based purely on the style of enamels is provided by our Group V (6 and 16). It so happens that there is a good *prima facie* case for regarding this pair as forming part of a group of which three other members have found their way on to the Pala d'Oro in Venice. There are three roundels of other saints there (Cat. nos. 114, 115 and 119) which, besides being of comparable size [45], have in common with those in Siena a particularly intense shade of blue in the haloes. Whether the shade is identical it is not possible to say with certainty [46], but the best available colour reproductions certainly support the theory. The iconography of this sequence is also consistent with their having originally formed a group : the two bishops on the Siena book-cover would be complemented by two warrior saints, Demetrius and Theodore (114 and 115), both slightly larger [47], and by St. Paul (119), of the same size, who would in all probability have been paired with St. Peter. The fact that the inscriptions on the Siena plaques are red

and blue respectively is complemented by the same feature on the roundels on the Pala d'Oro, where the military saints have their inscriptions in red and blue, and the apostle also in blue [48]. Even with the assistance of some known data for the history of the Pala d'Oro, it is still necessary to rely solely on style in order to suggest a date for these particular enamels, and two of them are dated to the 11th century on account of their similarity to the roundel of St. George, now in New York but originally from Djumati [49] ; the latter has been assigned to that century by reason of a comparable style to the enamels in the lower part of the Holy Crown of Hungary [50]. It can be seen that this ' stylistic chain ' starts with a relatively obscure group of minor enamels, and ends with a major piece of imperial regalia ; while it may be that a comparable style will have appeared at the same period in a broadly spread range of works such as these — with a correspondingly wide stratum of patronage — an assumption of uniformity has to be made that must be acknowledged. The level of artistry in the roundels in Venice and Siena is certainly well below that of both the Djumati enamels and of the Holy Crown of Hungary ; in view of this it is impossible to suggest any more accurate date than that of the later 11th or 12th century for the Siena roundels.

The case of our Group IV (25 and 45) is even harder. These unusual plaques can be related with some degree of certainty to a similarly shaped pair now

45. 6 and 16 are 36 mm in diameter, while those on the Pala d'Oro are 43, 42 and 36 mm respectively ; such variiatons in size should not be regarded as precluding them all being of one group — cf. nos. 105 to 111 on the Pala d'Oro (HAHNLOSER, *Pala*, Pl. LIII and Pl. LII).

46. Munsell 7.5 PB 3/10 ; this would have to be checked with the enamels in the Pala d'Oro, the colour reproduction being inadequate for such precise comparisons as this.

47. It has been assumed that the frames of the enamels on the Pala d'Oro have been excluded from the dimensions published ; they are clearly later, and occur on many other of the plaques.

48. If this grouping is accepted, it would of course strengthen the argument made earlier, that the Siena book-cover was assembled in Venice. Some further groupings between enamels in Venice and on the Siena lectionary can be tentatively suggested, using style,

colour range and size as the main criteria : the roundel 117 on the Pala d'Oro has many affinities with 43 on the book-cover, including identical size (see HAHNLOSER, *Pala*, Pl. LIII) ; and in the Treasury of St. Mark's the roundel of St. Matthew (cat. no. 107) can be linked with no. 46 on the Siena book-cover, and that of St. Tarachos (cat. no. 108) with our no. 32 (see HAHNLOSER, *Tesoro*, Pl. LXXVII and pp. 85 and 86). More precise information on the enamels in Venice would be needed before these hypotheses can be confirmed or (possibly) extended.

49. HAHNLOSER, *Pala*, p. 54.

50. WESSEL, *Enamels*, p. 120 ; the Holy Crown of Hungary has of course not been studied by any scholar for over 30 years, the period that it was in the hands of the Americans at the end of World War II being the only time that it was available for prolonged study by scholars (see J. P. KELLEHER, *The Holy Crown of Hungary*, Rome, 1951, pp. VII-IX).

forming part of a composite icon in Leningrad (figs. 14 and 15) [51]. These four enamels have in common, besides their unusual shape and almost identical dimensions [52], the fact that all are bishops — the Leningrad pair portray St. James Adelphotheos and St. Gregory Theologos. The style of all four, particularly in the handling of the cloisons in the drapery of St. James Adelphotheos and St. Gregory of Nyssa, is comparable; even the patterning on the stoles of the latter and of St. Gregory Theologos is to some extent similar. While the treatment of the ground is different between the two pairs, it is also different between the two Leningrad plaques, so this should not be given too much weight; the considerable difference in the inscriptions is perhaps the biggest single impediment to all four being regarded as one group. This may however be accounted for by another important feature : the two Leningrad figures are on a substantially convex surface, and the surrounding gold sheet has had to be cut to make them flat enough to attach to their present base. It is also possible that what now appears as a crack in one of the Siena figures (45) is the result of flattening a plaque previously mounted on a more convex surface (it may well also have been trimmed down). At all events it does seem possible to suggest that all these four figures may at one time have adorned, if not the same object, then at least objects of a similar character [53]. As far as suggesting a date is concerned, however, we are little better off with the association with the two Leningrad enamels, as they also have been detached from their original context [54]. It might be tempting to regard their attenuated proportions as indicative of an 11th or even 12th century date, but the unusual shape of the gold mount of each figure suggests that this feature may have been dictated by its original siting. This also makes comparisons with works in other media such as manuscript illuminations and ivories even less relevant in this case. As it is, the 11th century date given to the Leningrad enamels by Grabar [55] and Bank [56] could well be adopted for the pair in Siena, with the possibility of an extension into the 12th century.

In considering the six plaques which form our Group II, it might be hoped that the extremely strong and personal impression made by the great regularity and uniform spacing of the cloisons would suggest a relation with a group of which the date or provenance was known. Unfortunately, this does not seem to be the case. The strongest stylistic similarity that the present writer can suggest is with a plaque of St. Peter now in Tiflis [57]; this is said to be from the Gelati icon, and the character of the face, particularly, is certainly close to those on the book-cover [58], although the cloisons are not placed with such rigid parallelism. Amiranoshvili dates the Tiflis plaque to the 13th century, although without any supporting arguments. To the present writer this would appear to be too late, as there is no real suggestion of provincialism, as was the case with the feast scenes, that would have to be present for it to be of this date. Again, comparison with works in other media is unhelpful, and all one can say is that our group would seem to be work of a highly skilled enameller who may have had in mind

51. GRABAR, *Revetements*, pp. 75-76, and A. BANK, *Byzantine Art in the Hermitage Museum*, Leningrad, 1960, p. 126.
52. Viz : St. James Adelphotheos — plaque : 98 × 65 mm ; figure 86 mm high. St. Gregory Theologos — plaque : 93 × 63 mm ; figure 86 mm high. I would like to record my thanks to the staff of the Hermitage Museum, and to Dr. Judith Herrin, for giving me this information. (For the corresponding measurements of the Siena figures, see the Appendix, below).
53. This could have been a chalice ; in the Treasury of St. Mark's, Venice, there is a chalice with enamels in a clearly defined programme, with four bishops

represented on the foot (see HAHNLOSER, *Tesoro*, cat. no. 40, Pls. XL-XLI, pp. 58-59).
54. GRABAR, *Revetements*, p. 75, refers to the work as a reliquary icon.
55. GRABAR, *loc. cit.*
56. BANK, *loc. cit.* ; only the central enamel of the crucifixion is reproduced, but the inference is that this date relates to all the enamels.
57. S. AMIRANASHVILI, *Medieval Georgian Enamels of Russia*, New York, n.d., pp. 90-91.
58. They share the characteristics denoted by DAMI, *Evangelario*, p. 236, as " la sagoma delle figure ".

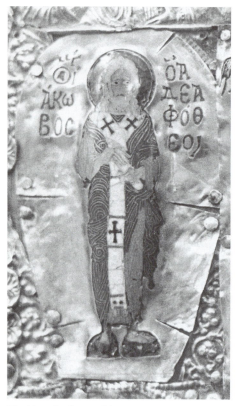

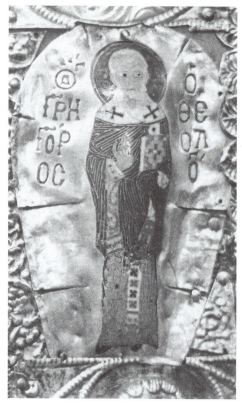

Fig. 14. — *St. James Adelphotheos*, from composite icon in the Hermitage, Leningrad.

Fig. 15. — *St. Gregory Theologos*, from composite icon in the Hermitage, Leningrad.

Fig. 16. — *Seraph* (Detail of fig. 1).

Fig. 17. — *Seraph* (Detail of Fig. 1).

the brilliant craftsmanship and sense of pattern and colour exhibited by such prestige works as the Holy Crown of Hungary [59] and the Djumati enamels [60]; while his skill was possibly comparable, the slightly dead and mechanical effect produced by his treatment of the cloisons forming the drapery suggest the attitude of a craftsman looking back at the work of an earlier generation, and a date in the 12th century is therefore most probable for this group.

The seven enamels proposed for our Group III have in common an evident love of decorative floral detail; this is found both in the flanking motifs of the single figures and in drapery forms. This is a taste which can be traced in other works, particularly in the illumination of a number of manuscripts. Several can be cited in which this characteristic is quite prominent [61], while others use a decoratively coloured trees as a purely ornamental feature [62]. While dating with any accuracy is again not yet possible, the fact that these manuscripts centre round the later 11th and first half of the 12th centuries would suggest that this group also was created in the 12th century, and most probably in the earlier decades.

The two roundels of seraphim (our Group VI) provide very little criteria for suggesting a date; the differentiation in colour in the wings that was mentioned is not unique, recurring in the enamels of the frame of the Kortsheli icon in Tiflis [63], although it is not present in the same subject in the Limburg reliquary [64]. While the latter is a product of court patronage of the second half of the 10th century, the former is regarded by Amiranashvili as a Georgian work of the 13th century, and is in any case a rela-

tively crude and provincial work; it is probable that the increase in colouristic range was an 11th or 12th century development, and on this basis our group can be assigned to this period. The sparse stylistic evidence does in any case make this the most probable date.

The two plaques of archangels which form Group VII (3 and 22) have an evident stylistic affinity with the much larger set of enamels in Group III, and may indeed have been produced in the same workshop at a different time. The main reason why they were not incorporated into the larger group is that they must have originally have been made for installation on a different object, and their subjects duplicate 9 and 19. Although using a somewhat different range of colours, and lacking the flanking ornamental motifs, there is still sufficient of the particular decorative qualities of Group III to suggest that the pair in Group VII must also date from the late 11th or earlier 12th century. There is also a lot of common stylistic ground between this pair and another of the same subject now attached to the frame of a book-cover in Venice [65]; all four enamels share the same range of colours for haloes, wings and loros, and are of very much the same level of workmanship, the principal difference being only in the proportions of the plaques. Opinions on the date of the Venice book-cover vary between the late 11th century and the 12th century [66], which confirms the conclusion already suggested.

Style must again be the chief basis for dating the two enamels of high quality which form the basis of Group VIII (31 and 41); the inclusion of the roundel of Christ (11) does not help by providing extra evidence,

59. WESSEL, *Enamels*, pp. 110-114.
60. WESSEL, *Enamels*, pp. 118-121.
61. E.g. cod. vat. gr. 1162 (Homilies of the Monk James) and Paris, Bibl. nat. MS grec 550 (Gregory Homilies); see C. STORNAJOLO, *Miniature delle Omilie del Monaco Giacomo*, Rome, 1910, Pls. 59 and 91; and C. OMONT, *Miniatures des plus anciens Manuscrits grecs de la Bibliothèque nationale*, Paris, 1929, pls. CVI-CVXV.
62. E.g. Paris, Bibl. nat. suppl. grec 27; Dionysiou, cod. 16; and Panteleimon, cod. 6; see OMONT, *Miniatures*, Pls. XCVII-XCVIII; S. M. PELEKANIDES *et al.*, *The*

Treasures of Mount Athos, Illustrated Manuscripts, I, Athens, 1973, figs. 49-50, and II, Athens, 1975, figs. 319-322.
63. AMIRANASHVILI, *Enamels*, pp. 67-69.
64. WESSEL, *Enamels*, Pl. 22b.
65. WESSEL, *Enamels*, pp. 168-169; HAHNLOSER, *Tesoro*, pp. 48-54.
66. D. TALBOT RICE, *Art of Byzantium*, London, 196, dated it to the 11th century, and WESSEL, *Enamels*, p. 168, with other refs., to the 12th.

nor is assistance to be found in the field of the design of reliquaries (with which our plaques may well be associated), and which might have corroborated a conclusion based on style. The figures are drawn with considerable delicacy and sensitivity, and comparison is suggested initially with the Esztergom reliquary, which contains the only other version in enamel of Christ brought to the Crucifixion [67]. There is considerable correspondence between the two versions of Christ, where each shows a slightly hesitant, submissive pose, and the use of the cloisons in the drapery of the Virgin (in the Deposition) and of the angels in the reliquary has similarities with those of the pair of standing figures (41). The technique in both cases is not of the supremely high quality of such major ensembles as the Holy Crown of Hungary or the Djumati enamels, but is still far superior to the comparable standing figures of the grieving Virgin and St. John on the frame of an icon in the Church of the Holy Sepulchre in Jerusalem [68]. As the subject of our pair strongly implies that they formed part of a reliquary of the true cross, which would at any time have been an important relic, it is likely that the level of patronage for which it was produced is comparable with that of the Esztergom reliquary. Current opinion is to date this work to the late 11th or earlier 12th century [69], and its relatively close correspondence to the style and purpose of our plaques suggests that they should also be assigned to this period.

Conclusion.

The establishment of a sequence of groups within the enamels on the Siena lectionary, each being the product of a different atelier — or the same atelier at different periods — allows some observations to be made on how different workshops organised their production. No such attempt has been made before, and it will be seen that some understanding of the variety of working methods that this shows is necessary for knowledge of the subject to advance on a secure basis.

It was pointed out when discussing the two feast scenes (Group I — figs. 9 and 10) that there was a distinct difference in the level of skill with which the faces of the various figures were formed, and that of the drapery areas. While the cloisons that depict the features are mounted with great accuracy (and on the scale of these enamels, where a head is only about five millimetres across, an error of less than half a millimetre would have a disastrous effect on the final appearance of the work), those which form the draperies have a much more haphazard and even crude appearance. The impression of two different standards of craftsmanship becomes even stronger when the plaques are seen under magnification. It would seem fairly certain that there was a division of labour here, comparable with that which it is usually assumed occurred in medieval painters' ateliers ; the difference would probably be that while a fresco painter would work from the head downwards, the master therefore having to paint the head before the assistant completed the body, in this case the assistant would in all probability have made the cloisons forming the drapery, and soldered them to the plaque, before passing it to the master to fix the cloisons of the faces. In this way the possibility of disturbing the more important and delicate areas by subsequent soldering would be avoided. The significance of two levels of workmanship being present in one enamel is that quality is often used in isolation as a basis for dating, or for suggesting a metropolitan or provincial origin. If two distinct levels of quality can be operative

67. Wessel, *Enamels*, Pl. 49.
68. Wessel, *Enamels*, Pl. 53, pp. 171-172, where the

work is convincingly dated to the first half of the 12th century.
69. Wessel, *Enamels*, pp. 158-163, with lit.

in one workshop at the same time, it is clear that this factor should be used with considerable caution, and always where possible in conjunction with others.

Another way in which the work could be divided within an atelier is demonstrated by the two roundels of seraphim (Group VI — figs. 16 and 17). It can be seen that the feathers of the wings in 7 are divided by the gold line of a cloison, which ends in a dot of solid gold (in this case the dot must have been formed by using a short length of gold wire of circular section about one millimetre in diameter). This is an effective technique for giving variety and a certain sparkle to wings, and can be found in, for example, the Limburg reliquary [70] and in the Pala d'Oro, where the scale allows the idea to be exploited [71]. In the other seraph (17) this device is not used, the feathers just being divided by a cloison in the form of a loop, with a corresponding drop in decorative effect. The inference here, therefore, must be that two plaques, which were in all probability made in the same workshop for installation on the same object, were to a large extent made by different craftsmen using dissimilar techniques ; it is only in the writing of the inscription that the same hand was clearly present in both plaques. Again, we must conclude that the same workshop could produce works of quite different appearance, and that caution should be urged in any attempt to form general conclusions from too isolated examples. Also, it is interesting that not more control was exercised over individual members of an atelier ; while particulars of scale and iconography must have been the subject of a *diktat*, within those terms (at least in this case) varieties of individual technique and expression were possible. It may even be that the differences in the range of colours used may also owe something to this relatively easy-going approach.

These considerations, coupled with the

fact that it has not been possible to date many of the plaques on the book-cover with any real degree of accuracy, show how much work remains to be done in the field of Byzantine enamels. Owing largely to the paucity of accurately dated enamels, those which (like these) have been extracted from their original context, in which there might have been some data such as an inscription on which to base some firm conclusions as to period and provenance, will continue to baffle historians until a more secure framework of reference is built up. Such a framework would have to take into account the kind of factors that have been singled out here, as well as others which have not really been touched on, such as the locality of different centres of production, characteristics peculiar to any individual centre, and the relationship that provincial enamel ateliers might bear to the leading workshops of Constantinople.

But perhaps the most surprising and even disturbing conclusion to be drawn from this discussion is that, in spite of the great strides that have been made in our understanding of Byzantine art during the last 50 years, it is not possible to be very much more secure or accurate in evaluating these enamels than was Luigi Dami, writing in 1922. Although our knowledge of many other aspects of Byzantine art has advanced out of all recognition during this period, we are today only little better placed than he was when faced with a disparate collection of enamels such as that which has been assembled on the Siena book-cover. Although the medium is one of great inherent richness and beauty, it has not attracted the kind of study that is clearly needed for the subject to be placed on a footing where the really fundamental problems of chronology and provenance can be solved.

One major reason for this situation is probably that while works in other media yield more readily to analysis in purely

70. R. RAUCH *et al.*, *Die Staurothek von Limburg*, in *Das Münster*, VIII, 1955, figs. 11 and 19 ; the ' dot '

is here formed by rolling up the end of the gold strip forming the cloison.

71. HAHNLOSER, *Pala*, Pls. XL-XIV.

stylistic terms, the production of enamels is governed by more purely technical considerations peculiar to that medium alone. This factor tends to give the whole medium a more self-contained stylistic character than is often acknowledged, and means that terms of reference and evaluation must be developed which take this major factor into account. It is perhaps to be hoped that this paper, by drawing attention to these factors, will underline the need for further work along these lines.

APPENDIX

Summary catalogue of the enamels on the cover of the Siena lectionary ; the numbers refer to the key on Figs. 18-20, and conform for the most part with Dami's enumeration. The measurements are in millimetres, and refer to the greatest dimensions of the relevant plaque.

Front cover.

1. St. Peter	75 × 40
2. St. John Theologos	75 × 40
3. Archangel	59 × 39
4. St. Theodore	53 × 34
5. Virgin (as in a Deesis)	74 × 39
6. St. John Chrysostom	36 diam
7. Seraph	47 diam
8. St. Dionysios	33 × 33
9. Archangel Michael	52 × 33
10. Christ Pantocrator	58 diam
11. Christ Pantocrator	38 diam
12. The Anastasis	71 × 65
13. Archangel	59 × 41
14. Virgin (as in a Deesis)	48 diam
15. St. John the Baptist	73 × 38
16. St. Basil	36 diam
17. Seraph	47 diam
18. St. John Elimosinarios	32 × 32
19. Archangel Gabriel	48 × 31
20. St. Paul	73 × 38
21. St. Matthew	73 × 38
22. Archangel Michael	58 × 40
23. St. Demetrius	52 × 34

FRONT

Fig. 18. — Distribution and key to enamels on front cover.

BACK

Fig. 19. — Distribution and key to enamels on back cover.

BACK COVER.

SPINE

24. St. Peter	52 × 32
25. St. John Chrysostom	88 × 39
26. St. Merkourios	32 × 32
27. St. Nestor	32 × 32
28. St. Theodore	37 × 36
29. Christ Pantocrator	34 diam
30. The Virgin	38 diam
31. Christ led to the Crucifixion	48 × 29
32. St. John Theologos	25 diam
33. Virgin (as in a Deesis)	.35 diam
34. Deesis	69 × 45
35. Christ Pantocrator	39 diam
36. The Ascension	68 × 62
37. The Virgin	30 × 24
38. Archangel	43 × 61
39. Christ Pantocrator	32 diam
40. The Virgin	38 diam
41. The Virgin and St. John at Cruci-fixion	49 × 29
42. St. George	27 diam
43. The Virgin and Child Hodigetria	37 diam
44. St. Paul	51 × 32
45. St. Gregory of Nyssa	90 × 39
46. St. Gregory Theologos	34 diam
47. St. John	34 × 33
48. St. Basil	32 × 32

SPINE

49. Virgin (as in a Deesis)	19 diam
50. Decorative roundel	19 diam
51. St. Nicholas	20 diam
52. St. John Chrysostom (?)	19 diam
53. The Virgin	20 diam
54. Decorative roundel	19 diam

Fig. 20. — Distribution and key to enamels on spine.

A Purchase of Byzantine Relics and Reliquaries in Fourteenth-Century Venice*

I: The Five Surviving Byzantine Reliquaries

On 28 May 1359 a contract was enacted in Venice for the sale of a substantial collection of relics and a Greek manuscript in a very precious and elaborate binding.[1] The parties to the sale, which took place in the house of Jacopo Bartolo '*de Florentia*' and '*in Contrata Santorum Apostolorum*', were principally Andreas Gratia, a syndic of the Hospital of Santa Maria della Scala in Siena, who was buying the relics, and Pietro di Giunta Torrigiani, a Florentine merchant in Constantinople, who was the seller. The second part of this article will provide an analysis of the documentary evidence associated with this transaction, and will seek to demonstrate the origins of the collection in the imperial palace in Constantinople, whence it had been sold in 1356 or 1357 by the Empress Helena, wife of John V. The first part, which follows here, provides the first full publication of the five Byzantine reliquaries which still survive in the possession of the Hospital in Siena.[2]

Reliquary A (figs. 1–3). This is a rectangular, box-like container made of gold, and with a sliding lid; it has a hinged loop for attachment to a cord. It is decorated on both sides with enamels and precious stones, and is a work of outstanding beauty and quality.

Dimensions: Height (excluding loop), 57 mm., width, 47 mm., depth, 10 mm.

* The material published here formed part of a paper given at the Association of Art Historians London Conference, 1981; I would like to thank those present for their helpful comments. I have subsequently benefited greatly from discussion, advice and assistance from the following: Dr. David Abulafia, Dr. Robin Cormack, Professor Colette Dufour Bozzo, Professor Cyril Mango, Professor Donald Nicol, the late Mr. Charles Oman, Dr. Charlotte Roueché and Dr. Jonathan Sumption; I am most grateful to them all. I would also like to thank Professor Hugo Buchthal for many helpful comments made in reading my final draft.

[1] G.D. Ristori, *Breve distinta Relazione delle sagre Reliquie e di un Evangelario greco manoscritto...*, Siena 1770; L. Dami, 'L'Evangelario greco della Biblioteca di Siena', *Dedalo*, III, 1922–23, pp. 227–39; H.W. van Os, 'Vecchietta and the Sacristy of the Siena Hospital Church', *Kunsthistorische Studiën van het Nederlands Instituut te Rome*, II, The Hague 1974, p. 5ff. For a complete bibliography of the book-cover see P. Hetherington, 'Byzantine Enamels on a Venetian Book-cover', *Cahiers Archéologiques*, XXVII, 1978, p. 117, n. 1.

[2] I would like to thank the Siena Hospital authorities for allowing me access to the reliquaries, and particularly Padre Vittorio Guerri, OFM, for his patient assistance.

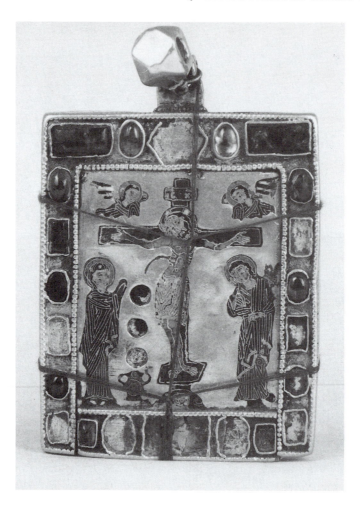

Fig. 1. Reliquary A, recto. Siena, Ospedale della Scala. (Roma, ICCD, Fototeca Nazionale, N 18735.)

Recto. This is chiefly occupied by an enamel scene of the Crucifixion, which forms the sliding lid. It is framed by a band set with gems which forms the lip of the box. Of the surviving stones set in the frame, those of rectangular cut are emeralds, and those of oval shape are in all probability pale rubies. Beaded gold wire separates the central scene from the frame, and surrounds the outer profile. Of the twenty-two stones which originally adorned the frame eleven are missing, but the enamel of the crucifixion is in almost perfect condition.

For the most part the iconography of the crucifixion scene is quite standard, with Christ shown centrally on the cross, the Virgin on the left and the grieving St. John on the right. The skull of Adam can be seen at the foot of the cross, a jet of blood spurts from Christ's side, and half-length lamenting angels occupy the top of two

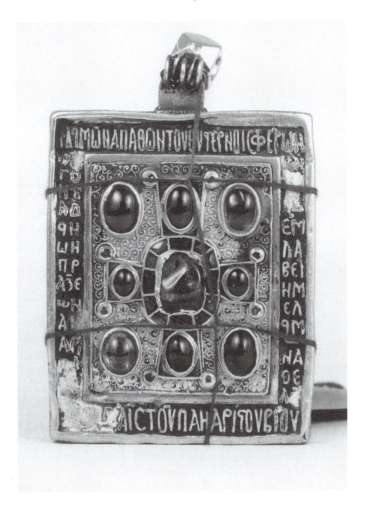

Fig. 2. Reliquary A, verso. Siena, Ospedale della Scala. (Roma, ICCD, Fototeca Nazionale, N 18736.)

corners.[3] All these features can be found in innumerable Byzantine versions of this subject.[4] Much more rarely found is the feature of the vase placed beside the foot of the cross; this occurs, for instance, in an earlier enamel now in Tiflis, but there it is held by a personification of Ecclesia, while the figure of Synagoga, on the other side, turns away.[5] As it is, the nearest parallel to the Siena reliquary would seem to be an enamel

[3] The colours of the enamels are as follows (Munsell system numbers are in brackets): cloaks of the Virgin and St. John: dark blue (7.5 PB 2/4); undergarments: lighter blue (5 PB 3/6); haloes of all figures: turquoise (2.5 B 4/6); cross: dark blue (7.5 PB 2/4); flesh of all figures: light brown (10 R 5/4); vase: dark red (5 R 3/6); hair of all figures: black; wings of angels: black and white bands.

[4] See G. Millet, *Recherches sur l'Iconographie de l'Evangile*, etc., Paris 1916, pp. 396–460; and G. Schiller, *Ikonographie der christlichen Kunst*, II, Gütersloh 1968, pp. 98–110.

[5] S. Amiranashvili, *Medieval Georgian Enamels of Russia*, New York n.d., pp. 38–9.

Fig. 3. Reliquary A, end. Siena, Ospedale della Scala. (Roma, ICCD, Fototeca Nazionale, N 18737.)

now in the Schatzkammer in the Munich Residenz (fig. 4). The much greater size of this one (250 mm. x 180 mm.) has allowed a much more complex scene to develop, with a second grieving woman and Longinus, as well as three soldiers disputing the ownership of Christ's robe. The very rare presence of the vase into which the blood of Christ falls suggests that it was originally made for a reliquary containing some of the Holy Blood, as well as possibly some of Christ's robe.[6] The reliquary in Siena is apparently unique in that it shows three huge drops of blood which fall into the vase; the circular recesses, although now almost completely empty, must at one time have held red enamel, traces of which can still be seen. This feature, with that of the vase, is absent from all the many other enamel versions of the crucifixion that must either at one time have been used as *staurothèques*,[7] or been used on book covers or other locations.[8] From the iconography of this scene it must therefore be concluded that our enamel was specially created to form part of a reliquary of the Holy Blood.

When we turn to the questions of style and date, a close comparison can be made with the crucifixion enamel now fixed with others to a form of 'composite icon' in the Hermitage, Leningrad (fig. 5), as well as with that in the lower row of feast scenes in the Pala d'Oro, Venice.[9] These, with other examples in both monumental and miniature art, are usually dated to the eleventh or twelfth century, and there seems to be no

[6] Although it is regarded as coming from either a book-cover or a staurothèque by both K. Wessel, *Byzantine Enamels from the 5th to the 13th century*, Shannon 1969, p. 167; and by A. Frolow, *La Relique de la Vraie Croix*, Paris 1961, p. 299.

[7] K. Wessel, *Byzantine Enamels...*, cit., stresses the rarity with which the vase is included in Byzantine crucifixion iconography; a useful, though not complete, assemblage is in W.F. Volbach, *La Stauroteca di Monopoli*, Rome 1969; see also A. Frolow, *La relique...*, cit., *passim*.

[8] See K. Wessel, *Byzantine Enamels...*, cit., figs 13a, 25, 52 and 66a.

[9] H.R. Hahnloser (Ed.), *Il Tesoro di San Marco; La Pala d'Oro*, Florence 1965, Pl. xxx, no. 57.

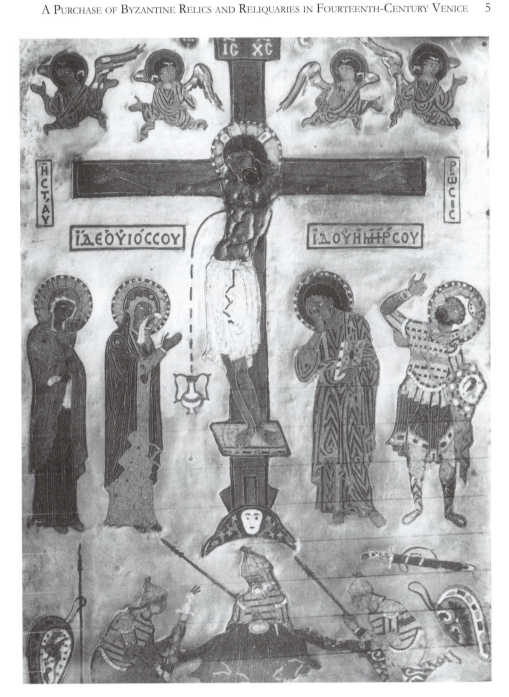

Fig. 4. Enamel of the Crucifixion. Munich, Residenz, Schatzkammer. (Bavarian Palace Department.)

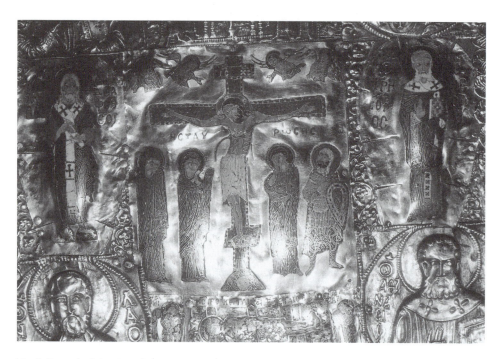

Fig. 5. Enamel of the Crucifixion, from composite icon. St Petersburg, Hermitage Museum.

immediate reason to depart from this.[10] The only feature that might be mentioned is that, in spite of its very small scale, the artist of the Siena enamel has been able to instil the scene with a surprising degree of emotion; the body of Christ is seen to sag more at the hips, the head to hang lower, and the grieving St. John drops his head further. But these are minor observations that need have no bearing on the conclusions that have been reached.

Verso. The principal feature of this face is a cross design formed from mounted gems. At the centre is a roughly-polished pale ruby, surrounded by a collar of alternate rubies and emeralds. In the arms of the cross and in the four corners of the central panel are eight finely-polished cabochon-cut light blue sapphires. The background is covered with a delicate pattern of fine gold filigree.

In the frame surrounding the main panel there is an inscription of four lines of dodecasyllabic verse; it is in enamel, with white letters on a blue ground.[11] This reads as follows:

Top: Λειμῶνα παθῶν τοῦ θεοῦ στέρνοις φέρων
Left: [λέ]γοντα δεινῶν πράξεων ἀκαρ[π]ί[αν]

[10] Criteria for a secure chronology of Byzantine enamels are still largely lacking; see P. Hetherington, *Byzantine Enamels....*, cit., pp. 140–42.

[11] Munsell, 7.5 PB 2/4.

Bottom: — — — — αις τοῦ παναρίστου βίου
Right: — — [Ἐ]δὲμ λαβεῖν με λειμῶνα θέλ[ω]

'*Wearing on my breast the flowers of Christ's passion, which tell of the terrible deeds done to Christ, I wish to win for myself the flowers of Paradise*'.[12]

The sense of the inscription makes it clear that it was composed specially for a reliquary of encolpion type,[13] which related to some aspect of Christ's passion. The palaeography of the inscription appears to be of 13th–14th century date, and this chronology is supported by the similarity of both form and content to many such epigrams composed by the poet Manuel Philes, who died c. 1345.[14] Among his published oeuvre there are many examples of such verses composed in the same vein, and using four lines of dodecasyllabics,[15] and so this date forms a very probable *terminus ante quem* for the production of this face of the reliquary in its present form.

This last phrase is used advisedly as there is good reason to suppose that the *verso* is in fact an assemblage of parts from two different periods.[16] The centrepiece of this side has no real parallels in Palaeologue art; from the 11th or 12th century there are a number of examples of gold jewellery formed by setting stones in a pattern of gold filigree, although those that have survived are principally from Russia.[17] Although none of these are in precisely this form, it seems most probable that this feature was taken from an earlier work, quite possibly itself an encolpion, and re-used in its present form.[18] If this is correct, a further hypothesis should be mentioned here; namely, that the frame set with stones on the *recto* might have come originally from the same earlier object as the centrepiece of the *verso*. While the character of some of the stones is different, with rectangular emeralds interspersed with cabochon-cut pale rubies, the dimensions of the two frames are virtually identical.[19]

Sides. The strip of gold that forms the sides of the reliquary has a repeated design running continuously round three of its sides (fig. 3). It is based on the vine-scroll

[12] I would like to thank Dr. Charlotte Roueché and Professor Cyril Mango for their help in reading this inscription.

[13] Very similar to that now in the treasury of the Church of St. Mary, Maastricht, which is much better known (K. Wessel, *Byzantine Enamels...*, cit., fig. 39); this, however, has a later surrounding band and a hinged lid.

[14] H. Hunger, *Die Hochsprachlicher Profane Literatur der Byzantiner*, II, Munich 1968, pp. 114, 118.

[15] A. Martini (Ed.), 'Manuelis Philae Carmina Inedita', *Atti delia R. Accademia di Archeologia, Lettere e belle Arti*, XX (Suppl.), Naples 1900, Nos, 4, 71, 102 and 118 on pp. 11, 92, 142 and 147; also E. Miller (Ed.), *Manuelis Philae Carmina*, I, Paris 1855, no. cxxxvi, p. 59.

[16] I would like to acknowledge the generous assistance given me by the late Mr. Charles Oman, who readily gave me the benefit of his experience in the discussion of this reliquary.

[17] B.A. Rybakov, *Russian Applied Art of Tenth-Thirteenth Centuries*, Leningrad 1971, pp. 30–31, figs. 29–30.

[18] The bezels of the gems do in fact show some signs of disturbance, and they would have had to be removed from their mounts when the soldering took place that gave the work its present form; this slight damage could have occurred at that stage.

[19] On both faces the top and bottom frames are 8.5 mm. wide, while the side frames are 7.5 mm. wide on the *recto* and 7 mm. on the *verso*.

motif, although much simplified; the spikey 'flowers' which occupy the central part of each scroll are green, the main strand of each scroll is blue,[20] and white 'sprigs' or buds form off-shoots, filling some of the space between the scrolls. Although this is a decorative theme with a long history, it has not been possible to find any precise parallels; however, since this side strip forms a unified, soldered join with the inscription, also in enamel, it follows that it must be contemporaneous with the latter.

In conclusion, it seems most probable that this reliquary was produced some time late in the first quarter, or early in the second quarter, of the fourteenth century, specifically to contain a relic of the Holy Blood. It was formed from an existing enamel of the crucifixion dating from the eleventh or twelfth century (which by reason of its iconography must itself have been part of a reliquary of this type), a jewelled cross and frame which could both be from the same period, and even perhaps the same object, while the inscription and sides were made specially for the reliquary in its present form. It therefore represents the styles of two, or perhaps three, different periods. Given our specific knowledge of its earlier location in the imperial possession,[21] it can be assumed that at least the latest part of the work on it must have been carried out in a Constantinopolitan workshop.

Reliquary B (figs. 6–7). This also takes the form of a rectangular, box-like container with a sliding lid. It is made of silver-gilt, and has a hinged loop for attachment to a cord.

Dimensions: Height (excluding loop). go mm., width, 54 mm., depth, 11 mm.

Recto. This entire face, which forms the lid, is occupied by a representation in repoussé of the Anastasis of Christ. The only inscription is the title of the scene: *H ANACTACIC.*

The iconography is largely one of the standard versions for this scene, with Christ reaching down with his right hand to draw up Adam, behind whom Eve can just be seen; there are three nimbed figures on the right, and the base of the composition is formed by two sarcophagi, placed either side of the diagonally crossed gates of Hades. The only unusual feature is the way Christ looks backward over his left shoulder.

Verso. This forms the base of the box, and is occupied by a representation in repoussé of the Crucifixion. The title of the scene is inscribed either side of the upper part of the cross: *H CTABPOCIC.* Above this are two further lines of inscription: *ΑΠΟ ΤΟΥ ΠΟΡΦΥΡΙΟΥ ΙΜΑΤΙΟΥ / ΑΠΟ ΤΟΥ CΠΟΓΚΟΥ* ('*From the purple robe / From the sponge*'). Two more lines fill the space below the composition: *ΚΑΙ ΑΠΟ ΤΩΝ CΠΑΡΓΑΝΩΝ / ΑΠΟ ΤΟΥ ΧΙΤΟΝΟS* ('*And from the swaddling clothes / From the tunic*'). In addition there are the standard names or abbreviations above each of the figures: *MP̃ ΘṼ, IC̃ XC̃* and *Ο ΑΓΙΟ ΙΩ Ο ΘΕΟΛΟΓΟS* . Behind the scene is a sketchy architectural frieze reminiscent of much Byzantine illumination. In general, the iconography is of standard middle or later Byzantine type, in which the Virgin and St. John are seen grieving on either side of the cross; Christ's feet are nailed separately on the suppedaneum, and the skull of Adam can be seen among the rocks at the foot of the cross.

[20] Munsell 7.5 GY 4/6 and 7.5 PB 2/4.
[21] See Pt. II, below.

Fig. 6. Reliquary B, recto. Siena, Ospedale della Scala. (Roma, ICCD, Fototeca Nazionale, N 18708.)

Fig. 7. Reliquary B, verso. Siena, Ospedale della Scala. (Roma, ICCD, Fototeca Nazionale, N 18707.)

The quality of the workmanship of both sides is high, and they are clearly (unlike Reliquary A) the product of the same date and very probably the same artist. A characteristic common to both scenes is the considerable degree of emotion and agitation that they display; in the crucifixion scene this is particularly evident in the unusually dramatic, even rhetorical, gesture of St. John, and his robe swirls about his slightly hunched figure and bent legs as he looks up at the sagging figure of Christ. In the same way, in the Anastasis the robe of Christ flutters out behind him, merging with the rocky background to the scene.

An extraordinarily close comparison can be made between these two scenes and their counterparts on the frame and mounting of an icon now at Vatopedi, on Mount Athos[22] (figs. 8–9). In the latter, all the feast scenes are of square format, and it can be seen that those on the reliquary have the same composition, with only the inscriptions filling the blank areas of the oblong shape. But far more telling is, in the crucifixion scene, the uniquely dramatic gesture of St. John, holding out his left hand towards the suffering figure of Christ; at least as rarely found is, in the Anastasis, the depiction of Christ looking back over his left shoulder, and the particular forms that his robe takes as it trails from his right shoulder across the rocky background to Hades. These touches, when combined with the way, for example, that Adam's head tilts right back as he is dragged upwards, and the generally agitated and *mouvementé* character that both pairs of scenes exhibit, must compel a conclusion that they were at least products of the same atelier; it may one day be possible to show that they are even products of the same hand.

Fortunately, the Vatopedi icon bears an inscription of some length, which makes it clear that the icon is the gift of a Papadopoulina, to 'her sister Arianitissa'.[23] The latter name was carried by an aristocratic lady who was the second wife of the *eparchos* Michael Doukas Arianites of Berroia; she died before 1326, and her father, the *skouterios* Theodore Sarantenos, died in 1328, leaving all his property to the monastery of Vatopedi. While it is not known what other family Theodore Sarantenos may have had,[24] the inscription certainly suggests that the icon-frame originated in aristocratic Byzantine circles, probably in the first quarter of the fourteenth century. This is entirely consistent with the style of the repoussé decoration as well as that of the verse inscription and its palaeography. In view of the very close links that have been demonstrated with the decoration of our Reliquary B, it can be taken that this too was the product of an atelier carrying out work for aristocratic Byzantine patrons at this date; with the known provenance of the reliquary, it is most probable that this atelier was located in Constantinople itself.

Reliquary C (figs. 10–12). This is a hollow, cruciform container made of gold; the cross has an unusually large titulus, and is now mounted on a slightly domed circular foot, of fifteenth century Sienese workmanship, which bears the arms of the Hospital in enamel. It must always have been intended to act as a reliquary for a piece of the True Cross.

Dimensions: Height, 105 mm., width across arms, 60 mm., maximum depth, 16 mm.

Recto. Most of this face, which is attached to the *verso* by small tabs projecting through the arms, is occupied by a representation of the Crucifixion in repoussé. The cross of Christ is depicted separately inside the form of the reliquary itself, and

[22] A. Grabar, *Les Revêtements en Or et en Argent des Icones Byzantines du Moyen Age*, Venice 1975, no. 21, pp. 49–52 and figs. 47–52.

[23] Discussed by A. Grabar, *Les Revêtements...*, cit., pp. 50–52. I would like to thank Professor Donald Nicol for his invaluable help on this point.

[24] D.I. Polemis, *The Doukai; A Contribution to Byzantine Prosopography*, London 1968, p. 104, with references.

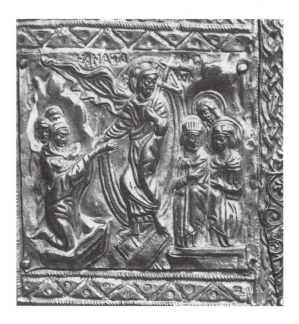

Fig. 8. Detail of icon frame: The Anastasis. Monastery of Vatopedi, Mount Athos. (Cliché Arch. Phot., coll. Médiatèque de l'Architecture et du Patrimonie © CMN, Paris.)

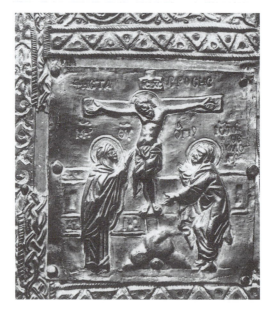

Fig. 9. Detail of icon frame: The Crucifixion. Monastery of Vatopedi, Mount Athos. (Cliché Arch. Phot., coll. Médiatèque de l'Architecture et du Patrimonie © CMN, Paris.)

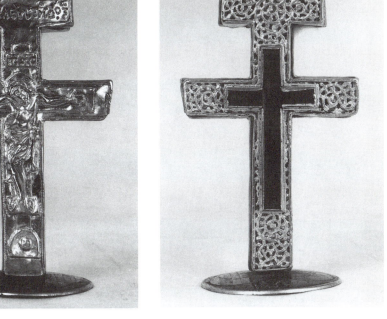

Fig. 10. Reliquary C, recto. Siena, Ospedale della Scala. (Roma, ICCD, Fototeca Nazionale, N 18728.)

Fig. 11. Reliquary C, verso. Siena, Ospedale della Scala. (Roma, ICCD, Fototeca Nazionale, N 18727.)

the small titulus above Christ just carries the abbreviated form of his name: ie. \widetilde{IC} \widetilde{XC}. In the much larger area formed by the titulus of the reliquary, above, is the inscription: *O ΒΑΣΙΛΕΥΣ ΤΗΣ ΔΟΞ[ης]* (*The king of glory*).

This representation is of standard iconography, with nothing at all exceptional; the feet of Christ are placed apart on the suppedaneum, and are nailed separately, a small spurt of blood comes from Christ's side, and the skull of Adam is shown rather summarily at the base of the cross. In the style and treatment of the figure, however, there are the same distinct characteristics as were noted in Reliquary B: indeed, within the limitations of scale and medium it is hard to find any substantial differences between the three versions of the Crucifixion that occur on this reliquary, Reliquary B and the icon-frame in Vatopedi (figs. 7, 9 and 10). They all display the same emphasis on drama and suffering, with the head of Christ hanging low on to his chest, and his body sagging at the hips; the latter also has the same slight eccentricity of using the titulus of the cross as a space to write the symbols for Christ's name. Given the provenance of the whole group, there seems little doubt that this was the product of the same craftsman, working at the same period and in the same workshop as where the other comparative works were produced.

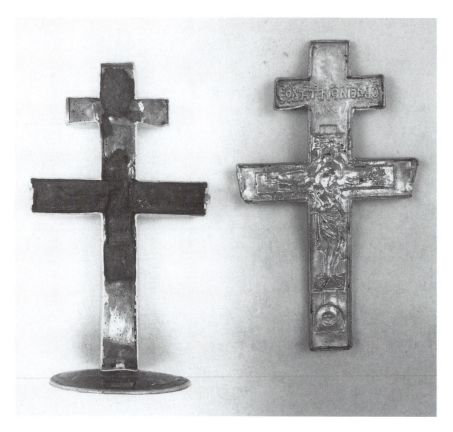

Fig. 12. Reliquary C, interior. Siena, Ospedale della Scala. (Roma, ICCD, Fototeca Nazionale, N 18726.)

Fig. 13. Detail of icon frame and revetment. Genoa, S. Bartolomeo degli Armeni (Roma, ICCD, Fototeca Nazionale, E 61780.)

Verso. The main feature of this face is a delicately executed design based on the vine-scroll theme, but pierced to reveal a sheet of plain gold behind. Let into this cast design is a cruciform piece of wood which is the relic for which the whole reliquary must have been made.

While the vine *rinceau* is an old and much-used decorative motif, the closest example of its use in just this way that is known to me is to be found in the silver-gilt revetment of the famous icon of the 'Sacro Volto', kept since (at the latest) 1388 in the Convent of San Bartolommeo degli Armeni, in Genoa.[25] It can be seen (fig. 13) that this use of a pierced vine-scroll design, through which a sheet of plain metal can be glimpsed, is produced by the same cast technique, and on just the same scale. The icon, with its richly decorated frame and revetment made expressly for it, was clearly intended to be a work *de grand luxe*; although the tradition that it was given to the Genoese church by the emperor John V Palaeologus is unconfirmed, there can be little real doubt of its origins in the immediate entourage of the Byzantine court.[26] This link provides further confirmation of the origins of our reliquary in a Constantinopolitan workshop which was carrying out commissions for the Byzantine aristocracy. Reliquary C was therefore in all probability made at the same period as that suggested for Reliquary B, at some time in the 1320's or early 1330's.[27]

Reliquary D (figs. 14–18). This is a box-like container in the form of a tall oblong, and with a rounded top. It is made of silver-gilt, and the lid is hinged at one side; there is a loop for attachment to a cord.

Dimensions: Height (without loop), 77 mm., maximum width, 31 mm., depth, 19 mm.

Recto. This forms the lid of the reliquary, and is entirely taken up by a representation in repoussé of St. John Chrysostom; the inscription either side of his head gives his name with the conventional abbreviations: ΑΓ ĨΩ Ρ̄.

The saint is shown full-face, wearing his bishop's robes, holding a book in his veiled left hand and making the sign of blessing with his right. The physical type of the saint, with a '*high, wrinkled forehead and receding hair*', is consistent with the traditional modes of portraying him,[28] the only slightly unexpected feature appears to be rather exaggerated side-whiskers.

Verso. This provides the body of the reliquary, and it is occupied by an inscription in repoussé; although broken into nine sections the inscription forms two lines of dodecasyllabic verse:

[25] See C. Dufour Bozzo, *Il 'Sacro Volto' di Genova*, Rome 1974; A. Grabar, *Les revêtements...*, cit., p. 64 draws particular attention to these *rinceaux perforés*. The revetment of the icon at Vatopedi also has pierced *rinceaux*, but of a more complex, interwoven form.

[26] For this problem, see C. Dufour Bozzo, *Il 'Sacro Volto'*, cit., pp. 64–5.

[27] These new data may assist in giving a more exact chronology for the manufacture of the revetment of the 'Sacro Volto'

[28] O. Demus, 'Two Paleologan Mosaic Icons in the Dumbarton Oaks Collection', *Dumbarton Oaks Papers*, 14, 1960, pp. 110–19, with sources; also the text of 'Elpius the Roman', in C. Mango, *The Art of the Byzantine Empire*, 312–1453, Englewood Cliffs, N.J., 1972, pp. 214–15.

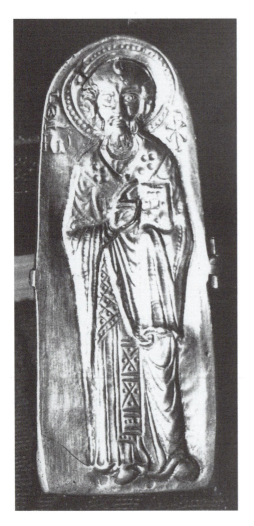

Fig. 14. Reliquary D, recto. Siena, Ospedale della Scala.

Fig. 15. Reliquary D, verso. Siena, Ospedale della Scala.

+ πρὸς τὸ χρυσοῦν μοι στόμα τοῦ Χρυσοστόμου
και νοῦς ἀπρακτεῖ καὶ λόγος οὐκ ἄξιος.

('For [as to] *the golden mouth of Chrysostom, both
my mind is at a loss, and my word is unworthy*').[29]

It is evident that the two parts of the reliquary were made for each other, and this inscription, with its play on the saint's name (which of course means literally "*John the Golden-mouthed*") makes the relationship with the *recto* even closer.

29 I am most grateful to Dr. Charlotte Roueché for her assistance in reading this inscription.

Sides. A further two lines of verse are inscribed in repoussé round the sides of the reliquary:

ὄλβιον χρυσοῦν λείψανον Χρυσοστόμου
ἐν ἀργύρῳ κρύπτεται τῶ διαχρύσ[ω].

('*The blessed golden relic of Chrysostom is hidden in gilded silver*').

The sense of the first verse would imply that it was perhaps part of the saint's mouth or jawbone that was contained in the reliquary;[30] the second inscription is of interest in that it shows an awareness of the precise medium from which the relic was made (i.e. silver-gilt) which is unusual; a far more generalised and less specific approach is more common. It furthermore suggests a close interaction between the patron, the composer of the verse (if indeed they were not one and the same) and the craftsman, as the gilding would certainly not have been applied to the silver body until after the inscription had been incised.

The palaeographic evidence of these inscriptions would suggest an early fourteenth-century date, and this would be consistent with the figure-style of the saint's portrait. The literary approach that they exhibit is again comparable with the many such verses of Manuel Philes; among his published works there are no less than six separate verses, each of four lines of dodecasyllabics, that relate to icons of St. John Chrysostom, although there are none that refer to relics.[31] While it has not been possible to locate any such precise parallels with the depiction of the saint as was the case with the feast scenes in Reliquaries B and C, there is nothing in its style or iconography that would militate against a date in the first two decades of the fourteenth century for this whole piece.

Reliquary E (figs. 19 and 20). This now consists of a capsule enclosed by a broad gold ring. A slightly convex circular enamel on a gold background occupies one face, and there was evidently a second enamel roundel on the other side. Round the gold ring which encloses the capsule are fixed loops for possible attachment to fabric; there is a larger loop at the top to accommodate a cord.

Dimensions: Diameter, including, outer band, 38 mm.; roundel alone, 34 mm.

Recto. This consists of an enamel roundel of Christ Pantocrator, denoted by the usual monograms: ĪC X̄C. The quality of workmanship is very high, and, with the exception of minor damage in the halo and monograms, the condition is perfect. The colours of the enamels follow the usual conventions, with the outer robe of Christ a slightly darker blue than the under garment, the halo a translucent green with red cross, flesh colour a pale brown and hair and beard black.[32]

[30] The bone now to be found in the reliquary seems unlikely to be a jawbone (or part thereof), but this need not be the original relic; again, I would like to thank Dr. Roueché for this suggestion.

[31] E. Miller, *Manuelis Philae Carmina*, cit., 1, nos. lxix–lxxiii, p. 33, and no. cxxix, p. 319

[32] Munsell 7.5 PB 2/6, 7.5 PB 5/8, 7.5 GY 5/6 and 2.5 YR 5/4 respectively.

Fig. 16. Reliquary D, side. Siena, Ospedale della Scala.

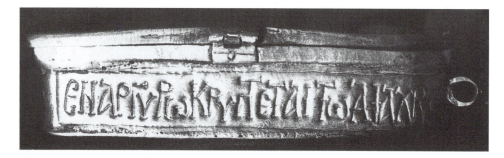

Fig. 17. Reliquary D, side. Siena, Ospedale della Scala.

Fig. 18. Reliquary D, end. Siena, Ospedale della Scala.

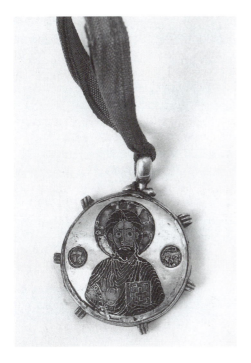

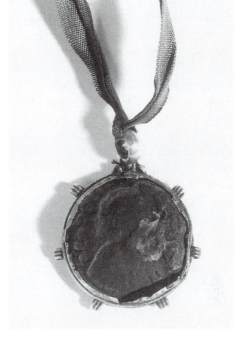

Fig. 19. Circular plaque of Christ, recto. Siena, Ospedale della Scala. (Roma, ICCD, Fototeca Nazionale, N 18725.)

Fig. 20. Circular plaque of Christ, verso. Siena, Ospedale della Scala. (Roma. ICCD, Fototeca Nazionale, N 18724.)

In all its main features the enamel is comparable to many other roundels of this subject.[33] It was probably not made originally for its present location, but was re-used from a previous object; it is fixed in its mount by a simple narrow flange of gold which has been burnished down over the edge of the roundel, thereby avoiding the application of solder or the necessity of heat. Such re-use of individual plaques became common in later Byzantine art.

The roundel is a good example of the problems that have to be faced when dating Byzantine enamels that have been divorced from their original locations; in all such cases they have no accompanying information in the form of an inscription, and there are very few dated works that provide secure comparisons.[34] The Siena enamel does in fact display two unusual features in its style: the mouth of Christ is drawn with a flatter curve than is normal (the cloisons were habitually made to curve down

[33] There were, for example, no less than five roundels of this subject included in the assemblage on the book-cover still in Siena, which are similar in all basic respects (see P. Hetherington, *Byzantine Enamels...*, cit.), and two more can be found un-mounted in the Treasury of St. Mark's, Venice: H.R. Hahnloser (Ed.), *Il Tesoro di San Marco; Il Tesoro e Il Museo*, Florence 1971, nos. 94 and 101.

[34] Scarcely more than a handful of ensembles of Byzantine enamels can be securely dated, and the great majority of these are the results of imperial or aristocratic patronage only; criteria for accurate dating of any isolated plaques are very largely absent.

to end in vertical points in the beard); there is also more decoration than is usual in the cuff of Christ's robe, and in the cloisons forming the hair. But it is possible to find examples of both these features in, for example, two of the roundels of Christ Pantocrator that were assembled on the book-cover now in the Biblioteca comunale in Siena,[35] and the former can be found also in another problematic work – the cross reliquary at Cosenza.[36] In view of this uncertainty it seems advisable only to suggest an approximate date for our enamel of some time in the later eleventh or twelfth centuries.

Verso. It is clear that at one time another enamel roundel was attached to this side; the impression of the reverse of the main recess can still be seen. The plaque has simply been prised from the surrounding narrow flange. The substance filling the cavity may have been some form of hard wax, which was poured in and allowed to set. The identity of the figure on the missing enamel cannnot now be established, but (from the appearance of the outline impression) it was probably a female figure, and so is most likely to have been an image of the Virgin.

Assuming that this object was indeed a reliquary when it was sold to the Hospital, it is not now possible to be sure of the identity of the relic which it contained or to which it was attached. Scrutiny of the inventories given in the documents does not yield any conclusive evidence.[37] It is now attached by a modern fastening to a cloth bundle, and so it may always have been related to the relics in the collection that were connected with the Virgin – her veil or her girdle.

II: The Acquisition and Provenance of the Collection

These five reliquaries constitute the main art-historical interest among the collection of relics which the Siena Hospital bought in Venice in 1359. The treatment and housing of the relics during subsequent centuries, with the building of a special sacristy and the construction of a large *armadio* (painted by Vecchietta), together with the granting of indulgences by successive popes, have been carefully studied by H.W. van Os.[38] What has remained in considerable obscurity is the precise nature of the circumstances under which the relics left Constantinople and ultimately reached the Hospital in Siena; this is the more surprising as the collection constitutes easily the largest assemblage of Byzantine works of art to reach Italy with an intact and documented provenance – a provenance which, it will be shown, reaches right back to the imperial palace in Constantinople.

[35] P. Hetherington, *Byzantine Enamels...*, cit., nos. 29 and 39.

[36] K. Wessel, *Byzantine enamels...*, cit., fig. 56a and pp. 176–81; although the figure of Christ is here enthroned. Estimates of the date of the enamels, which are in any case re-mounted, range from the 11th to 13th centuries.

[37] See *App. I* and *II*, below.

[38] H.W. van Os, *Vecchietta...*, cit. The *armadio* is now in the Pinacoteca at Siena, and the sacristy has been converted to a lecture hall for the Hospital.

The history of how the collection came to its present home can be traced back to the disastrous sequence of wars which drained much of the little remaining strength from the Byzantine Empire in the 1340s and 1350s.[39] In the summer of 1356 the youngest son of the Ottoman Sultan Orkhan, Halil, was captured by Genoese pirates and held for ransom by Leon Kalothetos of Phokaia. John VI Cantacuzenus had given Orkhan his daughter, Theodora, in marriage, and Halil may indeed have been his grandson, as well as being related to Helena, the wife of John V Palaeologus. As John VI and his wife, the empress Eirene, had both abdicated in 1354, it was left to John V to pursue the matter; he had an alliance with Orkhan, and eventually agreed to pay a huge ransom for Halil's safe return. The accounts of both Nicephorus Gregoras and John Cantacuzenus agree on the precise figure that was demanded and paid: 100,000 *hyperpera*.[40] This was at a time when the entire customs revenues for a year in Constantinople had sunk to only 30,000 *hyperpera*.[41] Again, in the summer of the following year, a further ransom of 'much money' had to be found for Matthew, the eldest son of John Cantacuzenus, who was being held for ransom by the powerful and treacherous Serbian governor of Drama, Vojichna.[42]

The money for both these ransoms had to be found when the Empire's funds were at their lowest ebb, and while the emperor, John V, was almost continuously absent from Constantinople, either in Thrace or in Tenedos. Large sums of money could only have been raised in the city itself, and so it would seem that John V's wife, the empress Helena, was called upon to assemble the necessary funds as best as she might.

The evidence for this supposition is contained in the document transcribed here as *Appendix I*. It indicates clearly that on 15 December 1357, in the quarter of Constantinople known as Pera, a substantial collection of relics had been acquired by a Florentine merchant living in the city, Pietro di Giunta Torrigiani.[43] It can be seen that the document was intended to act both as a record of the number and identity of the relics, but also to certify that they came from the imperial palace itself. The importance

[39] For the complex history of this period, see D.M. Nicol, *The Last Centuries of Byzantium*, London 1972; *The Cambridge Medieval History*, IV, 1, Cambridge 1966, pp. 356–7; also D.M. Nicol, 'The Byzantine Family of Kantakouzenos (Cantacuzenus) ca. 1100–1460', *Dumbarton Oaks Studies*, 11, Washington (D.C.) 1968, nos. 22, 23, 24 and 30. I am much indebted to Professor Nicol for detailed help in interpreting these events.

[40] See D.M. Nicol, *Last Centuries...*, cit., pp. 272–4; sources in F. Dölger, *Regesten der Kaiserurkunden der Oströmischen Reiches; 5 Teil: Regesten von 1341–1453*, Munich 1965, pp. 43–4, nos. 3055 and 3057. Nicephorus Gregorius, *Byzantina Historia*, xxxvi, 6–7 (CSHB III, Bonn 1855, pp. 504–5), gives the sum of ἑκατὸν χιλιάδων, while John Cantecuzenus, *Historiarum Libri IV*, iv, 44 (CSHB, III, Bonn 1832, p. 322) expresses it as δέκα μυριάδες. For further views, see also D.M. Nicol, *Kantakouzenos*, cit., pp. 134–5.

[41] *Cambridge Medieval History*, p. 363.

[42] J. Cantecuzenus, *Historiarum libri...*, cit., iv, 45 (CSHB, III, pp. 331–2); χρήματα τε ἐπηγγέλλετο πολλά... See F. Dölger, *Regesten...*, cit., p. 46, nos. 3064–5; D.M. Nicol, *Last Centuries...*, cit., pp. 256–7; and idem., *Kantakouzenos...*, cit., pp. 87 and 116–17. The economic realities were probably evident to all, as Vojichna tried to increase the ransom by threatening to put out his prisoner's eyes, but John V insisted that he should not be harmed.

[43] See below, *Appendix I*. Pera, across the Golden Horn, was of course the centre of the Venetian colony in Constantinople.

given to this event can be assessed from the individuals who were present. Besides the lawyer drawing up the document, there was taking part none less than the Apostolic Nuncio to Constantinople, the Carmelite Peter Thomas, bishop of Patti and Lipari; he had been in the city since April 1357, and was certainly the most senior Western cleric to be found.[44] Also present were the Venetian *bailo*, who had been a witness to the original purchase by Torrigiani,[45] a Dominican inquisitor, Philip de Contis, and three bishops, Henry of Tana, Gabriel *Argeronensis* and John *Vatnensis*.[46] During the proceedings, apparently as part of the process of authentification, two of the bishops were despatched to visit an empress who was a member of the Cantacuzene family ('*Imperatricem uxorem Cathecuzinos*');[47] she swore '*cum grandissimo singultu, Cordis dolore*' that it was only of necessity that the relics had been exposed for sale in the Loggia of the Venetians, and that the emperor had nothing more valuable.[48] Confirmation of this was provided by the Venetian *bailo*. There seems to be no real room for doubt that the Cantacuzene empress whom the bishops visited was the empress Helena, wife of John V Palaeologus. She was daughter of John Cantacuzenus, and was proud of her family name.[49] The only other empress then alive who might just have been referred to in these terms was Eirene, the wife of John Cantacuzenus, but she had abdicated with her husband in December 1354; she would not have been called an empress in 1357, as she was then living in a convent as the nun Eugenia.[50] This would also explain why John VI was not consulted; although he was probably at that time present in the city, he had become a monk on his abdication, and so could not have been involved in the sale.[51]

[44] Peter Thomas (later canonised) was the subject of a *Vita* by Philippe de Mézières (most recently edited by T.M. Quagliarella, *Vita di San Pietro Tommaso*, Naples 1960); the *Vita* is silent on this episode. From 1353 his life was devoted to papal diplomacy, mainly in the East, and he would have been the natural choice to give the utmost weight to this transaction. See also C. Eubel, *Hierarchia Catholica Medii Aevi*, I, Regensburg 1913, p. 384; and *Bibliotheca Sanctorum*, X, Rome 1968, cols. 577–87.

[45] The title of the governor of any Venetian colony, but ranking below the ambassador; it is of interest that the meeting was held in his house. The *bailo* is never mentioned by name; cf. F. Thiriet, *Régestes des délibérations du Sénat de Venise concernant le Romanie*, I, 1229–399, Paris 1958, pp. 84–7 for years 1356–58.

[46] See C. Eubel, *Hierarchia...*, cit., 1, p. 471, for Henry of Tana. *Argeronensis* may be an error for *Argolicensis* or *Algoricensis* (*i.e.* Argos, in Greece); C. Eubel, *Hierarchia...*, cit., I, pp. 105–6 has a gap between Joannes, in office in this diocese in 1334, and Venturinus, in office in Dec., 1358; *Vatnensis* may be an error for *Valaniensis* (i.e. Valania, in the district of Latakia, Syria); see C. Eubel, *Hierarchia...*, cit., I, p. 512.

[47] See below, *Appendix I*.

[48] Although protestations of this kind might have been expected in the circumstances, it should not be forgotten that by this stage the empress would presumably have been paid, and so her price would not then have been at stake. See also n. 71, below.

[49] D.M. Nicol, *Kantakouzenos*, cit., no. 30. She would have been in her mid-twenties during these years, having been married some ten years earlier.

[50] D.M. Nicol, *Kantakouzenos*, cit., no. 23. A long tradition attached to the relics cites Eirene as the empress consulted, but this must be incorrect. For an 18th century version, see G.D. Ristori, *Breve distinia relazione...*, cit., p. 2.

[51] *Cambridge Medieval History*, p. 367 and D.M. Nicol, *Kaniakouzenos*, cit., pp. 85–9. An old tradition asserts that John Cantacuzenus retired at once to Vatopedi (see e.g. G.D. Ristori, *Breve distinta relazione...*, cit., p. 1, who even gives his monastic name, and quotes Villani as source), but while he was not continuously

It should be noted that at this stage there was no mention made of Siena or of its Hospital, nor indeed is there any figure given that would suggest a price for the collection. The only reference to any ultimate home for it is that it should be conveyed to the Pope or the Roman Emperor.[52] The order in which the various kinds of items are listed is rather confused, with what would seem to be the most important being left to the end; there are also some repetitions.[53] The fact that there is no mention at all of what was later to be regarded as the foremost treasure in the entire collection – the Greek manuscript – will be mentioned later. In its main respects, however, this unusual document is sufficiently reliable to support the claims made here. It is unfortunate that it does not give evidence for the precise date on which the collection left the imperial household, but it must in the circumstances have been during the summer of either 1356 or 1357, or perhaps partly in both of these years.

At some point between December 1357 and May 1359 the collection of relics reached Venice. It was there that on 28 May 1359 the document given here as *Appendix II* was drawn up; it is basically a contract of sale for the collection, and although rather lengthy, is not in its main outlines in any way remarkable.[54] There was present at the sale one of the syndics of the Hospital in Siena, Andrea Gratia, and it was probably he who was responsible for initiating the whole purchase. It is not clear at what point the Hospital authorities had begun to take an interest in the purchase of the relics, but under the terms of the contract they were now committed to paying Pietro di Giunta Torrigiani the huge sum of three thousand gold florins for outright possession of the entire collection.[55] It is of interest that this sum was not to be paid all at once, but at the rate of one hundred gold florins every six months; the money was to be paid to Torrigiani, and if he should die, to his widow, Luchina, or on her death to his son Antonio. Torrigiani was also to be provided with a house for him and his family to live in.

The sale document is of interest in a number of ways, but before examining it in more detail, something should be said on the way that it was implemented. The records of payment given here as *Appendix III* show considerable irregularities, and are summarised at the end of the record of entries in the '*Libro Vitale*' of the Hospital. When Torrigiani died on 25 July 1362 payments were already over twelve months in arrears; they can be seen to continue sporadically until 1366, by when it appears that Luchina, his widow, had re-married. Payments were made more regularly thereafter, and

present in Constantinople, and certainly took an interest in Vatopedi, he never lived there (see D.M. Nicol, pp. 92–3). I am myself guilty of perpetuating this tradition, which is mentioned on a vellum label attached to Reliquary A (see P. Hetherington, *Byzantine Enamels...*, cit., n. 3).

[52] See below, *Appendix I.*

[53] The sequence '*de Sancto Armollao, de Sancto Pantaleone, de Sancto Joanne Chrisostomo*' is repeated two lines later with three more names inserted after Pantaleone. See below, *Appendix I.*

[54] I am most grateful to Dr. David Abulafia for reading the contract and other documents, and giving me the benefit of his experience of such material.

[55] For money values at this period, W.M. Bowsky, *A Medieval Italian Commune: Siena under the Nine 1287–1355*, Los Angeles 1981, pp. xvii and 184–259; also W.M. Bowsky, *The Finance of the Commune of Siena 1287–1355*, Oxford 1970, p. xx.

they ceased on 5 June 1372 with a massive bonus; the Hospital more than discharged its obligations to the seller, as an extra 360 gold florins was paid in excess of the sum agreed in the contract of 1359. The only reason to be found for this is a phrase in the final entry: '... *perché facemmo concordia con lui di detti cento florini d'oro, che doveva havere l'anno a sua vita il detto Antonio....*'[56]

The terms of the sale, and the economic aspects of its execution, are of interest in that they indicate the ultimate purpose of the whole transaction; this in turn will be seen to have implications concerning the display of works of Byzantine art in Siena. In the first place it is clear that the Ospedale della Scala, in common with other such institutions all over Europe, had gained access to very substantial funds, largely as a result of the Black Death of ten years earlier.[57] It was common to bequeath land, property and other goods to institutions of this kind, and the Hospital authorities must have been counting on this income to make the payments; the house with which they were supplying Torrigiani may well have come into their hands at the same time.

The relics themselves, however, once they were in Siena, would have been a major source of further wealth. The Hospital there had as a large part of its *raison d'être* not just the care of the sick, but also the lodging and feeding of pilgrims on their way to Rome.[58] The presence of a major collection of relics such as this would have constituted a great attraction, so increasing the flow of pilgrims spending time there on their journey; this in turn would have swelled the Hospital's income, so providing revenue to furnish the large payments to Torrigiani. It was therefore of great importance that the relics, many of them still in their Byzantine reliquaries, and hallowed by their association with the Byzantine emperors, should be regularly and suitably displayed.[59]

When assessing the art-historical importance of the collection, it is necessary to relate the two lists, or inventories, as they appear in the documents of 1357 and 1359, both to each other as well as to the objects still in the Hospital's possession.[60] The findings that emerge from such a comparison fall into four principal categories.

Firstly there are the items that have apparently simply disappeared. Of the most artistic interest among these is what must have been an icon with images of Christ, St. Peter and St. Paul, with a silver revetment; while the documents are not completely consistent on this,[61] there was certainly still an icon of this description in the collection

[56] While this must refer to the son, who had outlived his father, Dr. Abulafia has suggested to me that it may be a form of words to conceal payment of interest.

[57] For a history of the Hospital, see. G. Cantucci, *Statuti Senesi III*, '*Saluto dello spedale di S. Maria di Siena, 1318–1379*', I, Rome 1960, pp. vii–lxxx, For bequests to the Hospital in 1348, which apparently exceeded sixty in number, see M. Meiss, *Painting in Florence and Siena after the Black Death*, Prinecton 1951, pp. 78–80.

[58] H.W. van Os, *Vecchietta...*, cit., pp. 1–2, where the prime function of the lodging of pilgrims is emphasised.

[59] They were both carried in processions, and displayed at a grilled window in the Hospital's facade to the pilgrims assembled below; see H.W. van Os, *Vecchietta...*, cit., pp. 3–6.

[60] See below, *Appendix I* and *II*.

[61] While the most specific description is that quoted in n. 62, it would seem most probable that this was the item mentioned in the 1357 inventory as '*dedicta Ancona ad instantiam S. Constantini Imperatoris fabricata*', and in that of 1359 as '*unam tabulam de tribus imaginibus guarnitam de argento antiquam*' – a triple

in 1575, although it is omitted from later inventories.[62] Besides this there are mentioned such objects as '*unum Goffanetum de Osso vetus*', which may have been a casket with carved ivory panels, and of which there is now no trace, as also is the case with some textiles, '*quinque velletos et mantilletos*'.[63]

A second characteristic which emerges is that the buyers were unable to read Greek. This is shown in several ways; one of them, for example, is that there are discrepancies between relics listed in the sale document and the inscriptions on the reliquaries themselves. We can read in the former of '*unam Casellam argenti deauratam, ubi stat Purpura; unam Cassettam auri cum lapidibus, et smaltis, in qua sunt de omnibus Santis rebus Christi, que possunt reperiri in mundo, videlicet; de Spongia, Lancea, Canna, de Pilis Barbe Jesu Christi, de Sanguine Christi, quem zetavit Ancona...*'.[64] The latter of these two must be our Reliquary A, as the description of the image concerning the blood of Christ can only refer to the enamel on it. However, the former of them must refer to our Reliquary B, where the inscription clearly shows that it contained not just part of the purple robe, but also parts of the sponge, swaddling clothes and tunic of Christ;[65] nowhere is there any mention of the lance, reed or hair from Christ's beard. It would seem that there was here an error of identification, brought about by an inability to correlate a hand-list of relics with the reliquaries in which they were contained. No help was provided in this case by the document of 1357, and there may well have been other instances of this kind which cannot now be identified.

A third category might be called errors, but amount in fact to an over-optimistic assessment of the identity of a relic. An example of this is provided by one that is still in the collection with the label '*Sti Bartholomei Apostoli*' attached to it (figs. 21–22). A relic of this saint appears in both documents, although in that of 1359 it is said to be '*guarnitam argenti*', although it is in fact of gold. The *recto* of the sheet of gold, folded round a piece of bone, has a simple design in twisted wire, while the *verso* has ten loops for possible attachment to fabric. The appearance and workmanship is of very unrefined character, and may indeed not be of Byzantine origin. At some period Greek characters were crudely incised and filled with niello; while not recogniseable as the apostle Bartholomew, they may be read as Ὁ ΆΓΙΟC ΕΛΕΥΘΕΡΙΟC (*Saint Eleutherios*). The identity of the relic must in any case be in doubt.[66]

The fourth category is the most interesting, however. It represents what can only be additions that were made to the collection while it was in the hands of Torrigiani – between December 1357 and May 1359. A clear example of this are two small relics still in the Hospital's possession (fig. 23); they are both pieces of bone mounted

portrait with silver revetment. Some uncertainty is introduced by a footnote in a later hand in the 1357 document, which denotes this item as '*in modo scachorum*'; this may refer not to an icon, but a 'checkerboard' reliquary (comparable to e.g. the 'Echiquier de Charlemagne' at Roncevaux).

[62] H.W. van Os, *Vecchietta*..., cit., p. 83, where the whole of the 1573 inventory is published.

[63] See below.

[64] See below.

[65] See fig. 1.

[66] I am grateful to Professor Buchthal for suggesting this reading of the inscription. The reliquary was omitted from the main sequence on account of its uncertain character.

Fig. 21. Reliquary of St Eleutherios, verso. Siena, Ospedale della Scala. (Roma, ICCD, Fototeca Nazionale, N 18704.)

Fig. 22. Reliquary of St Eleutherios, recto. Siena, Ospedale della Scala. (Roma, ICCD, Fototeca Nazionale, N 18703.)

at either end in gold. Their parchment labels identify them as '*Sci Petri Apost.*' and '*Sci Pauli*' respectively. They appear under these names in the later inventory, but are not to be found in that made in Pera. It must be of interest that in the Treasury of St. Mark's, Venice, there is more than one similarly-mounted relic,[67] and it is very probable that there were at that period numbers of such objects in circulation in Venice which could have been bought by Torrigiani and inserted into the collection. It was of course in the interests of both parties that the relics should appear in the most venerable light: the buyer to increase the sanctity of the collection, and the seller to justify the huge price. In pursuing this practice, however, both sides seem to have been led astray. It can be seen clearly that the relic bearing a label denoting it as being a relic of St. Peter has an inscription in niello on both of its gold mounts: + ΛΕΙΨΑΝΟΝ ΤΟΥ ΑΓΙΟΥ ΜΑΡΤΥΡΟΣ ΑΡΕΘΑ + ('*Relic of the martyr Saint Arethas*'). This name does not appear in either of the two documents among the lists of relics. Counting on the inability of the purchasers to read Greek, the relic of the minor martyr Saint Arethas was introduced into the collection by Torrigiani, and elevated for the purposes of the sale to that of the prince of the apostles – an identity that it has kept ever since.

But the most substantial difference between the two lists is provided by the inclusion in the later document of the Greek manuscript in its highly ornate and precious binding, decorated with over fifty Byzantine enamels (figs. 24 and 25). It does not figure at all in the earlier inventory, while in the later one it is given pride of place, being put at

[67] Closest is cat. no. 32, but nos. 175 and 166 are also very comparable; see Hahnloser, *Tesoro*, Pl. XXX, CLXI and CLXXVI.

Fig. 23. Two mounted relics. Siena, Ospedale della Scala.

the top of the whole list. It must have been the most spectacular object in the entire collection, and it is inconceivable that it was omitted by error when the document in Pera was drawn up. When I first published this book-cover some five years ago, I was unaware of the existence of the two documents or the discrepancies between them,[68] and I was therefore obliged to assume, as had all previous commentators,[69] that it had always formed part of the entire collection that originated in the imperial palace in Constantinople. In spite of this, I concluded on grounds of style and iconography

[68] P. Hetherington, *Byzantine Enamels...*, cit., p. 117.

[69] E.g. G.D. Ristori, *Breve distinta relazione...*, cit., p. 1; L. Dami, *L'Evangelario...*, cit., p. 227; L. Mallé, *Cloisonnés bizantini*, Turin n.d., p. 163; etc.

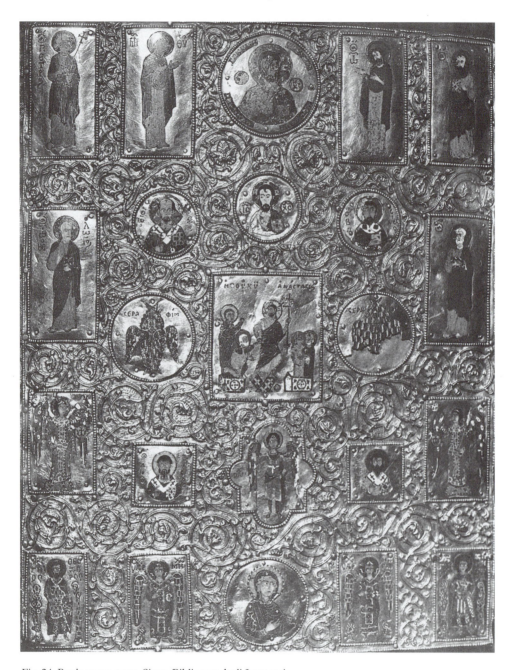

Fig. 24. Book-cover, recto. Siena, Biblioteca degli Intronati

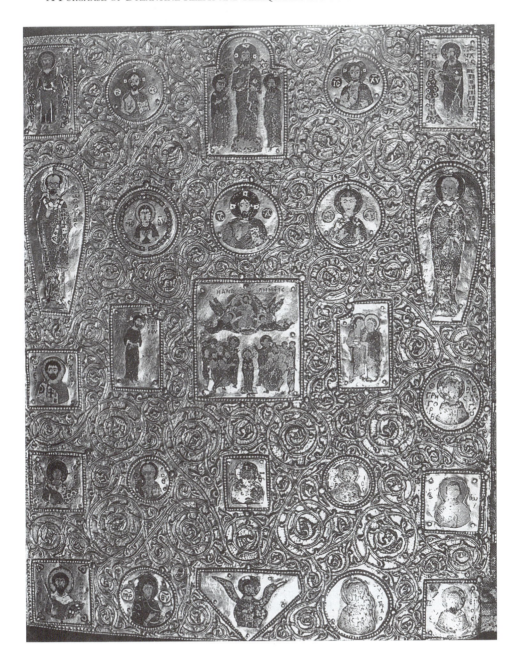

Fig. 25. Book-cover, verso. Siena, Biblioteca degli Intronati.

that although the enamels were all Byzantine, the silver-gilt cover on which they were mounted was of Venetian manufacture, and that it must therefore have been transferred to Constantinople between the date of its production and that of its sale in the mid-fourteenth century. These two inventories now constitute weighty evidence that the book-cover may well never have left Venice for the East at all, and that it was added to the massive collection of relics after they had reached the Republic. By doing this the value of the manuscript was greatly increased, as it automatically assumed a spurious imperial provenance,[70] and the character of the collection as a whole was enhanced, as it previously lacked a show-piece of this nature.

For modern scholarship one of the most important features of the purchase by the Siena Hospital authorities is the completeness of the documentation which accompanies it; it is indeed this that has permitted a number of the conclusions that have been reached above. This contrasts with the great majority of works of art and other objects that arrived in Western Europe from Constantinople during the later Middle Ages, which were the results of theft or loot. Besides shedding some light on the working of a large medieval hospital, the documents presented here also amplify the accounts of Nicephorus Gregoras and John Cantacuzenus, as well as suggesting that the seeds of some features of later Byzantine diplomacy were being sown.[71]

III: The Collection and Art in Siena

While it has always been recognised that artists of the generation of Guido da Siena and Duccio must have had considerable knowledge of Byzantine art, their sources have always had to be largely a matter of guess-work. We can now be sure that, with the purchase of the collection from Torrigiani in 1359, Sienese artists would have had access to a whole new repertory of works of Byzantine art. The icon, the painted evangelist portraits in the manuscript,[72] the feast scenes in enamel on the book-cover and the reliquary, and in silver-gilt, were all there, and all with the authenticity of an established origin in the palace of the Byzantine emperors.[73] Yet, whatever may have been the case in the days of Duccio, it would appear that by the 1360's interest on the part of Sienese artists in Byzantine art had largely disappeared. The fact is

[70] It is clear that the question of the provenance of the relics was always of vital importance, and became even greater as the centuries passed; for the first time only in 1575 was the name of 'S. Pio Boccadoro' (presumably St. John Chrysostom) given as the author of the manuscript (H.W. van Os, *Vecchietta...*, cit., p. 83 and n. 6).

[71] For the development of 'reliquary diplomacy' later in the century by Manuel II, see J.W. Barker, *Manuel II Palaeologus (1391–1425), A Study in Late Byzantine Statesmanship*, New Brunswick 1966, pp. 130–31, 176–7, 265, etc.

[72] All four evangelist portraits were included, each to a full page, on fols. 1ᵛ, 50ᵛ, 125ᵛ and 218ᵛ (G. Garosi, *Inventario dei Manoscritti della Biblioteca Comunale di Siena*, I, Siena 1978, pp. 21–3). It was no doubt the presence of these portraits that were the cause of the erroneous description of the codex as a 'Vangelario': see P. Hetherington, *Byzantine Enamels...*, cit., p. 117, n. 1.

[73] In the sale contract of 1359, former ownership of two of the reliquaries is credited to Constantine himself.

that the oeuvre of such artists as Bartolo di Fredi, Andrea Vanni, Giacomo di Mino Pelliccaio or Luca di Tomé can be searched in vain for any significant trace of the arrival or presence of all these works;[74] for all the visual impact that they made they might never have left Pera. In just one case van Os has suggested that the iconography of an altarpiece by Maestro Pietro a Ovile, depicting the assumption of the Virgin, was influenced by the presence of the relic of the Virgin's girdle that was kept in the Hospital church,[75] but even this did not involve any knowledge of a work of Byzantine art. Throughout the transaction and the documents that relate to it, it is clear that the relics themselves, and their illustrious origins, were of paramount importance. Where the reliquaries and the binding of the manuscript are mentioned at all, the terms are always those of conventional medieval usage, with no reference to style or period. Perhaps this negative conclusion may stimulate further research into the problem of what Italian artists of this period were seeking when they looked at the art of their Greek contemporaries.[76]

IV: The Reliquaries and Byzantine Art

The fact that all five of the Byzantine reliquaries published here have a provenance that goes directly back to the imperial palace in Constantinople gives them a significance that cannot be matched by any other such collection still extant. Although the losses in works in precious metal must always have been very high, we have here sufficient material to shed some light on the circumstances under which an atelier of artists was working for the Byzantine court in the first half of the fourteenth century. It is even possible now to re-assemble part of the output of this atelier which carried out commissions for aristocratic and imperial clients in Constantinople at this date. In addition to the later work on our Reliquary A, a homogeneity of style links our reliquaries B and C, the Vatopedi icon-frame, and parts of the frame of the Sacro Volto in Genoa; this in turn has been shown by Dufour Bozzo to have further strong stylistic links with two book-covers with silver repoussé decoration which are now in the Marciana Library (codd. gr. I, 53 and I, 55)[77]. I hope to develop the implications provided by this group in a subsequent study.

For the present, the works published here shed a fascinating light on the fortunes of the imperial household in Constantinople during the middle decades of the fourteenth century. While our Reliquaries A and E involved the adaptation and re-use of earlier material, other items in the group were clearly new creations *ab initio*. One of these, the cross-reliquary, C, is made from solid gold, but all the rest, even the immensely prestigious icon revetment of the Sacro Volto, are of silver-gilt. Yet even

[74] See M. Meiss, *Painting...*, cit., pp. 168–71.

[75] H.W. van Os, *Vecchietta...*, cit., p. 8.

[76] While modern usage of the word 'Byzantine' has connotations of spirituality and other-worldiness, this would not have been the case at this date; for Italians of the period the Greeks would have been known better as the traders in the exotica of the Levant, as well, of course, as being schismatics.

[77] C. Dufour Bozzo, *Il 'Sacro Volto'*, cit., pp. 28–32.

so, these observations provide an interesting commentary on the description given by Nicephorus Gregoras of the celebrations that took place in the Blachernae palace on 21 May 1347; they were in honour of the second coronation of John VI Cantacuzenus, and the five thrones that were used were for him, John V, the empresses Anne and Eirene, and her daughter Helena: '*There was then such poverty in the palace that none of the cups or bowls were of gold or silver; some were of leather, and all the rest of clay and pottery...*' and he goes on to describe the artificial gems in the imperial regalia, itself made from leather, and he adds sadly, '*it is not without shame that I relate these things*'.[78]

These festivities took place when the reliquaries that are the subject of this paper were still in the imperial possession, and it casts an interesting light on the priorities that were observed in the distribution of wealth within the imperial palace; the chapels and churches of the palace complex at Blachernae were evidently the last places to be emptied of their precious objects.

[78] Nicephorus Gregoras, *Historia*, xv, 2 CSHB, II, Bonn 1830, pp. 788–9.

APPENDIX

The documents published here have been transcribed from the Archivio Spedale S.M.S., nr. 120, now held in the Archivio di Stato, Siena. It will be seen that they carry an *affidavit* that they are copies made in 1680 from the originals. They are here presented in chronological order, which has entailed a slight re-arrangement. I would like to thank Dr. Anna Healey for checking my transcription of the Latin.

Emendations to the text are in square brackets, and have been confined to obvious copying errors.

Appendix I

Siena, Archivio di Stato. Archivio Spedale S.M.S., nr. 120 c. 120.

Nos frater Petrus Dei Gratia Patthensis, et Lippariensis Episcopus, in partibus Romanie Apostolice Sedis Nuntius. Cun[c]tis fidelibus Christianis notum facimus per presentes, quod nos existentes in Pera iuxta Costantinopolim percepimus fide dignorum relatione, quod venerabilis vir Doñus Petrus de Zunta Torrezzano de Florentia in Costantinopolim multas venerandissimas, dignissimasque Reliquias in suo obtinebat posse, et plenius informati ad domus accessimus in Costantinopolim Baiuli Venetorum, et tres Reverendi Episcopi in nostra fuerunt societate, nos ibi perspeximus Oculis, et tractavimus manibus tam pretiosas Sanctorum Reliquias, imo quedam, que ad ipsum Doñum nostrum Jesum Christum pertinent, et de ipsa vera Cruce, in qua ipse peperdit, quod in mundo non possunt esse pretiosora, et licet eorum antiquitas, que apparebat in decenti ornatu, quia ab Imperatoribus tempore lapso fuerant cum summa reverentia, et grandi decore, et nobili artificio honorifice preparate; de certitudine Reliquiarum nobis sufficiens proberet testimonium veritatis, tamen voluimus diligentius informari, et misimus duos de predictis Episcopis tum Inquisitores heretice pravitatis ad Imperatricem uxorem Catbecuzinos, ut scirent ab ea, si fuerant de domo Imperiali, et asseruit cum grandissimo singultu, Cordis dolore, quod pro necessitate fuerunt exposite venditione in Logia Venetorum, et quod Imperium iocalia non babebat tam pretiosa, nec de perditione aliqua tantum, dolebat, quantum sicut de alienatione earum; eadem retulit nobis Consiliarius doñi Baiuli, qui in venditione fuit presens. In medium tabule scatorum operata Reliquie autem sunt primo, et principaliter; dedicta Ancona ad instantiam S. Constantini Imperatoris fabricata, in modo tabula scachorum in qua per Imperii successores addite fuerunt multe Sanctorum Reliquie in opere in qua est operata primitus (10v.) de S. Luca, de Sancto Matteo, de Sancto Marco, de Sancto Stephano, de Sancta Marina, de Sancto Andrea, de Sancto Demetrio, de Sancto Christophoro, de Sancto Gregorio, de Ligno vere Crucis, de Sanguine effuso, et Immagine Christi, de Sancto petido, de Sancto Armollao, de Sancto Pantaleone, de Sancto Joanne Chrisostomo, de Sancta Anastasia, de Sancto Antonio, de Sancta Teodosia, de Sancto Theodoro, de Sancto Gregorio Theologo, de Sancto Stephano, de Sancto Armollao, de Sancto Pantaleone, de Sancto Andrea, de Sancto Bartolommeo, de Sancto Antonio, de Sancto Joanne Chrisostomo de Sancto Ollefero, de Sancto Basilio, de Sancto Cosma, de Lapide copertorii Sancti Sepulchri; item de Sancto Philippo Apostolo, de Sancto Prodio, de Sancto Martio, de Sancto Aristacho, de Sancto Polifetocho, de Sancto Gregorio fratre Sancti Basilii; item alieque Reliquie auro gemmisque munite quorundam Antiquorum Imperatorum Primo de Ligno

vere Crucis per Sanctum Costantinum conquisito, et de Vestimentis Christi, in quibus miserumt sortem; de corda, cum qua expulsit Christus Homines de Templo, de Spongia, de Arundine, de Pilis Barbe Christi, de Sanguine Christi, de Lancea, et de una alia ramba Christi, et acutum manus eius, et alie multeque Reliquie Sanctorum, Sanctarumque, Martyrium, et Conlessorum, de Velo Beate Marie Virginis, et de Zona eiusdem (B.M.) *tam pretiosa habet Iocalia, et venerabiles Reliquias auro, et margaritis, Lapidibusqnue pretiosis in earum vasa ornata, quod non possint calamao scribi, nec favi lingua, habent enim venerabilem virum Doñum Petrum Predictum; Videtur Doñus Jesus Christus in Constantinopolim posuisse, ut de manibus Scismaticorum tam dignas auferret. Reliquias et ad Loca transferret Sancta, prout filii Ishmael de mandato Doñi Egiptiorum portaverunt bona ipsias [?], enim obtinuerunt manu levando, et iste pecumiis, serviciis, Caustialis, et laboribus multis, de quibus omnibus, nobis, et Doñis Episcopis predictis, videlicet - (11r.) Henrico Tañen: Episcopo, Gabrieli Argeroñen: Episcopo, Ioanni Vatnensi: Episcopo constitit luculenter, et manifeste, et cum magna certitudine veritatis; et rogavimus eum, quod ad Doñum nostrum Papam, et ad Serenissimum Principem Doñum Imperatorem Romanum portaret, vel faceret deportari, quia talia eos decent, que sunt ceteris digniora -in testimonium premissorum, presentes litteras fieri iubsimus, et nostro sigillo muniri, una cum sigillis Doñorum Episcoporum predictorum.* ⸻
Datum Pere XV die Mensis Decembris Anno Domini MCCCLVII. Et ego frater Philippus de Contis Ordinis Predicatorum Inquisitor supra dictus vidi, et manibus meis propriis tetigi, et tenui supradictas Sanctas Reliquias. ⸻
Ego Bartolommeus filius quondam Francisci Tellini Civis Senensis Imperiali auctoritate Judex Ordinarius, atque Notarius Publicus totum quod supra Continetur, et scriptum est, scriptum inveni, vidi, legi in quibusdam litteris, ut in eis continebatur, notificationis facte per supra scriptum fratrem Petrium Dei Gratia Partenopensem et Lippariensem Episcopum in Partibus Romanie, Apostolice Sedis, Nuntium in Carta Pecudina sigillate quinque sigillis de cera alba, partim coopertis cera rubea, pendentibus quibusdam cartucciis Hedenis, in quorum primo erat sculta Imago Beate Marie Virginis cum filio in brachio, et cum figura unius Angeli ex utroque latere; super caput dicte figure Beate Marie Virginis est figura Salvatoris; et subtus figuram Beate Marie Virginis erat figura cuiusdem Episcopi cum Mitra in Capite; et in circulo dicti Sigilli sunt litere, que non possunt legi. In secundo sigillo sunt due figure, et non potest discerni quorum, vel quarum Sanctarum sint, et in circulo dicti Sigilli sunt litere, que non possunt legi. In tertio sigillo est figura Beate Marie Virginis cum filio in brachio, et ab utroque latere est figura, que non potest discerni, (11v.) et subtus figuram Beate Marie Virginis est figura cuiusdam Episcopi cum mitra in capite, cum duobus scudettis, cum quibusdem literis in circuitu, que non possunt bene legi. In quarto sigillo est quedam figura, que videtur representare figuram Salvatoris, subtus quam est figura cuiusdam Episcopi cum Mitra in capite, et Pastorali in manibus, et post se est quidam Scudettus, et in circuitu sunt litere, que non possunt legi. In quinto et ultimus est sculta quedam crux, subtus quam est quedam figura, que non potest discerni cuiuc sit, et in circulo sunt quedam litere, que non possunt bene legi. ⸻
Loco ⸻ ✠ ⸻ *Sigilli* ⸻
Collata fuere premissa cum quadam copia autenticha ut mihi visum fuit, et ita existimata existente in Archivio Hospitalis S. Marie Scalanina per me Francescum Matteum Ceniii Notarium pub. et Civem Senetum una cum infrascripto Sp̃ble d. Petro Paulo de Marzocchis Cive, et Notario p̃ubo Senenim et quia concordare inveni ideo hic me publice subscripsi hac die 22 Aplis 1680. ⸻
Ego Petrus Paulus Marzocchi Notarius publicus et Civis Sen. affirmo

Appendix II

Siena, Archivio di Stato. Archivio Spedale S.M.S., nr. 120 2 r.

In Christi Nomine Amen. Eiusdem Nativitatis Anno Millesimo trecentisimo quinquagesimo nono, Indittione duodecima, Die Vigesimo ottavo Mensis Maii. Venetiis in Contrata Santorum Apostolorum, in domo habitationis jacobi Bartholi de Florentia. Presentibus Nobili Milite Doño Alexandro de Agolantibus de Florentia de Contrata Santorum Apostolorum, Doño Petro quondam doñi Andree de Gambacontis de Pisis, Gerando eius fratre, ambo de Contrata Sante Marine D. Jacobo Griffi de Florentia de Contrata Santi Cassani, D. Jacobo Pagni de Senis de Contrata Santi Cassani, D. Jacobo quondam Bartholi de Florentia de contrata Santorum Apostolorum, Gorio quondam Benvenuti de Contrata Santi Cassani, et pluribus aliis Testibus ad hoc vocatis, et rogatis, pontificatus Santissimi in Christo Patris, et Doñi, Doñi Innocentii Pape Sesti; ibique providus et discretus vir frater Andreas Gratie de Senis Sindicus, procurator, Actor, Fattor, et Nuntius Specialis Hospitalis S. Marie della Scala de Senis, ut de Sindicatu costat hinstrumento Publico fatto in Millesimo Trecentisimo Quinquagesimo nono, modum, cursum, morem, consuetudinem, et observantiam Notariorium Civitatis Senarum scripto manu Ricbi filii Lensi Imperiali autoritate Notarii a me Notario viso et letto, cuius hinstrumenti tenor omnia talis est . in Dei nomine amen. Anno Doñi Millesimo Trecentesimo quinquagesimo nono, Indittione duodecima, die vigesimo quarto Mensis Aprilis secundum modum, cursum, morem, consuetudinem, et observantiam Notariorum Civitatis Senarum: Noverint universi qui presens publicum viderint documentum, quod convocatis universis, (
2 v.) *et singulis fratribus hospitalis Sante Marie della Scala de Senis ad Capitulum in quadam Camera inferiori ditti Hospitalis, ubi fiunt Capitula per fratres ditti Hospitalis de mandato R̃di viri Doñi Andree Thori Rettoris ditti Hospitalis ad sonum Campanelle ditti Hospitalis more solito, ibique convocati in ditta Camera statim intervenerunt, et congregrati fuerunt infrascripti fratres ditti Hospitalis, videlicet doñus Andreas Thori Rector, Doñus frater Petrus Ducii, frater Andreas Gracie, frater Sanus Magistri Nerii, frater jacobus Magistri Viviani, frater Jacobus Thurini, frater Franciscus Vanocii, frater Joanninus Remissii, frater Niccolaus Tbori, frater Petrus de Clusio, frater Lucas D. Maglini, fraler Mancinus Conlis, frater Petrus Magistri Ceccbi, frater Franciscus Paganelli, frater Ceccus Joanelli, frater Pinus Maphei, et frater franciscus D. Pucini, qui sunt due partes, et ultra fratrum ditti Hospitalis in ditto Hospitali residentium, et qui faciunt, et representant universum Capitulum ditti Hospitalis. Idem Doñus Andreas Rettor faciens infrascripta omnia, et singula in presentia, et cum consensu dittorum Iratrum presentium, et consentientium, et ipsi iidem fratres una cum ditto Doño Andrea Rettore, Collegialiter, et ut Capitulum, sibi ad invicem consentientibus, habito inter eos de, et super infrascriptas Colloquio, et trattatu, unanimiter, et concorditer fecerunt, costituerunt, et ordinaverunt providum, et discretum virum Iratrem Andream Gratie de Senis presentem, et hoc mandatum sponte recipientem, dittorum fratrum ditti Hospitalis, et Capituli, et conventus eiusdem, verum, et legittimum Sindicum, et Procuratorem, attorem, fattorem, el nuncium specialem ad conveniendum, trattandum, componendum, et paciscendum cum quacumque, (*3 r.) *et quibuscumque Pernosis sibi videbitur, et placebit; de, et super quibuscumque provisionibus, rebus, bonis, et contrattibus, de quibus, et super quibus eidem Sindico videbitur et placebit; et ad permutandum, et concedendum cuicumque eidem Sindico videbitur et placebit, ad vitam, vel ad tempus, et pro illo tempore, et eo modo, quo visum fuerit sibi convenire cui, et quibus sibi placuerit; possessiones perpetuas,*

res, et bona mobilia, et immobilia ditti Hospitalis, Capituli, et Conventus eiusdem; et ad obligandum dittum Hospitale, et eius fratres, et bona pro predittis observandis, prout, et sicut, quomodo, quoties, et qualiter eidem Sindico videbitur, et placebit ... (3 v.). et D. Petrus quondam Zunte Torrigiani de Signa Comitatus Florentie, habitans Costantinopoli, et Civis Venetus de Contrata Santi Severii, suo nomine proprio, et vice, et nomine Doñe Lucbine filie doñi Quintilii de Bobio babitantis Pere Uxoris ditti D. Petri, el Antonii filii ditt D. Petr, et quondam filii doñe Joannine olim uxoris ditti D. Petri ex altera paciscerunt, et convenerunt ad invicem in hunc modum, videlicet. Quia dittus D. Petrus quondam Zunte in presentia mei Albertini Notarii et testium dedit, tradidit, et assignavit, et deposuit purè, liberè, simpliciter, et irrevocabiliter inter vivos, (4 r.) iure proprio, et in perpetuum, et divini amoris intuitu obtulit, et donavit ditto fratri Andree Gratie Sindico, et procuratori dittorum fratrum, et Hospitalis Sante Marie della Scala de Senis ibidem presenti recipienti sindicatorio, et procuratorio nomine dittorum fratrum, et Hospitalis Zoiellos auri lapidum preciosarum, perlarum, argenti infrascrittas Reliquias Sanctas, videlicet . unum librum Evangeliorum in lingua Greca fulcitum auro, et argento cum smaltis; unam tabulam de tribus imaginibus guarnitam de argento antiquam; unam Cassettam Argenti in qua sunt infrascritta res . unum Claudum de Manu Sinistra Jesu Christi, Purpuram vestimenti Cbristi, de qua continetur in Evangelio; unam Casellam argenti deauratam, ubi stat Purpura; unam Cassettam auri cum lapidibus, et smaltis, in qua sunt de omnibus Santis rebus Christ, que possunt reperiri in mundo, videlicet: de Spongia, Lancea, Canna, de Pilis Barbe Jesu Christi, de Sanguine Christi, quem zelavit Ancona, et de multis aliis rebus Santis, que fuerunt Santi Costantini; unam Crucem auri incassatam anticam, plenam de Ligno vere Crucis, fuit Santi Costantini; medium Velum Virginis Marie Sanguinem de Lina; mediam Cofiam Virginis Marie acutam; mediam centuram Virginis Marie; tinam Reliquiam Ossi Santi Petri Aposioli sguarnitam; unam Reliquiam Santi Pauli Apostoli guarnitam auri; unam Reliquiam Santi Bartholommei guarnitam argenti; unam Reliquiam Teste Sancti Antonii de Vienna; unam Reliquiam Teste Sancti Stephani Martiris; unam Reliquiam Santi Joannis de Clemosznia; unum digitum Sancti Philippi Apostoli; unam Reliquiam Sancti Rodii; unam Reliquiam Sancti Martini Pape; unam Reliquiam Sancti Arcbistrati; unam Reliquiam Gambe Sancti Gregorii; (4 v.) unam Reliquiam Sancti Hippoliti; unam Reliquiam Sancti Ermolai; unam Reliquiam Sancti Pantaleonis; unam Reliquiam Sancii Quirici guarnitam argenti deaurati; unam Reliquiam Sancti Odori; unam Reliquiam Sancti Joannis Boccadori in uno munimento argenti; unam Reliquiam Brachii Sancte Castrite guarnitam auri, Perlis, et lapidibus preciosis; unam Reliquiam Sancti Cosme Damiani guarnitam auri; de Copertura monumenti Cbristi ligata in auro; unum petium de lapide munimenti Christi; unam Reliquiam Sancti Liberati cum duabus Perlis ligatis in auro; unum Camarum nostre Doñe guarnitum auri, lapidibus preciosis, et perlis; unum lapidem Sancti Domitrii guarnitum auri, lapidibus preciosis, et Perlis; unam Prassimam Sancti Gregorii in auro cum duabus perlis; unam Reliquiam Sancte Herere Martyris guarnitam auri; unam Reliquiam Sancti Georgii in uno agnusdeo auri; unam Reliquiam Sancti Maccarii; unam Costam Sancti Andree Apostoli guarnitam argenti; unam Reliquiam Bracchii Sancti Blasii guarnitam argento; Gambam Sancti Tbome Apostoli cum aliquantulo argenti; Testam Sancte Christine, de osso Capitis Sancti Stephani juvenis; unam Cassam magnam inauratam; unam Cassettam de Arcipresso; unum Goffanettum de Osso vetus; quinque vellettos el mantilettos, et aties [sic] res venerabiles, et ornatas, que sunt extimationis de voluntate dittarum partium, extimationis trium Millium Florenorum auri; ... (5 v.) pro quibus quidem rebus sic datis, donatis, et assignatis ditto Fratri Andree Gratie Sindico, et procuratori dittorum fratrum,

et Hospitalis Sancte Marie della Scala de Senis, recipienti D. Sindicatorio, et procuratorio nomine dittorum fratrum, et Hospitalis at preditto D. Petro quondam Zunte Torrigiani danti et tradenti, et assignantt . suo nomine proprio, et vice, et nomine preditte doñe Luchine sue uxoris, et doñi Antonii sui filii, predictus frater Andreas de Grati a Sindicus, et Procurator dictorum fratrum, et Hospitalis, per se, et suos Sucessores, et prodicto Hospitali promisit dicto D. Petro quondam Zunte Torrigiani ibidem presenti, stipulanti, et recipienti suo proprio, et principali nomine, et vice, et nomine predicte Doñe Luchine sue uxoris, et dicti Antonii sui filii, dare, et solvere eidem D. Petro in Civitate Senarum donec vixerit, aut suo Procuratori, et nuncio ducentos Florenos auri boni, et fini, et iusti ponderis quolibet anno, videlicet centum Florenos auri hic ad sex Menses prossime venturos, et alios centum Florenos auri hic ad alios sex Menses prossimè secuturos, et sic successive quolibet anno facere eidem solutiones dictorum ducentorum Florenorum auri, videlicet in fine quorumlibet sex Mensium centum Florenos auri. Item predictus frater Andreas Sindicus nomine dictorum fratrum et Hospitalis, et pro dicto Hospitali promisit per se, et suos successores dare, et assignare dicto D. Petro quondam Zunte Torrigiani hic ad tres menses prossimè venturos unam ex domibus dicti Hospitalis, commodam et honoratam pro sua, et sue familie habitatione, et predictorum Uxoris, et filiorum, exceptis domibus. que habitantur per fratres dicto Hospitalis, vel dominarum, (6.r.) et commissarum eiusdem; in qua domo dittus D. Petrus possit habitare, etiam locare, affittare, usum fructum ex ea recipere; que domus non possit sibi accipi per Rettorem, et fratres dicti Hospitalis, donec non fuerit sibi assignata alia domus dicti Hospitalis per dictum Rettorem, et fratres, que sit maioris extimationis, quam domus, que primo fuerat sibi assignata ...

(9v.) *Ego Albertinus Plastellini de Plastellis de Bononia Civis Venetiarum Imperiali autoritate Notarius iis omnibus interfui, et rogatus scribere predicta publice scripsi, signavi, et tradidi dicto Antonio, et scripsi.* ————————————————————————————

Loco ———————————————— *Signi Notarius* ——————————————————

Jo Francesco Matteo Cenni Sinalonghese, e Notario pubblico e Cittadino Senese ho confrontato il parte Intesso insieme con lo Squable S. Pietro Pauolo Marzocchi Notario pubblico e Cittadino Senese, e rittrovato confrontare con il suo originale esistente nel l'Archivio del Piissimo Spedale di S. Maria della Scala in tutte le sue Parti, approvando le soprascritte due postille, qui si devono leggere dove indicano il lor segno, et il ————————————————————————— *confrontato questo di 22 Aprile 1680. dichiarando et il* ———————————————————————— *originalle è in carta pecora, et si crede da noi originale.*

Appendix III

Siena, Archivio di Stato. Archivio Spedale S.M.S., nr. 120. 33.r.

Al libro Vitare Dare e Havere dall'anno 1350, lino at 1436, a fo. 144.
 Al nome di Dio Amen adi 24 Settembre 1359.
 Piero di Gionta Torrigiani da Signa del Contado di Fiorenza Abitatore in Costantinopoli e Antonio suo figliolo, e Maña Luchina sua Moglie debono havere dallo Spedale S. Maria ogni anno mentre che viveranno fiorini dugento d'Oro, cominciando la prima paga in Chalende Dicembre 1359, cioe de fiorini cento d'Oro, e in Chalende Giugno 1360 fiorini cento d'Oro, è cosi di Sei Mesi in Sei Mesi, come seguiranno per innansi ogni Sei Mesi fiorini cento d'Oro. e appresso deve havere dal detto

Spedale una Casa per sua habitatione di quelle dello Spedale, quale a lui piacerà fuori di quelle, quali sono concedute a Commessi, ò vero a Commesse del detto Spedale, et ancora fù fuore del Palazzo, che fù delli Scuarcialupi ...

(35 v.) *L'anno auto a di 5 Giugno 1372. ottocento ottanta-cinque fiorini d'oro, de quali denari ne li demmo cento cinquanta per lo tempo che haveva servito, e sette cento trenta cinque fiorini d'oro gli demmo, perche facemmo concordia con lui di detti cento fiorini d'oro, che doveva havere l'anno a sua vita il detto Antonio, è quittò lo Spedale di cio che dovesse havere per lo tempo passato, è per lo tempo avvenire, è della carta, è d'ogni cosa, come appare carta per mano di D Bartolommeo di Francesco Tellini fatta adi detto, come appare al memoriale delle perpetue di Viviano à fo 9. si quittò generalmente d'ogni cosa ——————— f CCCCC*

CCLXXXV. d'oro

(36 r.)
Pagamenti fatti lo Spedale a Sig. Torrigiani Come a fo 33· a fo 35 -

1359	*Adi 14· febb· q° - - -fiorini*	*33 p*	*100·*	*d'oro*
1360	*Adi 12 Nov* in q̃ ----- ——*	*33 p*	*100·*	*d'oro*
1361	*Adi 16 Giug. come in q̃*	*33 p*	*100·*	*d'oro*
	Mori il d. Pietro il 25 Lug° 1362			
1363	*Adi 7 Dice· dat'l. come in q°*	*34 p*	*200*	*d'oro*
1364	*Adi pr°· Luglio come in q°*	*34 p*	*100·*	*d'oro*
	Adi d· equi —— in q̃	*34 p*	*100·*	*d'oro*
1365	*Adi 19· Dice· ce· in q°*	*34 p*	*100·*	*d'oro*
1366	*Adi 3 Luglio ce in q°*	*34 p*	*100*	*d'oro*
	Adi 9 Luglio ce in q°	*34 p*	*50*	*d'oro*
	Adi 17· e 19 Sett —— in q̃	*34 p*	*300*	*d'oro*
1366	*Adi 2· Otto^{br} come in q°*	*35 p*	*625·*	*d'oro*
	Adi 3· Dice· come in q°	*35 p*	*52½*	*d'oro*
1367	*Adi 9 Giug°· c̄· in q°*	*35 p*	*100·*	*d'oro*
1368	*Adi 29. Aprile di contro*	*35 p*	*147½·*	*.d'oro*
1368	*Adi 7· febbraio come di contro*	*35 p*	*100·*	*d'oro*
1370	*Adi 14· Mag° come di contro*	*35 p*	*100*	*d'oro*
1371	*Adi 3· Sett^{re} di contro*	*35 p*	*100*	*d'oro*
1372	*Adi 5 Giug· ogni resto*	*35 p*	*885*	*d'oro*

n° 3360·——

VECCHI, E NON ANTICHI

DIFFERING RESPONSES TO BYZANTINE CULTURE
IN FIFTEENTH-CENTURY TUSCANY

For so long now has it been known that Tuscany, and pre-eminently the city of Florence, was during the fourteenth and fifteenth centuries the home of the new intellectual climate that was to change the course of European thought, that it is easy to forget that its citizens appear to have had considerable admiration for some aspects of the culture that we now call Byzantine. The new outlook that emerged has perhaps been given greatest exposure in the field of the visual arts, but it is also very evident in that of literature. This fact is perhaps the more noteworthy as, although this respect was well founded in first-hand experience of Byzantine art as well as other aspects of Greek culture, it is virtually impossibile to find any trace of this widespread enthusiasm in the development of the new artistic style being developed in Florence.

This paper [1] is the result of an attempt to find a reason for this apparent paradox, and to suggest an answer to the question: Why, at a time of apparent growing interest in, and admiration for, anything that was Greek, did not the art of contemporary Greeks have a greater impact on the new style that was being developed in Tuscany? While no final answer will probably ever be forthcoming, the evidence that can be assembled, particularly when comparison is made with developments in literature, still makes the question well worth asking.

Firstly, it should be noted that the range of vocabulary that was available to those writing on art during this period was of course very limited. The Florentine sculptor Ghiberti, when he wrote the second part of his *Commentaries*, had to formulate the phrase *maniera anticha cioè greca* to describe the style in which the Roman artist Pietro Cavallini had worked, implying that a standard

[1] The main points in this article originated as a paper read at the conference of the Association of Art Historians in Edinburgh in 1983. I would like to thank those present for the helpful comments which were contributed at the time.

term to describe this style did not yet exist.[2] Later, Vasari, in developing this approach, made free use of the term *maniera greca* to describe the style of almost any medieval art, but he also made a careful and interesting distinction between art that was produced before the age of Pope Sylvester (d. 335), which he termed *anticha*, and art that was produced between then and the time of Giotto, which he called *vecchia*.[3] (The term 'Byzantine' was not available to him, and he only used the word 'Bisanzio' as a noun, meaning, in effect, Constantinople).[4] For Vasari, writing in the mid-sixteenth century, it was clear that the artistic style which is always associated with Byzantium was something that was in every way regrettable, if not pernicious, although its presence had still to be explained. His approach was to claim that the medieval art of Italy was produced by Greeks, who were invited to Italy because they were the only practitioners available («... essendo soli in queste professioni...»). There is certainly no admiration intended by his well-known views on the mosaics of, for example, San Miniato in Florence, of which he makes his famous comment on their «occhi spiritati e mani aperte in punta di piedi».[5]

This attitude would not be remarkable were it not for the fact that it represents a change from views that were gaining currency during the fifteenth century, when there was evident and widespread enthusiasm for other aspects of Greek culture, both contemporary as well as ancient. Furthermore, we shall see that not only in Florence, but also in several other cities in central and northern Italy there were during the fourteenth and fifteenth centuries an increasing number of Byzantine books and artefacts to be found; it is the great admiration and respect with which they were treated which provides us with one half of our paradox.

What, then, is the evidence that in this case gave rise to the question? The Florentine enthusiasm for Greek culture took several forms. The best known is probably that for Greek learning and literature, and this needs little emphasis. As early as 1360 a Chair of Greek had been set up in Florence specifically to encourage the study of the language; although it should be mentioned that Boccaccio had had to convince the authorities, who were paying the professor's salary from public funds, that there were real commercial advantages to be gained from Florentines being able to understand Greek,[6] the admiration for Greek

[2] J. VON SCHLOSSER, *Lorenzo Ghibertis Denkwürdigkeiten (I Commentarii)*, Berlin 1912, I, p. 39.

[3] G. VASARI, *Le vite de' più eccellenti pittori scultori ed archittetori*, ed. G. MILANESI, Florence 1875, I, pp. 241-242.

[4] VASARI, ed. cit., p. 240.

[5] VASARI, ed. cit., p. 229.

[6] P. DE NOLHAC, *Pétrarque et l'humanisme*, Paris 1907, II, pp. 157-158. The first holder of this office was Leontius Pilatus, the translator of Homer.

Vecchi, e non antichi

language was an integral part of the humanist tradition in Florence from the early fifteenth century. So much has been written on this subject that it is perhaps worth mentioning that the language must have been accessible to only a small minority of the population; this would have still been the case when Manuel Chrysoloras taught in Florence between 1397 and c. 1405. Although his stay there has rightly been seen as a turning-point in the history of Italian humanism, his learning could only have been of relevance to a small, if distinguished, group.[7] It was, nevertheless, on the foundations laid then that the humanists such as Marsilio Ficino and his followers would build later in the century.

If the study of Greek literature was to remain an elitist activity, there was nevertheless an event which took place in Florence in 1439 which provides ample evidence of popular interest in Greek culture – contemporary, Byzantine culture, and certainly not just classical; this was, of course, the church council that re-opened in the city in February of that year. Both for humanists and for artists it was a unique opportunity for contacts to be made at all levels. It would seem to be hard to overestimate the impact that the presence of the Greek visitors would have had on Florentine life for a greater part of that year. Over five hundred horses were involved in conveying the Greek patriarch, Joseph II and his entourage of clergy and theologians, with all their belongings, into the city on their arrival there from Ferrara on 11th February. On entering the city he led this long procession through the streets to the Palazzo Vecchio, where he was received by the entire Signoria in front of the Palazzo. A long oration of welcome was read in Greek by the Chancellor Leonardo Aretino, and the patriarch was then escorted to the palazzo that had been assigned to him for the duration of the Council at 23 Borgo Pinti, near to the Cathedral.[8] When, a few days later, the Byzantine emperor, John VIII Palaiologos, whose entourage would have been equally impressive and numerous, entered the city on the Sunday of the Carnival (15th February) he also was greeted with another huge reception committee and a welcoming speech in Greek. He was then taken to his quarters in the Palazzo Ridolfi Peruzzi, now no. 3 in what is still known as the Borgo dei Greci, close to Piazza Sta Croce.[9] The total Greek contin-

[7] Petrarch had lamented that Florence was «a city dedicated to making money» (K. SETTON, *The Byzantine background to the Italian Renaissance*, «The Proceedings of the American Philosophical Society», 100, 1956, p. 69). For the increase in importance of Greek literature see M. BAXANDALL, *Giotto and the Orators. Humanist observers of painting in Italy and the discovery of pictorial composition 1350-1450*, Oxford 1971, p. 78 ff.

[8] J. GILL, S.J., *The Council of Florence*, Cambridge 1959, p. 181 ff., and V. LAURENT, Les «Mémoires» du Grand Ecclésiastique de l'Eglise de Constantinople Sylvestre Syropoulos sur le concile de Florence (1438-1439), Paris 1971, p. 387.

[9] L. GINORI LISCI, *I Palazzi di Firenze nella storia e nell'arte*, Florence 1972, II, p. 605, with illustration. The emperor's brother, Demetrios Palaiologos, arrived later, on 4th March, and was housed in the Palazzo Vanni Castellani on the Lungarno Diaz (LAURENT, *op. cit.*, p. 387).

gent amounted to about 700, and it must have been impossible for any of the inhabitants of the city to be unaware of the presence of this number of eminent visitors in their midst; the prices of most basic necessities must have become distorted, and whole sections of the population would have been intimately involved in maintaining the visitors.

We know that the Greeks, perhaps rather surprisingly, brought with them volumes of classical authors, as well as the many later theological studies which they would need for the deliberations of the Council. While the Greek representatives were still in Ferrara, the humanist Ambrogio Traversari wrote to a friend that he had seen a beautiful copy of Plato, a Plutarch and an Aristotle, besides a number of other classical authors among the Greek emperor's possessions.[10] The latter had no doubt surmised correctly that the possession of such works would impart valuable prestige to the Greek delegation in the negotiations which lay ahead. But, more importantly, it is clear from the records of the Council that there was exhaustive discussion of, and reference to, the Greek church fathers and theologians, and there were certainly many volumes of this character in the possession of the Greek patriarch and his bishops.[11]

While the presence of Greek manuscripts in the city is a matter of fact, that of Greek works of art must be more speculative. The meetings of the Council would have been preceded by processions across the city (the Pope, Eugenius IV, was installed in Santa Maria Novella), in which vestments and icons would have almost certainly been very prominent. There can be no doubt that when the Greek patriarch died in June, the funeral procession to Santa Maria Novella must have been a spectacular and memorable event, with icons and liturgical books being carried in prominent and abundant display. It is surely hard to doubt that the Council, besides being a major landmark in the long history of Greek-Italian relations, would also have exposed large numbers of Florentine citizens (with artists in their number) to a first-hand contact with works of Byzantine art. In this way it could be said that the Council of Florence actually increased and popularised the existing interest in Byzantine culture, rather than just satisfying it. An inscription recording the Union was subsequently erected publicly in the Cathedral, and the Decree of Union itself is still on permanent display in the Laurenziana Library.[12]

[10] *Traversariana*, Vatican City 1949, pp. 24-26 (quoted in SETTON, *op. cit.*, p. 70).

[11] Over 15 individual Greek authors (several with numerous works attributed to them) were cited in the *Acta*; see *Concilium Florentinum, Documenta et Scriptores*, Ser. B, II, fasc. II, Rome 1944, pp. 112-113.

[12] See F. BROWN, *Laetentur Caeli: The Council of Florence and the Astronomical Fresco in the Old Sacristy*, «Journal of the Warburg and Courtauld Institutes», 44, 1981, pp. 176-180. Cfr. *Ambrogio Traversari nel VI Centenario della nascita*, Convegno Internazionale di Studi (Camaldoli-Firenze, 15-18 settembre 1986), ed. G. C. GARFAGNINI, Florence 1988.

Vecchi, e non antichi

A little later, in the 1460's, when Vespasiano da Bisticci was asked by Cosimo de' Medici to supervise the production of books for his monastic foundations, he relates how he engaged forty-five copyists who in due course transcribed in the original Greek the writings of Origen, St Ignatius, St Basil, St Gregory Nazianzen, St John Chrysostom, St Athanasius of Alexandria, St John Climacus, and a number of other of the Greek fathers.[13] This can only indicate that the enthusiasm for Greek learning had been extended from beyond the immediate interests of the humanists into the world of Byzantine theology, and in that field had had extended into the seventh century. So that by then in Florence, the city that was the home of the new style in European art, a substantial body of Greek writings was available that ran from Plato and Aristotle through to the Greek theologians of the post-Justinianic age. Furthermore, this assemblage had been made at considerable expense and trouble, and not just acquired by accident or by theft and loot, as had the contents of the treasury of San Marco, Venice.

Yet during these years the great flowering of Florentine art showed virtually no signs of this persistent and expanding enthusiasm. Indeed, it is surely symptomatic that one of the best known productions from these years, which does indeed show some evidence of the interest in the Greek presence in the city, is the colourful series of paintings by Benozzo Gozzoli that still brilliantly decorate the walls of the chapel in the Palazzo Medici, in which it is possible that portraits of the Greek emperor and patriarch can be found. Yet not only is this a relatively superficial manifestation of the admiration for things Greek, but it was essentially a small and private place, never normally visited by the public, and was in any case painted some twenty years after the Council had ended.[14] As far as the *style* of these paintings is concerned, the Council could have taken place on a different continent.

This paradox, whereby an increased interest in, and access to, Byzantine culture was apparently accompanied by a decrease in the impact that it made on artistic style and production, was not confined to Florence. In 1360, the year that saw the foundation of a Chair of Greek in Florence, the citizens of Siena were starting to become accustomed to the sight of a substantial collection of outstanding Byzantine artefacts being carried regularly in procession through their streets. The previous year the syndics of the main hospital in Siena had purchased at great expense a large collection of relics, many of them housed in sumptuous reliquaries, with other Byzantine objects including an icon

[13] VESPASIANO DA BISTICCI, *Le Vite* (Vita di Cosimo de' Medici), ed. A. GRECO, Florence 1977, II, pp. 183-185.

[14] H. STOKES, *Benozzo Gozzoli*, London n.d. (1904), pls. 1-6.

and an illuminated Greek manuscript in a magnificent and spectacular binding on which were displayed over forty Byzantine enamels. The entire collection had been bought shortly before in Venice, having been bought the previous year in Constantinople. It came with a certified and guaranteed provenance from the emperor's palace, the icon even being regarded as having belonged to the first Christian emperor, Constantine the Great. Indeed, much of the early history of this collection is concerned with the efforts made by the authorities to provide adequate housing for it, and to ensure that the objects could readily be seen.[15]

We can also find evidence outside Tuscany for this admiration for works that were representative of Byzantine culture. In the city of Genoa, at much the same time, the famous icon of the *Sacro Volto* with its gilded and enamelled frame had been received by the clergy of S. Bartolommeo degli Armeni as a gift from the Byzantine court, and it too was regularly displayed.[16] In the following century the famous and spectacular manuscript of the *Menologion* of Basil II, with its hundreds of painted scenes, reached the court of the Sforzas in Milan; it was evidently highly prized there, being received «con molta solennità».[17]

In both the Tuscan cities there had, in the Duecento and early Trecento, been a widespread use of Byzantine models by artists, and it is well known that much of late duecento style is inexplicable without this influence. Yet by the time the collection of Byzantine objects had arrived in Siena no significant trace of Byzantine style can be found in the work of contemporary artists.[18] In Florence, a century later, there was the same almost studied indifference, with (besides Gozzoli's frescoes) only such evidence as Pisanello's medal of John VIII Palaiologos remaining as a tangible reminder of the imperial presence there.[19] So it could be said that the picture presented by this approach to the visual aspects of Byzantine culture appears to be one where, whatever opportunities for studying it might have existed, it made no impact on the development of the new artistic style.

In the field of humanist literature, however, this was certainly not the case.

[15] P. HETHERINGTON, *A Purchase of Byzantine Relics and Reliquaries in Fourteenth-century Venice*, «Arte Veneta», 37, 1983, pp. 9-30; and H.W. VAN OS, *Vecchietta and the Sacristy of the Siena Hospital Church; a Study in Renaissance Religious Symbolism*, «Kunsthistorische Studiën van het Nederlands Instituut te Rome», Deel II, The Hague 1974, p. 16 ff.

[16] C. DUFOUR BOZZO, *Il «Sacro Volto» di Genova*, Rome 1974, p. 63 ff.

[17] *Il Menologio di Basilio II (Cod. vaticano greco 1613)*, Turin 1907, I, p. V.

[18] HETHERINGTON, loc. cit., p. 23.

[19] G.F. HILL, *A Corpus of Italian Medals of the Renaissance before Cellini*, 2 vols., Florence 1984, no. 19.

Vecchi, e non antichi

Michael Baxandall has shown how one of the major areas of development in humanists' writing on art was in the exploitation of the *ekphrasis* – the description and commentary, within a strict rhetorical framework, of a work of art.[20] As a form of literary activity, or rhetorical exercise, this had been developed by the Greeks of antiquity, and had had a broadly continuous existence in Byzantium into the fifteenth century. In the case of the humanists of the Renaissance, however, it was very much a conscious – even self-conscious – revival, and it was taken up with evident enthusiasm. The absence of any such emulation in the visual arts makes this enthusiasm even more striking. One example will here have to stand for many other such productions.

When Guarino of Verona wrote an *ekphrasis* in Latin hexameters on a painting of Saint Jerome that had been sent him by Pisanello, he used rhetorical forms of expression like the following: «However plainly the picture declares itself to be a painted thing in spite of the living figures it displays, I scarcely dare open my mouth, and whisper with closed lips, so that my voice may not break rudely in upon one who contemplates God and the heavenly kingdom».[21] Poetry of this kind is manifestly in the same tradition as a number of poems written by the Greek poet of the previous century, Manuel Philes, and using Byzantine icons as a source of his inspiration.[22] One such poem which exemplifies his approach is on an icon of the prophet Moses, who must have been depicted holding the tablets of the Law. In it the poet addresses Moses, saying. «You have become silent, and are again slow of tongue ... thus do the living words give voice when they are written down [on the tablets of the Law]».[23] Among some twenty other surviving poems written by Philes on the subject of different icons there are a number of others which adopt this approach.[24]

[20] BAXANDALL, *op. cit.*, pp. 84-95, with full references.

[21] Based on BAXANDALL, *op. cit.*, p. 92, who gives the text in full on pp. 155-157; the painting concerned has not survived:

Quod cum declaret imago,
Picta quidem sed signa tamen vivacia monstrans,
Hiscere vix ausim clausisque susurro labellis,
Ne contemplantem caelestia regna deumque
Vox interpellet, vocitur quoque rusticus, asper.

[22] See H.-G. BECK, *Geschichte der Byzantinischen Volksliteratur*, Munich 1971, p. 201 ff. The poet lived c. 1275 to c. 1345, and over thirty of his surviving poems, here and in later eds. (see n. 24, below) were specified as being inspired by icons.

[23] *Manuelis Philae Carmina*, ed. E. MILLER, 2 vols., Paris 1855-57, I, p. 55 (no. 122 in the Escorial MS):

Σὺ μὲν σιωπᾷς ὡς βραδύγλωσσος πάλιν,
Σιγᾷ' δὲ σὺν σοὶ καὶ το πρὶν λαλοῦν στόμα
Ὁ σύγγονος γαρ οὐδαμῃ πάρεστί σοι.
Γραφέντες οὖν κράζουσιν οἱ ζῶντες λόγοι.

[24] E.g. nos. 69 (S. John Chrysostom), 126 (S. George), 261 (S. Demetrius) etc. in the MILLER ed., quoted above. A later collection was published by E. MARTINI), *Manuelis Philae Carmina inedita*, «Reale Accademia di Archeologia, Lettere e Belle Arti», 20, 1900. Philes wrote poems not just on icons depicting individual figures, but groups such as the Forty Martyrs, and on icons of the main feasts.

These poems, written respectively by an Italian humanist and a Byzantine poet, both have far more in common with each other than either of them has with the work of art which in each case was their point of inspiration. Both writers attempt to enter into the mind of the subject of the painting before them, imagining the thoughts of the figures depicted, even being prepared to put words into their mouths, and thus creating a new and imaginary poetic world. The tradition of the *ekphrasis* is the common ground that they share; in one language it had a continuous history, while in the other it was a conscious revival. What separates the two traditions exemplified in these poems is surely the interest in what the humanists called *natura*. The approximation of art to *natura* dominated the thinking and interests of the Italians, while for the Greeks it can only have been of extremely limited interest.[25]

It is clear that in central Italy at this time there was a dichotomy between a literary form, which could be revived virtually unchanged, and a visual form which had only survived in a totally altered state. Italian artists would no doubt have done far more than they did to recreate the paintings of the classical Greeks if they could have placed surviving examples of that art before them; but whatever might have been the case with sculpture, the paintings of ancient Greece could only be known to them through the distorting veil of some form of literary description. It is surely quite understandable that they were unable to correlate their reading of the appropriate texts with works such as the Byzantine icons that the contemporary Greeks brought with them to Florence in 1439. One must conclude that developing ideas on the theme of the approximation of art to *natura* must have overwhelmed all other interests, and as the art of modern Greeks did not exhibit this interest it had no appeal for either the Italian humanists or their fellow artists. The expressive – and indeed stylistic – range that modern Byzantinists can now find in Greek icons of the Palaiologue period could simply not have been apparent to contemporary Florentines, for whom variety was so important; [26] the relative homogeneity of their style would surely have been their most evident characteristic.

This dichotomy must have been given a further dimension in the context of spoken, as opposed to written, language. The Florentine humanists would normally only have heard Latin being spoken under quite restricted conditions, such as when they attended church services, but it is interesting to note that when Guarino of Verona went to Constantinople and heard demotic Greek being spoken around him, it was the sense of continuity with the classical past

[25] BAXANDALL, *op. cit.*, p. 74 ff. and p. 84 ff.

[26] See M. BAXANDALL, *Guarino, Pisanello and Chrysoloras*, «Journal of the Warburg and Courtauld Institutes», 28, 1965, pp. 183-204.

Vecchi, e non antichi

that excited him – a continuity that was denied him in the case of secular Latin.[27]

This is, of course, only one small facet of a much larger subject, on which a huge literature has grown up. Nevertheless, the main features of the paradox remain: that the emulation of Greek literary forms in fifteenth-century Florence, as well as the enthusiasm for some manifestations of Byzantine culture, found no real echo in the field of the visual arts. Among the artists there was simply no counterpart to such figures as Manuel Chrysoloras or the translator of Plato, Marsilio Ficino – to name just two of the best known of the humanists. Much as artists are known to have admired the art of ancient Greece, they must consciously have developed styles which excluded any real trace of contemporary Greek artistic influence. (In this respect the well-known prejudice of Vasari, quoted above, can be seen as an adopted inheritance of the fifteenth century). Did the impetus given to the formation and development of the new tradition in painting overwhelm the interests and achievements in other fields of the arts? There is certainly no simple answer, but one fact does certainly emerge: for all the experience of Byzantine culture, and admiration expressed for it, the literature of the Greeks met a completely different reception in central Italy from their art. Once again the pen, it would seem, was not only mightier than the sword: it was here, due to the apparent selectivity of Florentine artists, more durable than the brush as well.

[27] BAXANDALL, *Giotto and the Orators*, cit., p. 84. Guarino was, among the humanists, one of the most familiar with the language of the Byzantines; see ID., *Guarino*, cit., p. 186.

Studying the Byzantine Staurothèque at Esztergom

The town of Esztergom still retains the status that it has had for many centuries as the seat of the Roman Catholic Primate of Hungary, and the modern visitor will find the vast dome of its huge nineteenth-century cathedral – the largest church in Hungary – still looming protectively over the town from the hill on which it stands; a curve in the Danube separates it from Slovakia, and the site has been occupied by the successive strongholds of Hungarian rulers.[1] When archbishop János Kutassy, primate of Hungary from 1599, died here in 1601,[2] his will provided only the second acknowledgement of the existence of a Byzantine reliquary containing wood from the True Cross which was then to be found here; the first mention was in an inventory of the cathedral treasury of 1528 where it is noted as: '*Una tabula quadrangularis ligne ad formam Grecorum ex una parte in superficie cum argento inaurato et veris simulacris texta in medio lignum vite continens*'.[3] This paper concerns the staurothèque of which these provide the earliest surviving documentary records. It will look at how the work has been studied by scholars in the last century and a half, and at how the alterations to which it was subjected during the period that it was in Byzantine hands may be able to tell us something of the change that occurred in the usage and function of such relics during that time.

In spite of the sanctity of the relic, there is no existing record of its origin or that of its container, nor is it known how long, in 1528, it had already been in Esztergom. For the former, we have only a reference in Kutassy's will to a document which implied that it dated from 1190, but as this has disappeared it cannot now be evaluated;[4] for the latter problem there are two contending dates or periods which are most frequently

[1] The name of the town was changed from Gran to Esztergom in the early twentieth century. A full bibliography of the staurothèque up to 1948 can be found in Gyula Ortutay, *Esztergom Müemlékei; Föszékesegyázi Kincstár* (Budapest, 1948), pp. 219–21, no. 232; this was amplified in the most thorough study of the work to date by Arpad Somogyi, *Az Esztergomi Bizanci Staurothéka* (Budapest, 1959), and idem, 'La staurothèque byzantine d'Esztergom', *Balkan Studies* 9 (1968), pp. 139–54; further bibliography is given by Lydie Hadermann Misguich, 'Pour une datation de la staurothèque d'Esztergom à l'époque tardocomnèni', *Zbornik Narodnog Muzeja* 9–10 (1979), pp. 289–99 (10 ills).

[2] C. Eubel and P. Gauchat, *Hierarchia catholica medii aevi et recentioris aevi*, Vol. IV (Munster, 1935), p. 322. The will of cardinal Kutassy is cited in Somogyi, Staurothéka, p. 33.

[3] The 1528 inventory of the treasury was first cited by Émile Molinier, 'Le Reliquaire de la vraie Croix an Trésor de Gran', *Gazette archéologique* 12 (1887), pp. 245–9.

[4] The grounds for the date of 1190 are given in Somogyi, *Staurothéka*, p. 56; but see also Hadermann Misguich, 'Pour une datation', p. 299.

cited. One of these is a suggestion that the reliquary may have been among the long list of treasures that were robbed in the spring of 1205 by Hungarian brigands from three clerics who were envoys of Cardinal Benedict of Santa Susanna; the latter had acquired them in Constantinople as booty from the Fourth Crusade, and was having them conveyed to Rome.[5] We know of the episode from a letter that Pope Innocent III wrote on June 27th of that year to King Andrew of Hungary complaining of the robbery; among the long and interesting list of stolen goods in the papal letter, which enumerates *pallia*, carpets, ampullae, Saracen textiles, silver-covered evangelistaries, twenty-five rings, etc., there is itemised a *crux aurea, in qua erat de ligno Domini*;[6] this, it has been suggested, could be the Esztergom staurothèque. Although our reliquary could scarcely be described as a *crux aurea*, it is conceivable that the emergency which gave rise to the letter could have produced this rather inaccurate description. The other is even more tendentious, and concerns the fact that the king, Bela III, who ruled Hungary from his palace here from 1172 to 1196, had been educated at the Byzantine court and wished to recreate something of its splendour in his own court at this town beside the Danube. It is certainly possible that Byzantine artefacts were already to be found here before the Fourth Crusade brought so many more into the West, but we have no evidence that among them could be found our staurothèque. Any Byzantine artefacts housed at Esztergom would have remained here until its destruction in 1241 during the disastrous invasion by the Mongols; it was this invasion which caused Bela IV (1235–70) to move his capital from Esztergom to Buda, and the days of importance for the town as a secular centre were over.[7] Seven centuries later it is only its ecclesiastical status that is retained. For reasons which are both internal to the reliquary itself, as well as external, and which will be discussed below, I do not feel that any of these suppositions can be supported.

What the modern viewer of the reliquary sees (Fig. 1), is a framed ensemble of silver-gilt and enamel comparable in form to an icon, with horizontal bands dividing the field into three unequal sectors or zones; central to the design is the outline of a patriarchal cross imposed upon the two lower sectors forming what must have been a shaped recess. In the upper sector (the smallest), two angels in half-length (Figs. 2 and 3) lament with outspread wings, and in the central sector Saint Constantine and Saint Helena (Figs. 4 and 5) flank the cross, both gesturing towards it; four *sigillia* (X) are located above and below the arms of the cross. The bottom sector contains two narrative scenes: on the left the uncommon subject denoted by its inscription as the *Elkomenos epi staurou* shows Christ, with hands bound, being led (the word can mean 'dragged') to the crucifixion (Fig. 6), accompanied by a soldier and a veiled male figure,

5 P. de Riant, 'Des dépouilles réligieuses enlevées à Constantinople au XIIIe siécle, et des documents historiques nés de leur transport en occident', *Mémoires de la société nationale des Antiquaires de France*, 4th ser., 6 (1875), pp. 192–5.

6 P. de Riant, *Exuviae sacrae Constantinopolitanae*, 2 vols., (Geneva, 1877–78), II, p. 63, quoted in Molinier, 'Le Reliquaire'.

7 D. Sinor, *History of Hungary* (London, 1959), pp. 66–78; Gy. Moravcsik, 'Hungary and Byzantium in the Middle Ages', *Cambridge Medieval History*, Vol. IV, part I (Cambridge, 1966), pp. 567–92, emphasises the Byzantine associations of medieval Hungary.

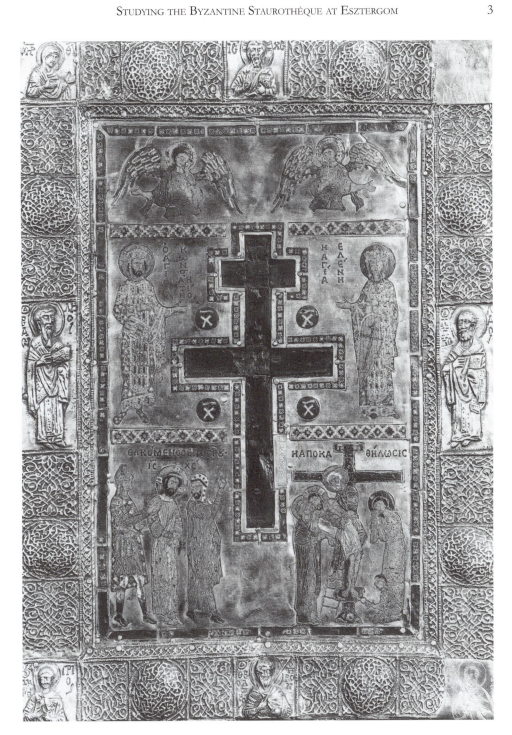

Fig. 1. Staurothèque of silver-gilt and enamel. Esztergom, Cathedral Treasury. (Béla Mudrák.)

Fig. 2. Detail of angel from staurothèque. (Béla Mudrák.)

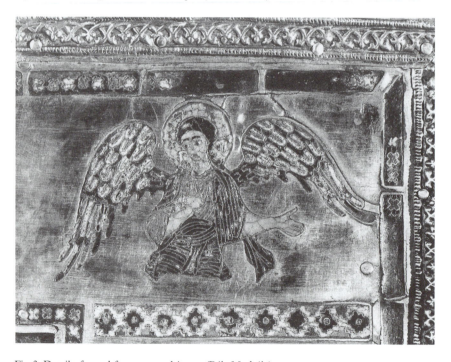

Fig. 3. Detail of angel from staurothèque. (Béla Mudrák.)

Fig. 4. Detail of Constantine from staurothèque. (Béla Mudrák.)

Fig. 5. Detail of Helena from staurothèque. (Béla Mudrák.)

Fig. 6. Detail of the *Elkomenos epi staurou* from staurothèque. (Béla Mudrák.)

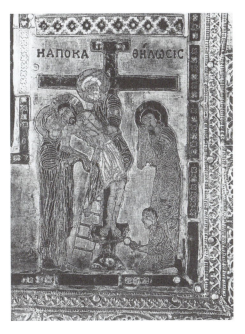

Fig. 7. Detail of the Deposition from the cross from staurothèque. (Béla Mudrák.)

presumably intended to represent a Jew, who points up at the cross. On the right the scene of the Deposition from the cross (Fig. 7) shows Joseph of Arimathea holding the sagging body of Christ, with the lamenting figures of the Virgin and Saint John on either side and Nicodemus pulling the nails from the *suppedaneum*. A decorative silver-gilt frame encloses the ensemble, in which eight panels of a fine interlace design are separated by what were originally six half-length and two full-length images in repoussé; two are modern replacements, but the top of the frame formed a conventional group of Christ (Fig. 8) between the Virgin (Fig. 9) and a (missing but predictable) image of the Forerunner, with (one can presume) three warrior saints along the bottom, of which Saint Demetrius (Fig. 10) and Saint Theodore Tyron (Fig. 11) survive from the original design.[8] Full-length standing figures of the bishops Saint Basil (Fig. 12) and Saint Nicholas (Fig. 13) are located on the sides.

The reliquary underwent a thorough restoration in 1955–58, and this confirmed that in general it had survived in good condition; one section of the enamel surround of the cross recess was replaced, and in the outer frame the two portraits in the right-hand corners were renewed. The bottom frame member was lowered to reveal the earlier surround of the main enamel area.[9] This paper will not be concerned with refining the dating of the work; there has been a consensus that the central panel of the staurothèque is work of the later eleventh/twelfth century, and the frame is a later addition of the later thirteenth/fourteenth century.[10]

Critical History of the Reliquary

Looking at the earlier literature on the work presents some interesting features, which are here interpreted as reflecting the simple facts of the reliquary's known history and the siting of its home for at least the last four centuries. Esztergom is a relatively out-of-the-way location, not easily visited, and the work has only been exhibited outside Hungary in 1985 and 1997.[11] This geographical factor gives the reliquary, which must be regarded as a substantial work, and quite high in the league of Byzantine artefacts of 'museum status', an interesting position as a locus within the history of the study of Byzantine enamel.

8 It can be assumed that the saint missing from the corner here was Saint Theodore Strateletes, the usual companion of Saint Theodore Tiron.

9 Technical details are given in Somogyi, *Staurothéka*, pp. 43–9; in photographs taken in 1955 the bottom of the inner enamel framing is concealed. It has not been noted by any commentators that the central plaque is among the largest single entities of Byzantine enamel to survive, with the exception of the largest plaques on the Pala d'Oro, Venice.

10 Alternative dates, involving dubious concepts of 'decadence' and comparison with a work that is now disputed, are summarised in Somogyi, *Staurothéka*, and further attempts to date the work are summarised in Klaus Wessel, *Byzantine Enamels from the 5th to the 13th century* (Shannon, 1969), pp. 158–63. See also, Hadermann Misguich, 'Pour une datation', p. 290, and note 25, below.

11 A. Legner, *Ornamenta Ecelesiae: Kunst und Künstler der Romanik*, 3 vols. (Cologne, 1985), no. H33; Helen C. Evans and William D. Wixom (eds.), *The Glory of Byzantium: Art and Culture of the Middle Byzantine Era A.D. 843–1261* (Exhibition catalogue: The Metropolitan Museum of Art, New York, 1997), no. 40.

Fig. 8. Detail of Christ from staurothèque.(Béla Mudrák.)

Fig. 9. Detail of Virgin from staurothèque. (Béla Mudrák.)

Fig. 10. Detail of St Demetrius from staurothèque. (Béla Mudrák.)

Fig. 11. Detail of St Theodore Tiron from staurothèque. (Béla Mudrák.)

Fig. 12. Detail of St Basil from staurothèque. (Béla Mudrák.)

Fig. 13. Detail of St Nicholas from staurothèque. (Béla Mudrák.)

Reviewing the comments of the various scholars who have written about it, one becomes aware of the fact that a surprisingly high proportion of them could not have been writing with first-hand experience of this quite remotely sited work of art. Their reliance, while formulating their views on it, on reproductions and on the comments of previous writers emerges as commonplace, and this limited first-hand access must account in some measure both for the confused and misleading opinions on it that have been published, and for the relatively poor 'press' that the reliquary has accumulated over the last one and a half centuries. So while one hesitates to disparage the writings of the father-figure of all Byzantine enamel studies, Nikodim Kondakov, how otherwise are his views, published in 1892 in his monumental and influential book, on this outstanding work at Esztergom to be explained? He wrote that: 'En général le dessein est mauvais; il est lourd, schématique; les enroulements dans le contour des vêtements, principalement sur les genoux, sont particulièrement déplaisants par l'absence de goût...'. While this may be taken as personal opinion, he then makes a revealing factual error when he describes the six plaques in the frame as being of 'émail champlevé...la surface...est gravée au poinçon et puis remplie d'émail bleu foncé'.[12] Yet the greater part of the recesses in the *eight* non-figural decorative plaques in the frame are still filled with enamel that is indisputably a light green, and the technique used to produce the relief might be mistaken for quite a refined repoussé, although closer examination reveals that it is in fact produced from the impression of sheet silver into two different matrices (see Fig. 9). Conventional champlevé, with metal removed by an engraving tool (*poinçon*), it certainly is not. If Kondakov was referring to the six remaining *figural* plaques (of eight), they are all in repoussé technique and could never have contained any enamel at all. Could it be that he had before him the engraving by Schönbrunner published by Bock in 1859 (Fig. 14)?[13] If so, he may also have been using, but not fully understanding, the description of Jules Labarte in his *Histoire des Arts Industriels* (2nd ed., 1872).[14] In this the French scholar referred to the *inner* frame ('le contour') of the reliquary as being of blue enamel and the *outer* frame ('le bordure d'encadrement') as just being also of gold. Even Bock seems to have been relying on the engraving by Schönbrunner that he published, rather than on first-hand observation, and it is evident that the engraver, for his part, was clearly not familiar with the Greek alphabet.[15]

Again, O.M. Dalton in 1911, although deprecating the great Russian scholar's censorious comments, repeated and then emphasised his factual *faux pas* of describing the frame as being of champlevé enamel, '...and thus afford[s] one of the rare examples of champlevé work executed by Byzantine artists.[16] A more appreciative note is struck

[12] N. Kondakov, *Histoire et Monuments des Emaux byzantins* (Frankfurt-am-Main, 1892), pp. 203–4.

[13] Franz Bock, *Der Schatz der Metropolitankirche zu Gran in Ungarn* (Vienna, 1859), pl. 2.

[14] Jules Labarte, *Histoire des Arts Industriels au Moyen Age et à l'Epoque de la Renaissance*, (2nd ed., Paris, 1872), vol. 1, pp. 329–30.

[15] It can be seen that the engraver has also transformed Adam's skull (at the foot of the cross) into a snake and the pincers held by Nicodemus have become a bell.

[16] O.M. Dalton, *Byzantine Art and Archaeology* (Oxford, 1911), p. 525.

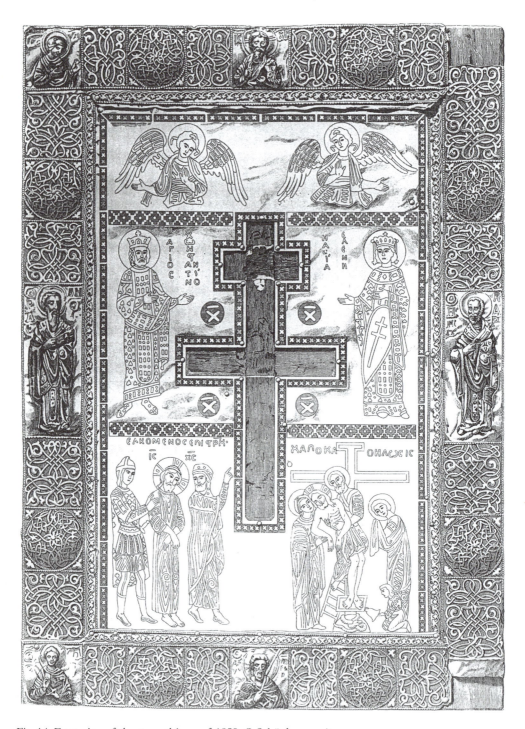

Fig. 14. Engraving of the staurothèque of 1859. (J. Schönbrunner.)

by Émile Molinier in his short article published in 1887,[17] where he wrote: 'Les émaux sont finement exécutés, ...les ornements de la bordure fort délicats'. Neither the reliquary itself, nor the heliogravure of it that Molinier published, could have been available to Jules Labarte, as he wrote in 1872 that the name of one of the standing saints was Saint Nicholas, but in the case of the other 'le nom est illisible'.[18] Yet the name of Saint Basil (Fig. 12) is extremely clear in both the heliogravure and in the work itself; he too must have been following Bock (who also appears not to have seen the object) who said that the title of Saint Basil 'uns jedoch nicht gelungen ist',[19] although as we have seen the only place where it cannot be read is Schönbrunner's engraving. The pejorative tone adopted by Kondakov was followed by Bàràny-Oberschall (although the work must have been familiar to her) in her discussion of the 'crown of Constantine Monomachos' of 1937, where it is grouped with the greater part of the Pala d'Oro as 'an example of decadence'.[20] This view even persisted as late as 1961, when John Beckwith saw in the enamels of the main field a 'debased naturalism combined with drapery treated as a meaningless network of lines [which] proposes advanced provinciality of style'.[21] So it would appear that studying the engraving published in 1859, or later monochrome photographs, had become for over a century a substitute for first-hand examination of the staurothèque at Esztergom.

To discuss Byzantine enamel without reference to its colours might be compared to omitting the mosaics of San Vitale from a discussion of what Byzantine art can be seen in Ravenna. Yet of these scholars it was only Bàràny-Oberschall who even mentions what is surely the most striking feature of the Esztergom reliquary, evident at first sight and growing with further viewing, which is the vivid and delicate colouring of its enamels: the luminous pinkish-violet[22] of Christ's robe in the *Elkomenos* (certainly highly unusual and unknown to the present writer in any other work of Byzantine enamel) and the strikingly subdued emerald green[23] in the figure of Saint Helena contrast with, for example, the brilliant blue, white, green and red in the figure of the soldier. It is hard to believe that comments on the work that did not mention the unusual and striking colours of its enamels could have been based on first-hand observation, but relied on monochrome reproductions. The earliest colour reproduction of the work that I have found is a poor one published in 1972,[24] but even here the caption and text give no hint of personal study. Esztergom, occupying its hill beside the Danube sixty-eight kilometres north of Budapest, is not on the way to any other major centre,

[17] Molinier, 'Le Reliquaire', pp. 245–9, pl. 32.

[18] Labarte, *Histoire des Arts*, vol. 1, p. 329.

[19] Bock, *Der Schatz*, p. 40.

[20] M. Bàràny-Oberschall, *The Crown of the Emperor Constantine Monomachos* (Budapest, 1937), p. 59.

[21] John Beckwith, *The Art of Constantinople* (London, 1961), p. 111 and Fig. 139; the 'network of lines' must refer to the edges of the gold cloisons.

[22] Munsell Color System 2.5 P 7/4.

[23] Munsell Color System 7.5 GY 5/4.

[24] A. Rhodes, *Art Treasures of Eastern Europe* (New York, 1972), p. 177; the most sensitive comments published on the colours of the enamels are those of Hadermann Misguich, 'Pour une datation', pp. 296–7.

and the Byzantinist has no other reason to visit the town. 'Studying the Esztergom
staurothèque' was an activity, it seems, that a number of scholars thought could
be carried out at second hand, with predictably chancy results. This aspect of the
reliquary's past, combined as it is with a complete absence of internal dating criteria
such as might have been supplied by an inscription, has no doubt contributed to the
varying estimates of its date.[25]

The Cathedral Treasury

Readers of the essays in this volume will be accustomed to seeking out isolated works
of medieval art in unlikely contexts, but it still comes as a slight surprise to find the
Byzantine staurothèque in the company that it keeps in the cathedral treasury.[26] Here,
where it would have spent at least four centuries, now contains what must be one of
the most sumptuous collections of any central European ecclesiastical centre, with
a massive quantity of gold and gilded objects for religious ceremonial of all kinds,
many of great richness and sophistication. Only Vienna and Prague in the Austro-
Hungarian empire could have matched the splendour and richness of this treasury.
Yet its contents are overwhelmingly of the kind that can only be found within the
Roman Catholic church; the Byzantine staurothèque is alone in deriving from a clearly
Orthodox origin. (This would also militate against the argument that the staurothèque
was once among many such objects to be found here before the Mongol invasion.)

The Original Form of the Reliquary

It was recognised from quite an early point that the broad outer frame of our reliquary
was of later workmanship,[27] but there has been no discussion as to what form the
whole work might originally have taken; the assumption has normally been made that
the relic of the cross was always displayed as if it had formed the centrepiece of an
icon, the *tabula quadrangularis* of the 1528 inventory, or 'en forme de tableau' as Labarte
puts it.[28] Frolow in his comprehensive study[29] assembles a number of staurothèques

[25] See, for example, the summary of E. Varjú, 'Die Staurothek in Gran (ung.)', *Magyar Müvészet*
7 (1931), pp. 433–9, in *Byzaninische Zeitschrift* 32 (1932), pp. 231–2, where the main reliquary is dated to
the eleventh century and the frame as late as the sixteenth century. Further possibilities were offered
by Somogyi, *Staurothéka*, who published (Fig. 15) a small piece of textile found on the reverse of the
reliquary which was said to be fourteenth to fifteenth century Egyptian fabric; this has not been taken up
in the recent literature.

[26] See Bock, *Der Schatz*, and, for a more recent discussion of some of the earlier pieces in the treasury,
giving a context to the staurothèque, see Arpad Somogyi, *Esztergomi Káptalani Kincstár* (Budapest, 1966).

[27] Although apparently not noticed by Bock, *Der Schatz*, in his study of 1859, most subsequent
writers have accepted this.

[28] Labarte, *Histoire des Arts*, p. 329.

[29] A. Frolow, *La Relique de la vraie Croix: Recherches sur le Développement d'un Culte* (Archives de l'Orient
chrétien, 7), (Paris, 1961); and idem, *Les Reliquaires de la vraie Croix* (Archives de l'Orient chrétien, 8) (Paris,
1965).

originating in the Byzantine world that correspond to this type, with the cross-shaped relic embedded in a recess, of which the tenth-century example at Limburg (Frolow, no. 135) is the most famous. But the majority of those constructed with the relic recessed in this way into a flat surface, usually supported by figural decoration, were felt to be so precious that they needed the protection of some form of covering or lid. The relic of the True Cross, with relics of the Passion, also had special status as being in the gift of the emperor,[30] and this status is emphasised by (for example) the inscription on a staurothèque in the Great Lavra, Mount Athos (Frolow, no. 233), referring to the τίμιον ξύλον βασιλικόν.

The protective covering either took the form of a sliding lid, usually with its own elaborate decoration, or could be of two leaves folding across the central panel and forming a triptych, as in those in the Great Lavra, Mount Athos, and in the Pierpont Morgan Library, New York (Frolow, nos. 233 and 347). This covering gave necessary protection when (as is well known and commonly cited) relics of the cross were carried on military campaigns.[31]

The first of these two forms of covering was, however, by far the most common in the Byzantine world, persisting from at least the tenth century from the famous reliquary at Limburg (Frolow, no. 135), through others in Frolow's compilation of 'pièces justificatives'[32] including examples in Brescia (no. 413), St Petersburg (nos. 408 and 430), Svaneti (no. 662), Venice (no. 663), Rome (no. 667), Moscow (no. 729), to the fifteenth-century reliquary that belonged to Cardinal Bessarion (no. 872). Reliquaries of this type can in the course of time lose their sliding lid, as in that in the Kremlin Armoury, Moscow (Frolow, no. 729), or the framing can become damaged – or both; the fact that the frame only covers three sides of the central panel, and has to be shaped to receive the edges of the lid as it slides in, means that its construction could well have been intrinsically weak. The suggestion can certainly be made that the reliquary at Esztergom was originally furnished with a sliding lid, and that this was subsequently lost or discarded and the channels into which it would have been fitted altered to give it its present form of a broad decorative frame.

This must remain in the realm of hypothesis, but is supported in several ways. First, in assessing the large majority of surviving staurothèques of this type which either retain, or clearly were made to accept, a sliding lid, it seems to have been normal to use the frame or the cover to display a specially composed inscription. In response to the importance of the relic this inscription seems often to have been both extensive and elaborate; examples can be found both on staurothèques that have survived, as on those at Limburg and in the Kremlin Armoury, Moscow (just mentioned) as well as where

[30] N.P. Ševčenko, 'The Limburg Staurothek and its Relics', Θυμίαμα στη μνήμη της Λασχαρίνας Μπούρας (Athens, 1994), Vol. 1, p. 292 and note 25.

[31] Frolow, *La Relique*, p. 279, no. 233; idem, *Les Reliquaires*, pp. 96–7, suggested that the Esztergom reliquary had a sliding lid, while Jean Ebersolt, *Sanctuaires de Byzance* (Paris, 1921), p. 124, proposed that it originally had the form of a triptych.

[32] Ševčenko, 'The Limburg Staurothek', pp. 292–3, with references.

they have not, but where the inscription has been recorded.[33] The absence of any such message on our example, if it had not been lost, would certainly be highly unusual. It must always have been an important feature of the reliquary of the cross that it should be able to give physical protection to the most precious of relics which it contained; in the same way, the apotropaic qualities that the relic provided for its owner were usually invoked by the individual who had originated the construction of the reliquary. Few other Byzantine staurothèques in Frolow's great work of assemblage, and none of comparable size, present the relic in such an unprotected form, and without any invocatory inscription.

A further point concerning the frame could be mentioned here. If photographs of the staurothèque made after the restoration of 1955–58 are compared with, for example, the engraving of Schönbrunner of 1859 or the heliogravure published by Molinier in 1887,[34] the inner framing of narrow enamel strips along the bottom edge is seen to be covered by the bottom member of the later frame. This was removed and relocated, being lowered to reveal the original enamel strip framing of the main field. This detail further emphasises the two phases in the work's history.

The Figural Enamels of the Central Field

If any imagery is included in the decoration of Byzantine staurothèques it seems always to have involved (as here) the figures of Saint Constantine and Saint Helena, usually with two lamenting angels. The presence of these figures requires no complex explanation: Constantine was always associated with the cross after the legend of his vision and subsequent dream before the Battle of the Milvian Bridge, with the text of *In hoc vinces*;[35] and his mother, the empress Helena, initiated the discovery of the True Cross in Jerusalem, and so here her image accompanies a fragment of the cross that she had brought to light.[36]

Unique to the Esztergom reliquary, however, is the combination of the two narrative scenes of the *Elkomenos* and the Deposition; no other surviving staurothèque displays both these images, although Frolow records (nos. 464 and 473) two lost examples of the Deposition in this context, and this suggests a personal association.

[33] Frolow, *La Relique*, nos. 212, 241 and 338, where all three bore inscriptions to the imperial family; inventories provide sources for a number of other such dedicatory texts on lost reliquaries.

[34] See above, notes 3 and 13, and Somogyi, Staurothéka, Fig. 1; Wessel, *Byzantine Enamels*, Fig. 49, used a photograph taken pre-1958.

[35] See the study of A. and J. Stylianou, '*By This Conquer*' (Nicosia, 1971).

[36] The shield-like form with a cross, which is represented as part of Helena's apparel, here has been interpreted by J. Ebersolt as part of her *thorakion* that has been turned back; see idem, *Mélanges d'histoire et d'archéologie byzantine* (Paris, 1917), p. 65, and idem, *Les Arts somptuaires de Byzance* (Paris, 1923), p. 94; it is evident also in e.g. the enamel of the empress Irene on the Pala d'Oro. See also, N. Teteriatnikov, 'The True Cross Flanked by Constantine and Helena', *Deltion tis Christianikis Archaiologikis Etaireias*, 4th per., 18 (1995), pp. 169–88.

While variations on the theme of the *Elkomenos epi staurou* can be found in a variety of areas in monumental art,[37] examples on portable objects seem to have been so much rarer before the late twelfth century that individual examples of its use have been recorded. One such known work is a large and much treasured icon that was to be found in the major church at Monemvasia, the fortress town in Laconia, which actually bore this dedication. The historian Niketas Choniates recorded that the emperor Isaac Angelos (1185–95) was so anxious to extract this icon in order to install it in a church dedicated to Saint Michael that he was restoring at Anaplus on the Bosporos that he resorted to a trick in order to gain possession of it.[38] Quite why he was so determined to acquire this icon the historian does not say; the emperor's seizure of all the icons of St Michael that he could find in Constantinople is more easily explicable. But his desperation could have been due to the scarcity of impressive versions of this subject, and the icon in Monemvasia may have had a particularly high status. In this context it could be of interest that, according to George Akropolites, it was the same emperor who, when defeated by the Bulgar Asen I in 1190 in the Šipka defile, lost a reliquary of the True Cross in which many minor relics were incorporated.[39]

The presence of the scene of the Deposition of Christ from the cross needs no explanation on the staurothèque, supporting as it does the existence of the relic that it contains, and following logically from the *Elkomenos*. The episode is not described in canonical gospel accounts, nor was it adopted as one of the Dodecaorton, but it begins to appear from the ninth century, and was well established by the period of the staurothèque; the element of emotion that is present in our enamel, with the weeping figure of John and the Virgin pressing her cheek to that of the dead Christ as he is lowered by Joseph of Arimathea, can already be found in tenth-century frescoes,[40] while the presence of Nicodemus removing the nails from the cross can be traced to a ninth-century textual source of a sermon of George of Nicomedia, and can also be found in tenth-century pictorial representations.[41] There is indeed no element of the Esztergom enamel that is not consistent with the known development of this scene by the twelfth century, and its appearance here does not raise any particular problems.

[37] A. Kataselaki, ʿΟ Χρίστος ʾΕλκόμενος ἐπί σταυροῦ. Εἰκονογραφία καὶ τυπολογία τῆς παραστάσης στη βυζαντινή τέχνη (4ος–15ος αἰ)ʾ, *Deltion Christianike Arkhaiologike Etaireias*, 4th per., 19 (1996–7), pp. 167–200.

[38] See Niketas Choniates, *Historia*, PG 139, col. 842, translation by H. Magoulias, *O City of Byzantium* (Detroit, 1984), p. 243; also H.A. Kalligas, *Byzantine Monemvasia. The Sources* (Monemvasia, 1990), pp. 69–70. It was almost certainly this icon, when installed at Anaplus, that was to become the inspiration for an epigram by John Apokaukos: see A. Papadopoulos-Kerameus, ʾΕπιγράμματα ʾΙωάννου ʾΑποκάυκουʾ, *Athiná* 15 (1903), pp. 475–6. The small enamel plaque of this subject now on a book-cover in Siena may also derive from a cross reliquary: see P. Hetherington, 'Byzantine Enamels on a Venetian Book-cover', *Cahiers archéologiques* 27 (1978), pp. 117–45.

[39] Frolow, *La Relique*, pp. 349–50, no. 381, with references.

[40] See A.W. Epstein, *Tokali Kilise: Tenth-Century Metropolitan Art in Byzantine Cappadocia* (Washington D.C., 1986), pp. 64–5, Fig. 38; also G. Millet, *Recherches sur l'Iconographie de l'Evangile aux XIVe, Xve et XVIe siècles* (Paris, 1916), pp. 467ff.

[41] George of Nicomedia, *Oratio VIII*, in Migne, PG 100, cols. 1485C–1489; Nicodemus also figures in the Cappadocian fresco referred to in the previous note.

The Frame of the Reliquary

Before enquiring further into the origins and purpose of the staurothèque, we should discuss the frame that now surrounds it. As mentioned above, this has long been recognised as a later addition to the ensemble, and we have here proposed that it replaced the slots into which a separate cover could be slid. It was also mentioned above that the ornamental panels must have been formed by thin silver sheet being stamped out from two different matrices, one somewhat larger than the other, and that light green enamel still fills most of the recesses in the flat parts of these silver-gilt panels.

A point could first be made that concerns the disparity in the refinement of the ornamental panels when compared with the small figural reliefs in repoussé technique; the latter are of relative crudity, with the chasing tools limited to only about three, all of which are straight. When the craftsman (who, incidentally, was almost certainly left-handed)[42] needed to produce a curved line, as in the haloes of Saint Nicholas or of the Virgin, or in the MHP symbol (Figs. 13 and 9), he had to make use of straight-edged chasing tools of which the repeated use has left a jagged outer edge to the curved line; the crudity of the IC XC symbols of the Christ relief (Fig. 8) is also notable. By contrast, the delicacy and assurance of the patterned panels strongly suggests that the matrix used for each was the product of much superior artistry.

An immediate point of comparison can be made with the revetments of icons that have been assembled and studied by André Grabar.[43] It is clear that by the thirteenth century quite a strong tradition had developed for icons to receive a decorative framing in precious metal, which sometimes included a partial covering of the front of the icon itself; this is not the place to discuss the full implications of this development, but it is clear that the frame of the Esztergom staurothèque can be seen to fit easily into this practice. The frames of two icons at Vatopedi, Mount Athos, and two more in Moscow, in the Kremlin Armoury and in the Tretyakov Gallery,[44] all display just the same range of design characteristics, with figural panels in repoussé individually chased, separated by stamped panels of uniformly decorative treatment. All are dateable to the later thirteenth or early fourteenth century.

The last of these (Fig. 15), where the patron/donors are portrayed in the frame, offers a very comparable example to the frame of our staurothèque. Two sizes of decorative panel here separate twelve figural reliefs, in a completely similar approach to the creation of a richly impressive frame.

We should now return briefly to a further aspect of 'studying the staurothèque'. It follows that if any part of the reliquary is both of Byzantine workmanship and is not earlier than the late thirteenth century, the work cannot have arrived in Esztergom until

[42] A right-handed silversmith would hold the chasing tool in his left hand and tap it with the hammer held in his right.

[43] A. Grabar, *Les Revêtements en or et en argent des icones byzantines du Moyen Age* (Venice, 1975).

[44] Grabar, *Les Revêtements*, nos. 18, 19 and 21, pls. 43–5 and 47–52; the first of these is dated here to the late thirteenth century and the other two to the early fourteenth; this seems the most probable period for the frame at Esztergom.

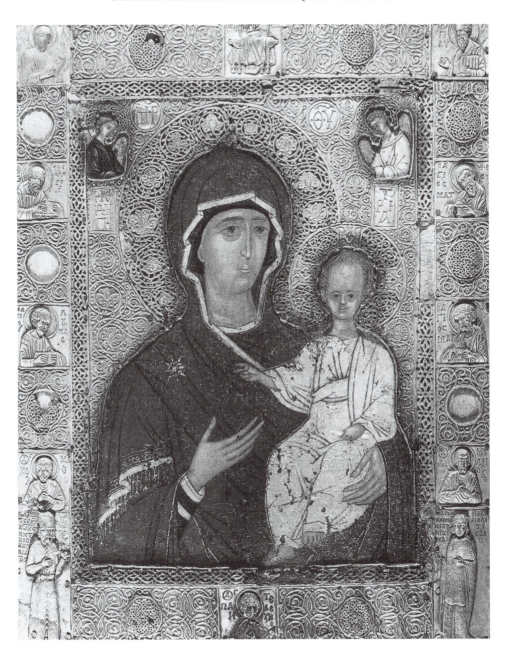

Fig. 15. Silver icon revetment, Moscow, Tretyakov Gallery. (Tretyakov Gallery.)

after that period. This can to some extent be confirmed by historical conditions which were external to the object, but which should have been taken into consideration when any proposal was made that it was already in Esztergom before 1241. King Béla IV had to flee for his life before the Mongol advance, and he took with him any gold or silver that he could carry; he was relieved of this by Frederick, Duke of Austria, who gave him sanctuary and then demanded an impossibly high price for his services.[45] Had the reliquary been already in his possession he would have left it behind at this point, and if it had remained in Hungary it would in all probability have been destroyed. In the absence of any other evidence, we must assume that the reliquary must have arrived in Esztergom at some point between c. 1300, when the frame would have been added, and 1528 when it first appears in the cathedral inventory.

The Changing Function of the Staurothèque

The accepted fact that the frame is a considerably later addition to the ensemble, and our suggestion that it replaced the fitment for a sliding cover or lid, contains the implication that the intended use of the reliquary may have changed during the intervening period. Instead of being an object that needed to be portable, but also well protected, to fulfil the function for which it had been created, its form may have become much closer to that of a conventional icon; by the later thirteenth century its appearance had become more 'in Form einer Tafel' as Bock expressed it.[46] While some small twelfth-century staurothèques were apparently created to exist permanently without protection, such as that in Urbino (Frolow, no. 411), as discussed above, it seems to have been normal for larger reliquaries to have been designed with some protective covering. For whatever reason, the character of use of major relics such as that contained in our staurothèque may well have changed from being a form of portable and powerful apotropaic to something apparently far more static that did not need the protection of a cover. This tendency does not seem to have received much comment, but it could probably be extended to explain the appearance of other survivals of this kind. So meanwhile, 'studying the staurothèque at Esztergom' suggests a new line of enquiry as to why the function of a reliquary of the True Cross should have become more comparable with that of an icon, and so perhaps retained for personal devotion rather than carried prominently and with some exposure to danger in front of troops entering battle.

[45] Sinor, *History of Hungary*, pp. 66–78.
[46] Bock, *Der Schatz*, p. 36.

Byzantine Enamels for a Russian Prince:
The Book-Cover of the Gospels of Mstislav

While there are many medieval manuscripts which provide posterity with the name of the scribe who wrote them, for the scribe also to pass on his account of how he achieved his manuscript's elaborate and precious binding, mounted with enamels and gems, must be virtually unique. Yet this information is given (albeit in rather obscure and ungrammatical terms) in a colophon to the text of the much treasured 12th century Slavonic manuscript of the Gospels now housed in the Historical Museum of Moscow, and usually known as the ›Gospels of Mstislav‹[1].

The colophon which is the source of this information has been discussed by several scholars, first over a century ago, with interest being divided between aspects of its language, its implications for Slav history, and its relevance for the study of the manuscript's binding[2]. The affirmation by the scribe, Naslav, contains information of considerable pontential interest to historians of Russian and Byzantine art patronage in general, and of the production and use of Byzantine enamel in particular, which may not have been fully assimilated[3].

This article, through an examination of the enamels that decorate the upper cover of its binding (the first detailed discussion since 1910), and further evaluation of the colophon, will offer an assessment of their relationship to the original scheme as intimated by the scribe.

Mstislav, prince of Kiev, succeeded his father, Vladimir Monomakh of Kiev, in 1125, and died in 1132[4]. During his reign, which was distinguished by military successes against the Polovtsy tribes and by the building of many stone buildings in Novgorod and Kiev, he initiated the writing of the manuscript of the gospels that still bears his name. The scribe, Naslav, according to the colophon that he wrote, had taken the manuscript to Constantinople where he had acquired enamels for its binding, and, on returning to Rus', had mounted them himself on the cover:[5]

»I, the unworthy servant of God, have written out for the sake of posterity for our tzar and the people and [carried to] completion the Gospels which Prince Mstislav had ordered, ... and took it [i.e. the manuscript] to Constantinople and ar-

I would like to thank the Director and staff of the Moscow Historical Museum for their kind assistance while I was studying the book-cover of the Gospels of Mstislav; and I am pleased to acknowledge the financial assistance towards this research provided by Wimbledon School of Art.

[1] Inv. No. 1203 (Manuscripts Department) since 1917; formerly in the Moscow Kremlin, initially in the Cathedral of the Archangel Michael and later in the Patriarchal Vestry.

[2] The first transcription was published by G. Filimonov: *Oklad Mstislavova Evangeliya*, Moscow (Arkeologicheskiya izsledovaniya po pamyatikam') 1861, 11; more recently presented (with other literature) by Vladimir Vodoff: Remarques sur la valeur du terme ›tsar‹ appliqué aux princes russes avant le milieu du XVe siècle, *Oxford Slavonic Papers*, XI, 1978, 1–42, repr. in ›*Princes et principautés russes (Xe – XVIIe siècles)‹* London 1989.

[3] For the enamels, see Filimonov, *Oklad* (note 2), particularly 50–54; N. Kondakov: *Histoire et Monuments des Emaux Byzantins*, Frankfurt a. M. 1892, 185–187, who

largely supports the former, even in the supposition that some of the enamels were originally attached to vestments; P. K. Simoni: *Mstislavovo evangeliye*, Moscow 1910, 15–24; M. M. Postinkova-Loseva, *et al.*: *Katalog Russkikh Emalei*, Moscow 1962, nos. 9–19, pp. 53–54; also B. A. Rybakov: Die Angewandte Kunst der Kiever Rus im 9. bis 11. Jahrhundert und der Südrussischen Fürstentümer im 12. bis 13. Jahrhundert, *Geschichte der Russischen Kunst*, I, Dresden 1957, 155–161; and A. Bank: *Byzantine Art in the Collections of the Soviet Museums*, Leningrad 1977, 305–306.

[4] Mstislav was the eldest son of Vladimir Monomakh and Gyda, the daughter of king Harold II, the last of the Saxon kings of England; see F. Dvornik: *The Slavs. Their Early History and Civilisation*, Boston 1956, 214–217; also P. Hollingsworth: *The Hagiography of Kievan Rus‹*, Harvard 1992, xxvi–xxxi.

[5] The transcription given here is taken from Vodoff, *Remarques* (note 2), 10:

Азь рабъ Б(о)жии недостоиныи ... съпьсахъ памяти дьля ц(а)рю нашему и июлемь о съконьчаньи ев(а)s(гели)а, иже бяшеть казаль Мьстиславъ

ranged to have made this [?these] enamel[s] [for it], and by the grace of God I returned from Constantinople and then made good all the gold and silver and precious stone[s], and coming to Kiev I finished the whole work on the 2nd August... and I the wretched Naslav undertook [this] with much pain and grief. But God comforted me by the prayer of the good prince and so may God grant to [provide] benefit for all people hearing him, obeying his kingdom [?reign] and in joy and love please God by his prayer, may all Christians and I the unworthy Naslav... find honour and grace from God and from his tzar and from the brotherhood...«[6].

This text raises a number of questions which it is still not possible to answer. It is not clear, for example, why the scribe, Naslav, had to go to Constantinople for the enamels, in that a local native tradition for this skill was by then in existence in Rus'[7]. Nor will we probably ever know why he took the whole manuscript with him on his journey, when it might have been possible to obtain enamels for the cover without exposing the manuscript to such a risk. The uncertainty that has arisen through his reference to the enamel that he »had made« for it is still debated, but before the discussion can be taken further we should first examine the book-cover in its present form.

What the modern viewer now sees on the upper cover (Fig. 1) is an intricate design of fine silver filigree which has been created round thirteen enamel plaques and 22 mounted gems (the lower cover is undecorated); strings of drilled seed pearls are mounted as frames for each of the enamels and

form a border for the whole cover. It is immediately clear that this cannot be the original 12th century binding, and it has indeed long been known that there is an inscription in the manuscript stating that in 1551 it was subjected to a renovation. The elaborately shaped central *mandorla* with enamel images of the four evangelists, the archangels Michael and Gabriel, cherubim and seraphim is clearly a mid-16th century Russian creation, and it must have been created at this point[8]. It should also be noted this central image must have been designed to include the enamel of the youthful cross-nimbed figure on its pointed plaque that is still in place today. Further, it is also clear that the intricate filigree pattern now covering the whole of the cover was created around all the enamels and mounted gems that are now present, and so it follows that this too must have been produced either at the same time as the central 16th century plaque or (just possibly) later. Indeed, to speak of even major renovation is too restrictive a term: the cover has clearly been re-made, and what we now see is effectively a mid-16th century creation. Whether it incorporates some or all of the enamels from the original cover is something this article will seek to establish, but for the present it should be noted that the *mandorla*-shaped enamel of 1551 was clearly designed to enshrine the earlier plaque attached to it; the inference must be that there was an intention here to preserve at least one earlier element from the original decoration of the cover.

Before returning to this aspect of the work we should make an initial brief assessment of the thirteen enamel plaques that are now on the cover;

КЬНАЗЬ ... И ВОЗИВЬ Ц(а)РЮГОРОДУ И УЧИНИХЬ ХИМИПЕТЬ, Б(о)ЖЕЮ ЖЕ ВОЛЕЮ ВЬЗВРАТИХЬСА ИСЬ Ц(а)РЯГОРОДА И СЬПРАВИХЬ ВЬСЕ ЗЛАТО И СРЕБРО И ДРАГЫИ КАМЕНЬ, ПРИШЕДЬ КЫЕВУ И СЬКОНЬЧАСА ВЬСЕ ДѢЛО М(Ь)С(А)ЦА АВГУСТА ВЬ 2 ... АЗЬ ЖЕ ХУДЫИ НАСЛАВЬ МНОГО ТРУДА ПОДЬЯХЬ И ПЕЧАЛИ, НЬ Б(ОГ)Ь УТѢШИ МА ДОБРААГО КЬНАЗА М(О)Л(И)ТВОЮ. И ТАКО ДАИ Б(ОГ)Ь ВЬСЬМЬ ЛЮДЬМЬ УГОДЯ ЕМУ ТВОРИТИ, СЛЫШАШЕМЬ ЕГО У(Е)С(А)РСМВИЕ ПРЕБЫВАЮЩЕ ВЬ РАДОСТИ И ВЬ ВЕСЕЛИИ И ВЬ ЛЮБЬВИ И ДАИ Б(ОГ)Ь ЕГО М(О)Л(И)ТВОЮ ВЬСЬМЬ ХРЬСТИЯНОМЬ И МЬНЬ ХУДОМУ НАСЛАВУ ... ОБРЬСТИ ЧЕСТЬ И МИЛОСТЧ ОМ Б(ОГ)А И ОМ СВОЕГО У(А)РЯ И ОМ БРАТИЕ ...

310

[6] I am most grateful to Dr W. F. Ryan for providing this translation.
[7] See Bank, *Byzantine Art* (note 3), 18–19; B. A. Rybakov: *Russian Applied Art of Tenth-Thirteenth Centuries*, Leningrad 1971, 28–36, who points out how Russia is mentioned by Theophilus as a source of workmanship in enamels (*electrorum*) and niello; and idem: *1000 Jahre Russische Kunst*, Schleswig/Wiesbaden 1988, 387–389 and Figs. 254–258.
[8] Filimonov, *Oklad* (note 2), 18–19; Simoni, *Mstislavovo* (note 3), 22–27, gives the text of the 1551 inscription; Postinkova-Loseva, *Katalog* (note 3), 59, states that the new enamel was made in Novgorod.

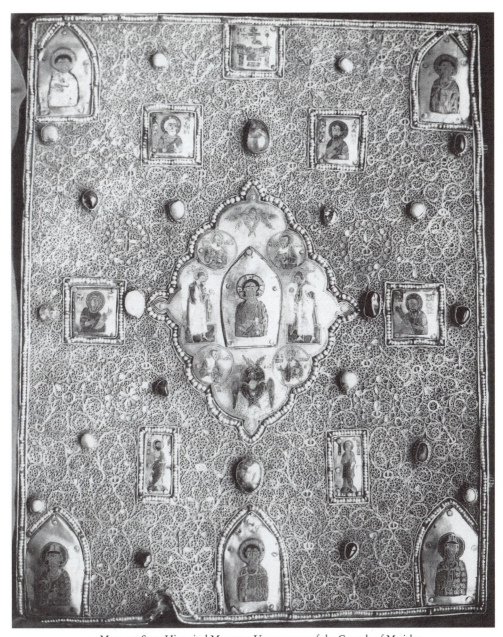

1. Moscow, State Historical Museum. Upper cover of the Gospels of Mstislav

X

they will be discussed with reference to the diagram and the Appendix giving their details (see below).

Firstly, it is clear that six of the plaques (A, C, G, K, L, and M; Figs. 2–7) share a number of features: they are all of comparable size and shape, being pointed at the top in the form of a lancet window, their style, quality of execution and colour range are also cohesive, and, most unusually, none of them is accompanied by an inscription or titulus giving the identity of the figure shown. All previous writers are agreed on the identity and characteristics of this group[9]. A second group (B, D, E, F and H; Figs. 8–12) also have sufficient in common in their size, shape, colour range, the form of their inscriptions and in the level of artistic skill that they display for them to be regarded at least initially as a second group. Thirdly, the two smallest plaques (I and J; Figs. 13–14) also share these characteristics but on a scale, in a format (and, it will be shown, of a period) that separates them into a third group.

The foremost question that must be asked when considering these three groups of enamels is therefore: are there any grounds for suggesting that any of these enamels were those that the scribe Naslav acquired in Constantinople in the years around 1130 specifically for the cover of his manuscript? To answer this it will be necessary to return to look in greater detail at some of them, and we will start with the largest group. The most prominent features they have in common are (as just mentioned) the outline of the plaque and the absence of tituli of any sort; in the case of individual images this is certainly uncommon, and for an entire group of saints' portraits which are in need of separate identification (in any medium, but par-

2. Detail of 1: a male martyr (?) (A)

3. Detail of 1: a male martyr (C)

[9] See Filimonov, Kondakov, Simoni, Postinkova-Loseva, locc. cit. in n. 3. The shape is rarely found and Filimonov, *Oklad* (note 2), 18, even claimed that this meant that they could not be Byzantine, but there are four plaques of exactly comparable shape located along the top of the upper zone of the Pala d'Oro which portray full-length figures and have Greek inscriptions; see H. R. Hahnloser (Ed.): *Il Tesoro di San Marco; La Pala d'Oro*, Florence 1965, nos. 87–90, Tav. XLIX.

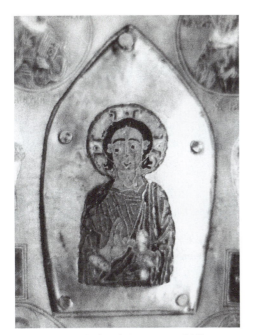

4. Detail of 1: Christ Emmanuel (G)

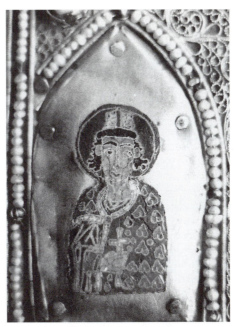

5. Detail of 1: St Boris (?) (K)

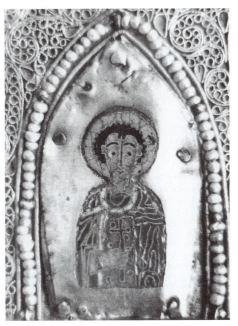

6. Detail of 1: a male martyr (L)

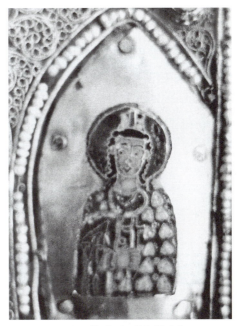

7. Detail of 1: St Gleb (?) (M)

ticularly a luxury art such as enamel) it must be virtually unique. It is possible to propose an identity for the youthful male figure on plaque G, with a cross nimbus and holding a scroll, as representing Christ Emmanuel; this is not a common subject, but was established as an image independent of the Virgin in Byzantine art by the 12th century[10]. We have also seen that in spite of the stylistic incongruity with the 16th century plaque on which it is now mounted (or perhaps because of it) there must be a supposition that it was being preserved as part of a valued earlier scheme; it would therefore follow that all the plaques in this group shared in some measure in this sense of value, and because of this were preserved from the original 12th century ensemble. Four of the other five plaques are clearly intended to represent young male martyrs, as each has black hair and is holding a small cross, while the damage to the fifth (plaque A) is such that if there was a cross it is now obliterated.

In the case of only two of these martyrs is it possible to suggest an identity with any degree of certainty, and this is the two plaques K and M, which represent youthful male figures each wearing a form of diadem or crown and vividly decorated clothing. As was recognised by the earliest Russian commentators on these enamels[11], these are almost certainly portraits of the Russian martyrs Boris und Gleb. They were young Russian princes (hence their crowns and decorative clothing), who were both killed in 1015, and their canonisation had taken place by 1072[12]. Many later representations of them exist in which these characteris-

8. Detail of 1: Hetoimasia (B)

tics, particularly the small crowns, can be seen[13]. For the other three there is no clear evidence for suggesting an identity, but for the present it could safely be said that this was a coherent group of enamels representing young male martyrs which included Boris and Gleb and which was probably originally grouped in some way round an image of Christ Emmanuel. The group may at one time have been more numerous than it appears now.

Before examining the other enamels a further point of interest should be raised concerning this

[10] The subject appears in monumental art by the mid-12th century in such widespread areas as Cyprus, Kastoria, Serbia, Cappadocia and Venice; for a summary, see the *Reallexikon zur Byzantinischen Kunst*, I, 1008–1010, although the enamel plaque of this subject (mentioned here) exhibited in Baltimore in 1947 (Ex. 531) may be post-Byzantine. Christ Emmanuel represented in isolation should be seen as a distinct type and separate from the representation in a medallion on the breast of the Virgin Orans or Blacherniotissa (*Znamenie* in Russia).

[11] See Filimonov, *Oklad* (note 2), 54; Simoni, *Mstislavovo* (note 3), 19–20.

[12] See P. Hollingsworth, *Hagiography* (note 4), xxvii and 97–116; A. Poppe: La naissance du culte de Boris et

Gleb, *Cahiers du civilisation médiévale*, XXIV, Poitiers 1981, 29–53, repr. in: *The Rise of Christian Russia*, London 1982.

[13] See e.g. the icons of the saints in V. N. Lazarev: *Moscow School of Icon Painting*, Moscow 1980, Pl. 1; M. V. Alpatov: *Early Russian Icon Painting*, Moscow 1984, Pls. 46–47, and in K. Onasch: *Ikonen*, Gütersloh 1961, pl. 20; an image of one of these saints in enamel, which may be mid-12th century, is published by Rybakov, 1957 (note 3), 155, fig. 140 and *idem.*, 1988 (note 7), 53, no. 66; also in Kondakov, *Histoire* (note 3), 336, fig. 104.

[14] Vladimir's mother was probably the daughter of the Byzantine emperor Constantine IX Monomakhos, see D. Obolensky: *Six Byzantine Portraits*, Oxford 1988,

9. Detail of 1: St Peter (D)

10. Detail of 1: St Paul (E)

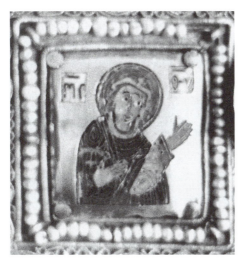
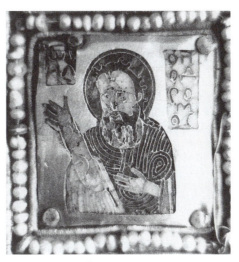

11. Detail of 1: the Virgin (F)

12. Detail of 1: St John the Baptist (H)

group. It relates specifically to the two figures (K and M) identified as the martyrs Boris and Gleb, and to their ancestry. In July 1015 prince Vladimir I had died, under whom Christianity had been introduced into Rus'. He had twelve sons by four mothers (one of whom had been Anna, daughter of the Byzantine emperor Romanos II) and he was succeeded by the eldest, Svjatopolk[14]. To secure his position, the latter had three of his brothers killed, two of the victims being Boris and Gleb, even though they had held true to the tradition of fraternal seniority and had shown humility to-

wards their elder brother, under whom they had been prepared to serve. Svjatopolk was himself overthrown in 1019, being succeeded by a half-brother, Jaroslav, who ruled until 1054. Three rulers shared the subsequent succession, of whom the last, Vladimir Monomakh of Kiev (1113 – 1125) was the father of the patron of the Gospels discussed here, Mstislav. The family descent of the two young martyred princes therefore means that they were the great-great-uncles of Mstislav of Novgorod. The date of their canonisation is still discussed, and may have been as early as the 1030's but had taken place at the latest by 1072[15]. It must be of relevance, however, that their feast day of 24th July is held to appear for the first time in the calendar contained in the Gospels of Mstislav[16]. A further important factor concerns the reason for their canonisation, which was not due to the more usual Western cause of refusal to renounce an article of religious faith, but, in their fidelity to the concept of fraternal seniority, they were seen as offering themselves as an innocent sacrifice comparable to that of Christ[17]. They have a particular place as being the first martyrs of Christian Rus', and exemplify a specifically Russian cause of martyrdom that could be said to be in effect political. Mstislav himself showed in his actions how he valued the ability to create peaceful relations between potential rivals. It can be seen in view of this that Mstislav of Novgorod could well have wished, as an act of natural piety towards his canonised ancestors, to include them in a group of

other young, male martyrs on the cover of the Gospels that he had initiated[18].

To return to the remaining enamels, which clearly fall into two disparate groups, the point should first be made that their preservation here must strongly suggest that they formed part of the original decoration of the manuscript; this would provide an explanation for the preservation of such an evidently heterogeneous group of plaques in the new design of 1551. Bearing this in mind, it can see that the subject-matter of the second group of five virtually square enamel plaques on the bookcover (B, D, E, F and H), is far more usual for this medium. However, while images of the apostles Peter and Paul are commonly found in the imagery on book-covers,[19] that of the *hetoimasia* that is found here does require some explanation. The form of this subject as it developed in middle and later Byzantine art shows a draped throne, on which a codex rests, with the dove of the Holy Spirit above and the adjuncts to the Crucifixion of the reed and sponge and the spear of the centurion Longinos; the function of the image, after the 11th century, is to indicate the preparation (thus *hetoimasia)* for the Last Judgement[20]. It occurs quite frequently in monumental art, and can be found in the enamels of icon frames in Jerusalem,[21] at Freising[22] and in the Great Lavra on Mount Athos,[23] as well as among the re-used enamels on a cross at Oignies, near Namur[24]. The subject also appears in the enamels of the Pala d'Oro[25].

83–114. Also A. Poppe: Le Prince et l'Eglise en Russie de Kiev depuis la fin du Xe siècle jusqu'au début du XVIe siècle, *Acta Poloniae Historica XX,* Warsaw 1969, 95–119, particularly 115–117, and Hollingsworth, *Hagiography* (note 4), xxvi–xxvii. Mstislav had married first (in 1095) Christina of Sweden, who died 1122; the name of his second wife is not known.

[15] Hollingsworth, *Hagiography* (note 4), xxvii, and Poppe, 1981 (note 2), 46–51; but also *idem,* 1969 (note 14), 113, where their canonisation is said to have taken place on 20 May 1072. Their names were originally Romanos and David; although it has been claimed that their cult was restricted initially both socially and geographically, in 1117 Vladimir Monomakh (father of Mstislav) had erected a stone church on the traditional site of their mar-

tyrdom, and in 1200 a church dedicated to them in Constantinople was reported by Anthony of Novgorod; Obolensky, *Portraits* (note 14), 100–101, and Hollingsworth (note 4), xxix.

[16] Poppe, 1981 (note 12), 51, but no mention appears in later gospels of 1144 and later in the 12th century.

[17] Obolensky, *Portraits* (note 14), 100–101, and Poppe, 1969 (note 14), 115.

[18] The three other male martyrs in the group, although all youthful, are differentiated in facial appearance, and it is probable that they were intended, as suggested by Filimonov, *Oklad* (note 2), 57–61 to represent the leading Greek martyrs St Theodore, St Demetrios and St George; these could well have figured in a group with this kind of identity.

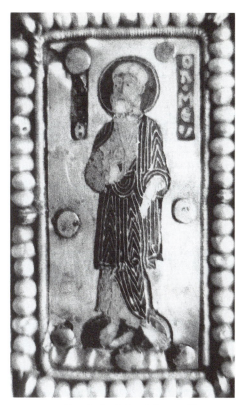

13. Detail of 1: St James (I) 14. Detail of 1: St Bartholomew (J)

Three features of the enamel on the Mstislav Gospels should be mentioned. One concerns the form of the strange inscription, which is in Greek characters, but of which the most probable reading is: ΠΡΕϹΤΛ ΓḢΔ. The best explanation for this would seem to be that it represents an attempt by a Greek enameller to render the Slavonic title: престол господэнь (*Prestol Gospoden*), or ›Throne of God‹; all the enamel examples mentioned above except the Pala d'Oro have the full title of the

[19] No full study has yet been made of the development of Byzantine book-cover design, but see T. Velmans: La couverture de l'Évangile dit de Morozov at l'évolution de la reliure byzantine, *Cahiers Archéologiques,* 28, 1979, 115–136, particularly 119–127.

[20] For this motif see T. von Bogyay: Zur Geschichte der Hetoimasia, *Akten des XI. Internat. Byzantinistenkongreß, München 1958,* Munich 1960, 58–61; also *Reallexikon zur Byzantinischen Kunst,* II, 1189–1202. It makes its appearance only in later book-covers, being found on both recto and verso of those in Venice mentioned in n. 27, below.

[21] P. Hetherington: Who is this King of Glory? The Byzantine enamels of an icon frame and revetment in Jerusalem, *Zeitschrift für Kunstgeschichte,* 53, 1990, 25–38, fig. 7.

[22] Best illustration in A. Grabar: *Les revêtements en or et en argent des icones byzantines du Moyen Age,* Venice 1975, pl. 39.

[23] Grabar, *revêtements* (note 22), figs. 71 and 72.

[24] Ferdinand Courtoy: *Le Trésor du Prieuré d'Oignies aux Sœurs de Notre-Dame à Namur et l'Œuvre de Frère Hugo,* Bruxelles 1953, 87–90, fig. 76.

[25] See Hahnloser 1965 (note 9), Tav. VI.

hetoimasia in Greek characters, and this suggests that in our case there was a lack of familiarity with the accepted meaning of the image. It is the result that might emerge from a Russian telling a Greek enameller what title to inscribe beside the image[26]. The second concerns the technique of this inscription, which (as noted in the Appendix) is different from all the others on the cover, and shows some of the characteristics of an addition to the plaque. The third feature concerns the period by which this subject seems to be adopted for the decoration of book-covers; it only begins to appear on Byzantine book-covers of the 14th – 15th century, being found before then (as mentioned above) only on decorated icon frames[27].

The third small group representing full-length figures of St James and St Bartholomew (plaques I and J) must be assumed to be survivals of a sequence of the twelve apostles. This pair of plaques has from the earliest discussions of the book-cover always been held to be both the earliest in date and to be of Byzantine origin[28]. The incongruity in scale between this pair and the rest again suggests that they were included here not for aesthetic or iconographic reasons, but because they formed part of the original 12th century decoration; their hallowed association with Mstislav and his ancestors must surely be the best explanation for their inclusion in the 16th century re-making.

Nothing has so far been said about the condition of any of the plaques other than the badly damaged one (plaque A), where the loss was always clear. An examination of the condition of the enamels does show yet further differences that exist between the largest group and the rest: the surface of the enamel in all the ›pointed‹ plaques is relatively rough, with the scratches of the abrading process still visible, and in several cases the enamel has retained small sunken patches which under any conventional finishing process would have been polished out to give a smooth, reflecting surface[29]. It is possible that perhaps another firing in the enameller's kiln had been intended, with later final polishing, and it would not be overstating the case to say that all the enamels in this group (also lacking, as they do, any tituli) appear never to have been finished.

Certainly the slight roughness of the surface of these plaques contrasts strongly with the conventional mirror-like finish of the enamels in the other two groups on the cover. If the lack of any inscriptions or tituli is added to this factor, the picture does begin to emerge of the six ›pointed‹ plaques having been removed from the enameller's workshop before the final stages of their production had been completed.

There is a lack of comparative unfinished examples of enamel against which to test this hypothesis; it would not have been anticipated, for example, that the inscription on an enamel plaque would normally have been added only at such a late stage. Yet the absence of tituli is such an extraordinary feature, contravening the artistic tradition of centuries throughout the Orthodox world, that a completely exceptional reason has to be sought. It is even possible that there had been an intention to insert the tituli when the plaques had been brought back to Rus'.

This is now the moment to return to the colophon of the scribe Naslav, where he states how he »took it [the manuscript] to Constantinople and arranged to have made this enamel, ... and by the grace of God returned from Constantinople, and then made good all the gold and silver and pre-

[26] See e.g. the inscriptions on the Russian enamels illustrated in Kondakov, *Histoire* (note 3), 367 and pl. 28; also Rybakov 1957 (note 3), 156–161; and *idem* 1971 (note 7), 43–49.

[27] For two of these later book-covers, see H. R. Hahnloser (Ed.): *Il Tesoro di San Marco; Il Tesoro e il Museo*, Florence 1971, Cat. nos. 38 and 39 (Tavv. XXXVIII and XXXIX). The inscription on the enamel of the Pala d'Oro may be concealed by the later framing.

[28] Kondakov, *Histoire* (note 3), 187; Postinkova-Loseva, *Katalog* (note 3), 53–54; Bank, *Byzantine Art* (note 3), 305–306.

[29] For a discussion of the stages of final polishing of enamel plaques, with reference to the instructions given in the *De diversis artibus* of Theophilus, see David Buckton: Theophilus and Enamel, *Studies in Medieval Art and Architecture presented to Peter Lasko*, London 1994, 1–13, particularly 10–11.

cious stone[s] ...« Suggested here are the kind of circumstances which could lead to the ›unfinished‹ group being taken in that state (for whatever reason) from Constantinople by Naslav, who may have intended to complete them himself but found that this was not possible, and who then »with much toil and grief« mounted them on the original bookcover. The evidence strongly suggests that this first group was among the enamels that the scribe Naslav brought back from Constantinople. This transaction would also explain the inscription on the plaque of the *hetoimasia* in the second group, in that it would provide the circumstances in which a Greek enameller would have been asked to add a Greek inscription with a Slavonic meaning. The implications of this for the origin of the other enamel plaques on the book-cover will be addressed shortly.

Turning from the question of the physical state of the original enamels, we should try to establish what theme (if any) is suggested by their subject-matter. This could never have conformed to what could be called the more ›normal‹ iconography for the cover of a lectionary or evangelistary, which by the 12th century involved the placing in the centre of the upper cover an image of the Crucifixion, and (possibly later) on the lower cover one of the Anastasis; they would have been surrounded by a sequence of images of angels, apostles, evangelists and perhaps prophets[30]. We have no evidence that this was the case in the Gospels of Mstislav, and there are in any case several examples in existence of book covers which departed from this ›norm‹. What is suggested by the evidence of the surviving plaques is that they would have formed some kind of programme in which enamels of young male martyrs were grouped round one of the youthful Christ Emmanuel. Of the group of six ›pointed‹ plaques, one is of the youthful Christ Emmanuel (G) and all the other

five (A, C, K, L and M) were of young male saints; four of these are certainly portrayed as martyrs, and the fifth (A) could well have been, although damage has removed any attribute he might have held.

If this general hypothesis is even partly accepted, the picture begins to emerge of the Gospels, with their calendar celebration of the first Russian martyrs, and particularly the enamels on their cover, being partly used by Mstislav to promote the cult of his great-great-uncles, Boris and Gleb, the »martyr-princes«. By setting them among a group of other male martyr saints their status would have been consolidated and their particular function strengthened. Their cult emphasised two aims: they were held to protect Rus' from pagans, and they were thought to save the state from antagonism between its princes[31]. The cover of the manuscript of the Gospels that he had had created would have been a suitably worthy vehicle for the expression of this act of piety, and in order to ensure that enamels of an appropriately high quality were used, Mstislav sent his scribe Naslav to Constantinople to acquire them. He must have returned with not just the main group of ›pointed‹ plaques, but with a further selection of enamels that he had been able to acquire while in Constantinople[32]. The same sense of ancestral piety may well have lain behind the creation in 1551 of a new book-cover on which the original enamels, with their implicit message, would be preserved and enshrined.

It is not possible at present to make any assessment of what plaques may have been lost from the cover; even the assumption that a figure of Christ must once have been located between the interceding figures of the Virgin and John the Baptist need not be true, as it may not have been present among the plaques available to Naslav. Nor is it possible to know if comparable decoration was ever ap-

[30] See Velmans, *couverture* (note 19), for a discussion of this development.

[31] Poppe 1969 (note 14), 115.

[32] It has been usual in the past to regard the six pointed plaques as Russian enamel; see Kondakov (note 3),

Histoire, 186, Bank, *Byzantine Art* (note 3), 18–19 and Postinkova-Loseva, *Katalog* (note 3), 53–54.

plied to the lower cover, and so perhaps subsequently been assumed into the 16th century decoration of the upper cover. While in Byzantium a prestige binding would certainly have been decorated on both covers, this may not have been the case in 12th century Rus'[33]. While Simoni states that the damage suffered by the cover before its remaking in the 16th century involved the loss of some of the plaques, nothing is known about their identity[34].

The various factors that have now been brought together indicate that the thirteen enamel plaques fixed to the book-cover in the 1551 re-making were always part of the original 12th century scheme. Certainly, it is hard to explain why the ensemble should have been preserved so carefully, and at the cost of creating such a disparate collection of plaques with such variety of size and figure-scale and incoherence of subject-matter, without some overriding and pre-eminent intention. Such an intention, it is suggested, could have been the preservation of enamels which had achieved a measure of sanctity by their inclusion on the original binding of the Gospels.

This in turn leads to the conclusion that not just the major group of ›pointed‹ plaques, but the other two groups as well, formed part of the original decorative ensemble. In this case the presumption must be that all the plaques were brought back from Constantinople by Naslav, and that they must therefore be regarded as of Byzantine origin. In the past it has been held that this only applied to the two standing figures of apostles, plaques I and J.

This thesis gives rise to two further considerations. One concerns the light that is shed by Naslav's colophon on the commercial practice of a 12th century Byzantine enameller's atelier. Here it may be regretted that the case we have been studying is both so unique and so isolated, and broad

conclusions drawn from it may be misleading. However, if we are correct in the view that the scribe brought back all the enamels from Constantinople, he would appear to have left with quite a varied selection. Some must have been made for him (proposed here as the ›unfinished‹ group, which includes the martyrs Boris and Gleb) but the disparate nature of the remainder suggests that he also at the same time acquired others (perhaps parts of two incomplete ensembles) that have every appearance of having been available and ›on the market‹ at the time[35]. This reinforces the view that enamel plaques were sufficiently highly valued to be retained if their original ›home‹ was (for any reason) dismantled or broken up, and could remain in circulation to be attached to other objects. If this could happen in the case of an item specifically known to be ›for export‹, it must be assumed that the same process could apply in the case of objects made for local use; this should be borne in mind when assessing any ensemble of Byzantine enamel plaques.

The other consideration concerns the chronology of the enamels in Moscow, on which little has so far been said. Again, it is unfortunate that they represent such a unique case, as our knowledge and understanding of this aspect of Byzantine enamel is in many respects still in its early stages; once an enamel plaque has become isolated from its original context, which might have provided us with data on its chronology, it is often still not possible (without rare internal evidence) to be at all accurate in assessing its date. However, it is of course axiomatic that all the plaques on the Mstislav book-cover (except that of 1551) must date from before 1132. The two figures of the apostles (plaques I and J) have always been regarded as the earliest, and their recent dating to the 10th – 11th century may well be correct[36]. The intermediate

[33] While the liturgical use and display of decorative bindings in Byzantium (usually applied to lectionaries) normally required that both upper and lower covers were given equally lavish treatment, this may not have been the case in religious centres in other contexts. Thus the Byzantine enamels that were re-used on the binding of the Pericope of Henry II (now in Munich) are confined to the upper cover.

[34] Simoni, *Mstislavovo* (note 3), 22; the identity of the person responsible for the 16th century work is not known.

15. Moscow Historical Museum: The Gospels of Mstislav. Diagram of enamels on upper cover.

group of five plaques (B, D, E, F and H) could have been assigned, on our current (and, it must be admitted, unsatisfactory) understanding of the chronology of the medium, to some point in the later 11th century, but if Naslav was instrumental in determining features of their production as has been suggested in the case of plaque B, then the early 12th century seems indicated.

[35] This was suggested by Filimonov, and appears to be supported by Kondakov, although the latter later claims *Histoire* (note 3), 186 that »ces médaillons rentrent déja dans le domaine de l'histoire de l'émaillerie russe.« There is no way of knowing whether enamellers

or merchants specialising in other precious goods retained old enamel plaques.
[36] Postinkova-Loseva, *Katalog* (note 3), 53–54; Bank, *Byzantine Art* (note 3), 305–306.

Finally, if the six ›pointed‹ plaques were created specially for the Gospels, they have to be dated between c. 1126 (as the earliest by which the manuscript could have been written and the journey made to Constantinople) and 1132, when Mstislav died[37]. This not only makes them one of the few quite precisely dateable groups of Byzantine enamel that we have, but also means that the plaques depicting the martyrs Boris and Gleb are almost certainly the two earliest portraits of the princes to have survived[38]. The other principal

creation of earlier 12th century enamel is of course part of the unique assemblage of plaques on the Pala d'Oro in Venice; this is not the place to rehearse the many arguments that have been expressed on the chronology of this hugely impressive and enigmatic creation, but it should be acknowledged that we now have in some of the enamels on the cover of the Mstislav Gospels further dated examples which may in due course allow us further to clarify our understanding of this period of enamel production in Constantinople.

Appendix: Technical Information on the Enamels

The letters refer to the accompanying diagram of the book-cover. Figures are of the overall dimensions of each plaque, with the height given first. The overall dimensions of the cover are 368 x 290 mm.

Identity, dimensions and condition

A: (Fig. 2) A male saint: 58 x 35 mm. All enamel is missing from the body of the figure, revealing scratched metal base; the condition of the head is fine but unpolished.

B: (Fig. 8) Hetoimasia: 30 x 28 mm. Inscription, partly disturbed by securing nails: ΠΡΕC / Τ Λ / ΓЍΔ. It is notable that this is the only plaque on the book-cover that has an inscription which is not formed by cloisons of enamel of one colour set in a background of another; the letters are formed just by shallow recesses. The condition is good and the enamel surface is polished. The subject, centred round the empty throne, includes a schematic lance and sponge, with a dove and cross and nails on a cushion below.

C: (Fig. 3) A male martyr saint: 58 x 34 mm. The condition of the enamel is generally good, but the the plaque has a repair adjacent to the figure's halo; only part of the surface is polished.

D: (Fig. 9) Saint Peter: 29 x 28 mm.

Inscription:

	O	Π
	A	E
	Γ	T
	H	P
	O	OC

The condition of the plaque is perfect and fully polished.

E: (Fig. 10) Saint Peter: 30 x 28 mm.

Inscription:

	O	Π
	A	A
	Γ	V
	H	Λ
	O	o
	C	

The condition of the plaque is perfect and fully polished.

F: (Fig. 11) The Virgin: 30 x 28 mm.

Inscription: M̃P̃ Θ̃ν̃

The condition is perfect and fully polished.

G: (Fig. 4) Christ Emmanuel: 64 x 36 mm. The condition is perfect

[37] The sense and tone of the colophon clearly implies that it was written while Mstislav was alive.

[38] While there would presumably have been icons of the saints set up in the church built in 1117 to honour them, they have not survived.

H: (Fig. 12) Saint John the Baptist: 31 x 28 mm.
Inscription:

W'	OΠ
НИ	PΔ
	PO
	M
	OC

Condition is good except for slight damage to inscription.

I: (Fig. 13) Saint James: 37 x 17 mm.
Inscription:

o	O
I	
A	O
K	C

Condition: slight damage to inscription, edges of the robe and ground beneath the figure; otherwise good and fully polished.

J: (Fig. 14) Saint Bartholomew: 38 x 16 mm.
Inscription:

.	O
.	Λ
Θ	M
	E
	10

Condition: damage to inscription and ground beneath the figure, otherwise good and fully polished.

K: (Fig. 5) A male martyr saint (identified as Boris) wearing decorative headgear (a diadem or crown, similar to M) and holding a cross: 62 x 35 mm. Condition: no damage; 90% of the surface of the enamel is ground smooth but left unpolished.

L: (Fig. 6) A male martyr saint holding a cross: 59 x 33 cm. Condition: no damage; some 75% of the enamel is ground smooth but left unpolished.

M: (Fig. 7) A male martyr saint (identified as Gleb) wearing decorative headgear (a diadem or crown, similar to K) and holding a cross: 62 x 35 mm. Condition: no damage; some 75% of the enamel is ground smooth but left unpolished.

Colours of the enamels

The following summary is not intended to be an exhaustive analysis of all the glasses used, but provides accurate information on the main colour areas, with particular reference to less usual pigments. While colours used vary from group to group, they remain quite consistent within each group. All glasses are opaque except for the translucent green used in Groups 2 and 3. The colour codes used are those of the internationally recognised Munsell Color System.

Group 1. The six ›pointed‹ plaques A, C, G, K, L and M: *Flesh colour:* this was produced by using a layer of greyish-pink (5 YR 7/4) over a pale green, which in some places shows through. It is the most unusual and distinctive aspect of the colouring used in this group.
Black is used for the hair of all six figures.
Dark blue: 5 PB 2/6, used in cloak of G, M undergarment of C and K, and haloes of K and M.
Red: 10 R 3/6, used in mouths of all figures, undergarment and diadem of K and M, cloak of C, K, L, and cross held by C, L, M.
Green: 2.5 G 4/4, used in undergarment of G, tablion of L, pattern in cloak of K, halo of C.
Dark turquoise: 10 BG 4/4, used in haloes of A, G. L and tablion of C and L.
Yellow: 2.5 X 7/4, used in diadems of K and M.
It is notable that the light grey-blue glass, which is very commonly found in Byzantine enamel, is absent from this group.

Group 2. The five square plaques: B, D, E, F and H.
Flesh colour: 5 YR 7/4 used throughout the group.
Dark blue: 5 PB 2/4, used in cloak of D, E, F. H, cloth draped over throne in B, and hair of E.
Pale blue: 10 B 6/4 used in hair of D.
Grey-blue: 2.5 PB 6/4, used in undergarment of D, E and H, sleeve of F.
Red: 7.5 R 3/6, used in bird, cushion and throne in B, cross-halo of G and book-cover of E.
Translucent green: 10 G 3/8, used in haloes of D, E and H. The inscriptions of all except B are in black on a white ground.

Group 3. The two plaques I and J.
Flesh colour: 7.5 YR 6/4 in both.
Dark blue: 5 PB 2/4 used in cloak of both figures.
Pale blue: 5 PB 3/6, used in halo of I and under-garment of J.
Grey-blue: 2.5 PB 6/4, used in undergarment of I and hair of J.

Translucent green: 10 G 3/8, used in ground under both figures and halo of J.
Inscriptions: in white on red ground (7.5 R 3/6) in both plaques.

Photo credits: All photographs by author.

The Enamels on a Mitre from Linköping Cathedral, and Art in thirteenth-Century Constantinople

Now displayed in the Statens Historiske Museet in Stockholm is a mitre richly ornamented with enamels, seed-pearls, embroidery and gems (Figs. 1–6).[1] A considerable amount is known about its history: there is general agreement that it is the result of a commission of around the year 1460 for a new mitre for Kettil Karlsson Vasa, who had been appointed in October 1459 as bishop of Linköping (a suffragan of Uppsala) in Sweden.[2] The mitre was in all probability created in the Bridgittine convent at Vadstena, and in the embroidery at the ends of the lappets of the mitre the arms of both the diocese and the bishop can still be seen, confirming his individual association with the work. The style of the finely executed stitched decoration of the mitre, with the lavish use of seed-pearls to depict on the front an image of the Annunciation and on the back standing figures of St Peter and St Paul, all confirm an origin in a mid-fifteenth century northern European context. The mitre was deposited in the museum in Stockholm in 1868.[3]

But while there is general agreement on the history of the mitre in its present form, no such certainty exists when the discussion turns to the origins of the enamels that were incorporated into this design, and it is with them that this paper will be concerned. It will be seen from the Appendix below that there are 87 plaques still in place from a total that (on the evidence of the empty spaces) was originally 116. They were formed from 38 figurative silver-gilt roundels and 78 distinctively shaped plaques all displaying decoration formed from meandering vegetal ornament; three of the roundels and 13 decorative plaques are completely lost and a number are damaged. It will be suggested below, when the methods of attachment are discussed, that some of the plaques were already in a damaged state when they were put in place. For over a century the enamels have attracted admiring opinions from a range of scholars, but there has not been any success in achieving final certainty as to where or when they

[1] All illustrations are of the mitre of Bishop Karlsson, from Linköping Cathedral, now Stockholm Historical Museum, Inv. Nr. 3920:1. I would like to thank the Senior Curator of the Museum, Mari-Louise Franzén, for her thoughtful care and assistance while I was studying the mitre, and for later responding to my queries.

[2] C. Eubel, *Hierarchia Catholica Medii Aevi*, II, (Regensburg, 1901), 196; Karlsson died in 1465.

[3] Å. Nisbeth & I. Estham, *Linköpings Domkyrka Inredning och Inventarier,* (Linköping, 2001), 111–113, Fig. 69.a.

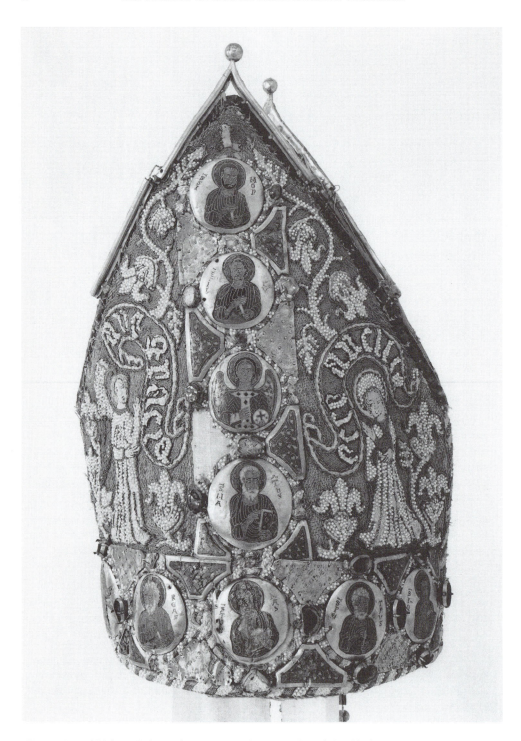

Fig. 1. Mitre of Bishop Karlsson, front. (National Heritage Board, Stockholm.)

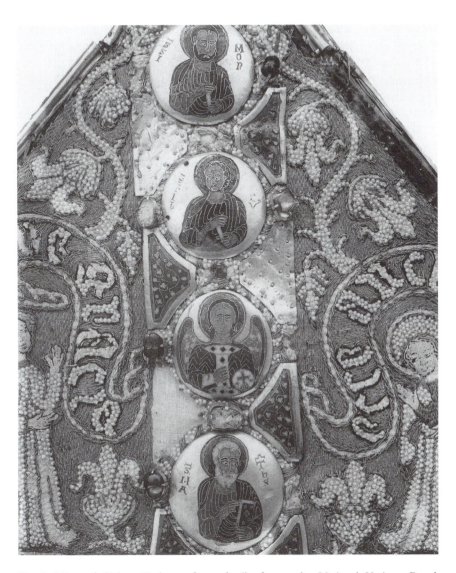

Fig. 2. Mitre of Bishop Karlsson, front, detail of enamels. (National Heritage Board, Stockholm.)

were originally produced; the only point on which there is agreement is that they must ante-date the creation of the mitre itself, and so must be an example of the quite widespread practice of the re-use of enamel plaques.

Nikodim Kondakov, in his monumental study on Byzantine enamel of 1892,[4] was the first scholar to illustrate and discuss them, and he saw them as deriving from a thirteenth-century German context, although demonstrating strong Byzantine influence. Rosenberg gave no opinion on the location of their origin, but offered an earlier date of *c.* 1150,[5] and Dalton in 1911 followed Kondakov's view of them as of German workmanship and judged them to be of twelfth-century date.[6] Montelius in 1912 emphasised the presence of Byzantine elements but regarded the Latin inscriptions as imposing a western origin without offering a specific location.[7] Previous to this point the possible variety of opinions had been further extended by Bock who suggested an origin in the Rhineland, and later by Munthe and Posse who in 1931 thought that they may have started life in Limoges.[8] A Venetian origin was first suggested by af Ugglas in 1933,[9] but thereafter southern Italy became favoured: it was Yvonne Hackenbroch who in 1938 first proposed a Sicilian origin,[10] and in 1957 Lipinsky favoured the specific location of Palermo under the Normans as providing the origin for the plaques now in Sweden, as well as for a number of other ensembles.[11] This area was at first supported by Josef Deér, but by 1966 he had been persuaded that the origin of the enamels was to be sought not in Sicily but in Venice.[12] Since then a Venetian origin has remained the prevailing view, first proposed in 1933 and repeated by Deér in 1966 and by Nisbeth and Estham in 2001.[13] It was an attractive hypothesis, but largely depended on the presumption that the Pala d'Oro was a Venetian work. This is, of course, contrary to the inscription on the Pala itself, which states clearly that it was originally commissioned in 1105 from Constantinople,[14] and the Venetian origin is

[4] N. Kondakov, *Histoire et monuments des émaux byzantins* (Frankfurt am Main, 1892), 241–243, Figs. 85–86.

[5] M. Rosenberg, *Geschichte der Goldschmiedekunst auf technischer Grundlage. Zellenschmelz* (Frankfurt am Main, 1921), 70, 80.

[6] O. M. Dalton, *Byzantine Art and Archaeology* (Oxford, 1911), 528.

[7] O. Montelius, *Mästerstycken i Statens Historiska Museum* (Stockholm, 1912), 21.

[8] F. Bock, *Die byzantinischen Zellenschmelze der Sammlung Zwenigorodskoï* (Aachen, 1896), 346–349, (with a date in the late fourteenth century); Munthe and Prosse were quoted by C.R. af Ugglas, *Kyrkligt och Silversmide (Ur Statens Historiska Museums Samlingar 2)*, (Stockholm 1933), 43 (this source was not available to the author).

[9] C.R. af Ugglas, *Kyrkligt och Silversmide*, 43.

[10] Y. Hackenbroch, *Italienisches Email des frühen Mittelalters* (Basel/Leipzig, 1938), 63–64.

[11] A. Lipinsky, "Sizilianische Goldschmiedekunst im Zeitalter der Normannen und Staufer," *Das Münster*, 1957, 170–172.

[12] J. Deér, "Die byzantinierended Zellenschmelze der Linköping-Mitra und ihr Denkmalkreis", *Tortulae: Studien zu altchristlichen und byzantinischen Monumenten* (Rome, 1966), 49–64.

[13] Nisbeth & Estham, *Linköpings domkyrka Inredning och Inventarier*, 111.

[14] The Latin inscription on the two enamel plaques installed on the Pala d'Oro in 1343–5 states what was then known of its history, which was that it was originally a work of 1105, but was "*nova facta*" in 1209 under Doge Pietro Ziani (1205–1229). See H.R. Hahnloser and R. Polacco, *La Pala d'Oro* (Venice, 1994), 87, 118–119, Pl. III, and for a succinct summary of the evidence, D. Buckton, "The Enamel of Doge

now no longer generally entertained. It seems appropriate, with the further research of recent years, that a fresh eye should now be cast on the extensive sequence of enamels in Linköping.

While not central to the debate concerning the original location in which the plaques were produced, there are several features involved, partly interrelated, which should first be discussed. One of these concerns the circumstances of their original use, and the kind of object that they would originally have adorned. From when it was first published there has been a presumption that the enamels had first been used to ornament the mitre of a former western bishop, but even a brief examination suggests that this is probably an over-simplification. A further factor, to which this first question relates, concerns the subject-matter of the roundels, while the third of these preliminary questions which needs to be asked (but never has been) is whether all the plaques, both figural and decorative, were produced at the same time and place, and for combined use on the same object.

Taking the first two of these considerations together, it can be seen that among the eighteen larger roundels (themselves of sizes varying between 42 and 50mm.) now adorning the front and back of the mitre, all except three have tituli;[15] of those without, two (5 and 14) present an image of a seraph and one (3) of an archangel. Of the fifteen named roundels, one (12) is of Christ, two (9 and 13) are of St John and two (4 and 18) of St Matthew. There are therefore, including the two duplicated named figures, fourteen "apostles" represented; all their names are in Latin except for Christ whose image has the Greek IX IC symbols. It is unusual to find just one archangel present among groupings such as this, whatever their origin, and it could have been expected that a representation of the Virgin would also have been given a place. The (originally) twenty smaller roundels on the lappets, all of male, nimbed, bust-length figures, cannot be identified with any conventional grouping as they have no names. However, the factors of evident duplication among the larger named plaques, and the likelihood of there having once been an enamel of the Virgin among them would seem to suggest that the assemblage now found on the Linköping mitre was in all probability brought together from more than one source or sequence of roundels intended for two or more original locations. While this need not affect an opinion on their area of origin, it suggests that a brief look might be taken at other comparable works in which enamels have been used in association with mitres and some other textiles.

One of the most eligible of these is the mitre now in the church of S. Lorenzo at Scala, near Ravello in Sicily.[16] Lavish use of pearls in conjunction with enamels is the most evident point of similarity, but there are a number of differences. Besides the presence of western saints among the enamels, namely St Francis of Assisi and St Louis of France, the main sequence of plaques has been shaped to a completely

Ordelaffo Falier on the *Pala d'Oro* in Venice", *Gesta*, XXXIX/1 (2000), 43–49.

[15] The bracketed numbers apply to those in the Appendix, given below. I would like to thank Mari-Louise Franzén for confirming the details of measurement here; those given by Nisbeth & Estham, *Linköpings Domkyrka Inredning och Inventarier*, 112, are incorrect at several points.

[16] Hackenbroch, *Italienisches Email des frühen Mittelalters*, 62–63.

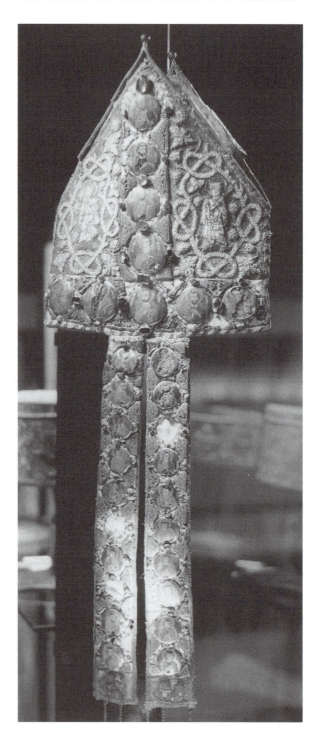

Fig. 3. Mitre of Bishop Karlsson, reverse, with lappets.

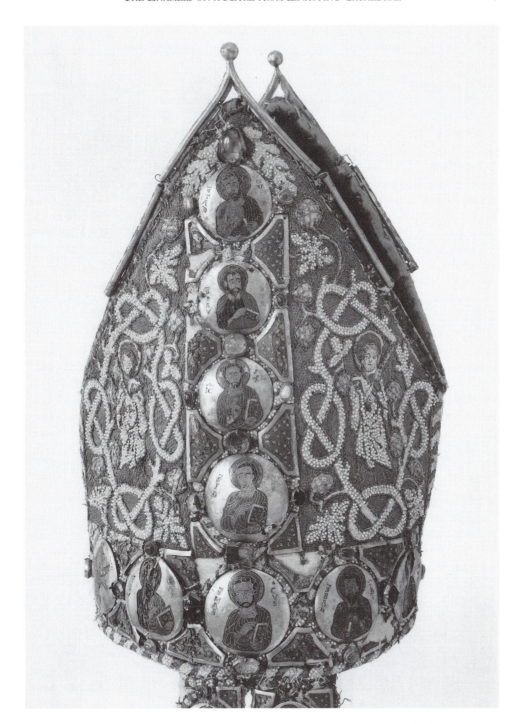

Fig. 4. Mitre of Bishop Karlsson, reverse, upper part. (National Heritage Board, Stockholm.)

western, gothic format; the plaques are also contemporary with the decoration in embroidery, with lavish use of pearls, and a later thirteenth century date for the entire ensemble is very likely. Of possibly greater relevance is the presence, mentioned in the studies of both Hackenbroch and Lipinsky, as well as Deér, of episcopal gloves adorned with enamel plaques. It would seem that western congregations all over Europe were accustomed by the thirteenth century to seeing a bishop wearing a mitre richly decorated with pearls and other ornaments who was also wearing highly ornamental gloves.[17] In, for example, the inventory of the treasury of St Paul's Cathedral in London, made in 1295,[18] among the nine mitres listed (three of which, incidentally, were heavily decorated with pearls) four are accompanied by episcopal gloves. It could be expected that these would be subject to greater wear than a mitre, and any plaques adorning them could have been salvaged for re-use when the gloves became outworn. In view of this, an explanation for the range of plaques on the mitre from Linköping, with its duplications and possible absences, could well be that they were the survivors of more than one mitre and possibly of some episcopal gloves as well. In the same way the enamels on the gloves now in the cathedral of Brixen, depicting as they do the unfamiliar pairing of the Virgin and St Peter, can best be explained by their chance re-use from an earlier context.[19]

While it is possible to locate parallels in both northern and southern Europe for the general decorative characteristics of the upper part of the mitre in Stockholm, the heavily decorated character of the lappets, which need their length of some 55 cms. for each to support the 10 enamel roundels and 24 decorative plaques adorning them, must be regarded as without a surviving precedent. Examples can be cited of even longer, but less heavily decorated, lappets,[20] or for having what could be quite a large gem mounted on each lappet, perhaps to ensure that its weight would make it hang down straight,[21] but the combined weight of the 68 enamels (not to mention the three lengths of chain attached to each of the ends) would have been so substantial that a suggestion could be made that also here additions from other ensembles may have become available and so been included.

At this stage a further factor should be pointed out that has so far not been raised: in observing the survivals from the 118 original plaques it is immediately clear that there are substantial differences of technique, construction and attachment between all the figurative roundels and the decorative plaques that surround them. These variations are not readily appreciated in photographs taken directly at right angles to the surface, but become very evident when the mitre is viewed from an oblique angle. Before any work was begun on creating the enamel itself, the surrounding edge of each of the roundels has been hammered (or "raised") to give it a profile that curves sharply inwards, and this means each plaque has a depth of some 3–5mm. which raises

[17] J. Braun, *Die Liturgische Gewandung im Occident und Orient* (Freiburg, 1907), 477–480.

[18] W. Dugdale, *The History of St Paul's Cathedral in London* (London, 1658), 205.

[19] Lipinsky, "Die byzantinierenden Zellenschmelze der Linköping-Mitra," Figs. 16b and 16d. The presence of large nail-holes in both plaques must indicate previous use elsewhere.

[20] Musée de Cluny, *Guide Officiel* (Paris, 1935), 114 and Pl. XXX.3.

[21] Dugdale, *History of St Paul's Cathedral in London*, 205.

it above the area of textile to which it is attached; only when they had been given this profile was the enamel image created on the slightly convex surface. They have all been sewn on, using holes drilled in the edge of the roundels that in most cases, although not all, are largely concealed. The (originally) 78 decorative plaques are different in that all are virtually flat, and are secured not directly by stitching, but are held by the bezel of a second metal plate of which the edges have been burnished over to retain them. This second plate was pierced with holes to enable it to be stitched to the textile base, and these can readily be seen in cases where plaques have become detached, revealing their supporting plate still sewn in to its original place. The decorative plaques would thus only have been attached after their base plate had been sewn into place.

This contrast in the "depth" of the two kinds of plaque reflects the two different forms of *cloisonné* enamel that have been used. While the roundels exemplify the so-called *senkschmelz* technique, in which metal is left forming an area surrounding the image, the decorative plaques are in *vollschmelz*, with the only metal visible being the lines formed by the edges of the gold strips that create the design.[22] The metal framing visible is formed by the bezels of the holding plates. This variety of approach should now be brought into the discussion of the third of the factors mentioned above: were all the plaques produced at the same time and place and for installation on the same object? There are two reasons why this question has never been raised; one is quite easy to find, as the relatively close fitting of the circular plaques into the recessed curves of the decorative ones would be difficult to explain without the presence of a prior unifying design. The other is that (as mentioned above) discussion of the mitre has always been based on photographs which were taken at right angles to its ornamented planes, and so the element of relief that clearly exists between the higher profile of the roundels and the flat ornamental plaques is not at all evident; it only becomes worryingly clear when in the mitre itself is viewed from an angle that is other than square to the line of vision (Figs. 1 and 4). There is absolutely no technical reason why the circular plaques could not have been made with a much lower profile to match that of their ornamental surrounds, and attached either by bezels to a secured plate beneath, or by visible stitching through holes in the outer edges of the plaques. Conversely, the decorative plaques could have been made with a more prominent profile which would have overcome the worrying disparity in the relative overall height of the enamel plaques. Either system would have produced a more coherent final effect.

This observation does, however, offer a lead that should now be followed. It was recognised by Deér that the distinctive ornamental design repeated on all the decorative plaques could be compared with detached plaques in Paris and Philadelphia and with one still in place on the Pala d'Oro in Venice, all of which displayed the decorative motif of meandering tendrils supporting small ornamental flowers and leaves.[23] While that in Philadelphia is perhaps the closest in its design, it seems that no-one has drawn

[22] While most earlier Byzantine enamel tended to use the *vollschmelz* technique consistently, it later became confined more to purely decorative areas.

[23] Deér, "Die byzantinierenden Zellenschmelze der Linköping-Mitra", Pl. 14 a–d.

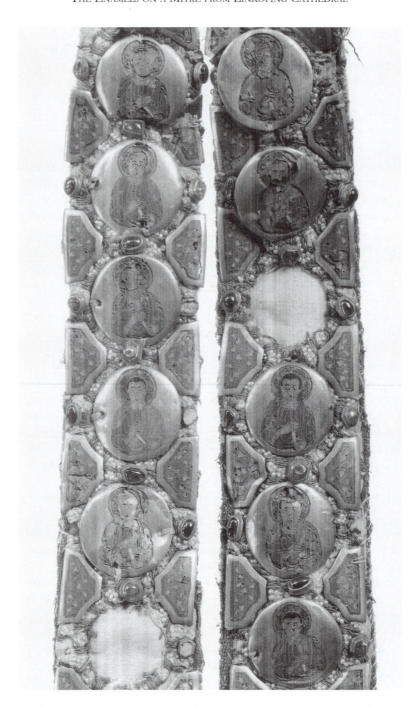

Fig. 5. Mitre of Bishop Karlsson, detail of upper part of lappets. (National Heritage Board, Stockholm.)

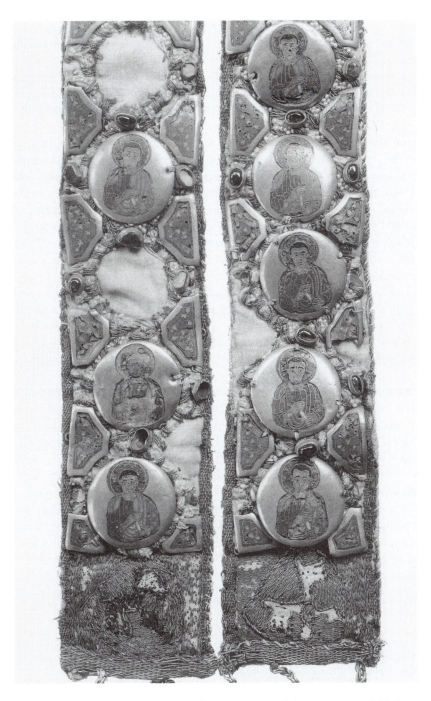

Fig. 6. Mitre of Bishop Karlsson, detail of lower part of lappets. (National Heritage Board, Stockholm.)

attention to the fact that the plaque on the Pala d'Oro, which Deér illustrates, is described as still being attached to cloth ("collocato sopra un sostrato di lino").[24] Among the 180-odd plaques on the Pala d'Oro this is the only one that has been described in this way, and this can surely only indicate that this plaque, too, must have had an earlier home where it was attached to a garment or textile object of some description. Without wishing to expand the argument to areas that would be outside the scope of this article, it could be mentioned that there are literary references, in sources such as the epic poem of Digenis Akritas,[25] to enamel ornament adorning secular garments, and that these refer indubitably to Byzantine usage. The possibility could therefore be suggested that the two different types of enamel found on the mitre from Linköping, despite the interlocking nature of their forms, might well indicate that the ornamental plaques were produced later specifically to enhance the roundels with their figurative content, and which could otherwise have appeared somewhat unsupported and isolated in their appearance. The two groups of plaques were therefore assembled for the purpose of adorning the mitre of a western bishop, but the indications are that the roundels ante-date their decorative surrounding plaques.

These suggestions about how the enamels came together can be used to contribute to a proposal for a new possible location for their production. Almost the only recognised centre for this kind of enamel production that has not been put forward as a source for the enamels from Linköping is Constantinople. Furthermore, it is now suggested here that the character of these plaques is very much what might have been expected in the capital in the years following the capture of the city by the Fourth Crusade. So little artistic production has been attributed to the capital during that period that it is almost as if a presumption existed that production of art objects must have ceased when this city was occupied by western rulers after 1204. Yet at least some of the same craftsmen who had been at work in the city prior to that date must surely have stayed on, at least for a few years, and so would have been available to fulfil commissions from these new victors of the Fourth Crusade. We know of so little pictorial art being produced in the capital during this period, with only the fragmentary remains of a wall-painting of a St Francis cycle in a chapel in what was the church of the Kyriotissa monastery, but now called the Kalenderhane, being still visible;[26] other than this one monument, very few examples of thirteenth century painting originated there with certainty.[27] In the field of manuscript illumination a few examples, which contain either their text in both Greek and Latin, or scrolls held by evangelists with their texts in Latin, such as Paris, Bibl. Nat. cod. gr. 54 and Athens, National Library cod. 118, or a close derivative, as Athos, Iviron, cod. 5, have been attributed to production in the

[24] Hahnloser and Polacco, *La Pala d'Oro*, 69–70, Pl. LIX.

[25] J. Mavrogordato (Ed.), *Digenes Akrites* (Oxford, 1963), 80; discussed in P. Hetherington, "Enamels in the Byzantine World: Ownership and Distribution", *BZ*, 81 (1988), 29–38 (here Study II).

[26] C.L. Striker and Y.D. Kuban, *Kalenderhane in Istanbul. The Buildings, their History, Architecture and Decoration* (Mainz, 1997), 128–142 and Pls. 155–170. This St Francis cycle has to be dated between the saint's canonisation in 1228 and 1261.

[27] The persistent growth of interest in the art produced in the Crusader territories has so far necessarily only extended in limited ways to Constantinople itself.

capital during the Latin occupation,[28] but final confirmation is still lacking. Certainly, no agreed consensus on artistic production in the city has ever been built up that would provide a background against which a tradition of small scale ornamental metal working might have survived during the period of Latin rule. Yet a possibility that, for at least a generation, Greek artists of various disciplines would have remained in the city (perhaps only *faute de mieux*), and been available to undertake commissions from its new occupiers, should be considered. Although Latin rulers might well have encouraged the arrival of western craftsmen in the city, with the needs of both a lay court and an ecclesiastical hierarchy having to be met, occasional patronage must surely have persisted at some level for any artists who were available. In more mundane fields of activity the Greeks of Constantinople indicated in 1214 with great eloquence that the very existence of life in the city was due entirely to their labours in the fields and vineyards. In a missive of complaint sent to Pope Innocent III via his unpopular cardinal legate in the city, Pelagius, they could claim that were it not for their labour, working in the countryside and sailing the seas, "…grain would not fill the threshing floor, nor [grapes] the wine-press; bread would not be eaten, nor meat, nor fish, nor vegetables; so human life and society would be unable to survive…."[29] While the complaint arose mainly from the religious intolerance of the Latins, this point concerning the provision of the basic necessities of life could not apparently be refuted, and underlines how essential was the presence of the Greek population for the continued existence of Latin rule.

If claims such as this could be made on behalf of the agricultural population, it is difficult to see why some skilled craftsmen working in precious metals would not also have been in the same position. In the early years of the Latin occupation the resources of the city would have been able to furnish goldsmiths able to create the finely worked gold *bullae* for the new imperial rulers which have survived in small numbers from the years of Latin rule.[30] Inscribed in both Greek and Latin, their design and presentation, with western elements such as the equestrian figures depicted dominating the Byzantine, it must be expected that their production took place in Constantinople, whatever the origins of the individuals who created them. They indeed exemplify the truly hybrid nature of the city's thirteenth century culture. For a long time Constantinople had displayed a multi-national character, with several quarters dominated by western or – to a lesser extent – middle-eastern groupings, but after 1204, although the western powers (and particularly the Venetians) exercised overall dominance and governmental control, the artisan population would have remained substantially intact. The city was not depopulated. While the underlying hybrid nature of the culture of Constantinople would have increased during these years, it must also surely have been reflected in artistic production. The well-known manuscripts with Latin and Greek

[28] The MSS are illustrated and discussed in K. Weitzmann, *Studies in Classical and Byzantine Manuscript Illumination* (Chicago/London, 1971), 314–334.

[29] J.B. Cotelerius (Ed.), *Ecclesiae Graecae Monumenta, III*, (Paris, 1686), 516–517; the implications of this letter are discussed in K.M. Setton, *The Papacy and the Levant (1204–1571)*, I, (Philadelphia, 1976), 42.

[30] R.H.G. Chalon, "Trois bulles d'or des empereurs belges de Constantinople,"*Revue de la Numismatique Belge*, 3rd ser., 5 (1861), 384–391; also *Arethuse*, Fasc. 28 (Paris, 1930), xxx–xxxi.

texts, mentioned above, that are now assigned to this period, are evidence in another field of this mixed cultural background.

With goldsmiths in Constantinople apparently working for their new thirteenth century Latin patrons, we should now return to the enamels from Linköping and see if this background could also be proposed as an appropriate locality for their origin. There is no reason to suggest that they were originally intended to ornament anything other than a Latin bishop's mitre, and possibly gloves; no other usage can be seriously envisaged for such an assemblage complete with the names of the apostles in Latin. Yet it has long been known that, in the newly established Latin patriarchate in Constantinople, many new archbishoprics and bishoprics were created, all of which would have needed appropriate regalia for their new western clergy.[31] Not only is there documentary evidence for the existence of newly appointed western bishops in the sees of *Romanía*, but seals survive, bearing (like the *bullae*, mentioned above) bi-lingual inscriptions; these were produced for the new secular and imperial rulers, and must surely demonstrate their use of locally sited craftsmen.[32]

A prominent feature of the enamels from Linköping has been shown to be their undeniably hybrid nature: this is projected through the Byzantinising style that has always been recognised but allied with Latin names, the combination of raised, figural *senkschmelz* and flat, ornamental *vollschmelz* indicating the likelihood of two separate phases of production, the fact that the roundels have not just been re-used on bishop Karlsson's mitre, but that they were formed from at least two earlier and more coherent sets, and that there was in all probability an intermediary user even before they reached him. It is suggested here that the uncertainty over their place of origin which has produced suggestions ranging (among other places) from Palermo to Venice, is due to the ambivalence that their character conveys. A persisting argument used by supporters of a Venetian origin has always been the factor of the Latin names of the apostles, which is compared to the Latin found on the Pala d'Oro. As long as the view was held that the Pala was made in Venice, this could remain as a possible argument, but as this view is no longer tenable the Latin features cease to be significant. If Constantinople in the years following 1204 is proposed as a point of origin, the cultural ambivalence of that society becomes an explanation for the uncertainties – which indeed contribute to the apparent uniqueness – of the plaques now assembled on the mitre in Stockholm.

If this possibility is considered, it would represent no more than a modest step towards trying to extend our understanding of the artistic climate of the capital, which must have continued to exist in some form in the decades that followed the conquest of the Fourth Crusade. In a forthcoming article[33] I suggest that the modern world now retains only some 2%, or even less, of the works in enamel that were produced by

[31] R.L. Wolff, "The Organization of the Latin Patriarchate of Constantinople, 1204–1261," *Traditio*, 6 (1948), 33–60.

[32] For a sequence of imperial seals, some with inscriptions in Greek and Latin, see G. Schlumberger, F. Chalandon, A. Blanchet, *Sigillographie de l'Orient Latin* (Paris, 1943), 165–169, Pl. VII.

[33] *Byzantion*, 76 (2006),185–220 (here Study I).

Byzantine artists, and this level of loss could explain why there is not a larger 'control' group against which to assess other works where comparable uncertainties exist. In due course it may become possible to attribute other works that have survived, but which lack a secure point of origin, to the artists of the city working under a new political regime.

APPENDIX

Mitre from Domkyrka, Linköping: the enamels

THE ROUNDELS OF THE TWO MAIN PANELS

FRONT: [Annunciation]

Diameter (mm.)	Identity	Location
1. 45	S. SIMON	
2. 45	S. PHILIP	
3. 43	ARCHANGEL	
4. 48	S. MATTHEW	
5. 45	SERAPH	
6. 45	S. ANDREW	
7. 44	S. THOMAS	
8. 43	S. PETER	
9. 43	S. JOHN	

REVERSE: [SS. Peter and Paul]

Diameter (mm.)	Identity	Location
10. 45	S. THADDAEVS	
11. 42	S. PAUL	
12. 42	CHRIST	
13. 50	S. JOHN	
14. 42	SERAPH	
15. 45	S. LUKE	
16. 50	S. MARK	
17. 47	S. BARTHOLOMEW	
18. 42	S. MATTHEW	

THE ROUNDELS FROM THE LAPPETS
Originally there were 20 roundels, with ten on each of the lappets; now 3 are missing. All display male, nimbed, bust-length portraits, with no identifying names or titles. All are 34mm. in diameter.

THE DECORATIVE PLAQUES
Originally there were 78 of basically isosceles triangular form. The design of most of them has two sides given a concave shape with the three points flattened; in pairs at the end of a sequence only a single side is concave; now 13 plaques are missing.

XII

Who is this King of Glory?
The Byzantine enamels of an icon frame and revetment in Jerusalem★

For Hugo Buchthal at 80

In recent years scholars of various disciplines have shown a growing interest in the image of the dead Christ that is usually known in the West as the »Christ of Pity«, or the »Man of Sorrows«, and in Byzantium as either Ἡ Ἀκρα Ταπεινωσις (»The Ultimate Humiliation«) or (more commonly) Ὁ Βασιλευς της Δοξης (»The King of Glory«). Quite a substantial literature has now grown up around this subject[1]. This paper is concerned with the magnificent enamelled revetment and frame that once enclosed an icon with the latter title, and which is now displayed in the Museum of the Greek Patriarchate in Jerusalem[2]. (Fig. 1). The revetment must be the most spectacular example that has survived into modern times of imagery that was associated with this subject, and it is the later icon that is now enclosed by the revetment that must have hithero discouraged any full analysis of the ensemble[3].

The Inscriptions

There are three separate inscriptions on the housing of the icon which provide us with a starting-point for a full discussion. The latest is incorporated into the design on the silver sheet covering the reverse of the icon (Fig. 2); it is in Georgian, and is transcribed as:

’k: k’valad: adide: / ganmaxlebeli: xa / t’isa: amis: dadia / ni: k’acia: / k̆t’es: aket: atas: / švidas: samoc / da: atsa’.

Which can be translated as:
»Ch[rist], make great again the restorer of [OR: he who has made new] this icon; it is the man Dadiani in the year of Our Lord 1770[4].

Dadiani was a territorial patronymic of the princes of Mingrelia, but it is not possible to be sure which member of the family this would refer to. It is known that the present contents of the Museum of the Greek Patriarchate, which were until recently housed in the sacristy of the Church of the Holy Sepulchre, had been kept for centuries in the Treasury of the Monastery of the Holy Cross, outside the 16th century walls of Jerusalem[5]. This monastery, traditionally founded in the 4th century on the site where the tree from which the wood of Christ's cross was cut, was rebuilt in the

★ This article first saw the light of day as two papers read during 1989; the first was at a colloquium held in the Warburg Institute to celebrate Hugo Buchthal's 80th birthday, and the second was during the tenth Symposium on Medieval Enamel held at the British Museum. I would like to thank those present on both of those enjoyable occastions for the helpful and constructive comments which they provided.

[1] Among the more substantial recent contributions to this subject are: R. Bauerreis: »ΒΑΣΙΛΕΥΣ ΤΗΣ ΔΟΞΗΣ. Ein frühes eucharistisches Bild und seine Auswirkung, in: Pro Mundi Vita: Festschrift zum Eucharistichen Weltkongress, München 1960, 49–67; Pallas, 197–283; C. Bertelli in: The Image of Pity in S. Croce in Gerusalemme, in: Essays in the History of Art Presented to Rudolf Wittkower, New York 1969, 40–55; H. W. van Os: The Discovery of an Early Man of Sorrows on a Dominican Triptych, in: Journal of the Warburg and Courtauld Institutes 41, 1978, 65–75; L. M. La Favia: The Man of Sorrows. Its Origin and Development in Trecento Florentine Painting, Rome 1980; Belting, Im-

age; and idem, Bild; the last has a full bibliography of the Imago Pietatis, 299–300.
[2] I would like to thank Bishop Nikiphoros A. Baltazis, the Superior of the Church of the Holy Sepulchre, for the care and kindness with which he provided all the facilities which I needed while studying the icon.
[3] Previous publications of part or all of the icon and its revetment are in: W. Mersmann: Der Schmerzensmann, Düsseldorf 1952, VII, XXXIII and Abb. 2; Byzantine Enamels from the 5th to the 13th century, Shannon 1969, 170–172; Belting, Bild, 184–5 and Abb. 70, and Image, Fig. 22. It was discussed in Gabriel Millet: Recherches sur l'Iconographie de l'Evangile, Paris 1916, 484–488; by Marvin C. Ross: Enamels entry in the Catalogue: Byzantine Art an European Art, Athens 1964, 406, item 475; and in Pallas, 204–206.
[4] I am most grateful to Dr George Hewitt for transcribing and translating this inscription for me; Pallas and Wessel both also give this date (see n. 3).
[5] See Peradze, 220–223; he was presumably an earlier member of the family mentioned in the inscription on the verso of the icon.

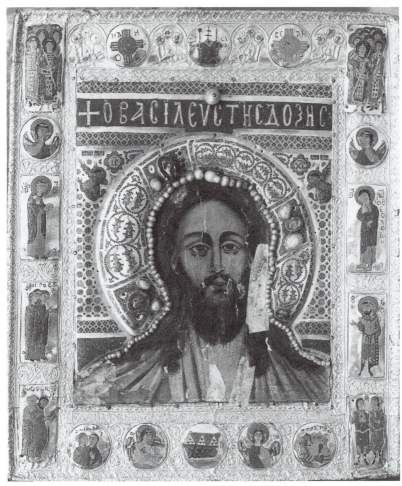

1. Jerusalem, Museum of the Greek Patriarchate. Icon with gold and enamel revetment and frame

12th century; it was one of the total of twelve Georgian foundations that existed at various times in or around Jerusalem. Georgian presence was gradually dwindling from the 17th century; although an inscription in Georgian of 1643, which is still visible below the altar of the catholicon, mentions a »Leon Dadiani«[6] from this period, Greek monks were exerting more and more control, and in c. 1739 Richard Pococke was there and wrote then that it »belongs to the Greeks«[7]. In the absence of any sure provenance for our icon, it must be this background which accounts for the 18th century Georgian inscription here.

The second inscription runs across the bottom of the frame just below the icon (Figs. 3 and 4).

6 Peradze, 246.
7 Richard Pococke: *A Description of the East,* 2 vols., London 1743–45, II pt. 1, 47; in describing the ceremonies of Easter eve in the Holy Sepulchre he does not mention any Georgian participants, but refers several times to Armenians being present (*loc. cit.,* 29).

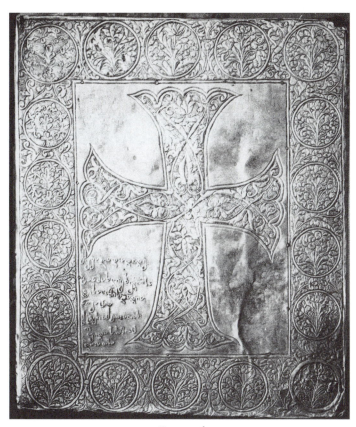

2. Reverse of 1.

It should be noted that the gold sheet on which the inscription is embossed is not a separate strip, but continues down to the lower edge of the frame; it has blank areas of the correct size left in its patterning to contain the five enamel roundels, and so must have been made expressly to contain them. The text is in Georgian script of the 13th–14th century; no transcription or translation has so far been published. It reads:

»miuc'domelsa šensa vnebasa šišit šemamk'obeli, sibrzeno da sit'q'uao, zc'olit šendami vqmob: momiqsene, mqsnelo, sasupevelsa šensa, upalo...«

It is a prayer which can be translated as follows:
»In adoring with awe thine immeasurable suffering, O [thou who art] wisdom and the word, in fear of thee I say: remember me, saviour, in thy kingdom, Lord...«[8]. As it mentions no individual by name, its presence serves chiefly to date a new phase in the history of the ensemble, but it does also show how, a century or so after its creation, the icon was already in Georgian hands.

The third inscription is of course the prominent title which adjoins the halo of the icon: + O BA–ΣΙΛΕΥΣ ΤΗΣ ΔΟΞΗΣ: »The King of Glory« (Figs. 6 and 7).

The palaeography of this title suggests a date not earlier than the second half of the 12th century,

[8] I am most grateful to Professor Zwab Sardzhveladze of Tbilisi for transcribing this problematic inscription, and for his translation.

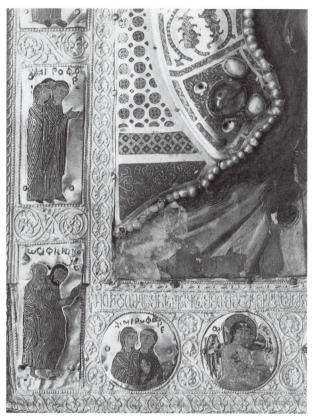

3. Detail of 1: lower part of frame (left)

and possibly later than that[9]. As the golden background of the enamel is continuous this must provide a date for the original ensemble of icon and revetment; it is not technically possible for the inscription to have been added later, as has been suggested[10].

Taking these inscriptions as a starting point, therefore, it would seem probable that the ensemble that we now have is the result of at least two separate changes being made to the original form and identity of the later 12th-century revetment and framing of an icon of the »King of Glory«: one when the present embossed gold of the outer frame was added in the 13th/14th century (i.e. something over a century later), and the second

in the 18th century, when the silver covering was placed on the reverse. It must have been at this point that the icon took on its present appearance; either the original was over-painted, or (more probably) a new one was substituted. The word used in the inscription (»restorer«) could be interpreted in either sense. There seem to be no grounds for thinking that the front of the icon (its revetment and frame) were altered to any great extent when the silver sheet was attached to the back in the 18th century.

[9] I would like to express my thanks to Professor Cyril Mango for his comments on the palaeography of this inscription.
[10] See Ross, *op. cit.,* (n. 3).

28

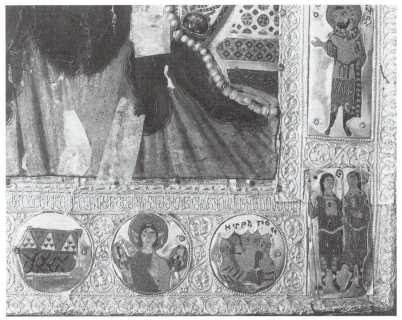

4. Detail of 1: lower part of frame (right)

The icon

The form for the subject of the »Man of Sorrows«
which had become established by about the mid-
13th century is that of a naked figure of Christ
with the head tilted down to the right shoulder
and the eyes closed; the figure is by then normally
seen in half-length and the hands are often shown
crossed[11]. It can be found in all principal media,
with the mosaic icon at Tatarna (Fig. 5) or the
miniature in the Gospels of Karahissar[12] exempli-
fying the smaller scale tradition, and the frescoes
of the Peribleptos, Mistra, showing its develop-
ment in monumental painting[13]. It is clear from
the asymmetry of the enamel halo in the Jerusalem
icon that the head of Christ was tilted down to
the right shoulder (which must confirm the iden-
tity of the subject of the original icon) but in its
present form there was certainly never space for
the rest of the figure in half-length. It must also
be noted that the profile of the neck and shoulders,
as dictated by the enamel revetment, would not
have allowed the head of Christ to be depicted as

is standard in other versions. While it is possible
to suggest that the icon was shortened when it
was »restored«, and so might originally have
shown more of Christ's body, the combination
of these two features is much more readily ex-
plained by the relatively early date of the original
ensemble. In the second half of the twelfth century
this would have been a highly innovative and ex-
perimental form of this subject; the tilting of
Christ's head, which probably derived from the
position of the dead Christ on the cross, as well
as the features just mentioned, all formed part of
the early development of this type[14].

[11] See e.g. Belting, *Bild*, Abb. 8, 10, 11, 13, 14, etc.
[12] Now Leningrad, Public Library, cod. gr. 105, fols. 65.v
and 167.v; see H. R. Willoughy: *The Four Gospels of
Karahissar*, Chicago 1936, pls. 34 and 106.
[13] The subject was normally located in the prothesis, as
here; see S. Dufrenne: *Les Programmes iconographiques
des Eglises byzantines de Mistra*, Paris 1970, 14, Fig. 62
and Dessin V.
[14] See Belting, *Bild*, 53ff. and Image, 12.

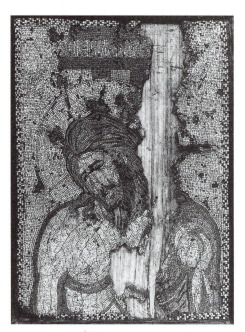

5. Monastery of Tripotamon, Tatarna, Evrytania. Mosaic icon of *The King of Glory*. (Courtesy of the Byzantine Museum, Athens)

The Enamels

Discussion of these can readily be divided between the large central revetment, shaped to reveal Christ's head, and the eighteen plaques that now surround it, let into pre-formed spaces in the decorated gold of the Georgian frame; (for a schedule of the enamels see Appendix).

Several features of the magnificent revetment call for some comment. The exceptionally large size of the single gold sheet forming the background should be noted; measuring some 23 × 21 cms., it is among the largest of middle Byzantine enamels with this irregular shape to have survived[15]. It should also be pointed out that the main inscription and the areas of decorative enamel forming the background are on one continuous area of gold. This is mentioned as the level of craftsmanship of the enamel forming the background is of an extraordinarily fine quality; each area of pattern is formed from tiny cloisons cut and fixed with a regularity that gives a brilliant and jewel-like re-

sult. This care, which is almost obsessive in character, is absent from the very bold lettering of the title; here there is nothing of the sharpness or love of crisp forms found in all other areas of the same gold sheet, but a simple emphasis on an easily read and emphatic message. The height of the letters, of some 2 cms., is unusually high, and so contrasts with the minute *tituli* of the archangels immediately below. This relative lack of interest in finish is carried through even to the somewhat pitted surface of the enamel of the title, which has been left largely unpolished, and with fragments of gold cloisons below the surface occasionally showing through[16]; this again contrasts with the two areas of blue enamel just above the shoulders of Christ, which contain a rinceau pattern of gold cloisons of the utmost refinement (Figs. 3 and 4). For whatever reason, this must indicate a division of labour within the enamel work on one sheet, but also means that the date suggested by the palaeography of the inscription must also apply to the rest of this area of the work.

The decorative vocabulary of the enamels in the background and in the halo is quite restricted, and does not break any particular new ground. The prominent lozenge design in the three patterned bands is already present in the enamels of the staurothèque at Limburg (964–985)[17]. The decorated rinceau forms of the halo compare with those in the frame of the famous enamel icon of St Michael in full-length in the Treasury of San Marco (Cat. no. 16);[18] even the small areas of blue enamel over Christ's shoulders also contain a delicate design of cloisons which again relate quite closely

[15] Besides the natural weakness of the shape of the revetment, where its bottom extensions would be naturally exposed to damage in the course of its life, the shape must also have been technically hazardous to produce; the uneven shrinkage of the metal as it cooled after the enamel had been fired would be more likely to produce flaking of the enamel than would a more regular shape.

[16] Relatively large areas of enamel need a »key« that was often supplied by small strips or scraps of gold that were not intended to show above the surface of the enamel in its final form.

[17] J. Rauch und J. Wilm: Die Staurothek von Limburg, in: *Das Münster*, VIII 1955, 201–240, Abb. 8 and 10.

[18] H. R. Hahnloser (Ed.): *Il. Tesoro di San Marco; Il Tesoro e il Museo* Florence 1971, 23–24 and Tavv. XVI and XVII.

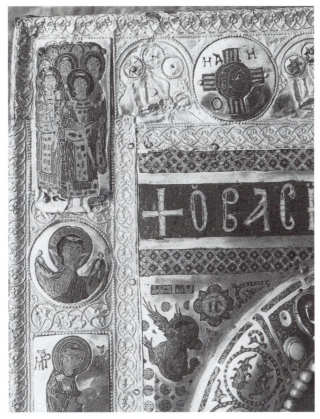

6. Detail of 1: upper part of frame and revetment (left)

to the enamel areas under St Michael's arms in the San Marco icon; although this is not a firmly dated work it is highly unlikely to be any later than the mid 12th century[19]. Finally, besides the asymmetry of the cross on the halo, mentioned above, there is also a good indication that the blank, slightly recessed outer border of the halo originally held a second row of pearls, as there are holes in the gold for its attachment.

Turning to the eighteen plaques mounted on the frame, a number of questions have to be answered. Are they all of the same date? Are they all from the same source, or, if not, from how many sources do they originate? What is their relationship with the central plaque of the revetment? At what point were all the enamels brought together?

It is evident from their subject-matter that with only three exceptions (and we shall see that they are important ones) the plaques must be regarded as originating within the context of the iconography of the events of Good Friday and Easter Day. To the former we can assign the figures of the grieving Virgin and St John, the roundels of the two angels adjacent to these and those of the sun and moon, the plaques of Longinos and the two standing soldiers, with (probably) the group of grieving women; all these are to be found in countless representations of the crucifixion[20]. To the events of Easter must be linked the plaque of

[19] A. Grabar in: Hahnloser, *op. cit.* (n. 18), 23–24 gives a mid-11th century date, as does Wessel, *op. cit.* (n. 3), 95.
[20] Millet, *op. cit.* (n. 3), 396–460.

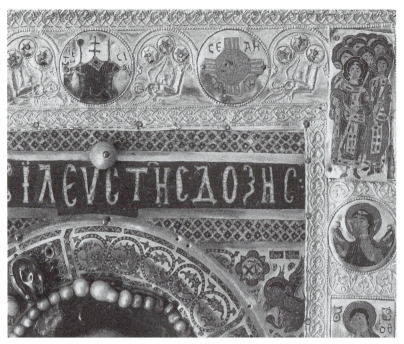

7. Detail of 1: upper part of frame and revetment (right)

Nicodemus and Joseph of Arimathea, the four roundels in the bottom row depicting the tomb, the group of sleeping soldiers, two myrrophoroi, and the two angels, one clothed in white (Fig. 3). As Byzantine art never developed a feast scene or iconography of the Resurrection of Christ, these must be seen (instead of the Anastasis, which was of course the *imago princeps* and standard feast scene for Easter) as implying the events of Easter Day. It can be seen at once that the plaques not embraced by this subject are the two groups of standing angels wearing loroi and the roundel of the Etoimasia. It is the consideration of the part played by these that allows for some new light now to be shed on the whole of this brilliant ensemble.

It is here that we must turn to one of the questions posed above: to what extent can all the eighteen plaques in the frame be regarded as being made for the same original setting? A preliminary answer must be that there appears to be no stylistic or technical reason that would prevent them from all all being seen as one homogeneous group. Sizes of plaques, treatment of cloisons, comparable colours of enamel, overall questions of style – on all of these grounds the evidence weighs heavily on the side of their being all members of one group. The only factor which might give cause for doubt here is the apparent duplication of one of the subjects: the title of *Myrrophoroi* is given both to a group of three standing women now placed opposite Longinos, and again below to two half-length figures in a roundel adjacent to the angel clothed in white. This does not, however, seem on its own sufficient to negate the uniformity of the group; the full-length figures would have appeared to the left of a crucifixion scene as the members of Christ's family, as in the central enamel of a composite icon now in Leningrad (Fig. 8), and were named as the Myrrhophoroi as no other brief title exists for this group of women.

It is also possible that there were one or two

losses from the enamels before they were fixed to the present frame in the 13th/14th century. There may have been two angels clothed in white (one either side of the tomb), rather than one, as now; there may also have been four roundels of angels to either side of the central image, not two, as now, as it is certainly quite common to find four grieving angels at the crucifixion[21]. If this was the case, it will only mean that one of the angels was transferred from the upper part of the frame to the bottom in order to maintain symmetry, but the general argument is in no way affected. (Such losses might indeed have been the cause for the »restoration« of the 13th/14th century).

With the one exception mentioned above, nothing has so far been said which departs to any significant extent from any previous opinions expressed on the enamels, but a comparison will now be made which breaks new ground. Most commentators have specifically stated that the central area of the revetment must be earlier than the enamels of the frame[22]. There are in fact only two figural elements in the central revetment which provide the basis for a stylistic comparison, and they are the two archangels portrayed in half-length adjacent to the sigilla of Christ's name, and named as Michael and Gabriel. If either is compared to the angel in the enamel roundel in the frame nearest to them (Figs. 6 and 7), it is hard to find any grounds for separating them to any significant extent, either in style or in period. After allowance is made for the different areas to be occupied by the two busts, and the variety of gestures that would in any case necessitate this, the features that the figures have in common are far more evident than any which separate them. Handling of cloisons in faces and drapery is very closely comparable. Given the differences already noted in the workmanship of the enamel areas of the central revetment, there does not appear to be any reason for separating them by any significant margin. It therefore becomes possible to consider that the entire ensemble of the enamels – the revetment and those in the frame – was not only produced at the same time, but also that they were always united on the same object.

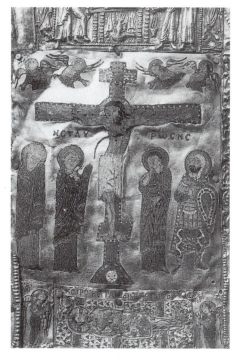

8. Hermitage Museum, Leningrad. Composite enamel icon; detail: central plaque.
(*Courtesy of the Museum*)

The liturgical context

So far this discussion has had to centre largely round considerations of style, technique and iconography. The time has now come to move from these to questions of the message implicit in the total ensemble of the original icon, its revetment and its frame – however these may have been assembled. Our attention will centre first on the subject of the imagery of the »Man of Sorrows« which must have formed the liturgical focus of the original ensemble. It is in this context that the three plaques which did not conform to any stan-

[21] The two conventions are represented quite evenly in Millet, *loc. cit.* (n. 3), 396–460.

[22] In both illustrations published by Belting the frame is omitted altogether, and Pallas, 206, actually suggests that the enamels in the frame were originally on a casket.

dard subject-matter concerning Easter – the Etoimasia and the two large plaques of groups of standing angels – will be seen to take their place.

In the recent literature on this field there has rightly been increasing emphasis placed on the part played by liturgy in the formation of new imagery, particularly during the eleventh and twelfth centuries. Indeed, it is now accepted that developments in liturgy played such a large part that images came into being whose very »language« was liturgical[23]. It has been established that the imagery surrounding the »Man of Sorrows« was developed in response to new rites centring on the Passion services; also, that it was in the monasteries of Constantinople, some of them the foundations of rich individuals, rather than in the services of the Great Church, that these new rituals were introduced[24]. Pallas showed how an image of the Crucifixion was initially used as a feast icon for the Passion services, and his conclusions were taken further by Belting, who has demonstrated how the imagery of the »Man of Sorrows« absorbed the significance of several icons into one complex visual allegory[25].

It is on this basis that we must begin to build a liturgical context for the Jerusalem icon. The icon itself must (we have seen) have been of the dead Christ, with his head tilted to the right and eyes closed. The titulus, which deliberately adjoins the halo by a small projection, declares triumphantly the dead Christ to be the King of Glory. This familiar phrase originates in Psalm 23:

»Lift up your gates, ye princes; and be ye lifted up ye everlasting doors, and the King of Glory shall come in. Who is this King of Glory? The Lord of hosts, he is this King of Glory«[26].

It is repeated in other contexts, including the Gospel of Nicodemus, the text which provided the main feast scene for Easter – the Anastasis[27]. It is indeed not so much with the central image that we should be concerned – its association with the Easter rituals can now be regarded as established. It is rather the other enamels now in the frame of the icon that should claim our attention.

The group of plaques which was related above, by reason of subject-matter, to Crucifixion iconography, takes its place in the context of Passion ritual without any apparent problem. It is the lack of any such firmly established imagery relating to the Resurrection and Easter which involves greater discussion on the part played by the other plaques. In this context it should be recalled that the title of Myrrophoroi was given to two groups of women – the rectangualar plaque of three and the roundel of two. These are mentioned several times in the services of Easter day, besides their appearance in the Gospel narrative; in the Oikos following the 6th canticle, for example:

»The Myrrophoroi forestalled the dawn, before the rising of the sun, seeking, as it were day, the Sun which had once set in the tomb,...«[26].

In this way the other roundels in the bottom row are all closely associated with the events of Easter morning: the group of soldiers, the tomb and the angels, one of them clothed in white, with the vertical plaque of Joseph and Nicodemus close by. Just as the enamels above implied by their presence the existence of an image of the crucifixion, but left the image itself to be supplied in the beholder's mind, so the enamels associated with Easter day implied the presence of an image of the Anastasis. The icon of the dead Christ as the King of Glory contained the essential theological reality of both these fundamental visual statements. As two of the central feasts of the Dodecaorton they were absent in physical form, but present in spirit.

This leads us to the final group of the roundel of the Etoimasia and the two rectangular groups of the choirs of angels. The latter would appear to be unique in the field of enamels, but can be found quite readily in representations of the Last Judgement in other media; certainly the Etoimasia is overwhelmingly a theme associated with judge-

[23] See Pallas, 1–10; Belting, Image, 2–3 and 6ff.
[24] Belting, Image, 2–3.
[25] Pallas, 87–102, and Belting, *Bild*, 160ff., Image, 10ff.
[26] Psalm 23, vv. 7–10 (Septuagint version).
[27] See M. R. James: *The Apocryphal New testament*, Oxford 1966, 134.
[28] Τὸν πρὸ ἡλίου ἥλιον, δύναντα ποτὲ ἐν τάφῳ, προέφθασαν πρὸς ὄρθρον, ἐκζητοῦσαι ὡς ἡμέραν, μυροφόροι κόραι, *Pentekostarion, Venice (Pinelli)* 1618, fol. 3.r.

ment[29]. (Fig. 8) The formal and theological link between this zone of the frame and the central revetment can be found in the two archangels, Michael and Gabriel; their gestures would seem to involve them as intermediaries between the Man of Sorrows and the choirs of angels above. It is perhaps these enamels which provide the strongest association between the icon and the liturgical context in which it was used: the King of Glory, having suffered the crucifixion and the three days in the tomb, is conducted in glory to the throne of judgement by angels and archangels. The concept of a progression or sequence of episodes recurs a number of times in the liturgy, as in this passage in the Hours for each day in the week after Easter:

>In the grave with the flesh, in Hell with the soul (as being God), in Paradise with the thief, O Christ thou did then exist enthroned with the Father and the Spirit, filling all and not capable of description«[30].

This discussion draws us towards the conclusion that the entire ensemble of icon, revetment and enamelled frame formed a single new creation *ab initio*, and one which presented a single and complete unity. Surrounding the central text naming the image below as the King of Glory, we have further clusters of meaning and allusion, drawn partly from the Easter liturgy and readings of texts which it contains, and partly from imagery lying behind this new presentation, and so forming a complex interaction with it. The Virgin and St John grieve at the foot of the cros (which is inferred, but not seen), while Longinos affirms in the Easter gospel that »truly this man was the Son of God«[31] and the Myrrophoroi below come »seeking the Sun, which had once set in the tomb«; the image of the Anastasis of Christ is also implied by the words of the Gospel of Nicodemus, and by the tomb to which Joseph of Arimathea and Nicodemus approach, as well as by the sleeping soldiers, but remains invisible to the physical eye. The Anastasis leads in turn to the Second Coming, implied by the throne of the Etoimasia; Christ, led by the archangels Michael and Gabriel and heralded by the two choirs of angels waiting on either side of the throne to greet the King of Glory,

then advances to the throne of judgement. In this way the icon, its revetment and its frame can be seen to have originally formed one total and complex unity.

The historical context

If this view of the ensemble is correct it will mean that, in response to the questions posed above, we will have to accept that all the enamels were created at the same time (which would have been in the second half of the 12th century) for the same single location, and for the embellismhent of an icon of the »Christ of Pity«; the icon and the original frame have not survived, but all (or certainly most) of the enamels have.

For what setting could this remarkable work have been created? We have already seen that the ensemble must have been of an experimental nature; it must also, given the extreme luxury of the materials used, have been provided by or for an exceptionally rich patron. An initial response must be that it was created in Constantinople; no other centre existed at this period where innovation and liturgical complexity would have flourished in such close proximity to a mature enamelling tradition of immense skill and sophistication.

There are however some other features which suggest that it may not have spent any appreciable time there after its completion. Even if it was created for a rich and idiosyncratic private individual, or for a minor but wealthy institution, one would have expected some of its features to have been perpetuated in some other artistic form; but there does not appear to have been any attempt to build on any aspect of the ideas implicit in the cycle as found on this work. While this apparent absence of any succeeding tradition could never be conclusive, it does suggest that the ensemble

[29] See Pallas, 102–104; and B. Brenk: *Tradition und Neuerung in der Christlichen Kunst des Ersten Jahrtausends; Studien zur Geschichte des Weltgerichtsbildes (Wiener byzantinische Studien, Bd. III)*, Wien 1966, 71–73.

[30] Ἐν τάφῳ σωματικῶς, ἐν ἰάδου δὲ μετὰ ψυχῆς ὡς Θεὸς, ἐν παραδείσῳ δὲ μετὰ λῃστοῦ, καὶ ἐν θρόνῳ ὑπῆρχες Χριστὲ, μετὰ πατρὸς καὶ πνεύματος, πάντα πληρῶν, ὁ ἀπερίγραπτος. Op. cit., fol. 6r.

[31] Matthew, ch. 27, v. 54.

was not generally available for wider inspection: for all its splendour it seems to have remained surprisingly uninfluential.

Following this thread, the only basis on which a tentative hypothesis might be erected concerns the association of the whole ensemble with Jerusalem and the *loca sancta* there. Not only do we know that it has spent at least some of its life in the city, but we have seen how the subject-matter of the enamels is dominated by the events and the liturgy of Easter. The question might fairly be asked: was the ensemble originally created expressly for export there, destined for some form of restricted or semi-private use?[32]

Of a few occasions on which some interchange certainly occurred at the period with which we are concerned, there is one on which a sumptuous object such as our icon might have found its way to Jerusalem from Constantinople. In 1158 a marriage was arranged between Theodora, a niece of the Byzantine emperor Manuel Comnenus, and Baldwin III, the Latin king of Jerusalem. Such a close relative of an emperor could not be married without conspicuous consumption, and William of Tyre relates that she arrived in Jerusalem with an immensely impressive array of objects and money: a dowry of 100,000 gold *hyperpera*, a contribution of 10,000 *hyperpera* to defray the expenses of the wedding, and a collection of objects in her trousseau valued at 40,000 *hyperpera* »...in quo tam in auro, quam in gemmis, vestibus et margaritis, tapetis et holosericis, vasis quoque pretiosis...«[33]. An icon of the kind discussed here could well have been among her personal possessions; her father was the *sebastokrator* Isaac, and it is quite conceivable that he could have initiated the commission for her. As an object of the »schismatic« Greek church it could not have been for use in Latin services, but could easily have remained in relatively private circumstances. Besides the general interest in the *loca sancta* of Jerusalem and the events of Easter, already mentioned, there is a feature of the enamels which suggests a genuine – and, for a Byzantine artist, unique – attempt to envisage the appearance of the Holy Sepulchre; there can be no other explanation for the represe-

nation of what appears to be a sarcophagus between the roundels of the two angels in the bottom of the frame (Fig. 4). For a Byzantine artist who did not know either the appearance of the Holy Sepulchre,[34] or of the church housing it, what could have been more natural than to adopt the characteristic form of an early Christian sarcophagus for this purpose?[35]

Theodora had been only twelve at the time of her marriage, and when Baldwin died five years later she retired, as a childless and beautiful widow aged seventeen, to Acre. An object such as our icon could well have been left behind when she left Jerusalem at this point. Certainly, her subsequent colourful and erratic lifestyle as the mistress of the future emperor Andronicus Comnenus, during which she bore him two illegitimate children, does not provide evidence of any particular devotion to liturgical observance[36].

[32] I would like to thank Dr Robin Cormack for his comments on this aspect of the problem.
[33] William of Tyre: *Historia rerum in partibus transmarinis gestarum*, Bk. 18, ch. 22 (RHC Occ., I, 2, Paris 1844, 857–8); the writer translates the Byzantine money into French coinage. See Bernard Hamilton: Queens of Jerusalem, in: *Medieval Women* (Derek Baker Ed.), Oxford 1978, 143–174.
[34] The empty tomb was commonly represented in Byzantine art as an opening in a rocky hillside, and this must be the intention of the artist in the Karahissar Gospels; see Willoughby *op. cit.* (n. 12), pl. 106 and Millet, *op. cit.* (n. 3), Fig. 567–571. The description of the sarcophagus by Pallas, 206, as an empty tomb (»leere Grab«) is difficult to reconcile with this representation.
[35] The enameller was also apprently unaware of the range of seals used by the Hospitallers in Jerusalem, some of which actually carried a representation of the Holy Sepulchre; see J. Delaville le Roux: *Mélanges sur l'Ordre de S. Jean de Jérusalem*, Paris 1910: »Note sur les Sceaux de l'Ordre de Saint-Jean de Jérusalem«, and »Les Sceaux des Archives de l'Ordre de Saint-Jean de Jérusalem à Malte«.
[36] Theodora was visited in Acre in 1166/7 by Andronicus Comnenus, and their liaison began there, his wife being meanwhile back in Constantinople; he subsequently invited her to go with him to Beirut and (according to William of Tyre) she was abducted by him while on the way to Beirut or (according to Nicetas Choniates) was persuaded to come »a sabbath day's journey with him« and was then forced to accompany him, the couple eventually coming to live in Damascus. See William of Tyre: *Historia*, bk. 20, ch. 2 *(ed. cit. 943–4); Nicetas Choniates: Historia*, bk. 4, ch. 1, CSHB, Bonn 1835, 185; also Hamilton, *op. cit.* (n. 33), 157ff.

While obviously nothing more than a hypothesis, this explanation would account for the period of the original creation of the ensemble, how it reached Jerusalem, why it displays an interest in the events surrounding the Resurrection which involves a unique representation of the sepulchre of Christ, why the ideas implicit in the enamel cycle found no subsequent following in Constantinople despite its being a period of artistic innovation, and why the the work is still to be found in Jerusalem. The point at which it came into the possession of Georgians cannot be known, but their importance in Jerusalem was paramount for several centuries. In 1050 part of Golgotha was given to them by the Byzantine emperor Constantine IX, and from at least 1347 until 1480 the key to the Holy Sepulchre was actually held by the Georgians[37]. This suggests that the icon could well have been in Georgian possession as early as 1163, but in any case must have belonged to them when the inscription on the frame was installed in the 13th/14th century.

[37] Peradze, 217–218; see also Pococke, *op. cit.* (n. 7).

APPENDIX

The Byzantine enamels of the »Man of Sorrows« in Jerusalem.
(Dimensions are in mm., with height given first.)

```
              2    3    4    5    6
              19                  7
                        1                  Overall dimensions of
  KEY:                                     the frame: 380 × 330
              18                  8
              17                  9
              16  15  14  13  12  11  10
```

	SUBJECT	DIMENSIONS	INSCRIPTIONS
1.	The revetment	232 × 210	Ο ΒΑCΙΛΕΥC ΤΗϹ ΔΟΞΗC
			ΙC ΧC
			Ο ΑΡΧ[ΑΝΓ]ΕΛΟC ΜΙΧΑ[Η]Λ
			Ο ΑΡΧ[ΑΩΓΕΛΟC] Ο ΓΑΒΡΙΗΛ
2 & 6.	Choir of angels	72 × 33	(none)
3.	The sun	36 diam.	ΗΛΗΟC
4.	The etoimasia	36 diam.	Η ΕΤΗΜΑCΙ[Α]
5.	The moon	36 diam.	CΕΛΗΝΗ
7 & 19.	Angel	36 diam.	(none)
8.	Saint John	70 × 32	Ŏ ĨΩ Ο ΘΕΟΛΟΓΟ[C]
9.	Longinos	68 × 30	Ο ΛΟ[ΓΓΙ]ΝΟC
10.	Two soldiers	59 × 31	(none)
11.	Five soldiers	37 diam.	Η CΤΡΑΤΙΟΤΕ..
12.	Angel	37 diam.	(none)
13.	The tomb	37 diam.	(none)
14.	Angel	37 diam.	Ο [ΑΝΓΕ]Λ[Ο]C ΤΕ..
15.	Myrrophoroi	37 diam.	ΑΙ ΜΙΡΟΦΟΡ..
16.	Joseph and Nicodemus	69 × 33	ΙΩCΙΦ Κ[ΑΙ] ΝΙΚΟΔ[ΗΜΟC]
17.	Myrrophoroi	62 × 32	Η ΜΙΡΟΦΟΡ..
18.	The Virgin	68 × 33	ΜΡ ΘV

The colours of the enamels

(The colour notation used here is that of the Munsell Color System.)

The palette of colours available in the workshop that produced the enamels is for the most part quite consistent with known 12th-century practice. The widely-used dark blue (7.5 PB 2/8) appears in the background to the main inscription, as well as being one of the colours in the adjacent patterned band (1); it is used also for the robes of the myrrophoroi (15 and 17), of St John (8) and of the Virgin (18) and in a number of smaller areas. The lighter greyish-blue (5 PB 4/6) is used throughout, and in larger areas appears as the colour of the under-garments of St John (8) and the Virgin (18), the armour of some of the soldiers (11) and for the whole of the moon plaque (5). The red (10 R 3/6) providing several of the inscriptions is also used for the sun (3), the soldier holding the sponge (10) and for part of Longinos' uniform (9) as well as being another of the colours in the patterned bands. As usual, most variety can be found in the colours of the haloes, although the quite common translucent green is absent here; those of St John and the Virgin (8 and 18) are a green-blue (7.5 GY 4/4), but more common is a turquoise blue (10 BG 4/4), used for Longinos, the angels (7 and 19) and for the angel choirs (2 and 6) as well as those in the revetment (1). A brownish-pink (10 R 6/2) is used consistently for flesh colour throughout, with just the two angels in the revetment being slightly darker. A yellow (2.5 Y 7/8) is used in several small areas such as the loroi of the angels (2 and 6) and in the pattern of Longinos' uniform (9). The only less common colour is a brownish-purple (2.5 YR 3/2) used for the robes in the myrrophoroi and for Nicodemus (17 and 6) as well as for part of the tomb (13).

Bibliography of frequently cited works:

– H. Belting: An Image and its Function in the Liturgy: The Man of Sorrows in Byzantium, in: *Dumbarton Oaks Papers* 34/35, 1980/81, 1–16 (hereafter »Image«).
– H. Belting: *Das Bild und sein Publikum im Mittelalter; Form und Funktion früher Bildtafeln der Passion,* Berlin 1981 (hereafter, *Bild*).

– D. I. Pallas: *Die Passion und Bestattung Christi in Byzanz. Der Ritus – das Bild.* München 1965.
– G. Peradze: An Account of the Georgian Monks and Monasteries in Palestine, as revealed in the Writings of non-Georgian Pilgrims, in: *Georgica* 4/5, 1937, 181–246.

The Gold and Enamel
Triptych of Constantine *Proedros**

The artistry and skill of the enamellers of the Byzantine period were so famous in their own age that their work was known and prized all over medieval Europe. Although only a fraction of their output has survived into modern times, their art was so renowned that all the main examples were thought to have been long known and published. It is therefore a great privilege to be able to display here an outstandingly brilliant example of Byzantine enamel that has remained hitherto completely unknown.[1] It has the form of a gold triptych of modest – almost jewel-like – scale and appearance (Figs. 1 and 2),[2] and from the Greek inscription on its suspension loop we know that it belonged to a Byzantine dignitary whose name was *Konstantinos* (Constantine) and who had the title of *proedros*.

The word *enkolpion* is used for a pendant that rests "on the breast", and the owner would have worn it suspended round his neck. The brilliance of its condition, with virtually no damage at all to its delicate enamels, suggests that during his life Constantine may have worn it inside his clothing, so protecting it from knocks and abrasions. It is also more common among surviving Byzantine *enkolpia*, that when they are made using gold, perhaps with enamel, they have the form of a box or capsule enclosing a relic that was devoutly believed to protect the wearer. One such work, although found in a grave in Bulgaria, would have been made in Constantinople during the twelfth century and is ornamented with enamel and a figure of the Virgin in relief; it probably contained a relic of a fragment of the Virgin's girdle (Fig. 3).[3] The triptych form appears to have been far less common in this field.

* Originally published as "'O Saviour, Save Me, Your Servant': An Unknown Masterpiece of Byzantine Enamel and Gold', *Apollo* (August 2006), pp. 28–33.

[1] The *enkolpion* is currently in private ownership; it was acquired by the present owner in 1968.

[2] The complete dimensions are: Height, including suspension-loop, 9.6 cm., without suspension-loop, 7.1 cm.; width (open), 11.4 cm., width (closed) 6.0 cm.; depth / thickness, 1.2 cm.

[3] The entry on this *enkolpion* and its relic in the catalogue *The Glory of Byzantium*, H.C. Evans and W.D. Wixom (Eds.), New York, 1997, no. 226, notes it as made in repoussé, but it has also been described as cast in gold throughout; see M. Vaklinova, *Mittelalterliche Schmuckstücke aus Bulgarien*, Sofia, 1981, p. 58. The enamel inscription on another *enkolpion*, which contained relics of Christ's Passion and which has a suspension loop very comparable to that discussed here, actually refers to its owner "wearing on my breast the flowers of Christ's Passion". This is now in Siena; see exhib. cat., L. Bellosi (Ed.), *L'Oro di Siena. Il Tesoro di Santa Maria della Scala*, Milan, 1996, pp. 107–110. The dimensions of the Sofia enkolpion are 5.3 x 3.7 cm., and those of the one in Siena are 5.7 x 4.7 cm.

Fig. 2. Back of the *enkolpion*. (P. Schälchli.)

Fig. 1. Front of the *enkolpion* with wings closed. (P.Schälchli.)

When the triptych is closed, displaying as its exterior the outer faces of the wings and the reverse of the centre panel, the overwhelming impression is one of great richness deriving from repeated patterns of ornament. Those on the two wings display a slightly more geometrical quality, with each column repeated four times, while on the reverse of the centre panel the ornament has a more flowing character based on a linking vegetal theme. Despite the luxurious appearance of these areas of pattern, the means of achievement are surprisingly limited, with colours restricted to just dark blue, dark red, green and white enamel. The extraordinarily fine condition of the enkolpion is emphasised by the fact that even the two tiny hinged catches seen at the centre of the top and bottom of the outer frame still function perfectly, and are entirely undamaged.

When these are turned and the triptych is opened (Fig. 4) this rich and continuous ornament gives way to a sparer use of enamel, and with the interest focussed instead on a sequence of beautifully chased gold figures in low relief. The central panel displays an image of the *Deesis* ('Entreaty' or 'Petition'), in which the enthroned Christ is flanked by full-length figures of the Mother of God and St John the Baptist, their hands outstretched towards him in supplication. This theme originated in connection with that of the Last Judgement, when these two figures intercede with the Saviour on behalf of the faithful.[4] Here, the basic *Deesis* of three figures has been expanded by the inclusion of half-figures of the archangels Michael and Gabriel, hovering above with their hands veiled, and on the inner wings of the triptych by standing figures of twelve apostles. On the left wing the saints Peter and Paul, Mark and Luke, and Thomas and Simon are shown in pairs in three registers, while on the right the saints John the evangelist, Matthew, Andrew, James, Bartholomew and Philip are shown in the same way. The four evangelists and St Paul all hold books to indicate their status as authors, while the others are shown with scrolls. At the feet of the enthroned Christ kneels the richly clothed figure of a man, who must be the Constantine *proedros* named on the loop above. Christ is shown barefoot, as was customary, and his left foot is held in Constantine's right hand; the kneeling figure looks upward towards the Virgin, so addressing his prayer to her.

While the image of a donor figure kneeling at the feet of Christ or the Virgin can be found quite frequently in monumental Byzantine art, where the provider of mosaics or wall paintings is shown with a dedicatory message, or in manuscript illumination where a volume may be being presented, it is not usually found in small-scale works of this kind in metal or ivory. Although a written prayer or other text can often be found as part of the design, it would seem to be unique for a portrait of the patron to be included in a Byzantine enamel *enkolpion*. This appears to be one of several features that point to a personal intervention on the part of Constantine *proedros,* who must have been an individual of highly original artistic vision.

[4] See C. Walter, *Art and Ritual of the Byzantine Church*, London, 1982, pp. 181–184.

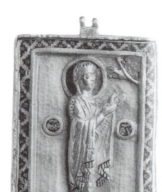

Fig. 3. *Enkolpion* with the Virgin Hagiosoritissa. (Natsionalen Arkheologicheski Muzei, Sofia.)

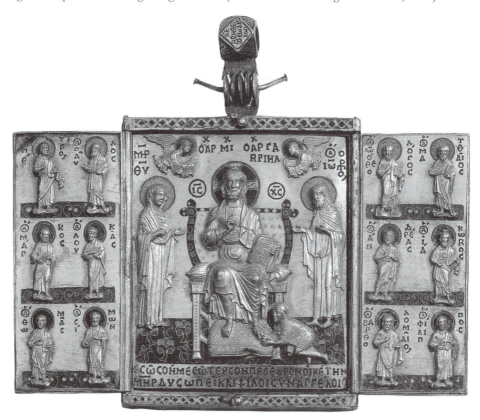

Fig. 4. Front of the *enkolpion* with wings open. (P.Schälchli.)

It can be seen that the enamel on the triptych is opaque except for the green, which would have originally been translucent but may have become less transparent over the centuries. Every halo has a red border, and that of Christ has special ornament where the white cross is edged in red and is dotted with blue and red lozenges imitating gems. The archangels' haloes are green, and those of the Mother of God and the Baptist turquoise. On the wings the three colours used for the six pairs of apostles form a counterpoint with those at the top having turquoise haloes, those in the middle green and those at the bottom purple-blue. Each pair of apostles stands in a green horizontal ground decorated with simple scrolls terminating in round cells of white or red.

As the overall display of enamel is somewhat reduced on the interior faces, emphasis is given to the beautifully modelled and chased gold figures in low relief. This particular combination of enamel and relief represents another rare departure in Byzantine art: while the central figure on the Sofia *enkolpion* (Fig. 3) was cast in one piece,[5] in our triptych each of the figures in burnished metal relief was cast separately and then fixed in place by split pins.[6] Their only colour is in the enamel of their haloes and the small areas of ornamented green enamel against which they stand. The art form of which this ensemble is most reminiscent is in fact not to be found in work in metal, but rather in that of ivory. A number of Byzantine ivory triptychs have survived which, when closed, display non-figural ornament, but when opened reveal tiers of standing saints, carved in relief and (in two of the most spectacular examples) also present a *Deesis* in their central panel.[7] Constantine could well have been familiar with ivories of this kind, and they could have provided him with his initial inspiration. If this association did indeed lie behind the commission of this work, it represents a further highly original viewpoint on the part of the patron.

All these factors now draw our attention back to the personality who must have initiated the commission for this outstanding work in gold and enamel, Constantine *proedros*. It must surely have been he whose personal influence lay behind this production of such striking individuality. On the multi-faceted suspension loop from which the *enkolpion* hangs is an inscription divided between three of the facets: two of them are visible from the front and the back, and one can only be seen from above. The three facets read:

Κ[ΥΡΙ]Ε ΒΟΗΘΕΙ (Τ)Ω ΣΩ ΔΟΥΛΩ / ΚΩΝΣΤΑΝΤΙΝΩ / ΠΡΟΕΔΡΩ
Lord help your servant Constantine *proedros*

while beneath the central scene of the *Deesis* is the inscription in which these two lines convey the invocation made by the kneeling figure of Constantine:

[5] This technique, which involves creating a relief from a single flat sheet of metal, is much the most common way of achieving this result in Byzantine work in metal.

[6] The split pins, inserted through holes in the metal background and then opened to hold each figure in place, were a simple but effective technique. It would have been adopted here to avoid the use of heat, which (if used) would have destroyed the existing enamel.

[7] The two ivory triptychs mentioned here are those in the Museo Sacro of the Vatican and the Harbaville Triptych in the Louvre; see A. Cutler, *The Hand of the Master. Craftsmanship, Ivory and Society in Byzantium*, Princeton, New Jersey, 1994, Figs. 169 and 170.

+ ΣΩΣΌΝ ΜΕ ΣΩΤΕΡ ΣΟΝ ΠΡΟΕΔΡΟΝ ΟΙΚΕΤΗΝ
ΜΗ[ΤΗ]Ρ ΔΥΣΩΠΕΙ ΚΑΙ ΦΙΛΟΙ ΣΥΝ ΑΓΓΕΛΟΙΣ
O Saviour, save me, your servant the *proedros*
Your Mother beseeches you as do [your] friends and the angels[8]

While this prayer is addressed to Christ, Constantine includes in his invocation all those portrayed in the triptych – the Mother of God, the Baptist and the 'friends' (the twelve apostles) with the archangels Michael and Gabriel. Their intercession on his behalf is implicit in the *Deesis* iconography. The entire composition of the open *enkolpion* in this way forms a unified programme of pious supplication and intercession on the part of the kneeling figure as he looks up towards Christ and his Mother. Imagery and words combine to provide a seamless unity, expressive of the highest ideals of Byzantine art.

Any attempt to give a date to this work should start by trying to find out more than just the name of Constantine *proedros*. Firstly, what would have been the station in life of this patron of an artist who must have been among the very finest of his age? The title of *proedros* denoted different things at different times, but in general it meant that its holder was the pre-eminent figure (or literally 'president') of a group. In earlier centuries the title would have been carried by a civilian or lay dignitary[9] as well as by a bishop or head of a monastery, but during the twelfth there is general agreement that it became more confined to the latter group.[10]

However, when we come to examine his clothing it is clear that he was not a cleric, but a senior lay figure (Fig. 5). He wears a cloak, known in the Byzantine world as a *chlamys*, with an overall ornament shown as simplified leaf forms; the scale of the portrait is such that the artist would certainly have had to reduce a more elaborate textile pattern.[11] The *chlamys* is fastened across his chest by two separate straps or chains; it has a border with a more complex and smaller-scale pattern. This garment carries very prominently a rectangle of even more richly decorated cloth that adjoins the border at the neck and the frontal edge of the *chlamys*, and supports the two fastenings across the wearer's chest; this is called a *tablion*.[12] This detail of clothing has a long history in Byzantium, and if Constantine had been depicted frontally he would also have been showing the right side of his *chlamys* which would have displayed a second *tablion*, linked to the left by the double cords. The *chlamys* was in early centuries fastened on the

[8] We wish to express our thanks to Professor Cyril Mango for his assistance with various aspects of the inscription.

[9] The title of proedros was first awarded in the tenth century to an eminent courtier Basil the Nothos, and thereafter to senior figures in both ecclesiastical positions as well as in a range of activities such as palace officials, the civil service, the legal system of notaries, those in charge of games in the hippodrome, controllers of the mint, or of silk production, and so on.

[10] We would like to thank Dr John Nesbitt for giving us his views on the use of the proedros title.

[11] As in e.g. the aristocratic portraits in the later superbly illustrated Lincoln College Typicon, gr. 15; see I. Hutter, *Corpus der Byzantinischen Miniaturenhandschriften*, Bd. 5.2, Oxford College Libraries, Stuttgart, 1997, Colour pl. 11 and 12.

[12] For this see P. Grierson, *Catalogue of the Byzantine Coins in the Dumbarton Oaks Collection*, vol. 2, pt. 1, Washington D.C., 1968, pp. 76–78.

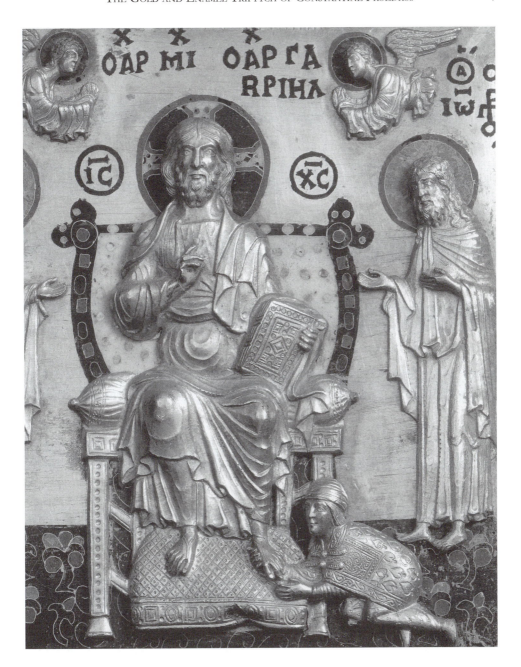

Fig. 5. Detail of centre panel, with Constantine *Proedros*. (P.Schälchli.)

shoulder with a clasp, but later could be joined across the chest, as here. The portraits on the opening page of a manuscript in Paris indicate these features very clearly, where four named individuals, all *proedroi*, attend a later eleventh century Byzantine emperor (Fig. 6).[13] Each of the courtiers wears a *chlamys* in which the *tablion* can be seen on both sides at chest height. This feature of lay ceremonial clothing would have carried considerable importance for Constantine, who would have had to pay to be allowed to wear it. It is very clear that in spite of its minute scale (the goldsmith had to reduce its size to just 3 mm. square) he was certainly taking the greatest care to ensure that it was visible. In any case this clothing makes it clear that Constantine was not a *proedros* from a monastic context but was a civilian dignitary.

As he had become a senior figure in Byzantine lay society, reaching what might have been quite a prominent position in the civilian life of the city and probably in the imperial court, one could have expected that the hat he is wearing might provide some further evidence of his status, but this does not seem to be the case, and do-nors in other contexts are often bareheaded. There is nevertheless one other feature that should be mentioned, and that is his clearly beardless state. The age that he must have reached to attain the honour of *proedros* was such that even if he had shaved in his youth, as a senior member among his peers he would have been expected to be bearded. We can therefore assume that he was a eunuch, and in this respect he was in a long and honoured tradition of Byzantine life. Eunuchs had existed in considerable numbers and occupied positions of great authority and success in Byzantine civil, re-ligious and even military spheres; in some cases certain positions were even, until the eleventh century, largely reserved for them. A monastery in Constantinople, founded c.900 by the emperor Leo VI and dedicated to St Lazarus, was actually reserved for monk-eunuchs.[14] The two figures wearing white hats on the right of the emperor in the Paris manuscript (Fig. 6), and wearing the *chlamys* with both sides of the *tablion* vis-ible, are portrayed as important eunuchs, and can be seen to be beardless. However, during the course of the eleventh century eunuchs began to be less favoured for the highest positions, and in the twelfth century became subject to some discrimination, although still existing in some numbers.

In proposing a date for this triptych it would, of course, have been both fortunate and conclusive to have been able to relate the name of Constantine to that of an indi-vidual with a known and identifiable personality and career within the Byzantine state. It so happens that the name of Constantine *proedros* can be found inscribed on the rim of a silver dish that recently came to light with twelve others which were exhibited at

[13] The manuscript (Homilies of St John Chrysostom) is Paris, Bibliothèque nationale, Coislin 79; the emperor depicted is Nikephoros III Botaniates (1078–1081). One of the eunuchs is the *proedros pro-tovestiarios*, who was concerned with the imperial wardrobe, and the other is the *proedros tou kanikleiou*, who acted as a private secretary of the emperor.

[14] For a full survey and discussion of this subject see R. Guilland, *Recherches sur les Institutions Byzan-tines*, I (Berlin/Amsterdam, 1967) pp. 165–380, "charges et titres des eunuques." The monastery dedicated to St Lazarus was probably close to the Sea of Marmara on what is now Seraglio Point ; see R. Janin, *La Géographie ecclésiastique de l'Empire byzantin*, Pt. 1, *Le Siège de Constantinople et le Patriarcat œcuménique*, Vol. 3, *Les Églises et les Monastères*, Paris, 1969, p. 299, with lit.

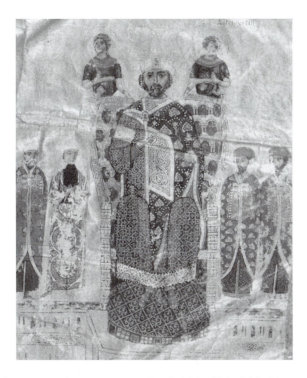

Fig. 6. Paris, Bibliothèque nationale, Manuscrits, Coislin 79, fol. 2. (Cliché Bibliothèque nationale de France.)

the Benaki Museum, Athens.[15] Here the individual is further identified as "Constantine *proedros* Alanos" ("the Alan"), but the forms of the inscription make it likely that its date is earlier, and insufficiently close for this to be the same as the Constantine on the triptych. Other ways in which we might have been able to further identify the patron could have been in documentary sources, and even more evidence could come from the thousands of lead seals which have survived, having been attached by officials to the documents that they had issued. There are indeed some such seals which name a Constantine *proedros* as having issued and used them,[16] but their date has always been too far from that of the style of our triptych to allow us to link the two.

So we must now turn to the internal evidence of the style of the enamel ornament, and the closest comparison that can be made is with a sequence of the decorative enamel plaques that were incorporated into the huge and matchless ensemble called the Pala d'Oro, in San Marco, Venice. The upper part of this contains mainly enamels that were taken as booty when Constantinople was sacked in 1204, and added to the

[15] We would like to thank Dr Anna Ballian for communicating valuable information on this treasure; see Anna Ballian and Anastasia Drandaki, 'A Middle Byzantine silver treasure', *Mouseio Benaki*, 3 (2003), esp. pp. 65–66.

[16] For example, we know from his seal that an eleventh century official Constantine proedros was in charge of communications and the postal service; see V.Laurent, *Le Corpus des Sceaux de l'Empire Byzantin*, II: *L'Administration centrale*, Paris 1981, p. 243.

existing enamels on the Pala in 1209 (Fig. 7).[17] These plaques display two forms of ornament that correspond closely with those on the triptych. One has the appearance of a formalised flower known as a Sassanian palmette,[18] very comparable to that found on the back of the triptych, and the other is more geometrically based, and relates closely to the ornament on the outside of the wings. This area of ornament on the Pala shared many of the characteristics of the large feast scenes now located just above them, and the fact that the enamels of the upper part are on gilt copper,[19] not gold, suggests to us a later twelfth century date. It is the style of the figures that is the most elusive when comparative material is sought. A good comparison can be made with the twelfth century *enkolpion* in Sofia (Fig. 3), and in the treasury of San Marco a Crucifixion group exists of three figures in cast gold relief mounted on lapis lazuli,[20] but the context here is relatively modern and their twelfth century date cannot be refined further. So the evidence points to a later twelfth century date for Constantine to have initiated and seen to completion this outstanding triptych, although this will mean that an existing consensus that lay *proedroi* did not exist after c.1150 may well now need revision.

Fig. 7. Detail of ornament of the Pala d'Oro, San Marco. (Per gentile concessione della Procuratoria di San Marco, Venezia.)

So there are at least three ways in which this enamel pendant of the utmost rarity displays (with its patron) exceptional qualities. Firstly, the way that enamel is combined with gold in relief is unprecedented among surviving Byzantine works; it is more remarkable for apparently being achieved with complete assurance and maturity of execution. Secondly, the adoption of a triptych format for a gold *enkolpion* would also seem to be broadly a new concept, irrespective of any ultimate source. Thirdly,

[17] The history of the Pala d'Oro is a complex one and is still debated; it was given its present form in 1343–45, but there is general agreement that the upper part was added in 1209. The most recent study is by H.R.Hahnloser and R. Polacco, *La Pala d'Oro*, Venice, 1994.

[18] For this ornament see H.R. Hahnloser and R. Polacco, op. cit., p. 69. The same decorative motif recurs in manuscript illumination and in silks.

[19] This does not apply to the figurative roundels mounted on the decorative strips, which are on gold or (as in the case of the roundel of St Panteleimon in Fig. 7), silver-gilt.

[20] H.R. Hahnloser (Ed.), *Il Tesoro di San Marco. Il Tesoro e il Museo*, Florence, 1971, Cat. no. 19, Pl. 23. It was far more common to create figures or ornament in relief using the repoussé technique on sheet metal, rather than by casting.

for Constantine to have had himself portrayed so explicitly within his triptych also represents a departure from other works of this kind. We have to regard this eunuch, who had attained the high dignity of a *proedros*, as providing the primary creative mind and will behind a completely exceptional work of art; he seems to have been able to convey to an artist in enamel and gold the essence of what to us is this largely new art form. We might close with the thought that, like many other men of the Great City, Constantine after making his mark in the world could in old age have become a monk and retired to a monastery. In his case this could well have been that of St Lazarus, where he would have passed his final years treasuring this *enkolpion* which some eight or more centuries later we are now privileged to admire.

The Frame of the *Sacro Volto* Icon in S. Bartolomeo degli Armeni, Genoa: the Reliefs and the Artist

The famous icon of the *Sacro Volto* in Genoa and its impressive silver-gilt frame have been the subject of numerous studies, but the complexity of the issues that are involved means that some gaps still exist in our knowledge of its origins.[1] Not only does the heavily varnished icon itself have to be related to the tradition of images of the Mandylion, and its position in the chronology and development of this tradition established, but the history of the original relic has to be related to the legend as narrated on the frame in S. Bartolomeo.[2] This article will not be concerned with the icon itself, but will be confined to studying its revetment and frame, where the ten reliefs portray episodes from the early history of the original 'Image of Edessa' (Fig. 1). These will be discussed with reference to some elements of the Abgar legend,[3] and the history of the relic itself after its importation into Constantinople in 944 and subsequent transference to Paris, probably in 1247.[4] While these reliefs offer a

[1] For most of its life in Genoa the icon was kept out of sight, being exposed only for three days each year, at Easter until 1557, and then subsequently at Pentecost; it is now on permanent exhibition in the church. The monograph by Colette Dufour Bozzo, Il *'Sacro Volto' di Genova*, Rome 1974, is still fundamental to its study, and her exhaustive bibliography (pp. 144–53) is virtually definitive to that date; some later literature will also be referred to here.

[2] The original Mandylion with its image of Christ, an *acheiropoieta* held in Edessa, was yielded up to the Byzantine John Kourkouas in 944 as the price of his raising his siege of the city, and he brought it at once to Constantinople, where it was kept in the Pharos chapel. Its appearance can be surmised from its many copies, of which that in Genoa is one of the most famous examples. Prominent in the literature are the studies of E. von Dobschütz, *Christusbilder, untersuchungen zur Christlichen Legende*, Leipzig, 1899, particularly pp. 102–96; S. Runciman, 'Some Remarks on the Image of Edessa', *The Cambridge Historical Journal*, 3, 1929–31, pp. 238–52; C. Bertelli, 'Storia e vicende dell'Immagine Edessena di San Silvestro in Capite a Roma', *Paragone*, 19, 1968, pp. 3–33; and A. Cameron, 'The History of the Image of Edessa: the Telling of a Story', *Okeanos: Essays Presented to Ihor Ševčenko on his Sixtieth Birthday (Harvard Ukrainian Studies*, 7), Cambridge, Mass, 1984 , pp. 80–94.

[3] For the sources of the legend of the mandylion, and its history into the tenth century, see below, notes 18–24.

[4] It was seen in the Pharos chapel in 1204 by the Frenchman Robert of Clari, who described it as hanging by one of two silver chains with its companion of the tile on which the original image had become imprinted: *'En l'un de ches vaissiaus, si i avoit une tuile, et en l'autre une touaile'*; see idem, *La*

narrative sequence of the creation and early history of the relic, consideration will also be given to questions not so far covered in the quite extensive literature; these concern their very individual technique, and their place in the art of their period and in the oeuvre of the artist who created them.

But first we should recount the few facts about the history of the Genoa icon on which there is general agreement. It is known that the icon was in the possession of the monks of S. Bartolomeo degli Armeni in Genoa by 1388, and had perhaps been in Genoa by as early as 1362; by tradition it was a gift of the emperor John V Palaiologos to the Genoese adventurer Francesco Gattilusi, and it had come into the possession of the Doge of Genoa, Leonardo Montaldo, who had bequeathed it to the monastery.[5] The 'gift' to Gattilusi was, it is now thought, more probably a theft,[6] but this will not concern us. The icon was stolen from Genoa in 1507 and spent a year in France,[7] but in spite of its varied travels and the relatively delicate appearance and technique of both panel and revetment, it remains in an outstandingly fine state of preservation, with no significant areas of damage.

The Artist and his Œuvre

For the purposes of this study a brief list of the scenes on the frame is given below as an Appendix, which includes notes on the colours of the enamel used and the literary sources which lie behind each of the scenes. Our knowledge of the icon and its main features is due in a major part to the extensive research and publications of Colette Dufour Bozzo. In her monograph on the icon she initiated the study of the frame and its reliefs by making comparisons of small details of some of the figures in the frame reliefs with book-covers now in the Marciana Library, Venice.[8] This article will develop this aspect of the frame and its creator by linking his style to other works and so allowing us to build up a picture of his developing œuvre.

The question of the filigree revetment will be left on one side, although study of the specialised artistry involved in this area could in due course be used to develop knowledge of personal styles; Alice Bank has already grouped a small number of such icon revetments, all of which exhibit filigree which is certainly of the same type

Conquête de Constantinople (Ed. Ph. Lauer), Paris, 1924, p. 82, ch. 83. Among the relics that were sent to Paris by Baldwin II in 1247 was one item, '*sanctam toellam, tabulae insertam*' of which the canvas (*toella*) is usually thought to have been the Mandylion itself (see Runciman, *op. cit.*, 251, and the Catalogue, *Le Trésor de la Sainte-Chapelle*, Paris, 2001, pp. 49–50); it was lost from the Sainte-Chapelle during the French Revolution. For other relevant data on the relic and its container see the entry by J. Durand in the Catalogue, *Le Trésor*, pp. 70–71; also P. Riant, *Exuviae sacrae Constantinopolitanae*, 2 vols., Geneva, 1878, II, p. 211 ff.

[5] Dufour Bozzo, *op. cit.*, p. 64–5, with references to the sources; also Dobschütz, *op. cit.*, pp. 191–3 and M. Balard, *La Romanie Génoise (XIIe – début du XVe siècle)*, 2 vols., Rome, 1978, pp. 884–5.

[6] See Dufour Bozzo, *op. cit.*, 64–5 and 86–7.

[7] It was stolen by the soldiers of Louis XII, who had occupied Genoa, and taken to Paris; a delegation of Genoese went to Paris and were able to return with it.

[8] Dufour Bozzo, *op. cit.*, pp. 27–32, Figs. 4–10 and n. 27–8, pp. 52–3.

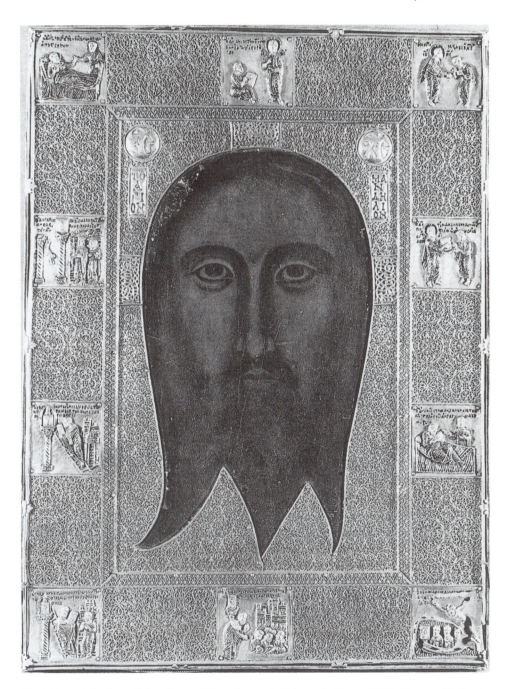

Fig. 1. Icon of the Sacro Volto, Genoa, S. Bartolomeo degli Armeni. (Roma, ICCD, Fototeca Nazionale, E 61779.)

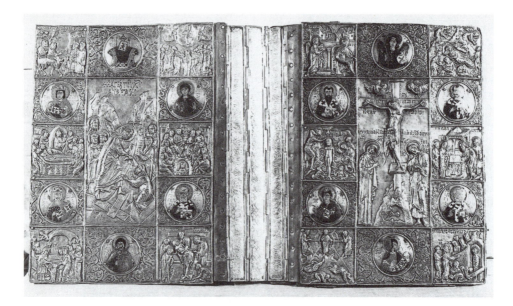

Fig. 2. Cover of ms. Gr. I. 53, Venice, Biblioteca Nazionale Marciana. (Foto Biblioteca.)

as that on the Genoa icon,[9] and there must have been specialists working continually – and probably exclusively – in this technique during the period with which we are concerned. Confining our observations to figural works in relief, two further associated works will be presented here; this will allow us to enjoy the rare privilege of being able to re-assemble part of the production of a workshop producing court and imperial commissions during the mid-Palaiologue period. These works can be linked, as a group, by quite extensive and unique documentation to the imperial palace.

We should start by summarising the main comparisons that were originally proposed by Dufour Bozzo, in which details from the reliefs of the icon frame were linked to details from the book covers in the Marciana.[10] She juxtaposed the figures of Christ in the Transfiguration scene from gr. I. 53 (Fig. 2) and in scene 2 of the Genoa icon frame (Fig. 3), of Christ again in the relief of the Noli me tangere on the book-cover and of his hands being washed in the icon relief of scene 3 (Fig. 4), and those of the crouching figures of one of the foremost apostles in the Koimisis relief on the book-cover and of the bishop Eulalios pouring oil on the attacking Persians in scene 9 of the icon frame (Fig. 5). To these details of whole figures she added three more: the heads of Christ and other figures (one from Marciana cod. Gr. I. 55), and a further

⁹ A. Bank, 'L'argenterie Byzantine des Xe–XVe siècles. Classification des monuments et méthodes de recherches', *Corsi di Cultura sull'Arte Ravennate e Bizantina*, Ravenna, 1970, pp. 335–53. See also A. Lipinski, 'Orificerie bizantine dimenticate in Italia', *Atti del I Congresso Nazionale di Studi byzantini, Ravenna 23–25 maggio 1965*, Ravenna, 1966, pp. 107–37.

¹⁰ As in n. 8, above.

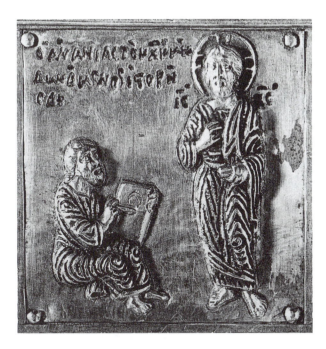

Fig. 3. Frame of Sacro Volto, scene 2: Ananias is unable to portray Christ. (Roma, ICCD, Fototeca Nazionale, E 61780.)

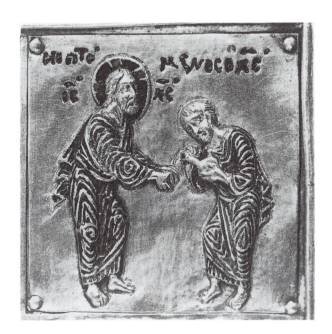

Fig. 4. Frame of Sacro Volto, scene 3: Christ washing. (Dufour Bozzo.)

tentative suggestion was made that brought an icon in the monastery of Vatopedi on Mount Athos into the discussion.[11]

These detailed comparisons have provided the most convincing arguments to date for the origins of the artistic personality behind the creation of the Genoa reliefs; although the question of relative scale was not discussed, any further conclusions have to start from these observations. It is also important to our discussion to realise that the figural details assembled by Dufour Bozzo related only to an association of

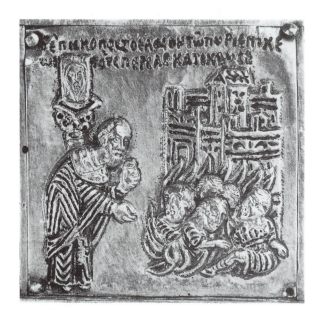

Fig. 5. Frame of Sacro Volto, scene 9: Bishop Eulalios pours oil on the Persians. (Dufour Bozzo.)

the reliefs on the book-cover in question with the Mandylion frame, and not to the enamel roundels incorporated into the design of Marciana Gr. I. 53.[12] This point will be taken up again later.

A further important link is now provided by a new association of the reliefs on the Genoa icon frame with two other works: a reliquary that shares with it the rare distinction of a proven origin from the imperial palace in Constantinople and the frame of an icon with an inscription naming a member of the imperial family of Doukas. To take the reliquary first (Fig. 6), which contained fragments from the purple garment of

[11] Dufour Bozzo, *op. cit.*, Fig. 22. This detail, from an icon of the Trinity, is here named as representing St John, whereas it is in fact of St Nestor.

[12] See H.R. Hahnloser (Ed.), *Il Tesoro di San Marco: Il Tesoro e il Museo*, Florence, 1971, no. 38 and Tav. 38; upper cover reproduced in colour in K. Wessel, *Byzantine Enamels from the 5th to the 13th century*, Shannon, 1969, pl. 66a.

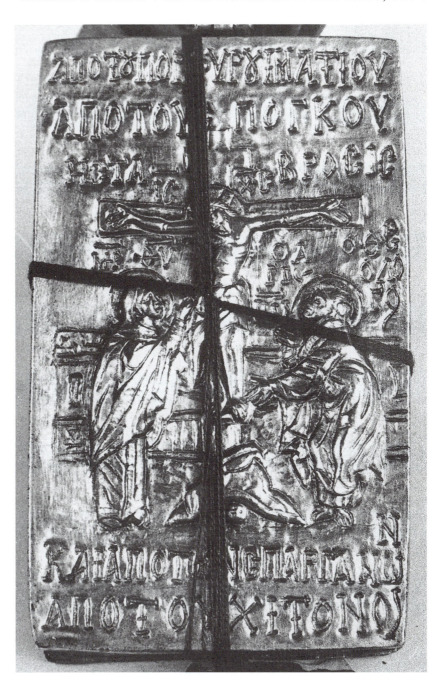

Fig. 6. Reliquary, Siena, Ospedale della Scala. (Roma ICCD, Fototeca Nazionale, N 18707.)

Christ's mocking, from the sponge used at the Crucifixion, from the swaddling clothes and from Christ's tunic; it was listed in a group of some forty relics and reliquaries that were sold in Constantinople by the empress Helena in 1357 to a Florentine merchant in order to raise the money to pay a large ransom demand. They were all at that time in the possession of the imperial family, being kept in the imperial palace, and the empress only parted with them 'with great sobbing'.[13] In 1359 they were re-sold to the authorities of the main hospital in Siena (the Ospedale della Scala) for the very large sum of 10,000 gold florins, payable in instalments. The records of this transaction must constitute the most complete documentation of the transference of such a major group of artefacts not just from Constantinople, but from the imperial palace itself, to an institution in Italy.[14]

An evident feature of the facet of the reliquary shown here is the emotional gestures of the figures beside the cross,[15] and it is this emotional and dramatic quality that provides the unifying characteristic of the silver-gilt repoussé reliefs found both on the reliquary and in the small reliefs of the Marciana book-cover; significantly, it can be also be seen to recur in the expressive details of the figures on the Genoa frame first mentioned by Dufour Bozzo. Her observations can even be extended by further comparison, such as that of the figure of Symeon in the Presentation in the temple relief on the book-cover with those of scene 4 on the Genoa frame, Ananias receiving the mandylion from Christ (Fig. 7) and scene 5, Abgar embracing the mandylion (Fig. 8). This intention to convey a new level of emotion is perhaps (as mentioned above) at its most evident in the Crucifixion relief of the reliquary, where the vivid gesture used by St John has a quality of real drama, and is in clear contrast to the more restrained placing of the right hand against his cheek, which is much more commonly found. The fact that this element of emotion can be found to be less evident in the large relief on the Marciana book-cover, suggests that the artist's individualism may have been restrained when the larger reliefs were created, but allowed greater expression when working on a smaller scale.

The second of these works created by an individual with a very distinctive style is the frame and revetment of an icon of the *Virgin Hodegetria* now in the monastery of

[13] '*Cum grandissimo singultu*'; see P. Hetherington, 'A Purchase of Byzantine Relics and Reliquaries in Fourteenth-century Venice', *Arte Veneta*, 37, 1983, pp. 9–30, where it is given as Reliquary B, Figs. 6–7; the documents concerning the original sale and subsequent re-sale, which are all still in Siena, are given here, pp. 28–30. Also published here as Reliquary C (Fig. 11) is a staurothèque where cast silver elements are identical to part of the revetment of the *Sacro Volto* in Genoa. Both reliquaries were exhibited in the Ospedale della Scala in 1996–97; see L. Bellosi (Ed.), *L'Oro di Siena*, Siena, 1996, pp. 111–12 and pp. 120–23.

[14] The documents were partially repeated by G. Derenzini, 'Esame paleografico del codice X.IV.1 della Biblioteca Comunale degli Intronati e contributo documentale alla storia del "tesoro" dello Spedale di Santa Maria della Scala', *Annali della Facoltà di Lettere e Filosofia dell'Università di Siena*, 8, 1987, pp. 41–76, without reference to their previous full publication in 1983 in *Arte Veneta*; see n. 13, above.

[15] The emotional quality of the Siena reliquary relief was already noted in 1947 by W.F. Volbach, 'Venetian-Byzantine Works of Art in Rome', *The Art Bulletin*, 29/2, 1947, pp. 86–94, particularly p. 94.

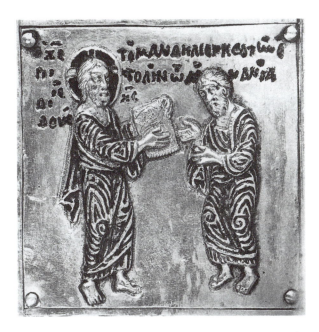

Fig. 7. Frame of Sacro Volto, scene 4: Ananias receiving the Mandylion from Christ. (Dufour Bozzo.)

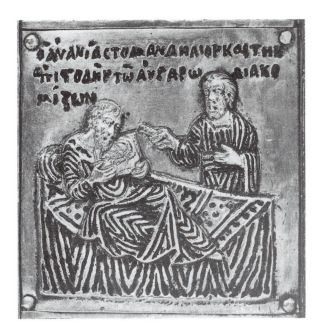

Fig. 8. Frame of Sacro Volto, scene 5: Abgar receiving the Mandylion from Ananias. (Dufour Bozzo.)

Vatopedi on Mount Athos (Fig. 9). Not only does this bear a distinctive dedication of one Papadopoulina to her sister Arianitissa Kharis, but it can also now be shown that they were related to the imperial family of Doukas, and that the latter was *eparchissa* in the northern Greek town of Verrhia in 1375;[16] the association with aristocratic patronage is therefore maintained as well as providing us with a possible date. Both the revetment and frame, as well as its nine small reliefs, contain a number of elements that link it with that of the mandylion icon, but of particular interest for us is the small scene of the Crucifixion (Fig. 10), where again St John extends his left hand in the same highly individual gesture as in the reliquary. It is as if the ability to impart a quality of vivid emotion with the use of gesture that had begun to be present in the Marciana book-cover, as noted by Dufour Bozzo, had become more intense and personal in the reliquary sold in 1357, and can still be found maintained in the icon frame of c. 1375. All three of these works have demonstrable connections with either the imperial palace or with the imperial family.

Besides the personal style of the artist who created the reliefs in Genoa, an even more evident feature of his work is that of the technique which he used. To the relief elements in each of the ten plaques the artist, using a narrow punch in conventional repoussé technique, gave thin recessed striations, mostly parallel, to the main convex forms. These he then filled with enamel using an extremely small range of colours: only two shades of blue, a dark green, dark red and a very small amount of white were used, with a black substance, niello; this is not strictly enamel at all, being a material formed from metal sulphides, and usually has a lower melting-point than enamel.[17] This technique used for creating the enclosures (or *cloisons*) that contain the areas of different coloured enamel and the niello is, to the present writer's knowledge, a unique one, and cannot be found on any other surviving work of Byzantine enamel. The conventional method for all other Byzantine cloisonné enamel was for the *cloisons* to be formed from gold strips that were set on edge and attached to a base; these were filled with the powdered glass of the enamel before the plaque was fired in a kiln, but for some reason, which will be discussed below, this was not adopted.

The question must therefore be asked: what was the reason for this apparently new and experimental technique being adopted for the frame of such a prestigious icon, housed in the imperial palace? We may never have a secure answer to this, but

[16] E. Trapp, *Prosopographisches Lexikon der Palaiologenzeit*, no. 1314, Fasz. 1, p. 123, and no. 21746, Fasz. 9, p. 140, Vienna 1976–89. The inscription was first published by A. Grabar, *Les revêtements en or et en argent des icones Byzantines du Moyen Age*, Venice, 1975, p. 49–52, cat. no. 21, Figs. 47–52, and later by Th. Papazotos, 'Χριστιανικής επιγραφές Μακεδονίας', *Makedonika* 21, 1981, pp. 401–10, but neither developed the imperial connections of the donor or the style of its reliefs with other works. For the family association see D.I. Polemis, *The Doukai. A Contribution to ByzantineProsopography*, London, 1968, p. 104, no. 66.

[17] For some of these technical details I have relied on Pico Cellini's contribution to Dufour Bozzo, *op. cit.*, pp. 119–22, but he does not point out the problems of combining niello and enamel in one plaque. The making and use of niello is described in the 12th century treatise *De Diversis Artibus*, of Theophilus, chs. 28 and 32 (ed. C.R. Dodwell, London, 1961, pp. 80–84) but its application to metal is clearly regarded as a separate process, not carried out in combination with enamel, presumably because its melting point is considerably lower.

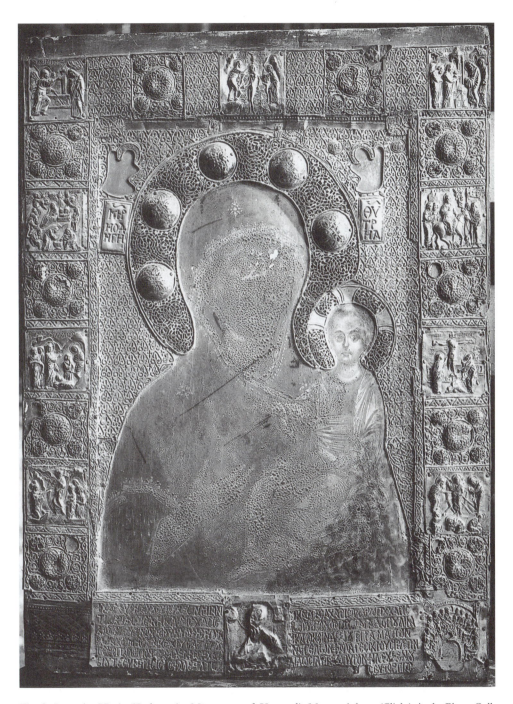

Fig. 9. Icon the Virgin Hodegetria, Monastery of Vatopedi, Mount Athos. (Cliché Arch. Phot. Coll. Médiatèque de l'Architecture et du Patrimonie © CMN, Paris.)

Fig. 10. Detail of frame of the Virgin Hodegetria, the Crucifixion.
(Cliché Arch. Phot. Coll. Médiatèque de l'Architecture et du
Patrimonie © CMN, Paris.)

it is nevertheless possible to offer explanations for some of the characteristics that
we find here. The artist of our reliefs would certainly have been able to have before
him examples of conventional twelfth century enamel, but he clearly was for some
reason unable (although surely not unwilling?) to attain the delicacy and accuracy of
the *cloisons* that he could observe there, and so adopted his own technique for creating
them by forming the narrow channels in repoussé mentioned above. In the same
way he must have had access to only a small fraction of the wide range of enamel
colours that artists from the great centuries of Byzantine enamelling would have
taken for granted. These observations are made even harder to explain by the fact
that the Marciana book-cover of Gr. I.53, from which details have been compared
with the Genoa frame, actually contains twelve enamel roundels which bear all the
characteristics of being a continuation into the Palaiologue period of established
enamel technique, with a developed colour range and finely formed *cloisons*. The
question has to be asked: considering these two works, why was the book-cover
supplied with roundels in conventional enamel technique and with a broad range of
colours, while the supposedly much more prestigious commission for the frame of
the Sacro Volto icon was adorned with ten reliefs which display a greatly diminished
level of enamelling expertise and much reduced range of enamel colours, but retain
the qualities of individual artistic expressiveness discussed above?

The answer must lie in the field of the availability of a skilled enameller when
the time came for the Genoa frame to be made. Such an individual must have been

available when the roundels for the book-cover were created, but could not have been still active when an artist of his expertise would have been the natural choice to contribute to the sumptuous commission of the frame of the Sacro Volto. Some such explanation, suggesting the passing of a skilled tradition, is needed to indicate why an artist of great originality, working to fulfil a commission of exceptional richness, appears to have not only confined himself to a very small range of enamel colours, but also to have been attempting to re-create a *cloisonné* technique for which practising specialists, with their particular skills and resources, were no longer available. It could be surmised that the creator of these reliefs was not really an enameller at all, but an artist in repoussé who embarked on this commission, for which an element of enamel was requested, and in the process invented a largely new technique. The result was therefore not so much a matter of the artist's choice, but was his solution to problems which were in some way imposed upon him.

It is certainly hard to believe that the originator of an imperial commission would have been prepared to accept enamels with such a simple and limited set of colours, if there were elsewhere in the city practitioners who were still able to achieve a richer and more varied range. In the same way it is hard to imagine that the greater delicacy to be found in the conventional formation of the *cloisons* from gold strips set on edge was simply rejected; an explanation is therefore offered here that the skills needed to achieve these results were no longer available when the frame was commissioned.

Inherent in this argument is the question of chronology. If the unique characteristics of these reliefs are the result of an attempt to re-create a technique of cloisonné enamelling in partial emulation of that of an earlier age, and when practitioners of this skill were no longer available, it is necessary to establish a date by which these conditions could have arrived. Here the limits of our current knowledge of the medium inevitably become apparent, with so few examples surviving with certainty from the decades after 1261, but some points can still be made. The book-cover in the Marciana with twelve enamel roundels (Fig. 2) represents one of the scarce examples of Palaiologue figure style in the established medium of cloisonné enamel; even the inscriptions on some of the enamels would have to be dated to well after 1261. Yet these plaques exhibit a range of colours which, with their style, allows them to be placed securely in the tradition of Byzantine enamelling practice; this enameller must have been working in the city in the late thirteenth century, or even later, but was certainly perpetuating an existing tradition. These roundels could not be called 'experimental' in the sense that we have used the word above, but rather are evidence of continuity; innovation is limited to development in style, rather than technique. It is here that the association with the patron Papadopoulina is important in allowing us to build up a picture of our artist being directly involved in the production of not just the reliquary sold in 1357, but also the icon with an inscription of c. 1375. This view of the chronology of the Genoa frame and its reliefs must also be seen not to conflict with characteristics of the Abgar legend as it can be understood from the scenes in the frame.

The Abgar Narrative

Much has been written on the legend concerning the acquisition of the mandylion by Abgar, the first century king of Edessa, and its subsequent travels. First mentioned by Eusebius in his *History of the Church* in the fourth century,[18] the narrative evolved in various ways, recurring in the *Historia ecclesiastica* of Evagrius Scholasticus in the sixth,[19] in the *De Fide Orthodoxa* of St John Damascene in the later seventh,[20] and being given fuller and more coherent treatment in the tenth, with the *Narratio de Imagine Edessena*,[21] attributed to Constantine Porphyrogennetos but more probably one of his entourage, and in the *Synaxarium ecclesiae Constantinopolitanae*,[22] and was still being repeated in the twelfth in the *Synopsis Historion* of George Kedrenos;[23] there is also a passing reference in Theophanes Continuatus.[24] While this is not the place to rehearse these various versions of the legend, some discussion of the selection of ten scenes that adorn the Genoa icon frame is certainly necessary. Our starting point here will therefore not be the textual sources, but the ten narrative reliefs, of which basic details are given in the Appendix, below.

The sequence opens with Abgar, mortally ill, sending a servant named Ananias to ask Christ if he would come and heal him. Christ does not come, but says that he will send his portrait. When Ananias is not able to paint the image of Christ due to the radiance that surrounds him, Christ washes his face and then takes a towel (mandylion) and, pressing it to his face, leaves the image impressed upon the cloth. Ananias takes this with a letter, back to Abgar, who casts down an idol and raises the image of Christ; this has now become a miraculous icon, and is set up on a column outside Edessa with a lamp suspended before it. Later, a bishop, Eulalios, to whom has been revealed the nature of the image, conceals it against a tile, and the mandylion imparts an impression of the image to the tile. The bishop Eulalios casts oil from the lamp, which has now taken on special powers, upon the Persians who are besieging the city, and they are burnt up. The final scene is of the healing of a demoniac while the mandylion is in a boat when it is being taken to Constantinople.

While there are a number of features of the episodes selected for treatment by the artist, such as the second, where the only literary source is the seventh century writings of John Damascene, there are, more importantly for our subject, two aspects of the

[18] Eusebius, *Historia Ecclesiastica*, I, 13 in P.G. 20, col. 120–29; see Dobschütz, *op. cit.*, pp. 102–4, and Runciman, *op. cit.*, pp. 238–40.

[19] Evagrius, *Historia Ecclesiastica*, IV, 27, in P.G. 86 pt 2, 2745–9; Evagrius narrates the expedition of Chosroes against Edessa, and mentions that the image then had miraculous powers.

[20] John Damascene, *De Fide Orthodoxa*, I, 27, in P.G. 94, 1173, where he briefly narrates the episode of the painter being unable to paint Christ's face due to the radiance emanating from it; his reference to the legend in *De Imaginibus*, I, 27 is no more than a passing allusion.

[21] The whole text of the *Narratio de Imagine Edessena* is in P.G. 113, 423–54.

[22] The event is the major commemoration for 16th August; see H. Delehaye (Ed.), *Synaxarium ecclesiae Constantinopolitanae. Propylaeum ad AASS Novembris*, Bruxelles, 1902, col. 893–901.

[23] Kedrenos, *Synopsis Historion*, I, 308–15; ed. Bekker, Bonn, 1838, p. 432.

[24] The text of Theophanes Continuatus, VI, 48, ed. Niebuhr, Bonn, 1838, p. 432, just relates the reception of the mandylion at Constantinople.

tenth and final scene on the frame (Fig. 11) that should be discussed here; this occupies ch. 27 in the *Narratio* as well as figuring in the *Synaxarium*, and concerns the healing of a demoniac. The first of these is that, instead of a relatively minor event which concerns the healing of a demoniac on the way to Constantinople (one of numerous miracles), it would have been much more appropriate to show the episode of the

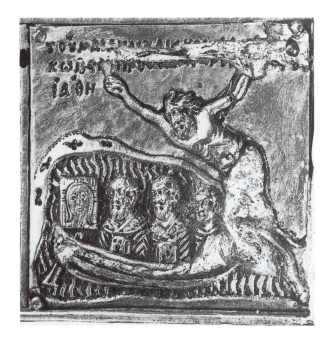

Fig. 11. Frame of Sacro Volto, scene 10: healing of the demoniac. (Dufour Bozzo.)

triumphant arrival of the relic in Constantinople or its installation in the Pharos church, which Constantine Porphyrogennetos achieved in 944.[25] From that point it was one of the foremost relics of the city. Leaving aside other aspects of this series of reliefs, it could be suggested here that a persuasive reason for the absence of an image of the mandylion arriving at the city and being installed in one of its foremost locations might be that it was not then still present there; such an image would not have been seen as appropriate if the relic had already been taken from the city by the western rulers, and was by then in the Sainte-Chapelle in Paris. While the date of its transference is not certain, as already mentioned it was probably among those that are known to have been taken to Paris in 1247,[26] and this would then both explain the

[25] The mandylion was taken to Constantinople the same year that it had left Edessa; see Dobschütz, *op. cit.*, p. 104.

[26] See n. 4, above.

absence of such an image, and provide us with a further date for a possible *terminus post* for the frame.

The second is the nature of the scene involving the demoniac. While this is only secondary to the theme of the artist of the reliefs, it has not been pointed out that to clearly indicate the scene taking place in a boat is in complete conflict with the text of the narrative as given in the versions in the *Narratio*, the *Synaxarium* and in Kedrenos;[27] no other version of the legend has been published in which this episode appears in this form. Not only would the overland route be the usual choice to bring the relics to Constantinople in the mid-tenth century, with individual towns such as Samosata (the modern Samsat) being mentioned, but the episode of the healing of a demoniac is described as being located not in a boat but at a monastery dedicated to the Virgin 'which was called "of Eusebios", and which was in the theme of the Optimatoi'.[28] This theme, of which the capital was Nicomedia, was in the north-west of Asia Minor and would only have been reached overland from Edessa. This must indicate that either the artist had used a textual or visual source now unknown to us, or that he had misunderstood such a source that is known. It is possible that one day a version of the legend will come to light which will allow this individual peculiarity to be explained, but for the present it must be said that the treatment of the Abgar legend by our artist does no more than offer a good reason for showing that it must have a *terminus post* of c.1247.

The Date of the Frame and Revetment

So in establishing a possible chronology for the Genoa frame and its reliefs we are left with the stylistic associations initiated by Dufour Bozzo and now extended here by the introduction of further works, and its technical characteristics. If it is accepted that the ability to produce enamels with a full range of colours and the traditional formation of *cloisons* could not have been present at the time when this major commission was originated, we have to start by considering the earlier decades of the fourteenth century. The fixed points that relate to the discussion are those of 1357 when the reliquary now in Siena was sold from the palace, and the later one of c. 1375 when the Vatopedi icon was inscribed; we have seen that these were in all probability the work of the same artist, and that they may be seen as a mature manner which was in evidence in its incipient form on the Marciana book-cover reliefs and those of the Genoa frame. The period during which the Abgar reliefs would have been created could on this basis be suggested as being towards the end of the second quarter of the fourteenth century – perhaps 1335–45. The reliquary would presumably have been in existence for some

27 The *Narratio*, ch. 27, the *Synaxarium*, *ed. cit.*, col. 900 and Kedrenos, p. 314, all agree completely on the location of this episode; refs. in nn. 21–3, above.

28 For the location, see R. Janin, *Les Eglises et les Monastères des Grands Centres Byzantins*, Paris, 1975, p. 93. The fact that the demoniac is reported to have cried out: 'Receive, O Constantinople, glory and joy, and thee, O Porphyrogenitus, thy kingdom' may have been due to current political rivalries; see Runciman, *op. cit.*, pp. 249–50.

years before it was sold by the empress Helena in 1357, and the Vatopedi icon could also antedate the year of 1375 when Arianitissa was known to have been in office in Verrhia. It was to this general period that Grabar dated all the later examples in his study of icon revetments,[29] and until or unless some further evidence is produced that allows us to operate with greater accuracy, this will have to remain as the best available evidence of chronology. It is, for example, possible that a late tradition for the episode of the healing of the demoniac while at sea in a boat, rather than on land, may also one day emerge, providing further data for a chronology.

This view of how an enameller might have survived in the decades after 1261 to create the roundels for the book cover using traditional techniques, but had not then been available for the mandylion icon frame, offers an insight into the operation of a workshop at this time. An ensemble of enamels, filigree and repoussé would almost certainly have been the result of collaborating specialists, and if, as in the case of the Genoa icon-frame, no enameller could be found, a non-specialist in enamel must have had to take his place.[30] In our case he was in all probability the same artist who had been working in silver repoussé, and who had then to invent his own technique for applying enamel to his reliefs. This seems to provide the best explanation for the experimental and unique nature of the enamel technique of the reliefs in the frame of the Mandylion icon in Genoa.

[29] Grabar, *op. cit.*, p. 48 ff.; Volbach, *op. cit.*, also dated the Siena reliquary to the mid-14th century.

[30] The reliefs with their enamel decoration have been omitted from all general studies of Byzantine enamel; this may be due in part to the fact that until recently the Sacro Volto was only available to public view for three days each year, and scholars of Byzantine enamel such as Kondakov, Bock, Schulz, Dalton and Wessel do not appear to have been aware of its existence.

APPENDIX

Details of the Ten Reliefs in the Frame of the *Sacro Volto*

All the reliefs are of silver-gilt, and of the same square format, measuring 48 x 48mm. The condition of all of them is excellent except for two; in the eighth the base of the columns is lost, and in the tenth parts of the inscription, of the demoniac's body, and of the figure on the right in the boat are missing. The inscriptions given below have been transcribed and emended into modern Greek text. The colours indicated are those of the enamels that fill the striations and other recessed parts. The enamel colours used are dark green, dark crimson and dark blue with a lighter blue used three times; the small areas of white are partially transparent, and those in black are in the medium of niello; this substance is used for all the inscriptions and for some figural areas in all the scenes.

The literary sources for the scenes as given here are not intended to be definitive (Syriac and Armenian versions are in any case excluded), but indicate the complex development and variety of the Mandylion legend. They are signified as:

A: Eusebius, *Historia Ecclesiastica*, I, 13.
B. Evagrius Scholasticus, *Historia Ecclesiastica*, IV, 27.
C: St John Damascene, *De Fide Orthodoxa*, IV, 16.
D: *Narratio de Imagine Edessena* (attrib. Constantine Porphyrogennetos).
E: *Synaxarium ecclesiae Constantinopolitanae* for 16th August.
F: George Kedrenos, *Synopsis historion*, I, 308–15.

The distribution of the reliefs is according to this sequence :

```
1   2   3
6       4
7       5
8   9   10
```

1. Abgar, [mortally ill], sends Ananias to Christ [with a letter].
Inscription: Ὁ Αὔγαρος πρὸς τὸν Χριστὸν τὸν Ἀνανίαν ἀποστέλλων
Colours: Abgar: green robe, black and red dots in collar; his bed: black, with red in the pillow; Ananias: green tunic, black upper garment.
Sources: A, B, C, D, E and F.

2. Ananias is unable to paint a portrait of Christ.
Inscription: Ὁ Ἀνανίας τὸν Χριστὸν μὴ δυνάμενος ἱστορῆσαι ĪC X̃C
Colours: Ananias: green and black robe; Christ: halo of green with black cross, green tunic, black upper garment, holding red letter.
Source: C.

3. Christ washes [his face, using a towel].
Inscription: Νιπτόμενος ὁ Χριστός
Colours: Christ: halo of black with blue cross, tunic in lighter blue with red on right sleeve, blue upper garment; Ananias: black tunic, red at neck, green upper garment.
Sources: D, E and F.

4. Christ hands to Ananias the towel [with the impression of his face] and the letter.
Inscription: Ὁ Χριστός τὸ μανδήλιον καὶ τὴν ἐπιστολὴν τῶ Ἀνανία διδούς ĪC X̄C
Colours: Christ: halo of black with lighter blue cross, clothing black with green at upper arm; Ananias: green tunic, black upper garment.
Sources: D, E and F.

5. Ananias brings to Abgar the image of Christ on the mandylion and the letter.
Inscription: Ὁ Ἀνανίας τὸ μανδήλιον καὶ τὴν ἐπιστολὴν τῶ Αὐγάρω διακομίζων
Colours: Abgar : garments of green and black; his bed: black sheet, green and red mattress, red pillow; Ananias: black tunic, green upper garment.
Sources: C, D, E and F.

6. Abgar overthrows the idol and sets up the image of Christ.
Inscription: Ὁ Ἀὔγαρος το εἴδωλον καταλύσας, τὴν εἰκόνα ἴστησι τοῦ Χριστοῦ
Colours: both columns: red and green ; Abgar: green and black tunic, red cloak and shoes; Ananias: garments of green and black, black shoes.
Sources: E and F.

7. It is revealed to the bishop that he must wall up the mandylion with the tile.
Inscription: Ὁ ἐπίσκοπος ἀποκαλύψει διὰ τοῦ κεραμιδίου τὸ μανδίλιον ἐντειχίζει
Colours: Column: red, green and black; bishop: black robe and white pallium; city frontage: black and green, with white dots on right door-frame.
Sources: D, E and F.

8. It is revealed [to the bishop] to discover the mandylion, the tile bearing the image.
Inscription: Ἀποκαλύψει τὸ μανδίλιον διακαλύπτει τοῦ κεραμιδίου ἔχοντος τὴν ἐικόνα
Colours: Column: green, red and black; bishop's robes black, pallium white; second figure: black robe with red at neck; city frontage: green, red and black.
Sources: D, E and F.

9. The bishop, pouring oil on the fire, burns up the Persians.
Inscription: Ὁ ἐπίσκοπος τὸ ἔλαιον τῶ πυρὶ ἐπιχέων τοὺς Πέρσας κατέκαυσε
Colours: Bishop: blue with white pallium; Persians: blue; flames: red; city: blue and red.
Sources: D, E and F.

10. Transporting the mandylion to Constantinople, a demoniac is cured.

Inscription: Τοῦ μανδηλίου δια[κομιζομένου εἰς τὴν Κωνσταντινουπόλιν ὁ δαιμονιζόμενος] ἰάθη

Colours: The sea: green and lighter blue; bishops' robes and third figure, black; their pallia, white; book covers, black and red.

Sources: D, E and F (but see comments, above).

The Byzantine Enamels on the Staurothèque from the Treasury of the Prieuré d'Oignies, Now in Namur

With an excursus on the association of pearls with Byzantine enamels

It is well known that among the hundreds of precious objects brought back from Constantinople to western Europe as loot by participants in the Fourth Crusade were considerable numbers of Byzantine enamels. Most of these would have already formed part of the adornment of objects to which they had always been attached, and any visitor to the Tesoro di San Marco in Venice will have seen numerous examples of such works, many of great splendour, where Byzantine enamels have remained united with their original ensembles into modern times.[1]

In many other cases, however, plaques of Byzantine enamel either became detached from their original home, or may indeed have arrived in the West as isolated objects. These can often still be found in museums or church treasuries, but it can be assumed that in all cases they would originally have been attached to some larger object. In a few other instances Western artists have re-used these plaques as ornament for objects of their own making; one example of such a practice is the cross in the Czech Republic that has now been returned from Prague to Vyšší Brod, which incorporates eleven plaques of Byzantine enamel.[2] This paper concerns a very comparable cross that is now kept in Namur by the Soeurs de Notre-Dame,[3] among a remarkable collection of religious artefacts that originated in the Augustinian Priory of Oignies.[4]

[1] H.R. Hahnloser, *Il Tesoro di San Marco: Il Tesoro e il Museo*, Florence, 1971, records (among other items) four book-covers and six chalices which have all retained their original enamel plaques.

[2] P. Hetherington, "The Cross of Záviš and its Byzantine Enamels: A Contribution to its History", in *Thymiama ste mneme tes Laskarinas Bouras*, Benaki Museum, Athens, 1994, pp. 119–122. The cross had spent over 60 years in the treasury of Prague cathedral until recently being returned to Vyšší Brod.

[3] I would like to record my sincere thanks to Soeur Suzanne Vandecan, SND, for her kind assistance while I was studying the cross in Namur.

[4] The only full catalogue of the collection is by Ferdinand Courtoy, *Le Trésor du Prieuré d'Oignies aux Soeurs de Notre-Dame à Namur et l'Oeuvre du Frère Hugo*, Bruxelles, 1953. (A seventeenth century inventory

The cross in Namur (Figs. 1 and 2) was constructed to contain two relics, both apparently of the true cross; the larger is patriarchal in form, the smaller is of Latin type, and both are recessed into the body of the cross, which is further embellished with eight plaques of Byzantine enamel.[5] Six of the plaques have retained their circular format, but two are now oval in shape; it will be suggested that these also were originally circular, and were altered to fit the available space on the vertical of the cross. This is formed from silver-gilt sheets, with a variety of relief and applied decoration, and which are attached to a wooden core; it is mounted on a triangular base of gilded cast copper. Although not by the same hand, consensus has largely been reached that both the cross and its base derive from the Mosan area, and were produced in the first third of the thirteenth century. This is accepted by Courtoy, the author of the catalogue of the Oignies treasure, who gives a bibliography.[6] If this date is correct it suggests strongly that the enamels that were incorporated into the cross must have arrived in the West shortly after the Latins entered Constantinople in 1204. The enamels are integral to the design of the ensemble, and so could not have been added after the cross was made.

The cross and its eight enamels seem, surprisingly, to have attracted most scholarly attention during last century, with only the analysis of Courtoy since 1906 amplifying the occasional mentions in general studies such as those of Helbig[7] and Collon-Gevaert.[8] The first publication by Didron in 1846 claimed that only the foot of the cross was a work of western artists, the cross and its enamels being Byzantine, and of the tenth century.[9] It was to be fifty years later that Bock, having chided both Labarte and Kondakov for not going to see it before publishing their comments on it (that of Kondakov in his great work on Byzantine enamel was particularly non-committal[10]) separated the cross, as a work of "frater Hugo", from its Byzantine enamels, for which he suggested an eleventh century date.[11] Since then this has been the prevailing view.

of it, not mentioned by Courtoy, was published by H.P.Mitchell, "Some Works by the Goldsmiths of Oignies, II", *Burlington Magazine*, vol. 39, 1921, p. 273–285.) This remarkable collection of over 40 objects, many of them attributed to the same goldsmith, *frater Hugo*, has remained intact by being concealed in its entirety on two occasions: in 1794 during the Revolution, and again in 1939, when it would otherwise have been destroyed when the convent was burnt down during bombardment in 1940.

5 A schedule with full descriptions is appended to this article.

6 Courtoy, *Trésor*, op. cit. (n. 4) 87–97; see also A. Frolow, *La Relique de la Vraie Croix*, Paris, 1961, pp. 479–480, No. 652, with further bibliography.

7 Jules Helbig, *L'Art Mosan*, 2 vols., Bruxelles, 1906, I, p. 94.

8 S. Collon Gevaert, *Histoire des arts du métal en Belgique*, Bruxelles,1951, VIII, p. 208–209. The cross has been loaned to several exhibitions in recent years.

9 A. Didron, *Annales Archéologiques*, t. V, 1846, p. 318–328.

10 J. Labarte, *Histoire des Arts Industriels au Moyen Age et a l' époque de la Renaissance*, 2eme. ed., 3 vols. Paris, 1872, I, pp. 330–331; N. Kondakov, *Histoire et Monuments des Emaux Byzantins*, Frankfurt, 1892, p. 157, where the bland comment that the enamels 'ne manquent pas de caractère' does not suggest a first-hand appraisal.

11 F. Bock, *Die byzantinische Zellenschmelze der Sammlung Dr. Alex. Zwenigorodskoi*, Aachen, 1896, pp. 323–327 and pl. XX.

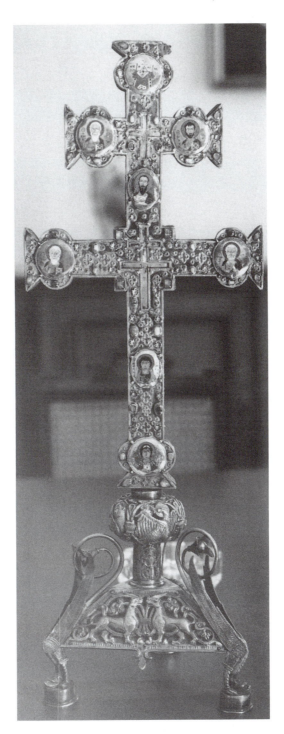

Fig. 1. Namur, Convent of the Soeurs de Notre-Dame; Reliquary of the cross.

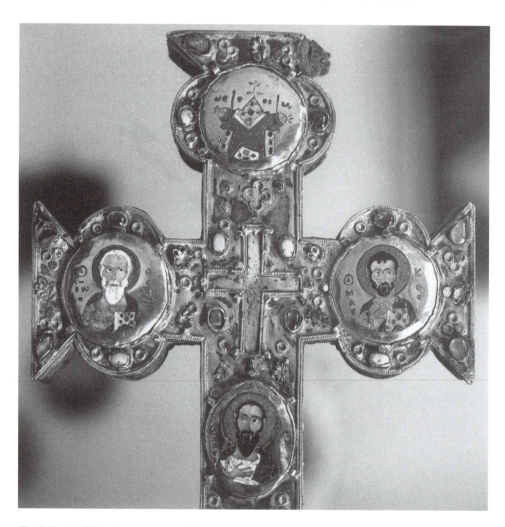

Fig. 2. Detail of Fig. 1; upper arms of the cross.

The schedule given below indicates that for the most part the plaques now united on the cross in Namur correspond broadly to what might be regarded as part of a predictable ensemble, such as might have been originally created for a Byzantine object intended for liturgical or cult use.

This paper will be concerned with four questions that have not so far been asked about the enamels now found on the cross: Did the eight plaques now on the cross all derive initially from the same object? What would have been the function or class of object to which they were originally attached? Would they have been part of a larger ensemble, and if so, what plaques may have been lost from it? And what is the significance of the means by which they were reattached in their new location? Answering this last question will involve a short excursus on the association of pearls with enamels.

To take the first of these questions, it is clear that the purely physical characteristics of the collection of plaques share a number of common features. Not only are the dimensions of the roundels all virtually identical, but the characteristics of style, the nature of the inscriptions and the range of colours used are homogeneous throughout the group. It is also clear that there is no physical reason why the two oval plaques (Figs. 2 and 5) could not also have originally been circular and of the same diameter before being trimmed down to fit into the width of the cross. The inscriptions of all eight plaques are also the same in scale, type and colour. These factors must collectively strongly suggest that the plaques in Namur would originally all have been created for installation on the same object, and that none have been inserted from elsewhere.

Of perhaps even greater significance is the fact that they all share a common feature which is rarely, if ever, found on other groups of plaques that have been re-used in a comparable way. This is the narrow frame that surrounds each of the roundels, and which has four small loops attached equidistantly round their circumference; in some cases these loops have been flattened (Figs. 3 and 4). This aspect will figure again in responding to both the last two questions posed above. It has been suggested that these were for attachment to liturgical vestments,[12] but this view is rejected for reasons which will be given below. For the present it can be shown that there are a number of examples of enamel plaques of varying shapes still attached by comparable frames to the objects for which they were originally made; a group of such objects is assembled below in a brief excursus, and can be seen to include eight chalices, three book-covers and two crowns. The reason for making this point will be shown to be that the loops protruding from the holding frames were created expressly for the attachment of pearls that were drilled and threaded on wire. For the present, however, it should be noted that in all these examples each set of frames can be seen to have the same number of loops attached, but that the number varies from one ensemble to another: from three on those of the earliest of the book-covers, to four on the votive crown (as on the Namur cross), five and six respectively on the two chalices that have circular enamels, to fifteen on the roundels of the other book-cover.[13] This variety offers further evidence that for the frames of all eight plaques on the Namur cross to have the same number of loops, their original identity as a single group has been maintained.

But further evidence can be drawn from this question of the frames. In the examples cited above, the loops attached to the frames had been created in order that the roundels could be adorned with a circlet or surrounding string of pearls. (The same technique can be found where the enamel plaques are rectangular.) It can be seen that in almost all cases the pearls are still attached,[14] and that this was achieved by their being

12 Courtoy, *Trésor*, op. cit. (n. 4), p. 89

13 See notes 35–39, below. Pearls threaded in this way can surround plaques that are either circular or rectangular, can form a frame round en entire book-cover, or (as in the Hungarian crown) form a continuous string round its whole circumference.

14 This is only partially true of the book-cover in Hahnloser, *Tesoro*, op. cit. (n. 1), cat. no. 35 (Pls. XXXII–XXXIII), where the pearls that surrounded the cross and ten enamel roundels on the verso are no longer in place.

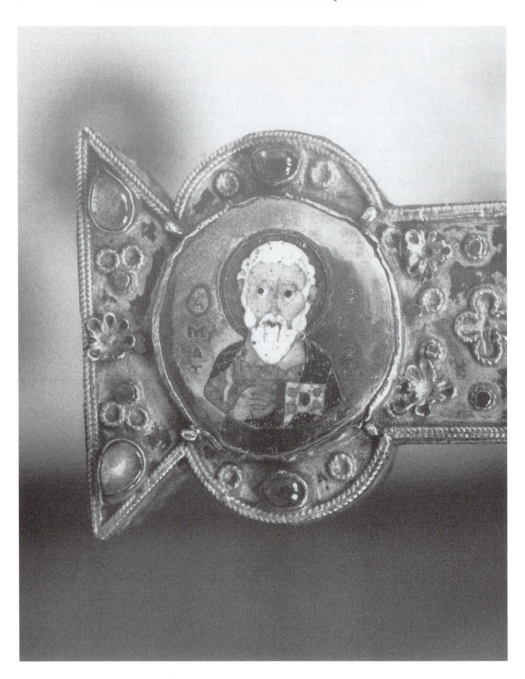

Fig. 3. Detail of Fig. 1; left arm, enamel of St Matthew.

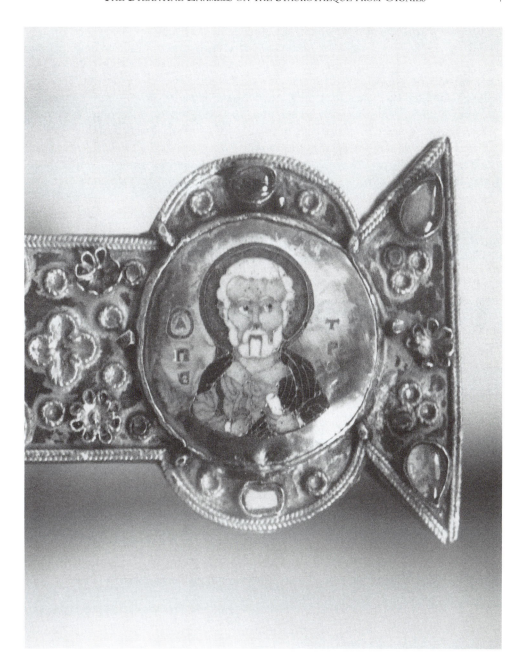

Fig. 4. Detail of Fig. 1; right arm, enamel of St Peter.

drilled and threaded on wire, which was itself passed through the loops to form the anulus of pearls. This method of mounting pearls as ornament was used in numerous other examples (as noted in the excursus below), usually where divisions occurred in the elements of the design. In the case of one of the book-covers in the Marciana Library, although the pearls have all gone, the loops exist to show how the wire support was threaded.[15] It can surely be assumed that the enamels on the cross in Namur would, in their original location, have been adorned by pearls attached in this way.

This leads to the second of the questions posed above: to what kind of object were the pearls originally attached? A significant feature of the Namur cross is that these loops can also be found (Figs. 1 and 2) fixed to all the corners of the frames of both the cross-shaped openings (12 in the smaller, Latin cross and 18 in the larger, patriarchal cross); just the same use of pearls attached to the outline of a cross can be seen on both the recto and verso of the book-cover in Venice, Marciana, Ms lat. Cl. 1, no. 101.[16] The presumption must be that the function of these loops would also here have been to support threaded pearls, and there is therefore a high probability that the eight enamel plaques and the relics were all originally installed on the same object. If this is the case, then this object must have been a reliquary of the true cross, and the enamels and relics may always have been united. When the ensemble of enamel plaques and relics was installed in the cross in Namur, the pearls which would have surrounded each element in its original location were almost certainly abandoned, if they had not already become detached. Examination of available spaces surrounding the plaques shows that there would simply not be space for these pearls, threaded on wire, to have been re-attached; this is particularly clear in the case of the two oval plaques, but almost all of them have relief ornament or mounted gems where the pearls would have been fixed. Instead, the loops (after in some cases being flattened) were used as points of attachment for soldering to the new cross.

It is indeed for this reason that the suggestion that the enamels were originally attached to liturgical vestments has to be rejected. While not known to be a common Byzantine practice in the first place, there is no precedent for a relic of the true cross having ever been attached to vestments in this way.

Having established that the enamels and the two relics appear to have originated on the same object, and that this must have been a reliquary of the true cross, we may now approach the third of the questions with which we began: is it possible to suggest what enamels may have been lost from the original ensemble? By analogy with other comparable reliquaries, we could with some degree of certainty propose that a portrait of the only one of the four evangelists (Figs. 2 and 3) now missing, St Luke, was originally present. It is also highly likely that the archangel Gabriel (Fig. 6) would have been accompanied by a balancing plaque of St Michael. There is no need to pro-

[15] The book-cover in the Marciana Library, lat. Cl. III, 111, must be an extreme case: the points of attachment are still present but the pearls have all gone, and the total length of wire-threaded pearls dividing the compartments of the design must have been over 750 cms. See Hahnloser, *Tesoro*, op. cit. (n. 1), cat. 37, pls. XXXVI–XXXVII.

[16] Hahnloser, *Tesoro*, op. cit. (n. 1), cat. no. 35, Pls. XXXII–XXXIII.

pose that other apostles would have been included, but the portrait of St Panteleimon (Fig. 5) is more problematic, and does require some explanation.

He is portrayed in his usual type as a doctor holding a spatula, and it is unlikely that he would have appeared in isolation. Apart from the roundel on the Pala d'Oro,[17] the only other enamel plaque with his image that is known to me is on the frame of the icon in Freising, which used to be in the cathedral there, but is now in the museum.[18] Here St Panteleimon is accompanied by the two other 'moneyless healers' St Cosmas and St Damian, and a presumption could be made that this pair would have accompanied St Panteleimon in the original ensemble of the Namur plaques. (St Damian is also in the same group on the Pala d'Oro.)

Apart from the four evangelists, St Peter, St Paul and the Etoimasia with archangels, it could also have been expected that the original group would have included warrior saints to act as guardians of the relics. St Demetrius, either of the Sts Theodore or St George usually appear in this capacity on reliquaries or icons, where their apotropaic function as guardians is clearly intended; they can be found, among other locations, on both the frame of the Freising icon and on the staurothèque in the Pierpont Morgan Library, fulfilling this role.[19] On this basis it would seem to be a reasonable assumption that the original group of plaques would have numbered fourteen or fifteen.

Roundels of both St Cosmas and St Damian and of St Demetrius can be found among the largest assemblage of such enamels that have become detached from the objects which they originally ornamented: that in the Treasury of San Marco, Venice.[20] Here no less than fifteen can be found, all with different characteristics. While it would be misguided to propose that (although being of comparable size) these originally were to be found on the same reliquary as the plaques now in Namur, their presence in Venice exemplifies how this dispersal has taken place.

The fourth question posed above concerned the significance of the frames by which the plaques were attached to the body of the cross. It was established that they had been formed in a way that permitted them to support threaded pearls; this phenomenon, which does not appear to have attracted any specific attention, is sufficiently widespread for it to be the subject a brief discussion here. In this way further light may be shed on the nature of the original home of the plaques now on the cross in Namur.

* * *

[17] H.R. Hahnloser & R. Polacco, *Il Tesoro di San Marco: La Pala d'Oro*, Venice, 1994, no. 140, Pl. LVI.
[18] Although the Freising icon has been the subject of several recent studies there has been no definitive publication, and the illustrations in A. Grabar, *Les Revêtements en or et en argent des icones byzantines du moyen age*, Venice, 1975, Pls. 39–41, remain the best.
[19] Pierpont Morgan Library, *The Stavelot Triptych*, New York, 1980, Pl. 7.
[20] Hahnloser, *Tesoro*, op. cit. (n. 1), Cat. nos. 104 and 102 (Pl. LXXVII).

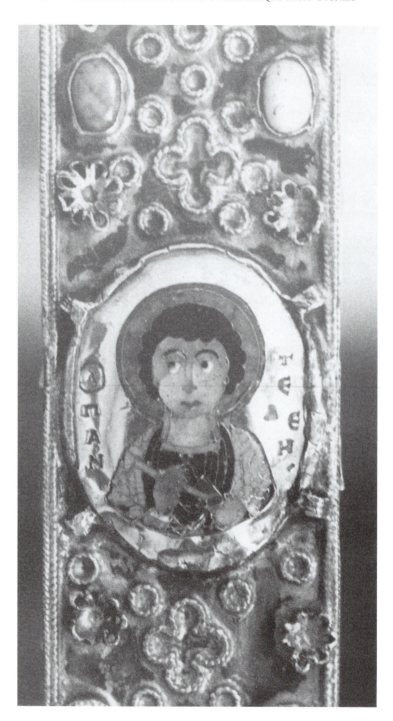

Fig. 5. Detail of Fig. 1; enamel of St Panteleimon.

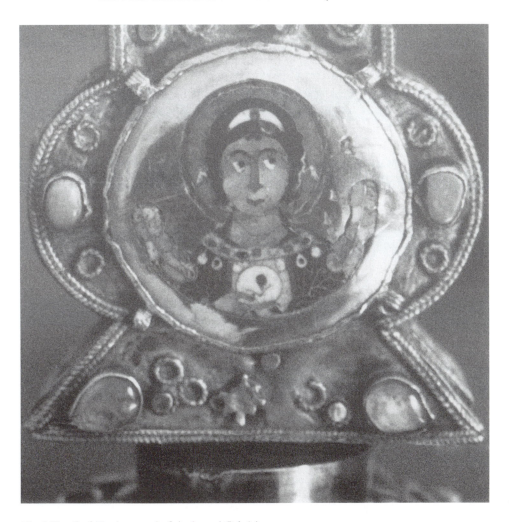

Fig. 6. Detail of Fig. 1; enamel of Archangel Gabriel.

Excursus: Pearls, and their Association with Byzantine Enamels

The imagery of pearls clearly had great power and appeal as a literary simile or rhetorical device in antiquity and the early Christian centuries. Among classical authors, the elder Pliny[21] in particular extols their supreme value ("omnium rerum pretii margaritae tenent") and dwells at length on the special way that pearls were formed, which he claimed allied them more closely with the heavens than with the earth and sea ("caelique eis maiorem societatem esse quam maris") This sense of their uniqueness,

[21] Pliny, *Historia naturalis*, IX, 54–59; he also alludes to how women used pearls lavishly as ornamental jewellery.

rarity and beauty is apparent in the New Testament references to the value of pearls, particularly with Christ's parable of the "pearl of great price" and the presence of pearls on the gates of the heavenly Jerusalem.[22] Subsequently, their qualities suggested to so many theologians of the early Christian period that pearls could be invoked as offering an analogy to the perfection and uniqueness of Christ and his teaching that individual citation here would be otiose. Besides the apocryphal Acts of John,[23] the writings of church fathers such as Ignatius of Antioch,[24] Clement of Alexandria,[25] John Chrysostom,[26] Gregory of Nyssa,[27] Sophronius of Jerusalem[28] and Ephrem of Syria[29] (among many others) all bear eloquent testimony to the power of the pearl as a simile for uniqueness, perfection and sanctity.

Although the development of later Byzantine theology seems to have reduced the appeal of this kind of rhetorical metaphor as a form of perfection, or as an analogy of Christ and his teachings, pearls maintained their role as exemplifying a unique range of qualities. The evidence for symbolic significance being attached to many mineral gems may have become stronger than it was for pearls,[30] but the association of the latter with a divine perfection, which had become established in earlier centuries, persisted in the later medieval period in more generalised ways. The qualities of uniqueness and value of pearls continued to be recognised, as in (for example) a text attributed to the eighth century patriarch of Constantinople, Germanos,[31] and they are mentioned in

[22] Chiefly Matthew, ch. 13, v. 45 and Revelation, ch. 21, v. 21.

[23] E. Junod and J.-D. Kaestli, *Acta Iohannis*, Turnhout, 1983, p. 301, where the pearl is invoked in a series of images ("the seed, the logos, the grace, the salt," ...) in which God is glorified.

[24] Ignatius of Antioch, in *Paidogogos*, II, 12 (P.G., t. 8, 540) uses the pearl in two passages as an epitome of excellence.

[25] Clement of Alexandria, *Epistola Interpolata ad Ephesios*, 11 (P.G., t. 5, 745), refers to "the spiritual pearls" Paul brought to Rome from Syria, and may have been the first to exploit the parallel of the pearl growing in the flesh of the oyster with Christ being born of the Virgin without male seed.

[26] John Chrysostom, in *Eclogae*, 47 (P.G., t. 63, 898) where the pearl is likened to a crumb of the eucharistic bread, which must not be allowed to fall from the hand. A selection of ascetic writings of Chrysostom later became known as *Margaritai*, "The book of pearls"; see J. Bompaire, "Les Catalogues de Livres-manuscrits d' époque byzantine (11e–15e s.)", in *Mélanges Ivan Dujčev*, Paris, 1979, p. 62 (eleventh cent.), and p. 67 (thirteenth cent.)

[27] Gregory of Nyssa, in *Epist. Canon.* (P.G. t. 45, 229B), develops the NT reference to pearls being cast before swine.

[28] Under Sophronius, the seventh century patriarch of Jerusalem, pearls were being used to decorate the cloth covering the paten during the eucharist (see *Comment. Liturg.*, P.G., t. 87, III, 3985).

[29] In a sermon on the birth of Christ the fourth century theologian Ephrem of Syria (P.G., t. 86, II, 2107) renewed the mystical parallel between the way a pearl was formed in the flesh of the oyster and the conception and birth of Christ. This, with some of the above allusions, was discussed by O. Casel, "Die perle als religiöses Symbol", *Benediktinische Monatschrift*, t. 6, 1924, p. 321–327.

[30] Cf. Z. Kadar," Über die Symbolik der Edelsteine der ungarischen Krone", in: Insignia Regni Hungariae, I: *Studien zur Machtsymbolik des mittelalterlichen Ungarn*, Budapest, 1983, p. 147–152. The 4th century bishop Epiphanios of Salamis (Cyprus) had already written a treatise on gems (P.G., t. 43, 293–372) based on the twelve stones in Aaron's breastplate.

[31] Germanos I, *Historia ecclesiastica et mystica contemplatio,* (P.G. t. 98, 385), used the analogy of pearls to describe the teachings of Christ.

seven of the hymns of the ninth-tenth century saint, Symeon the New Theologian,[32] but only in terms of preciousness rather than symbolic perfection. They continue to be differentiated from other gems, as in the tenth century Book of the Eparch, where they are mentioned as part of the stock-in-trade of the city's goldsmiths: "... goldsmiths are authorised, when requested, to buy ... gold, silver, pearls and precious stones."[33] This separation of pearls from any minerals is also quite standard in the factual context of inventories and brevia.[34]

For some reason which has yet to be fully explained, surviving evidence indicates that in the Byzantine world it was only after the tenth century that pearls started to become quite a prominent feature in association with enamels on certain classes of object with a liturgical function. At first sight this would seem to present a paradox: that the period which appears to have seen the most lavish use of pearls in the context of decorative luxury arts was that in which they may have received diminishing attention as an allegory or metaphor in the writings of theologians.

An explanation may be sought in developments within the field of the luxury arts. In the first place, it has been shown in recent years that the concept of "early" Byzantine enamel is erroneous, and that as an art form enamel only began to be used during the ninth or tenth centuries;[35] prior to this innovation gems would therefore have been the only other colourful medium with which pearls could have been associated. A second consideration must relate to the typically spherical form of pearls, which makes them difficult to mount in a bezel or claw setting, like other cabochon-cut stones or gems. This must have been the reason for their being drilled and threaded on wire (as discussed above) when their use became more widespread. This in turn leads to a third and possibly crucial factor: pearls attached to larger objects in this way are essentially quite vulnerable to damage, and as a decorative device it is quite fragile. It would seem that this may have been the decisive factor in influencing the class of objects in which threaded pearls became associated with enamels.

Taking surviving objects in which pearls have been used in this way, it is possible to distinguish some quite clear trends. Although major reliance has to be placed on the contents of the Treasury of San Marco, Venice – the repository of the largest assemblage of Byzantine luxury objects – no discussion of this kind should be limited to a single assemblage, and use can also be made of documentary sources.

[32] Among the 58 hymns of St Symeon the New Theologian, (Ed. J. Koder), 3 vols., Paris, 1969–73, pearls are not given metaphorical or allegorical meaning, only being mentioned as objects of value or in connection with New Testament texts.

[33] I. Dujčev (Intro.), *The Book of the Eparch*, London (Variorum repr.), 1970, p. 230.

[34] See the full and explicit inventory of the treasury of Hagia Sophia made in 1396 in Fr. Miklosich & Ios. Müller, *Acta et diplomata graeca medii aevi sacra et profana*, t. II: *Acta Patriarchatus Constantinopolitanae MCCXV–MCCCCII*, p. 566–570 ; this is discussed by P.Hetherington in "Byzantine and Russian Enamels in the Treasury of Hagia Sophia in the Late 14ᵗʰ Century", *Byzantinische Zeitschrift*, t. 93.1, 2000, p.133–137. (See also n. 41, below.)

[35] This important revision is due to David Buckton; see *idem*, "Byzantine Enamel and the West", in *Byzantium and the West c. 850–c. 1200*, (Ed. J.D. Howard-Johnston), Amsterdam, 1988, p. 235–244.

Thus we can find among surviving objects eight chalices,[36] three book-covers,[37] at least one icon,[38] a votive crown,[39] and the Holy Crown of Hungary,[40] all of which were created with their enamels being enhanced by strings of threaded pearls. In addition, referring only to one inventory – that of the treasury of Hagia Sophia made in 1396 – it is possible to cite at least one more chalice and a book-cover which (although no longer extant) are described in terms that indicate that they were decorated with both pearls and enamels, as well as two more icons embellished with pearls.[41] These sources will certainly not be definitive.

It should, on the other hand, be pointed out how threaded pearls are not invariably included in the decoration of objects that were products of the highest and wealthiest levels of patronage. Pieces such as the Fieschi-Morgan reliquary in New York,[42] and particularly the reliquary of the Proedros Basil, in Limburg,[43] must fall into this category; considerable funds must also have been needed to initiate the smaller enamelled enkolpia reliquaries in Maastricht[44] and Siena,[45] two patens of agate and alabaster which both display central enamel roundels,[46] and (to mention one secular work) the pair of enamel armlets in Thessaloniki[47] which all might have been expected (given the level of patronage that they represent) to have pearls among their decoration. Certainly, in such works as the Limburg reliquary there could be no question of shortage

[36] The eight chalices in S. Marco which are (or were originally) adorned with enamels and pearls are in Hahnloser, *Tesoro*, op. cit. (n. 1) Cat. nos. 40, 41, 42, 43, 44, 49, 55 and 118 (the last two now only have inscriptions in enamel).

[37] The three book-covers are Hahnloser, *Tesoro*, op. cit. (n. 1), Cat. nos. 35, 36 and 37.

[38] One of the icons is in Jerusalem and the other in Berlin; see P. Hetherington, "Who is this King of Glory? The Byzantine enamels on an icon frame and revetment in Jerusalem", *Zeitschrift für Kunstgeschichte*, t. 53, 1990, pp. 25–38; and D. Buckton, "The Gold Icon of St Demetrios", in; *Der Welfenschatz und sein Umkreis*, ed. J. Ehlers and D. Kötzsche, Mainz, 1998, pp. 277–286.

[39] The votive crown of Leo VI, now attached to an aedicule, is Cat. no. 92 in Hahnloser, *Tesoro*, op. cit. (n. 1).

[40] See Éva Kovács and Zsuzsa Lovag, *The Hungarian Crown and other Regalia*, Budapest, 1980.

[41] Miklosich and Müller, op. cit. (n. 34), II, 566–570; two icons, embellished with pearls, that were kept in the treasury of Hagia Sophia, almost certainly also had enamels.

[42] For recent discussion of the Fieschi Morgan reliquary and its date see Anna D. Kartsonis, *Anastasis. The Making of an Image*, Princeton, 1986, pp. 95–125; and D. Buckton, "Enamel", op. cit. (n. 35), particularly pp. 242–4.

[43] See J. Rauch and J. Wilm, "Die Staurothek von Limburg", *Das Münster*, t. VIII, 1955, pp. 201–240.

[44] For the Maastricht reliquary see the Dissertation of Hildegard Vogeler, *Das Goldemail-Reliquiar mit der Darstellung der Hagiosoritissa im Schatz der Liebfrauenkirche zu Maastricht*, Bonn, 1984; better illustration in Klaus Wessel, *Byzantine Enamels from the 5th to the 13th century*, Shannon, 1969, p. 52, fig. 39.

[45] For the enkolpion now in the Ospedale della Scala in Siena, see P. Hetherington. "A Purchase of Byzantine Relics and Reliquaries in Fourteenth-century Venice", *Arte Veneta*, t. 37, 1983, pp. 9–30, figs. 1–2.

[46] The alabaster paten is in S. Marco (Hahnloser, *Tesoro*, op. cit. (n. 1), Pl. 58), and that of agate was in the Stoclet collection, but has recently been acquired by the Louvre (D. Lion-Goldschmidt, *Adolphe Stoclet Collection*, Part I, Brussels, 1956, p. 144–149.)

[47] For the unique pair of armlets *(perikarpia)* found in Thessaloniki in 1959, see S. Pelekanides, "Ta khrusa byzantina kosmemata tes Thessalonikes", *Deltion christianikes archaiologikes etaireias*, 1959, pp. 55–77 (particularly 59–71) and pls. 24–28; also Wessel, *Enamels*, op. cit. (n. 44) p. 62, fig. 14.

of funds being the reason for threaded pearls not being used in its sumptuous enamel decoration. In the same way it would be fruitless to attempt to link the presence or absence of pearls to a chronological development; after the early eleventh century the evidence does not support the concept of the practice being tied to a given period.

What conclusions can be drawn from this? A factor that could provide us with the basis of an explanation may lie in the field of the intended forms of useage. Chalices, evangelistaries, icons and crowns (both ceremonial and votive) would have been retained within the security of church or palace premises, and the fragility inherent in threads of pearls surrounding enamel plaques would not have been an important factor. For many reliquaries, however, of the type of which the staurothèque at Limburg is perhaps the most famous, such security was not part of their existence. Reliquaries of the cross could have been intended to be carried abroad on military campaigns,[48] and even the smaller enkolpia would by their nature have been subject to daily minor abrasion while worn round the neck of their owner. It must be significant that of the few pearls placed in conventional bezel settings among the other gems in the Limburg staurothèque, a number had been lost when its restoration was undertaken in 1951;[49] the settings could not always have been adequate to contain them. The same would certainly be true of the armlets in Thessaloniki, where there is no sign of there ever having had this form of adornment. The reason for the absence of pearls surrounding the enamel roundels on the two patens may lie likewise in the need to avoid fragments of the eucharistic bread being trapped in the strings of threaded pearls that might otherwise have been expected to surround their central enamel medallions. Two other patens in Venice have threaded pearls round their rims, but leave the central area clear.[50]

Somewhat apart from this discussion is the phenomenon of much larger pearls which, after being drilled, were secured by being transfixed by a long pin or nail, which was embedded in the object to which they were attached. This method of attachment must have been regarded as being more robust than threads of smaller pearls, and was used on several major cross relics, with the pins usually being driven into the angles of cruciform relic itself. Frolow notes a few relics of the cross decorated in this way,[51] and it is possible that the famous relic now in Limburg, which prior to its restoration

[48] See Nancy P. Ševčenko, "The Limburg Staurothek and its Relics", in *Thymiama*, op. cit. (n. 4), pp. 289–294; Frolow, *Relique*, op. cit. (n. 4), dwells on this practice, and gives details of individual relics (nos. 367 and 529, pp. 342 and 426) that are known to have been carried into battle – the former having a long inscription of Manuel I Komnenos. The exposure to danger of reliquaries is also demonstrated by Frolow, citing a reliquary that Isaac II Angelos lost when he was defeated by the Bulgars in 1190; see *idem*, loc. cit., p. 349–350, and *idem*, *Les Reliquaires de la vraie croix*, Paris, 1965, p. 102.

[49] Wilm and Rauch, op. cit. (n. 43); their Fig. 8 clearly shows where pearls had been lost from bezel settings prior to restoration.

[50] The two patens in S. Marco, Venice with pearls but without enamels are Hahnloser, *Tesoro, op. cit.* (n. 1) cat. nos. 68 and 72, Pl. LX.

[51] See Frolow, *Relique*, op. cit. (n. 4), nos. 157 and 276 (pp. 244 and 299) for examples of this practice.

in 1951–54, had only the eight pins remaining, would originally have had pearls trans-
fixed by them.[52]

So that while the generalised perception of pearls as conveying a sense of precious
uniqueness, and possibly sanctity, had persisted from earlier periods, their use may
have been confined to contexts where daily use would not put their fragile existence
in danger, so causing loss.

While these comments have been confined to objects in which pearls have been
used in conjunction with enamels, it should be mentioned, before closing this excur-
sus, that they were also used extensively on liturgical vestments and other textiles. This
practice was already current in the thirteenth century, when the envoys of Michael
VIII to the Council of Lyons in 1274 presented an altar cloth to Pope Gregory X that
was lavishly embellished with many pearls,[53] and persisted in the fourteenth century,
when the inventory of the treasury of Hagia Sophia records a number of vestments
decorated with pearls.[54] This documentary evidence is supported by slightly later sur-
viving examples such as an epigonation of the fourteenth–fifteenth century in the
monastery of Putna[55] and the fifteenth century "great sakkos" of the metropolitan
Photios in the Kremlin Armoury Museum in Moscow,[56] where many hundreds of
drilled pearls have been stitched into the embroidered textile designs. There is also
contemporary evidence that pearls were present in the ceremonial robes worn by the
emperor and his family in the fourteenth century.[57] Their use in these contexts, where
they were not being exposed to any external hazard, supports the general conclusions
reached above when considering their use in association with enamels.

* * *

We must now return to the cross in Namur and its enamel plaques. It was pointed out
above that the loops which would have been the points of attachment for threaded
pearls can still be seen both on the frames holding the enamels and on the surrounds
of the excised spaces where the cross fragments are displayed. The broad conclusion
suggested in the excursus was that drilled and threaded pearls used in this way as
decorative surrounds for enamel plaques do not appear to have been applied where

[52] For photograph of the Limburg reliquary prior to the 1951 restoration, see Frolow, *Reliquaires, op.
cit.* (n. 48), Fig. 38a; that in Wilm and Rauch, op. cit. (n. 43), Abb. 31, shows the modern substitutes after
restoration.

[53] The hanging has not survived, but is known from the papal inventory; see L. de Farcy, *La broderie
de l'XIème siècle jusqu'à nos jours*, Anger, 1890, p. 35; pearls were even used in its Greek and Latin inscrip-
tions, as well as in its many scenes.

[54] Miklosich and Müller, op. cit. (n. 34), II, 568–9, where an epitrakhelion, an omophorion, an epi-
manikion and three sakkoi are all described as having pearls among their ornament.

[55] O. Tafrali, *Le Trésor byzantin et roumain du Monastère de Poutna*, Paris, 1925, Cat. no. 80, pl. 39.

[56] E. Piltz, *Trois Sakkoi byzantins*, Uppsala, 1976, pp. 31–41 and pl. 33–42.

[57] The learned chronicler Nikephoros Gregoras would have been present at the celebrations in the
Blachernae palace on 21st May, 1347, as he describes the decoration of the robes worn by the imperial
family, which showed the lustre of real pearls contrasting with artificial gems; see *Historia*, CSHB ed., XI,
11, Bonn, 1830, pp. 788–789.

the circumstances of use would readily expose them to the danger of physical damage. This explanation seems, for the present, to be one of the most likely reasons for works of the period, of high esteem and displaying enamels of great richness, not bearing this form of decoration.

In his great work of assemblage and analysis, Anatole Frolow discusses at length the different forms taken by reliquaries of the true cross.[58] While his study concerns reliquaries from all over Europe, including Slav countries, it becomes clear that the majority of Byzantine reliquaries of the true cross that have survived unaltered into modern times are not in the form of a cross, but more often take the form of a triptych, or of a panel in which the relic was recessed, and covered with a lid; this is the type noted frequently as "en forme de tableau".[59] This contrasts quite markedly with the western tradition in the design of reliquaries; while there is still great variety in the forms taken it would be safe to say that the most commonly found receptacle adopted for cross reliquaries during the western middle ages is cruciform.[60]

When the Byzantines did make use of a cruciform design, albeit perhaps less frequently, it too could be highly elaborate and (as in the case of the major cross reliquary in Genoa[61]) be further decorated with strings of drilled pearls. In this case, as in that of the very comparable cross in the Great Lavra, Mount Athos,[62] it is highly improbable that the cross was ever intended to be carried into battle or exposed to comparable risks.

Although there are a number of cruciform staurothèques that correspond in broad terms to that now in Namur,[63] the original aspect of that which provided both the relics and the enamels now adorning it may have been unique. No other surviving example seems to have brought together these four characteristics: besides housing a relic of the cross and being cruciform in design, it was decorated with enamels and these (with the fragments of relic themselves) were garnished with surrounding circlets of threaded pearls. Of the Byzantine staurothèques of cruciform type which have survived, none of which we have knowledge seem to have been adorned with both enamels and pearls, and of those that have been re-made by western artists, such as that at Vyšší Brod,[64] none give evidence of having incorporated threaded pearls. The fragility inherent in their addition must imply that in its original form the Namur relic was not intended to be highly portable; unlike the box or casket form of reliquary, the cross would never have been intended to be exposed to physical risk.

[58] The studies by Frolow remain fundamental; see *idem, Reliquaires*, op. cit. (n. 48), citing throughout relics enumerated in *idem, Relique*, op. cit. (n. 4).

[59] Frolow, *Reliquaires*, op. cit. (n. 48), particularly pp. 93–115, and idem, *Relique*, op. cit. (n. 4), *passim.*

[60] Frolow, *Reliquaires*, op. cit. (n. 48), pp. 115–151.

[61] See Frolow, *Reliquaires*, op. cit. (n. 48), Fig. 71, and *idem, Relique*, op. cit. (n. 4), p. 437, where the thirteenth century re-making of the reliquary is summarised; threaded pearls outline one face of the cross.

[62] For this see A. Grabar, 'La précieuse Croix de la Lavra Sant-Athanase au Mont-Athos', *Cahiers Archéologiques*, t. 19, 1969, 99–125.

[63] Frolow, *Reliquaires*, op. cit. (n. 48), p. 127, n. 2.

[64] See Hetherington, op. cit. (n. 2).

This suggestion corresponds with the forms of reliquary established by Frolow, and through analysis of the ornament has identified the original form of the staurothèque on which the Mosan goldsmith based his new creation. Unlike the type of staurothèque in which the relic was displayed only when a covering lid or shutters were opened, this was not intended to be carried abroad as an instrument of divine protection or on military campaigns, in which the relic itself needed protection;[65] although often of great magnificence, the decoration of this type would have been less delicate. The staurothèque which provided the enamels now in Namur would have been destined for a more static existence, and so would not be expected leave the safer environment of a protective building of some kind; its decoration could therefore be of a more fragile nature. So it seems that, although conforming to a general type, the reliquary which carried the enamels now in Namur may have been unique in its combination of decorative features.

A Schedule of the Enamels on the Cross in Namur

Overall dimensions: Total height: 73.3 cm. Width: 18 cm.
Dimensions and inscriptions of individual plaques:
1. Etoimasia 33mm. diam. Inscr.: HE TOI M
2. St John Theologos 33mm. diam. Inscr.: A IΩA ΘEOΛ
3. St Mark 35mm. diam. Inscr.: A MAP KOC
4. St Paul 35 x 25mm. Inscr.: A ΠAY ΛOC
5. St Matthew 33mm. diam. Inscr.: A MAT ΘAIOC
6. St Peter 33mm. diam. Inscr.: A ΠE TPO
7. St Panteleimon 35 x 25mm. Inscr.: A ΠAN TEΛEH
8. Archangel Gabriel 33mm. diam. Inscr.: ΓA BPI

Six of the eight plaques are circular, with two (4 and 7) being oval; the condition of all of them is virtually perfect.

[65] See n. 48, above.

The colours used in the eight plaques display a clear consistency throughout, emphasising the coherence of the group. The principal colours used are as follows (using the Munsell system of colour terminology):

Darkest blue: 7.5 B 2/6, used in outer robe of 2, 3, 4, 5, 6 & 8.
Medium blue: 5 PB 2/8, used in haloes of 3, 4, 7 & 8 and the draped cloth in 1
Light blue: 10 B 8/2, used in hair of 5
Pale grey/blue: 2.5 PB 6/4, used in hair of 6.
Turquoise: 5 B 4/6, used in under-robes of 2 and 5
Translucent green: 2.5 G 3/6, used in haloes of 2, 5 and 6
Yellow: 5 Y 7/8, used in book-covers of 1,2,3 & 5, and loros of 8.
Flesh colour: all equivalent to 5 YR 7/4.
White: hair of 2 & 5, under-robe of 4.
Black: hair of 3,4,7 & 8.

All the haloes have a narrow border of red, whatever the colour of the main area of the halo.

All of the inscriptions are in red, most have conventional abbreviations, and none are significantly damaged.

The Cross of Záviš and its Byzantine Enamels:
A Contribution to its History[1]

Among the many publications of Laskarina Bouras in the field of Byzantine art is the brief but brilliant monograph on the Cross of Adrianople, now in the Benaki Museum.[2] The work discussed here, decorated as it is with Byzantine enamels, shares with it sufficient features to make it an appropriate subject for this memorial volume.

There is no dispute about the later history of the cross reliquary, usually known as the Cross of Záviš, that is now kept in the treasury of St Vitus' Cathedral in Prague.[3] There is general acceptance of an early tradition that it was given to the Cistercian monastery of Vyšší Brod in Southern Bohemia by Záviš of Falkenstein. Záviš was a patron of the monastery, and the cross is said either to have been a gift during his life, or bequeathed after his death; he was executed on 4th May 1290, and his tomb can still be seen in the monastery. The earliest documentation of the gift dates from 1464.[4] The cross remained there until 1938, when it was transferred to its present location.[5] Its base was made for it in 1839–40, and the restoration carried out in 1986–87 revealed that the cavity which was intended to hold a relic of the True Cross contained coins of 1775 and a document of the same year written by Hermann Kurze who was abbot of Vyšší Brod in 1767–95.[6] This paper will suggest how some fresh light may be shed on where its various parts may have been brought together, and thus on its early history.

[1] I would like to thank Dr. Eliška Fučíková, Dr Anežka Merhautová and Dr Dana Stehlíková for the extensive help they provided while I was studying the Zàviš Cross in Prague.

[2] L. Bouras, *The Cross of Adrianople*, Benaki Museum (Athens, 1979), with text in English and Greek.

[3] There is quite an extensive bibliography on the cross, which will be given in full in the forthcoming catalogue of the Treasury (I would like to thank Dr Merhautová for making the draft of this entry, by the late Kl. Benda, available to me). The more recent bibliography is sufficient here: K. Chytil, 'The Byzantine Enamels on the Záviš Cross at Vyšší Brod, Prague', *SemKond* (1930) (also published in a Czeck edition); K. Chytil and A. Friedl, 'Les émaux byzantine de la croix de Záviš, du couvent de Vyšší Brod en Bohème', *L'art byzantin chez les Slaves*, II (Paris, 1932), 394–412; A. Frolow, *La relique de la Vraie Croix* (Paris, 1961), 423–4, no. 522, and idem, *Les reliquaires de la Vraie Croix* (Paris 1965), 126, 142 and fig. 82; K. Wessel, *Byzantine Enamels from the 5th to the 13th Century* (Shannon, 1969), 163–4 and figs 50a–e; H. Fillitz, *Romanik in Böhmen*, ed. E. Bachmann (Munich, 1977), 235, 252–3 and figs 160–61.

[4] Chytil, *op.cit.*, 25–8; it is referred to on that date as 'quam legavit dominus Zavissius'.

[5] Documentary source given to me as a personal communication by Dr Anežka Merhautová. (Both Frolow and Wessel, writing in 1961 and 1969, refer to the cross as being still in Vyšší Brod).

[6] This information is given in full in the as yet unpublished catalogue entry by Kl. Benda

The form of the cross, which was almost certainly intended originally for processional use, has two distinguishing features: one is the second cross-member which allies it to the patriarchal type, and the other is the fleur-de-lys forms at its extremities. There has been considerable discussion of these features, but they are sufficiently common for it to have remained largely inconclusive. A further characteristic of the Záviš Cross is the evident disparity in style that exists between the decoration of its two faces. This, too, has received comment, but with no more success.[7]

It is to the reverse face of the cross that most attention will be given here (Fig. 1). The whole area is clad in gold sheet, fixed to the wooden core; a uniform pattern of gold filigree covers the whole area. This has been made as usual from strands of wire twisted together, but the filigree seems to have been subjected to more intensive flattening than is often the case, so that it has become in effect a flat strip some 3 mm wide and with an irregular edge. The strip has been cut into quite short lengths which were then curved uniformly and their edges attached in a regular pattern to the gold plates forming the reverse, with a tiny gold bead soldered at the centre of each small spiral. It is clear that the design was intended to accommodate the eleven enamel plaques and ten gems which are still mounted on the cross.

Although the filigree of the Záviš Cross is formed into a very regular pattern, and so lacks the more varied forms of other examples of this kind of decoration, its execution is nevertheless highly skilled and gives the work a very distinctive character. It could even be said that the dense regularity of the pattern, emphasised by the sparkle of the gold beads and the uneven edges of the filigree, was intended to give emphasis to the larger plain areas of the gold plaques with their enamel imagery. It is surprising that as Italy, and in particular Venice, was so closely identified with the development of gold filigree of this kind, this area has never been suggested as a possible point of origin for the cross.[8] Although the famous *opus veneticum ad filum* developed throughout the second half of the thirteenth century a more inventive and varied use of this technique,[9] the filigree on the Záviš Cross could readily be associated with this Venetian tradition, perhaps before it attained its full richness and exuberance.

Leaving this question on one side, let us examine the enamels for which the design was created.[10] It is clear at once that the nine figural plaques are of Byzantine origin, and that they are a random selection; they display a variety of shapes, sizes and styles, and even duplicate subject-matter. Like a number of other works – some of great magnificence – the Záviš Cross exemplifies the practice of re-using plaques that had been made originally for attachment to other objects. (In this respect they differ from the closest comparable example to the Záviš Cross, which is that in the Treasury of the

(see n. 3 above).

 [7] See *Romanik in Böhmen, op. cit.*, for a summary of the widely differing views that have been expressed.

 [8] For a recent summary of the development of this form of filigree, with extensive bibliography, see D. Gaborit-Chopin, *Venetian Filigree, The Treasury of San Marco Venice* (Milan, 1984), 233–6.

 [9] The primary research of this subject is by H.R. Hahnloser; see *Il Tesoro di San Marco: Il Tesoro e il Museo*, ed. H.R. Hahnloser (Florence, 1971), 131–6, with full bibliography.

 [10] These enamels were the last works of art to be studied by Kondakov before his death in 1925 (Chytil, *The Byzantine Enamels* [as in n. 3], 9).

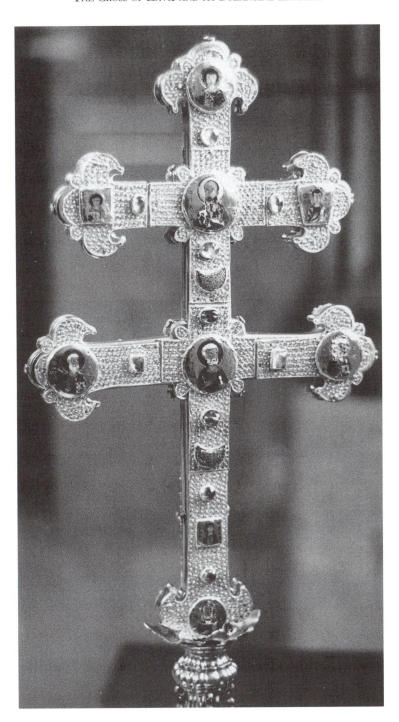

Fig. 1. Cross of Záviš of Falkenstein. Monastery of Vyšši Brod, formerly Treasury of St Vitus' Cathedral, Prague.

Prieuré d' Oignies at Namur, where the eight Byzantine enamel roundels are clearly a homogeneous, though incomplete, group.[11]

The Prague enamels are here given a suggested grouping which indicates that the eleven plaques were originally created for at least five different objects or uses:

Group A: Hitherto somewhat neglected in discussions of the cross are the two non-figural plaques, nos 5 and 9; of crescent shape and slightly convex profile, they are usually referred to as lunulae. Their most probable original function would have been as items of jewellery, and may well have been ear-rings. A close comparison can be made here with a comparable object in the Dumbarton Oaks Collection.[12] Certainly the forms of the cloisons, particularly those in the lower part of the Washington piece, as well as the colours, are remarkably similar in both works. A finger-ring in Berlin may also come from the same workshop.[13] The most problematic aspect of these works is that of chronology; there is very little comparable material, and none of it is dated. For the present the view of Marvin Ross, that the Dumbarton Oaks piece is a Constantinopolitan work of the eleventh century, must be regarded as probably correct, but as yet unproven. The same opinion must for the present apply to the lunulae.[14]

Group B: Also in a class on its own is no. 4, the plaque with a rhomboid shape depicting St Thomas. Its form is typical of plaques which were applied as decoration to some vessel such as a chalice, and the Treasury of San Marco, Venice, has two such pieces; enamels of a similar rhomboid shape can be found on the foot of the 'Chalice of the Patriarchs'[15] and of tall rectangular form on the lip of the Chalice of the Emperor Romanos.[16] The former is closer in shape, but the latter offers a more precise comparison in style; several plaques in the latter chalice have very comparable colouring, with alternating light and dark blue areas of enamel for the drapery, a distinctive purplish-brown undergarment showing at the neck, and the representation of the ears of the figure given a form that is not found on the other plaques. These features all suggest that this is of the mid-tenth century, and is almost certainly the oldest of the collection.[17]

All the other figural plaques lack the qualities which can distinguish the enamels of the tenth century from later phases of production; our knowledge of chronological development is still too uncertain to be able to offer a more precise time scale than

[11] F. Courtoy, 'Le Trésor du Prieuré d'Oignies aux Soeurs de Notre-Dame à Namur et l'Oeuvre du Frère Hugo', *Bull. de la Comm. des Monuments et des Sites*, III (Brussels, 1952), 201 ff., no. XXIV, figs 81–7.

[12] M.C. Ross, *Catalogue of the Byzantine and Early Medieval Antiquities in the Dumbarton Oaks Collection*, II: *Jewelry, Enamels and Art of the Migration Period* (Washington DC, 1965), 103, no. 151, pls C and LXVIII.

[13] H. Battke, *Die Ringsammlung des Berliner Schlossmuseums* (Berlin, 1938), 65, no. 45 and pl. IV.

[14] The Dumbarton Oaks piece surely cannot have been a button, as claimed by Ross, but must have had a decorative use comparable to the lunulae.

[15] *Il Tesoro di San Marco* (as in n. 9), 58–9, no. 40, pls XL, XLI.

[16] *Ibid.*, 59–60, no. 41, pls XLII, XLIII.

[17] Cf. particularly the figural enamels on the lid of the famous staurothèque of Basil the Proedros, in Limburg; see J. Rauch and J.M. Wilm, 'Die Staurothek von Limburg', *Das Münster* 8 (1955), 201–40, fig. 15.

that all the other enamels here are most probably of the eleventh or earlier twelfth centuries.[18]

Group C: The two rectangular plaques, nos 2 and 10, are sufficiently similar to have originated on the same object, although their slight difference in size could mean that even here there are the remains of two ensembles rather than one. The saints portrayed, St George and St Demetrios, certainly complement each other as the two most common of the warrior saints.

Group D: Of the six roundels, those representing St George and St Athanasios (nos 1 and 11) share a number of stylistic features, and may have originated on the same object, although their difference in size would then suggest that no. 11 may have been reduced before it was united with the rest of the plaques; of all of them it has the greatest surrounding space.

Group E: This leaves the roundels nos 3, 6, 7 and 8. Nos 3 and 7 (St Paul and St Peter) are the two largest enamels in the ensemble, and there are good reasons for disregarding their very small difference in size and taking them to have originated as a pair. They are both of very comparable style and of uniformly high quality of workmanship, and their subjects are clearly complementary. The last two, nos 6 and 8 (St John Theologos and St Luke), are difficult to allocate finally as the latter has the largest area of damage of the whole ensemble; however, the subjects, dimensions, inscriptions and remaining colours do not conflict with their being regarded as another pair. There is also a very evident kinship of style between nos 6 and 7; although the differences in their sizes conflict with their being originally made for the same object, adequate grounds certainly exist for suggesting that they at least came from the same atelier.

While making no claims for finality, this division of the enamels of the Záviš Cross into five groups must represent the minimum number of the original objects from which they were taken; in time this number may well have to be increased to six or more.

We can now return to the question of where the cross, with the filigree decoration of its reverse side mounted with Byzantine enamels, was produced. In discussing the question of the filigree it was suggested that Venice, being the major centre for work of this kind, should be brought into the discussion. It is now proposed that there are further grounds for Venice being in some degree connected with the genesis of the cross.

It has long been known that objects which incorporated plaques of Byzantine enamel were always highly prized, and that large quantities arrived in the West in the years after the sack of Constantinople in 1204. Venice was the focus for much of this booty and many of these enamels were (and still are) attached to the *objets de grand luxe* for which they were made; the Treasury of San Marco houses the largest assemblage of such works in existence. There must also have been substantial numbers of individual enamel plaques which had already become detached from the objects for which they

[18] P. Hethering on, 'Byzantine Enamels on a Venetian Book-cover', *CahArch* 27 (1978), 117–45, particularly 141–2. (Here Study VI).

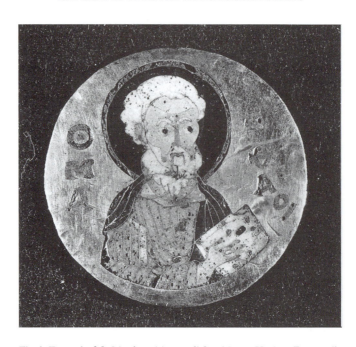

Fig. 2. Enamel of St Matthew. Tesoro di San Marco, Venice. (Per gentile concessione della Procuratoria di San Marco.)

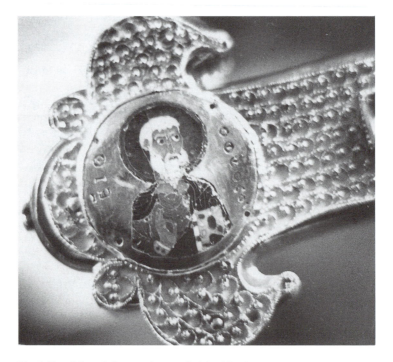

Fig. 3. Detail from left arm of cross: St John Theologos.

were originally made, or else became detached while in the hands of their new Western owners. These continued to circulate and be re-used in the West, and it has been shown that even in the mid-fourteenth century a large silver-gilt book-cover, now in Siena, was made in Venice and decorated with an assemblage of forty-eight Byzantine enamels of widely varying character.[19]

Among the unique range of larger pieces in the Treasury of San Marco there are also fifteen separate roundels of Byzantine enamel, all of which must at one time have been attached to larger objects.[20] The period (or periods) at which they arrived in San Marco is not known, but they can be assumed to have been in circulation in Venice for some considerable time after their arrival, which was probably during the early thirteenth century. It could be suggested that at least one of these plaques in San Marco may have originated as part of the same group as one now attached to the Záviš Cross. If the roundel of St Matthew in Venice[21] (Fig. 2), is compared with that of St John Theologos in Prague (Fig. 3) they can be seen to share sufficient characteristics for their origin on the same object to be considered: colours, facial type and inscription are all supported by the complementary nature of their subjects, as both are evangelists, and the disparity in size is sufficiently small to be discounted. If the roundel of St Luke (no. 8) on the Záviš Cross was also in this group, as suggested above, it may be that only that of St Mark has not survived from its original home. In time it might become possible to identify other individual Byzantine enamels which have become separated from their original grouping and found a home on other objects.[22]

Space does not permit this discussion to be pursued to an assessment of the history of the cross before it came into the possession of Záviš of Falkenstein; it may yet emerge that the disparity that is evident in its decoration can be explained by there being two or more phases in its construction. While the date in which it was given the appearance that we can see today may well be c. 1240–50, rather than 1270–80 as proposed by Chytil,[23] the role of Venice, which would always have been the most probable source for its enamels, should perhaps now be considered.

[19] *Ibid.*

[20] *Il Tesoro di San Marco* 82–6, nos 93–108, pls LXXVI–LXXVII.

[21] *Ibid.*, no. 107 (34 mm. diam.).

[22] If they were in more perfect condition, it might be possible to show that, e.g. no. 11 on the Záviš Cross (St Athanasios) had originally been part of the same ensemble as no. 46 (St Gregory Theologos) on the Siena book-cover; see Hetherington, *op.cit.*, 145, fig. 2.

[23] Chytil, *The Byzantine Enamels*, 25–8.

APPENDIX

Particulars of the Byzantine enamels on the Cross of Záviš. Measurements are in millimetres, with height given first.

Key To The Plaques

1.	1 . St George. Roundel, 37 diam. Undamaged.
	2. St George. Rectangle, 25 x 24. Undamaged.
2. 3. 4.	3. St Paul. Roundel, 41 diam. Undamaged.
	4. St Thomas. Rhombus, 28 x 19 x 27. Undamaged.
5.	5. Decorative lunula. 14 x 23. Undamaged.
	6. St John Theologos. Roundel, 38 diam. Undamaged.
6. 7. 8.	7. St Peter. Roundel, 40 diam. Undamaged.
	8. St Luke. Roundel, 37 diam. Severely damaged in face and halo.
9.	9. Decorative lunula. 14 x 23. Minor damage to left point; surface unpolished, as 5.
10.	10. St Demetrios. Rectangle, 22 x 20. Undamaged.
11.	11. St Athanasios. Roundel, 30 diam. Severely damaged in halo and part of right shoulder.

The overall height of the cross, without base, is 445, and the width of the two cross-arms is 235 and 280.

Byzantine Steatites in the Possession
of the Knights of Rhodes

In the Cathedral Museum at Mdina, Malta, there is a box-like diptych covered on the outside in red velvet and decorated with five enamel shields.[1] (Fig. 1). Four of the shields bear the emblem of the Hospitallers of St John of Jerusalem before the Order came to Malta;[2] the fifth corresponds with the arms of Hélion de Villeneuve as they appear carved at several points in the buildings of the Old City of Rhodes[3] (Figs. 2 and 3). Hélion de Villeneuve was the first Grand Master of the Knights to be elected after the Order had established itself in Rhodes in 1309–10; although his election took place in 1319, he did not in fact arrive in Rhodes until 1332, and he died in 1346.[4] The metalwork of the mounts is consistent with a fourteenth-century date,[5] and so it would seem safe to assume that the diptych attained its present form during the period that Villeneuve was Grand Master of the Order. The work is first recorded in an eighteenth-century inventory, now at Mdina, as: *'Una Cassetta fatta a Libro con alcune piannatte d'argento entrovi reliquie, e figure alla Preca di diverso Santi.'*[6] The second half of this

[1] I would like to record my thanks to the Curator of the Museum, Fr John Azzopardi, for his help while I was studying the diptych. I would also like to express here my gratitude to the following, from whom I have benefited in general ways either in discussion or by correspondence: Professor Hugo Buchthal, Mr Richard Camber, Dr Robin Cormack, Professor Jaroslav Folda, Dr Anthony Luttrell, and Mr Ian Roper.

[2] Gules, a cross argent.

[3] The Villeneuve arms as recorded in V. H. Rolland: *Supplément à J. B. Rietstapp, Armorial générale,* IV, The Hague [1937], p. 389, were gules, fretty of six lances or, with escutcheons or interspersed, and Mr Charles Oman first pointed out the similarity between these arms and those on the diptych. Anywhere that the Villeneuve arms appear on the buildings of Rhodes, however, they are shown as Fig. 3 here, a simple fretty with escutcheons interspersed; see A. Gabriel: *La Cité de Rhodes,* I, Paris [1921], pp.101 and 107, and Pl. XV, 3, and II, Paris [1923], pp. 12, 147 and 175 and Pl. XXXVII, 3. Although the former was erected by Giovanni Battista Orsini (d. 1476), this does not affect the argument of identification here; see also n. 31, below. For arms of Villeneuve that have since disappeared see also B. E. A. Rottiers: *Description des Monumens de Rhodes, Atlas,* Brussels [1828], Pl. LXXII, 5.

[4] See K. M. Setton (Ed.): *A History of the Crusades,* III, Wisconsin [1975], Ch. 8 (by A. Luttrell), esp. p. 290.

[5] I am most grateful to Mr Charles Oman for giving me the benefit of his opinion in this respect.

[6] See C. Oman: 'The treasure of the conventual church of St John at Malta, Part I', *The Connoisseur,* 173 [1970], pp. 101–7. Again, I would like to express my thanks to Mr Oman for making his copy of the Inventory available to me.

Fig. 1. Exterior of diptych, closed. (Cathedral Museum, Mdina).

Fig. 2. Detail of exterior, with arms of Hélion de Villeneuve in silver, silver-gilt and enamel.

description refers to the inside of the diptych, which was the subject of an engraving published by P. Paciaudi in 1755 (Fig. 4).[7]

When the diptych is opened it can be seen to contain twenty-four small steatite reliefs of slightly varying colours, with one of a darker tone, probably haematite. They are manifestly of Byzantine origin, and are separated by thin wooden frames, to which are attached strips of silver stamped with a rather crude pattern. In the left-hand leaf there are gaps where two more reliefs may at one time have been housed (they were already missing in the eighteenth-century engraving), while another compartment holds what clearly are relics, protected by a sheet of mica.

Besides the evident Byzantine style of the reliefs, it can be seen that all the inscriptions are in Greek and that in no case does the identity of the saints represented (see *Appendix*, below) raise any doubts as to the Eastern origin of the individual reliefs. In view of this, it very soon becomes evident that we are dealing with a confection. Besides the mixture of half-length and full-length figures, one need look no further than the top row of the right-hand leaf (Fig. 5), where it can be seen that St Nicholas is placed asymmetrically within a conventional Byzantine Deesis group, to conclude that this is certainly not the form in which a Byzantine artist would have left the work, nor that in which a Byzantine patron would have accepted it. It would seem

[7] Paulli Paciaudii: *De cultu S. Johannis Baptistae antiquitates Christianae . . .* Rome [1755], pp. 389–99.

Fig. 3. Relief of arms of the Order of St John of Jerusalem and of Hélion de Villeneuve. Rhodes city.

that either Hélion de Villeneuve was himself responsible for assembling the reliefs in their present form, or else that he took them over like this and added his own arms to the outside. The work of re-assemblage or amalgamation of the Byzantine reliefs must, it would appear, have been undertaken by a Western hand that had no great interest in preserving the formal or iconographical properties of the setting in which the beliefs originally appeared, but nevertheless, valued the ensemble sufficiently to expend interest and money on it.

Before looking at some of the individual reliefs in more detail, we should establish one point that has already been mentioned in passing: that there are basically two groups of reliefs that have here been combined. One, occupying all the right-hand leaf and three compartments on the left, is of half-length figures, and tends to be of a darker colour of steatite, while the second consists of five reliefs of full-length figures, of which only two are of the same size. The only relief of a Feast scene, that of the *Crucifixion*, can be related quite readily to the larger of these two groups. It can be seen, for instance, that the rather crude workmanship of the half-lengths, evident in, for instance, the rather heavy irregular gashes which represent the hair of Christ and the Baptist in the *Deesis* group, can also be found in the Christ and St John in the *Crucifixion* (see Figs. 7 and 8). Here also the rather clumsy left hand of the grieving saint can be compared with that of the Baptist or that of St John Theologos (Fig. 9) among the half-lengths. The facial type of the Virgin in the *Crucifixion*, with the rather heavy arched ridge forming the eyes and eyebrows, also recurs in the reliefs of St Basil and St Paul (Figs. 8 and 9). This rather crude style contrasts with the smaller group of full-length figures, which are the work of an artist with a greater sense of pattern. Besides the band of foliate ornament along the bottom of each relief, there is a frequent use of the drillpoint to produce a delicate, decorative effect. It seems that we can safely

Fig. 4. Engraving of open hagiothecium of 1755 in P.Paciaudi, *De cultu S.Johannis Baptistae*. (1230.e.15 p.389)

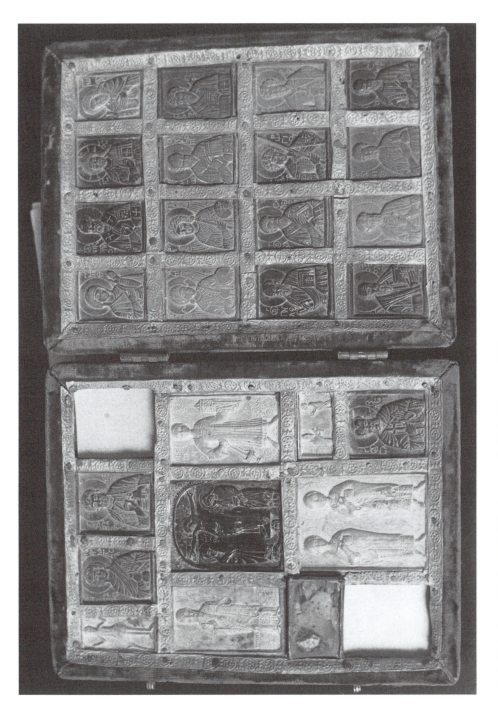

Fig. 5. Hagiothecium in form of diptych, open. Cathedral Museum, Mdina.

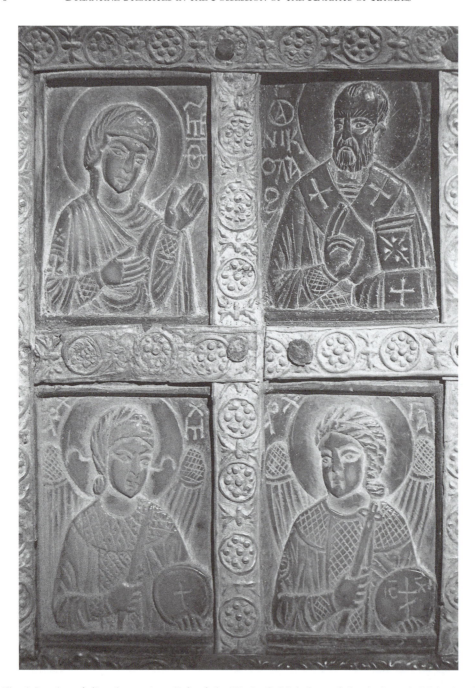

Fig. 6. Interior of diptych: steatite reliefs of the Virgin, St Nicholas and the Archangels Michael and Gabriel.

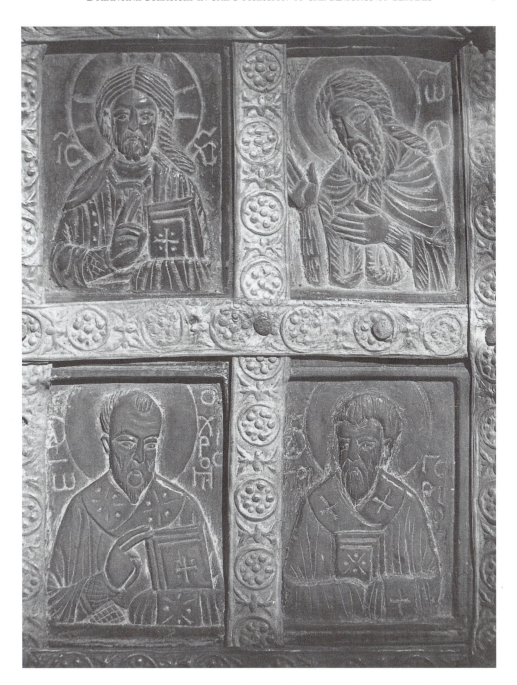

Fig. 7. Interior of diptych: steatite reliefs of Christ and SS. John the Baptist, John Chrysostom and Gregory.

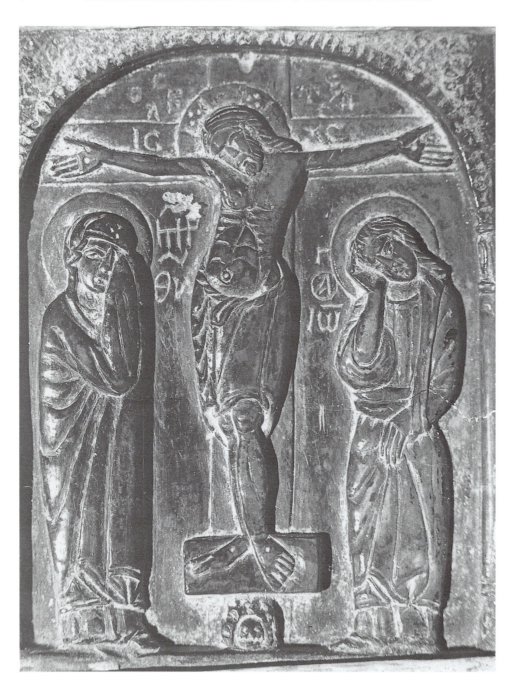

Fig. 8. Interior of diptych: steatite relief of the Crucifixion, with the Virgin and St John.

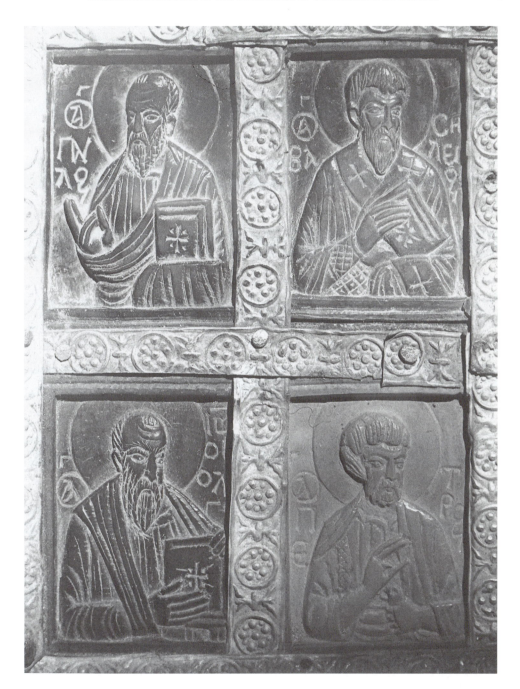

Fig. 9. Interior of diptych: steatite reliefs of SS. Paul, Basil, John Theologos and Peter.

conclude that we are dealing with the products of just two ateliers of sculptors in relief, and that the *Crucifixion* came from the same one as did the half-length figures.

There are three basic questions, therefore, about the Mdina steatites, which should be asked: in what form or forms were they originally arranged, and for what purpose; what is their date; and where did they originate?

The larger group, consisting of the half-length figures and the *Crucifixion* relief, should first be isolated for closer study, and here it is at once clear that the general level of our knowledge of Byzantine steatite relief carving is disappointingly low. Unlike ivories, which, with work in precious metals such as enamel, have received quite a lot of attention, steatites have remained something of a poor relation.[8] Certainly among published examples[9] there is no group which corresponds at all closely to ours; only one collection, now in the Vatican, has much in common with ours, and these also have been re-mounted at some later date (Fig. 10).[10] But even if the origins of the Vatican group were known, the associations are not sufficiently strong to be of any real help. For the most part, small, rectangular steatites that have survived seem mainly to have been only single reliefs, sometimes having a heavy pierced eyelet at the top, and even on occasion being double-sided. None of our group can be associated with this tradition of personal useage or adornment.

When comparison is made with works in the related field of ivory carving, some closer links can however be found. A completely typical example of an eleventh or twelfth-century ivory triptych[11] (Fig. 11) shows both the extent and the limitations of this connection. The triptych has in common with the steatites a *Crucifixion* relief, with half-length figures of two archangels, SS Peter and Paul and two Martyrs, all turning towards the central subject. In spite of these similarities, however, there are good reasons for rejecting it as evidence of the form in which our steatites were originally arranged. The more fragile nature of the material means that it can never have been made to hinge in the way that ivory can. Even if the individual steatites were held in some kind of wooden frame, their scale in relation to the *Crucifixion* is completely different from any normal ivory triptych; the Feast scene is invariably larger than the supporting saints, instead of virtually the same, as here. Finally, there are no less than fifteen saints in the Malta group, and it is not possible to make even a conjectural reconstruction of a devotional ensemble that would be comparable to any surviving

[8] For a brief summary of current general knowledge of Byzantine steatite reliefs, with a bibliography, see *Byzantine Art an European Art*, Catalogue of the Ninth Exhibition of the Council of Europe, Athens [1964], 2nd ed., pp. 189–91.

[9] I would like to thank Dr I. Kalavrezou Maxeimer, who is making a study of Byzantine steatite carvings, for her help on this subject.

[10] See A. Muñoz: *L'Art byzantin à l'Exposition de Grottaferrata*, Rome [1906], pp. 120–23 and Fig. 85. The rectangular reliefs comprise a Deesis group with two archangels, as here, but then have scenes from the life (probably) of St Catherine. In Munich there is a small sequence of six half-length saints in ivory, very comparable in size and proportion to our steatites, but which is thought to derive from triptych leaves that have been cut up; see A. Goldschmidt and K. Weitzmann, *Die byzantinische Elfenbeinskulpturen*, II, Berlin [1934], p. 54.

[11] See Goldschmidt and Weitzmann, *op. cit.*, Pl. LIV, no. 155a.

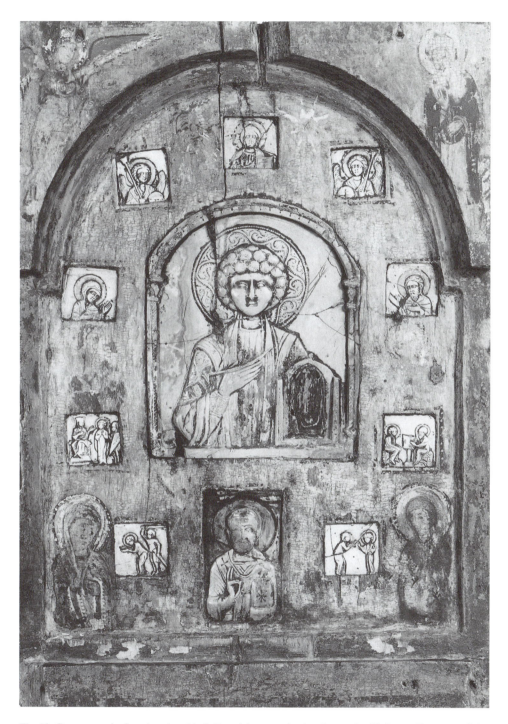

Fig. 10. Centre panel of a triptych, with St Panteleimon and saints in steatite, Vatican. (Courtesy of the Vatican Museums.)

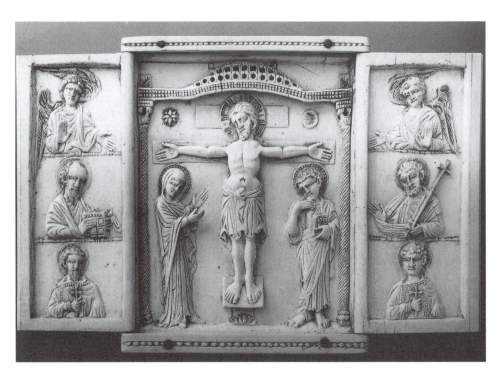

Fig. 11. Ivory triptych of the Crucifixion and saints, Liverpool. (Photo: © National Museums Liverpool.)

ivories. The only other form in which small ivory panels were used was as cladding on caskets; there is, for example, in the Bargello in Florence a casket with a series of small ivory plaques portraying saints on its top and sides.[12] Although these have probably been re-arranged in the past, it is still hard to see how the steatite reliefs could have been used in this way. There are no holes by which they could have been attached to a wooden carcass with small nails, in the way that is normal for ivories, and it is clear from the known surviving fragments in this medium that it is too fragile to be used in this way.[13]

We will be able to get nearer to an answer to our first question – the form in which the reliefs were originally assembled – if we look more closely at the identity of the individual saints. Most of them are quite common, and can be found in countless works in ivory, metal relief and enamel. However, two of them in the form that they occur here appear to be unique in Byzantine art; they are the two iconic representations of St Nicodemus and of St Joseph (Fig. 12). The former must be the 'ruler of the Jews' of John, Ch. 3, who was associated with the burial of Christ, and who is actually shown as a *myrrhophoros*, holding a flask. This makes it virtually certain that St Joseph must be Joseph of Arimathea, who is mentioned in all four gospels as being the owner of the

[12] Goldschmidt and Weitzmann, *op. cit.*, I [1930], no. 99, Pl. LVIII–LIX

[13] Compared to ivories, a far higher proportion of surviving examples are damaged or in a fragmentary state.

Fig. 12. Interior of diptych: steatite reliefs of SS. George, Theodore, Nicodemus and Joseph.

tomb in which Christ's body was laid after the Deposition and who was present with Nicodemus when this action took place. While innumerable scenic representations of the Deposition contain representations of these saints as part of the narrative action, they do not seem to have been used as independent images elsewhere.[14] A third portrait is also both rare and specific: St Anastasia Pharmakolytria (Fig. 13). She was a fourth-century martyr, who visited Christians who were in prison during the persecutions under Diocletian, tending the sick and binding up their wounds.[15] The only other pre-Conquest depiction of her[16] that has been published is that in the narthex of the church of the Anargyroi in Kastoria, where she is shown as a martyr, holding a cross, rather than as a healer holding a flask of ointment, as here.[17] There was a monastery dedicated to her in Constantinople,[18] although her principal relics were at another monastery near Thessalonika.[19] Other of her relics are today to be found in several parts of the Greek mainland, in Istanbul and in Crete.[20]

The significance of these portraits, rare or even unique as they are, must be considerable. To start with the two male saints, it is hard to escape the conclusion that the original ensemble of the reliefs must have had a strong connection with the Church of the Holy Sepulchre in Jerusalem. Indeed, Paciaudi in the eighteenth century guessed that the relic, still encased in the diptych, was actually a piece of the Holy Sepulchre itself.[21] How else, even without any relic, could their presence be explained? This brings us to the female saint connected with healing – St Anastasia Pharmakolytria. While not linked so specifically to any one locality as the other two, she must have played at least as prominent a part in the original ensemble – possibly more so, as she is depicted frontally.

At this point we should recall what little is known of the history of the diptych in its present form. From the mid-fourteenth century, at the latest, it was in the hands of the Hospitallers, and, as it has been in Malta since at least the eighteenth century, it

[14] Nicodemus is commemorated on 3rd Aug., and Joseph of Arimathea on 17th March; cf. *Bibliotheca Sanctorum*, Rome [1961–69], VI, cols. 1292–5 and IX, cols. 905–7. Even if not unique, the implication of their presence in the ensemble is clear.

[15] See the *Synaxarium Ecclesiae Constantinopolitanae* (Ed. H. Delehaye, Brussels [1902]), cols. 333–6; also the *Anonymi de Antiquitatibus Constantinopolitanae* in Migne, P. G., CXXII, col. 1248.

[16] She appears in later Byzantine art more frequently, and can be found in the Stroganof *Podlinnik* among the saints celebrated on 29th October, and in the *Hermeneia* of Dionysius of Fourna, among the female martyrs. See the *Lexikon der christlichen Ikonographie*, V, Rome/Freiburg etc. [1973], col. 131, and the *Reallexikon der Byzantinischen Kunst*, II, col. 1089.

[17] See A. K. Orlandos: 'Ta Byzantina Mnēmeiōn tēs Kastorias,' *Arkheion tōn byzantinōn tēs Hellados*, IV [1938], pp. 3–106, p. 27.

[18] R. Janin: *La Géographie ecclésiastique de l'Empire byzantin*, Pt. I, *Constantinople*, III: *Les Eglises et les Monastères*, Paris [1953], pp. 29–30; the building was mentioned by observers in 1190 and *c.* 1200. See also E. Miller: *Manuelis Philae Carmina*, I, Paris [1855], p. 311, for a poem in honour of this saint.

[19] For this monastery, also dedicated to the saint, see P. N. Papageorgiou: 'Ekdomē eis tēn basilikēn kai patriarkhikēn monēn tēs hagias Anastasias tēs Pharmakolytrias tēn en tē Khalkidikēs,' *Byzantinische Zeitschrift*, 7 [1898], pp. 57–82.

[20] See O. Meinardus: 'A study of Relics of Saints of the Greek Orthodox Church', *Oriens Christianus*, 54 [1970], pp. 130–278, particularly pp. 139–40.

[21] Paciaudi, *op. cit.*, p. 394.

Fig. 13. Interior of diptych: steatite reliefs of SS. Onuphrios, Anastasia Pharmakolytria and Bartholomew.

is safe to assume that it has been in Hospitaller territory since Hélion de Villeneuve's arms were fixed to it. Could it be that the ensemble has spent all its existence in the hands of the Hospitallers? There are some good reasons for drawing this conclusion. Firstly, there could hardly be a better explanation for the combined presence of the three saints, one very rarely depicted and the other two apparently unique, than that they originated in connection with a place of healing in Jerusalem. The Knights of the Order of the Hospital of St John of Jerusalem did of course have as their original *raison d'être* precisely such an institution, and the hospitals that they built when they occupied Rhodes, and later Malta, testify to this continuing function. But why a female healing saint, rather than the universally known 'moneyless healers', Cosmas and Damian? The most logical answer would be that it was for a women's hospital, and here again the Knights Hospitallers offer the best solution: both in Jerusalem, as well as in Acre, they maintained hospices specifically for women.[22] There is nothing in the ensemble as it now survives which would militate against the general direction of this argument. Indeed, the presence of St Sabas as another of the three frontally depicted saints maintains the connection with the Holy Land, as the most famous monastery dedicated to him still stands a short way outside Jerusalem. The group must almost certainly be incomplete; it would be very rare to have only one Evangelist (in this case, St John), rather than all four. The fact that Bartholomew is the only apostle could be explained by the fact that he is the third of the frontally portrayed saints. In any case, even since it was re-assembled in its present form, the diptych has lost two of its reliefs, and so any reconstruction would have to be very speculative.

[22] See E. J. King: *The Knights Hospitallers in the Holy Land*, London [1931], p. 66; and J. Riley-Smith: *The Knights of St John in Jerusalem and Cyprus 1050–1310*, London [1967], pp. 240–42.

However, given these provisions, we can now return to the question of the original form and function of the ensemble. If that of a small-scale devotional work such as a triptych, as well as that of a casket, have both to be rejected for practical considerations, we are left with the principal remaining form for religious works of this scale, which is the reliquary.[23] Here the range of possibilities is much larger, with a wide variety of forms and types still in existence.[24] The possibility of the steatites having formed the housing for relics is strengthened by several aspects of their subject-matter. The frontal depiction of three of the least important saints, combined with their very slightly larger dimensions, gives them a significance that it is hard to explain in any other way. The unusually small relative scale of the *Crucifixion* scene ceases to be such a problem, and could indeed have been complemented by another scene, such as the Deposition or the Anastasis. The relics which the object would have contained must presumably relate to SS Anastasia, Bartholomew and Sabas, and very probably to the Holy Sepulchre as well; the only other way this connection could have been established, other than by the inclusion of SS Nicodemus and Joseph of Arimathea, would presumably have been by the presence of a scene of the Entombment, but this would of course have been open to other interpretations.[25]

Given the two-dimensional character of the reliefs as they now exist, and the fact that they show unusually little wear (even when compared, for example, with the group of full-length reliefs in the left-hand leaf of the diptych), it would be most probable that the ensemble had a cover over it – possibly a sliding one, of wood.[26] The conjectural reconstruction of this group of reliefs, as proposed here (see diagram), has been formed with all these various factors in mind, and with reference to the admittedly very fluid tradition for the appearance of this type of object.[27] While it must remain highly speculative, within the terms established by the reliefs themselves, it is a logical arrangement. The scale of the ensemble is largely established by the dimensions of the surviving reliefs, and while some (such as evangelist portraits) are virtually certainly missing, it is unlikely that these amounted to a substantial number.

Before going on to consider the other two questions that remain to be answered – on the date and place of origin of the reliefs – something should be said about the smaller group of five full-length figure reliefs (Figs. 13, 14, 15 and 16). This group must be more incomplete than the other, and no attempt will be made to suggest so positively what its original form might have been. The connection with Jerusalem and the Holy Land was, however, maintained in several of its reliefs. Thus St James

[23] The possibility of the reliefs being used as part of a book-cover cannot be entertained on either formal or practical grounds.

[24] The study by Frolow of the forms taken by the reliquaries of the True Cross indicates the range possible within just one class of relic, and there are of course countless others; see A. Frolow: *Les Reliquaires de la vraie Croix*, Paris [1965], esp. pp. 21–151.

[25] See G. Millet: *Recherches sur l'Iconographie de l'Evangile* ... repr. Paris [1960], pp. 461–88.

[26] As in e.g. these examples from Frolow, *op. cit.*: No. 135 (Fig. 38a and b), No. 271 (Fig. 51), No. 413 (Fig. 53), No. 435 (Fig. 56), No. 648 (Fig. 55), No. 729 (Fig. 43), etc.

[27] A comprehensive study of the whole field does not exist, but there certainly does not appear to have been a 'norm' or standard type of reliquary for any kind of relic.

Fig. 15. Interior of diptych: steatite relief of St James Adelphotheos.

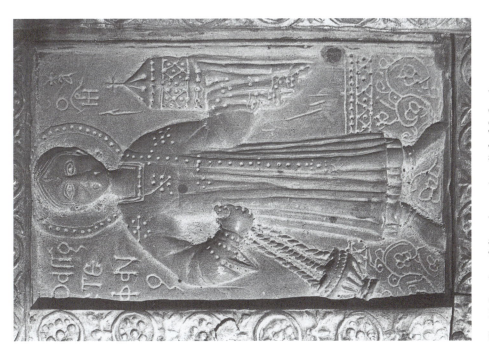

Fig. 14. Interior of diptych: steatite relief of St Stephen.

Adelphotheos (Fig. 15) was traditionally the first Bishop of Jerusalem; according to her legend it was on the threshold of the Holy Sepulchre that St Mary of Egypt was converted from her previous way of life as an Alexandrian courtesan, and is shown (Fig. 16) in the smallest of the reliefs in a subsequent episode, receiving the sacrament from St Zosimas;[28] while the site of the martyrdom of St Stephen (Fig. 14) just outside the walls of Jerusalem had been commemorated by a building since the fifth century.[29] The presence of SS Cosmas and Damian does of course maintain the connection with healing that was established in the larger group by St Anastasia Pharmakolytria. However, we probably have less than half of the original ensemble here, and no conclusion as to its original scope and content can safely be attempted. This is of course doubly unfortunate, as it might have been of some help in consolidating the reconstruction of the larger group.

We can now approach the other two main questions that concern the diptych – namely its date, and its place of origin. These two problems are so closely interrelated that they will largely have to be considered together. As far as the date of both groups of reliefs is concerned we have a firm *terminus ante quem* of 1346 – the year in which Hélion de Villeneuve died.[30] The establishment of a *terminus post quem* is less easy,[31] but a strong indication is given by the palaeography of the inscriptions. This denotes fairly certainly a Palaeologue date for the smaller group, and probably the same for the larger group of half-lengths as well.[32] While it has not been possible to find any clear stylistic parallels which would provide confirmation of this, the general character of the carving of both groups is certainly entirely consistent with Palaeologue style, and it would seem safe to regard both as dating from not earlier than the second half of the thirteenth century.

When considering the place of origin of the reliefs, one should begin with the known major centres of artistic production. In spite of the relative provinciality of their style, it is certainly not impossible that our steatites were produced in Constantinople in the early years of the Palaeologue dynasty. There are even donations of relics that are known to have been made to the Hospitallers in Rhodes by the Emperor in the later fourteenth century, although the descriptions of them do not correspond with

[28] For the life of the saint, with sources, see H. Leclerq: *Dictionnaire d'Archéologie chrétienne et de Liturgie*, X, 2, Paris [1932] cols. 2128–31.

[29] M-J. Lagrange: *Saint Etienne et son Sanctuaire Jérusalem*, Paris [1894], pp. 73–84; by 1102 the original basilica had disappeared, but an oratory had been built on the site.

[30] See note 4, above.

[31] It might be assumed that the presence of a patron's coat of arms implied his personal sponsorship, and in the case of Villeneuve this would mean that his re-assembly occurred between 1332 and 1346, which were the years he was on Rhodes; while this is probably true of smaller, portable objects, Dr Luttrell has pointed out to me that the arms of Blanchefort (Grand Master 1512–13) appear on buildings at Rhodes and Bodrum, although he died a year after his election and before he ever reached Rhodes (see also note 3, above).

[32] I am most grateful to Professor Cyril Mango for giving me the benefit of his opinion in this respect.

Fig. 16. Interior of diptych: steatite reliefs of SS. Cosmas and Damian, Zosimas and Mary of Egypt, and Sabas.

Villeneuve's diptych.[33] However, there are several aspects of the reliefs which make a metropolitan origin unlikely. Apart from their style, which certainly does not readily correspond to what we know of work in the capital of the Empire after 1261, the very specific nature of the subject-matter of the reliefs suggests a much more direct form of local patronage. If the association of the Hospitallers is accepted, it would seem inherently much more probable that they were made in a provincial atelier where there was direct contact with Hospitaller patrons than that they were the result of an order sent to metropolitan craftsmen. The relative cheapness and fragility of the material from which the reliefs were made would in any case argue against any very elaborate background of patronage. On these grounds, Thessalonika, where St Anastasia's relics are still housed,[34] must be thought of as an even less likely place of origin.

This obliges us to consider other centres of production for our steatites. There are in all four localities with which the Hospitallers were concerned, and which therefore might be the source of the reliefs. First, Jerusalem itself: although the subject-matter

[33] Cf. 'Relation du Pélérinage à Jérusalem de Nicolas de Martoni (1394–1395)' (Ed. E. Le Grand), *Revue de l'Orient Latin*, III [1895], pp. 566–669, esp. pp. 641–3.

[34] See note 20, above.

of both groups of reliefs makes this in some ways the most tempting solution, it cannot be supported in the light of the stylistic and epigraphic evidence. The Knights Hospitallers had to leave Jerusalem when it was taken by Saladin in 1187, and activity by Greek artists in the later thirteenth century, although possible, cannot be thought of as likely.[35] Secondly, Acre: this was of course the headquarters of the Hospitallers after they left Jerusalem, and their activity there as patrons of the arts was certainly considerable.[36] As has recently been pointed out, most of the icons and manuscripts that are known to have been produced there date from after c. 1250,[37] and so a date at some point in the thirty years prior to 1291, when the city fell to the Moslems, is certainly tenable on historical grounds. The suggested function of one of the groups of reliefs – that they formed a reliquary connected with the Holy Sepulchre – is also consistent with their origin during this period, as the relics could well have been brought from Jerusalem in the twelfth century, and given a new housing in Acre. It is also known that the Hospitallers maintained a hospice for women there.[38] Thirdly, Cyprus: the Hospitallers based themselves there after leaving Acre, and before their occupation of Rhodes in 1309; although it was an extremely unsettled period for the Order, and so in one way less likely to be the point at which patronage of works of art would have taken place,[39] Cyprus has one claim to be regarded as the most likely place of origin for the reliefs in that there was certainly activity by indigenous Greek artists prior to the arrival of the Hospitallers.[40] Finally, there is Rhodes itself. Little is known of the kind of artistic life that would have existed there in the earlier fourteenth century, but it cannot be regarded as very likely that their urgent needs at the time would have allowed the Knights – most of all their Grand Master – to indulge in this kind of patronage. There is also the question of the degree of wear exhibited by some of the reliefs, particularly the smaller group of full-length figures; this must mean that they had been in circulation for a period of time perhaps before they were re-set in their present form.

While this summarizes very briefly the arguments for each of the four centres with which the Hospitallers were concerned, nothing has so far been said about one

[35] The study of the art of the Crusader kingdoms has recently been intensified; the principal studies in this field include the following: T. S. R. Boase: 'The Arts in the Latin Kingdom of Jerusalem', *The Journal of the Warburg Institute*, II [1938–39], pp. 1–21: H. Buchthal: *Miniature Painting in the Latin Kingdom of Jerusalem*, Oxford [1957]; K. Weitzmann: 'Thirteenth Century Crusader Icons on Mount Sinai', *The Art Bulletin*, XLV [1963], pp. 179–203; K. Weitzmann: 'Icon Painting in the Crusader Kingdom', *Dumbarton Oaks Papers*, 20 [1966], pp. 49–83; and, most recently, J. Folda: *Crusader Manuscript Illumination at Saint-Jean d'Acre, 1275–1291*, Princeton, N.J. [1976].

[36] See Folda, *op. cit.*, esp. pp. 3–26; the Hospitallers were the most important of the Knights at Acre.

[37] Folda, *op. cit.*, p. 23.

[38] Riley-Smith, *op. cit.*, pp. 240–42.

[39] Riley-Smith, *op. cit.*, pp. 198–226; the period between 1291 and 1300 was characterized by internal conflict and lack of purpose in the Order, and that from 1300 to 1309 was devoted to the mounting of a Hospitaller crusade, which ended ignominiously.

[40] Cf. e.g. the works in Cyprus published by D. Talbot Rice: 'Some Byzantine Objects in Cyprus', *The Burlington Magazine*, 75 [1939], pp. 204–10.

of the principal problems that the diptych presents: why should Greek artists have been employed to carry out works for Western patrons at all – even if the patrons had established ties in the Eastern Mediterranean? Certainly, as far as monumental sculpture is concerned, all the surviving evidence in both the Holy Land and in Rhodes itself shows that sculptors working for the Crusaders maintained completely Western stylistic traditions.[41] Only in some groups of painted works – manuscripts and icons – have Western artists been shown in some cases to have adopted a Byzantinizing style.[42] If the Mdina steatites were produced directly under the auspices of Crusader patronage in any of the centres just mentioned, they must (according to present knowledge) be unique in this respect.

Bearing this factor in mind, we should return to the two most probable of the centres of Hospitaller activity – Acre and Cyprus. In order for either of these to be regarded as a possible place of origin for the steatites it would be necessary to propose a reason for a Crusader patron abandoning a style with which he would have been familiar, and turning to Byzantine artists working in an unfamiliar medium, and whose products he may well not have understood. In Acre there would surely have been no need for such a departure,[43] and it is only possible to suggest that an isolated occasion arose when contacts with a local Greek Orthodox community might have occurred. An episode such as the War of St Sabas might have provided this kind of opportunity, when, during a dispute between the Genoese and Venetian quarters of the city concerning the local monastery of this name, the Knights allied themselves with the local Syrian Orthodox community on the side of the Genoese.[44] The conflict lasted from 1256 until 1260, and might have provided the kind of situation in which at least one of our groups of steatites might have changed hands; for the present, however, this must remain completely hypothetical.

The case for Cyprus is inherently stronger, and is of course based on the known presence of Greek artists in the island. The Crusaders could hardly have brought with them any entourage of artists from the débacle of the fall of Acre; indeed, even the salvaging of relics would have been the most that could be achieved under the conditions of the siege and fall of the city. If any such relics had been brought with the Hospitallers to Cyprus, local Greek artists might well have been the only ones available to create a new housing for them. This would explain the phenomenon of a Western patron accepting a work in Byzantine style, which would hardly (at best) have been familiar to him. Such a background would also not be inconsistent with the generally insecure state of the Hospitallers during their early years in Cyprus.[45]

[41] As in e.g. the capitals probably intended for the Church of the Annunciation at Nazareth (cf. Weitzmann, 'Icon Painting', p. 52), but the tendency was still certainly present in the sculpture on the buildings of the Knights in Rhodes.

[42] As in the famous case of Queen Melisende's Psalter, and a number of other MSS. and icons; see Buchthal, op. cit., and Weitzmann, 'Icon Painting'.

[43] The activity of the artists in the scriptorium of Saint-Jean-d'Acre is unlikely to have been confined just to the field of illumination; cf. Folda, op. cit.

[44] Riley-Smith, op. cit., p. 184

[45] See note 39, above.

Neither of these suggestions can of course be proved, but if the association with the Hospitallers is accepted some such explanation must follow. Indeed, the true position is in any case unlikely to be simple; the fact that the two groups of reliefs show differing degrees of wear indicates strongly that they had different histories before being assembled on the same diptych, and it is possible that both the suggestions given here are partially correct. The enigmatic character of the whole problem also extends to the personality of Hélion de Villeneuve himself. He is known to have been an extremely able financier, and transformed the fortunes of the Hospitallers during his period of office; the pilgrim Ludolph of Suchem wrote of him as being a mean man, who had amassed enormous treasure, and freed the Order from incredible debts.[46] As the diptych contains no gold and only small amounts of silver, it must be concluded that Villeneuve valued the reliefs for their associations rather than for any intrinsic worth.[47] This would certainly be understandable if they represented a legacy of his Order brought from the Holy Land – and even possibly from Jerusalem itself.

[46] Ludolph De Suchem: *De itinere Terrae Sanctae liber.* Freiburg [1825], p. 77: '. . . *der maister der Ordens der minen ziten mas hiess Heliang von Nüwendorf* [sic], *vast alt und kurg der selb besamlet gross schetz und erloset den Orden von ungeloblichen Schulden.*' Cf. Setton, *op. cit.*, p. 291, n. 21; the Stuttgart edition of Ludolph's narrative was not available to me. (He was travelling in the Mediterranean during the years 1336–40.)

[47] Far more typical of Villeneuve's taste would have been the silver-gilt ostensory which was re-moved from the Chapel of Italy in the Church of St John, Valletta, by Napoleon. It was decorated with enamels and precious stones, and bore his (Villeneuve's) coat-of-arms; like the diptych, it must have been brought from Rhodes to Malta. See Sir Hannibal P. Scicluna: *The Church of St John in Valletta*, Malta [1955], p. 95. For a reproduction of the illustration of it in the Mdina inventory, see Oman, *art. cit.*, Fig. 6, p. 103.

APPENDIX

Particulars of the reliefs in the diptych in the Cathedral Museum, Mdina.

The numbers refer to the diagram, below; measurements are in millimetres, with the height given first.

1	2	3	empty	10	11	12	13
4	5	6		14	15	16	17
relics		8		18	19	20	21
empty	7	9		22	23	24	25

1. St Onuphrios (39 by 17)
2. St Anastasia Pharmakolytria (39 by 22)
3. St Bartholomew (39 by 30)
4. St James Adelphotheos (55 by 33)
5. The Crucifixion, with the Virgin and St John (55 by 44)
6. St Stephen the protomartyr (55 by 34)
7. SS Cosmas and Damian (63 by 45)
8. St Mary of Egypt receiving the sacrament from St Zosimas (17 by 31)
9. St Sabas (38 by 29)
10. The Virgin (35 by 25)
11. St Nicholas (35 by 26)
12. Christ (35 by 26)

13. St John the Baptist (35 by 25)
14. The Archangel Michael (35 by 26)
15. The Archangel Gabriel (36 by 26)
16. St John Chrysostom (37 by 25)
17. St Gregory (38 by 26)
18. St Paul (37 by 26)
19. St Basil (37 by 25)
20. St George (38 by 25)
21. St Theodore (37 by 26)
22. St John Theologos (37 by 26)
23. St Peter (37 by 26)
24. St Nicodemus (37 by 26)
25. St Joseph (36 by 26)

Conjectural reconstruction of the larger group of Steatite Reliefs as Reliquary.

Archangel Michael	The Virgin	Christ	St. John The Baptist	Archangel Gabriel
Relic	Relic	Crucifixion with the Virgin and St. John	Relic	Relic
St Peter				Relic
St. John Theologos	missing	St Bartholomew	missing	missing
St. Basil	St. John	St. Sabas	St. Gregory	St. Nicholas
St. George	St. Joseph	St. Anastasia Pharmakolytria	St. Nicholas	St. Theodoro

AN AFTERWORD

First published in 2000 by Fondazzjoni Patrimonju Malti.

It was some twenty-five years ago that I began the research for the article that the organisers of this exhibition have now paid me the compliment of reprinting. After re-assessing what I published in 1978, I think I can say that if, in the year 2000, I was examining the diptych and its steatite reliefs for the first time, what I wrote would perhaps differ in emphasis, and with some broader conclusions attempted, but I feel that in general my findings would not be very different from those that I first reached.

The arguments that I put forward in 1978 seem to me to be still largely valid: that the steatites are of Byzantine workmanship, that they originated in two separate groups, that there were clear associations with Jerusalem and with places of healing, and that they were assembled in their present form by the Hospitallers during the Grand Mastership of Hélion de Villeneuve. A date in the mid-Palaeologue period still seems completely possible, and although I would not now have been as specific in suggesting a possible Cypriot origin for the reliefs, the logic that produced this proposal still seems to me to have been well-grounded. One element that has changed the overall picture to some extent is the realisation of the very probable uniqueness of the ensemble of reliefs, which I had been reluctant to propose; this is due to the publication of a study of the medium by Ioli Kalavrezou-Maxeiner: *Byzantine Icons in Steatite* (Vienna 1985), where 174 examples are analysed. Any satisfactory explanation of the origins of the Mdina steatite reliefs will have to recognise this feature, and may make it ultimately more elusive. Meanwhile, it is clear that our present knowledge of the conditions of Hospitaller patronage at this period remains very limited.

In her discussion of the diptych (pages 180–4), which is the only extensive contribution to have been made since 1978, Kalavrezou-Maxeiner equates the reliefs with the description by the Italian notary Nicolas de Martoni of seven relics among a collection that he saw on Rhodes in 1395; they figure among a group of relics that were shown to pilgrims by a German frater Dominicus, who claimed to have been given them by the emperor in Constantinople, who was his *carus durabilis amicus*. Martoni lists the seven relics as being parts of (*De*) Christ's robe, of the wood of the cross, of John the Baptist's finger, and of bones of SS Bartholomew, Christopher (*sic*), Theodore and Nastasia. The identity of this generous emperor is not revealed by Martoni, but he was presumably Manuel II Palaiologos, whose reign in Constantinople began in 1391. He certainly had reason to be grateful to the Hospitallers, but Martoni is quite clear that the seven relics brought to Rhodes '*incluse sunt in quodum magno lapide jaspidis*'. I rejected this association in 1978 (p. 816 and n. 33), and I still feel that Martoni's description of this large reliquary container made from *jaspis*, and its contents, has too little in common with the Mdina steatites for it to apply to them. To equate the two entails ignoring major gaps in correlation between the text and the object as well as abandoning the association with Jerusalem and the involvement of Hélion de Villeneuve or any of his

contemporaries. The further proposition that the diptych as it now exists may even have been assembled at any date up to c. 1750, after the removal of the Knights to Malta, but attaching to it the armorial of a Grand Master who died in 1346, seems to me to be even more difficult to relate to any known practice of the Knights. This apart, the achievement of the book (unclaimed by the author) in showing how the Mdina steatite reliefs appear indeed to be a unique ensemble must be important, and in this respect this later study might be seen as offering support for my interpretation.

However, until further evidence comes to light one thing remains very clear; the last word on this fascinating and enigmatic diptych, its Byzantine reliefs and what it can tell us about Hospitaller patronage still remains to be written.

XVIII

A WELL-HEAD IN IZNIK;
AN EXAMPLE OF LASKARID TASTE?

In 1966 a well-head of Proconnesian marble was found in the garden of a building adjoining the main street in Iznik, and it now has a place in the collection of the Iznik Museum (Figs. 1 and 2).[1] This short article will attempt to place this well-head in the context of Byzantine sculpture of comparable type and function and, given its findspot in Nicaea, assess the date at which it might have been produced.

It can be seen that the decoration, of a bold rather than a refined character, takes the form of a broad band of interlace with decorative motifs inserted into the circular spaces of the design.[2] The spaces created by the design are all the same size except for one slightly smaller one which encloses a cross; the other loops are occupied by quite a restricted range of repeated decorative motifs: whorls, twelve-petal flower forms, hexagons with separated segments and four-leaf clover designs. All these motifs occur frequently in Byzantine art, often carved on rectangular reliefs that were produced during the middle Byzantine period for incorporation into architectural ensembles such as templa and gallery parapets.[3] Carved as it is from a monolith of Proconnesian marble, there can be no real doubt that this is the work of a Byzantine sculptor. It should also be said that, once given its present form, it must always have been intended to serve the purpose of a well-head; scored grooves on the inner lip worn by the ropes of those using the well can still be seen, and there can be no question of its having been made to serve some other function, and then adapted.[4] Its presence, however, does raise a number of interesting problems: the use made of wells in Byzantium, the relationship of this example to the tradition of Byzantine well-head design, and the inter-related question of its decoration, its date and its findspot in Iznik.

There is first the question of the extent to which the Byzantines used wells at all. The water supply of Constantinople itself was a persistent problem for its inhibitants, but over the centuries they developed a system that chiefly involved the storage of water in cisterns, which were filled either by rainwater or by water conveyed—often over considerable distances—by aqueducts; the number of natural springs appears to have been

[1] Inv. no. 1625; its dimensions are: diameter 88 cm., height 60 cm.; the garden is now that of the police station, on Attaturk Caddesi. I would like to thank the Museum Director at Iznik for his help and informative co-operation. I am also much indebted to Professor Cyril Mango for reading an early draft of this article; while I have benefited greatly from his comments, responsibility for the views expressed here, as well as for any errors which may have intruded, must rest with me.

[2] Cf. T. Ulbert, Studien zur dekorativen Reliefplastik des östlichen Mittelraumes (Munich 1969) who discusses the subject of relief sculpture and lists reliefs in the museum at Iznik.

[3] Cf. A. Grabar, Sculptures byzantines de Constantinople (I), (IVe–Xe siècle) (Paris 1963) Pl. LXIII, no. 5; a rectangular relief in the Istanbul Archeological Museum, Inv. no. 2906, dated here to 10th cent.

[4] It is not unknown for classical capitals to have been hollowed through in later centuries and used as well-heads; see A. Ongania, Raccolta delle Vere da Pozzo in Venezia (Venice 1911) Pls. 90 and 153.

negligible.[5] In view of this it is surprising that the use of well-water was not more extensive, at least within the city. While references to man-made wells are recorded in title-deeds, and they are still a feature of most monasteries,[6] these do not seem to have played any significant part in the overall water provision of the city, and may have been a regular feature only of rural or monastic life. One explanation for well-water being the least favoured form of water supply could be that, besides being laborious to procure, it lacked the purity of spring-water; there is indeed some very limited textual evidence which suggests that, at least for drinking water, this was the case.[7] Its poor reputation may have been responsible for there being such limited use of wells in Constantinople. Springs of running water were probably regarded as the best form of supply, but if they were absent, aqueducts and cisterns came next in order of preference. For the more static quality of well-water to retain its purity there was need for quite strict control of all activities close to the well;[8] it is quite possible that this was not enforced in either urban or rural areas, which would contribute to a reputation for this source of water being liable to pollution.

Setting aside the question of the extent to which well-water was used, there does not seem in any case to have been anything approaching a consistent tradition for the design of well-heads in Byzantium. When they were used, it would appear that most often they were built of bricks or masonry; the major sculpture collection of the Istanbul Archeological Museum contains no examples of this form, and it seems that among the numerous survivals from the city's medieval past there is little or nothing that corresponds to what could be a 'purpose-made' monolithic well-head. Even looking further afield, in the survey of Byzantine sculpture by Grabar, covering the 4th to the 14th centuries, not a single mention is made of such a work.[9]

This impression is reinforced if attention is given to representations in art. These are not very numerous, but do not suggest that there was any very clear tradition in their design and certainly none in their decoration. While there need never have been a direct link between artistic representation and actual practice,[10] sufficient pictorial evi-

[5] E.g A. Berger, Das Bad in der Byzantinischen Zeit (Munich 1982; Misc. Byz. Monacensia 27), 105-6.

[6] A. Karpozilos and A. Kazhdan in Oxford Dictionary of Byzantium (Oxford 1991) 2191; also A. Orlandos, Μοναστηριακὴ Ἀρχιτεκτονικὴ (Athens 1958) 101-2.

[7] For an early 13th century reference to the subject in the writings of John Apokaukos, bishop of Naupaktos, see E. Bees-Seferlis, Unedierte Schriftstücke aus der Kanzlei des Johannes Apokaukos des Metropoliten von Naupaktos (in Aetolien). Byzant.-neugr. Jahrb., 21 (1975) 55—160, where in letter no. 67, written to the bishop of Thessalonica, John Apokaukos says (p. 123) of the inhabitants of Naupaktos that they are fortunate in that they can gather clear water just by cupping their hands (at a spring), and do not need to dig underground like moles to make wells, and then chafe their hands hauling the filthy water from the well-head (τὸ στόμα τοῦ φρέατος); see P. Magdalino, The Literary Perceptions of Everyday Life in Byzantium. Byzantoslavica 48 (1987) 28—38.

[8] This was understood in Venice, where by 1325 legislation had been passed prohibiting the deposit of dirt and refuse in the vicinity of wells; see A.-L. Seguso, Delle Sponde marmoree e Vere dei Pozzi e degli antichi edifizii della Venezia marittima (Venice 1859) 9—10.

[9] Grabar, op. cit. in n. 3, above, and Vol. II (XIe—XIVe siècle) (Paris 1976). Another exhibit in the Museum at Iznik is most probably to be identified as the fragmentary top of a small octagonal marble well-head, on which there appear to have been crosses carved in relief; I would like to thank Professor Cyril Mango for drawing this to my attention.

[10] It is hard, for example, to imagine that a cruciform well-head, such as the one depicted in the 14th

dence exists to allow some confirmation. While it is more common to find representations of springs of water which run or spout into a trough or other container, the Gospel narrative of the conversation between Christ and the Samaritan woman mentions a well on which Christ was said to seat himself, and so illustrations of this text provide a number of examples of what must have been recogniseable as well-heads.[11] A range of manuscript illuminations from the 9th to the 12th century supply evidence for a variety of well-head designs,[12] but the most common shape is a cylindrical form, usually with a broader base, and devoid of any decoration. It is often hard to tell what material it is made from, but this could be of mortared stone, rendering (possibly with plaster) or be a plain monolith of yellowish stone;[13] it would, however, be safe to say that no evident norm existed in representational art. So using both actual and pictorial evidence it does seem that a monolithic, cylindrical well-head, with a careful decorative scheme, would have been an uncommon sight; there is no apparent consistent tradition in Byzantium for either the design or the decoration of this particular form.

It now begins to appear that our well-head in Iznik, with its apparently very unusual decoration, may be quite rare, and this suggests that equally unusual conditions may have governed its production. Nicaea was built close to the fresh-water lake of Askanios, and this must have provided all its basic needs for water. There had been an aqueduct, probably originally constructed by Hadrian after an earthquake in 120, and then re-built by Justinian in the 6th century,[14] but it is not known at what point this fell into permanent disuse. Within the city there were no streams and (it would seem) no natural springs. If there was need of water and, for any reason, it was not convenient or adviseable to venture outside the city walls, or if for any reason the aqueduct was not functioning, the local water table would have been sufficiently high for wells dug in the area to have provided water at no great depth. If well-water was indeed less popular, the prevailing conditions must have been sufficiently serious to overcome these objections. While it is of course possible that the well-head was imported, already carved, from

century wall-paintings at Lesnovo, Serbia, could ever have had a useable existence in real life; see T. Velmans, La Peinture du moyen âge en Yougoslavie, Fasc. IV (Paris 1969) fig. 34.

[11] St. John, Ch. 4,5 ff. It is possible that there was some uncertainty about the meaning due to the vocabulary available; the word used here for 'well', πηγὴ, is also found in both the OT and NT meaning 'spring', while φρέαρ is used in the Septuagint of (e.g.) the well that Abraham is said to have dug at Beer-sheba (Genesis, Ch. 21,31), as well as by John Apokaukos in the 13th cent. for a man-made well (see n. 7, above).

[12] For the variety of types found, see H. R. Willoughby, The Four Gospels of Karahissar (Chicago 1936) vol. II, 380—385.

[13] From the 9th cent., Athos, Pantocrator MS 61, fol. 242v. (S. M. Pelekanides et al., Οἱ Θησαυροὶ τοῦ Ἁγίου Ὄρους, vol. 3 (Athens 1979) p. 191); later examples in MSS include Leningrad, Saltykov-Shchedrin State Library, cod. gr. 105 (H. R. Willoughby, op. cit., Pl. CXIX); Athos, Iviron, MS 5, fol. 371r. (S. M. Pelekanides, et al., The Treasures of Mount Athos, vol. 2 (Athens 1975) fig. 34); Paris, Bibl. nat., cod. gr. 74, fol. 173r. (H. Omont, Évangiles avec Peintures byzantines du XIᵉ siècle (Paris n. d.) Pl. 150.). Well-heads are also depicted in the mosaics of San Marco (O. Demus, The Mosaics of San Marco in Venice (Chicago/London 1984) pt. I, vol. 2, pl. 147) and (from the Palaeologue period) in the Kariye Djami (P. A. Underwood, The Kariye Djami (London 1966) vol. 2, pl. 257 a.)

[14] The first mention of an aqueduct at Nicaea would seem to be in Procopius, where he refers to its re-building by Justinian; see G. Wirth (Ed.), J. Haury (Reg.) De Aedificiis (Leipzig 1964) 154.; it may have been built by Hadrian, but the Chronicon Paschale mentions only the ramparts and public buildings being constructed there by him; see L. Dindorf (Ed.) Chronicon Paschale (Bonn 1832) (CSHB), 475.

Constantinople, there are considerable problems in accepting this explanation which will be referred to shortly: all the indications we have would point to its creation in the city of Iznik itself. There remain, therefore, the interlocking questions of its date and its decoration.

In looking for precedents for a more vigorous tradition of well-head production, the first place to review is Venice. For it was this city which, to a more complete extent than anywhere else in Europe, was from the early medieval period into modern times solely dependent on well-water.[15] The decoration of the many hundreds of well-heads from which it was drawn became a minor art form in its own right, and established its own traditions; from the 10th to 12th century one of the more common forms of decoration involved horizontal bands of interlace or running scrolls, as can be seen in a number of surviving examples[16]. So that when looking at the relief ornament of the well-head in Iznik, and given the lack of any perceived tradition for the decoration of Byzantine well-heads, it is certainly possible to see the Iznik design as a loose adaptation of this Venetian tradition for the decoration of *vere da pozzo* of the 10th to 12th century. (If this is accepted, it must represent one of the few 'gifts' of the Venetians to the Greek East.)

Whatever the general character of the interlace relief, the individual motifs that are incorporated into it are, as shown above, completely Byzantine. This brings us to the most problematic aspect of the Iznik well-head, which is the period in which it was produced. A *prima facie* case could certainly be made for proposing a 10th—11th century date for the work, based on known Byzantine sculptural practice of that period; this would, however, have to relate to the conditions—both economic and political—prevailing in Nicaea at this time.

While there would have been times of relative prosperity during this period, the generally rather disturbed political history of the city seems unlikely to have provided the conditions which would encourage the production of a novel and, it would appear, relatively expensive, if functional, piece of sculpture. Certainly, a well-head constructed from brick or masonry would always have been both cheaper and very much easier to produce. Yet during the 10th to 12th centuries it is very hard to identify a sustained period when the leisured climate that was necessary for expenditure on a relatively rare, if minor, showpiece such as the well-head, was prevalent. When needed, one could always have been constructed much more cheaply from brick or stone. An earthquake in 1063 was of sufficient severity to destroy some of the city's massive defensive ramparts,[17] and in 1077 Nikephoros Botaneiates entered the city in triumph after his revolt.[18] The Turks were a constant presence during the 11th century, sometimes being welcomed into the city; for a period of sixteen years (1081—1097) initially under the

[15] A. Rizzi, Vere da Pozzo di Venezia; I Puteali pubblici di Venezia e della sua Laguna (Venice 1981) is the most recent study, with full bibliography. It was only in the later 19th century that water was piped from the mainland into Venice; until then wells had been its sole source of water.

[16] See F. Ongania, *op. cit.*, e.g. Pls. 31 and 123; for one now in England dated to the 12th century, with its base probably earlier, see P. Hetherington, Two Medieval Venetian Well-heads in England. Arte Veneta 34 (1980) 9—17.

[17] V. Grumel, Traité d'études byzantines, I: La Chronologie (Paris 1958) 480, citing Skylitzes; see also R. Janin, Nicée, étude historique et topographique. Échos d'Orient 24 (1925) 482—490, esp. 485.

[18] B. G. Niebuhr (Ed.), Nikephoros Bryennios, Commentaries, Bonn 1836 [CSHB], Bk. III, ch. 23, 125; see also Janin, *loc. cit.*

Seljuk sultan Suleiman of Konya, they were in exclusive occupation of it as a garrison, installed by Nikephoros Melissenos when he joined Alexios I in the West.[19] It was only after its capture by the Crusaders in 1097, following a long siege, that Alexios I took over its defence against further Turkish aggression.[20] Nicaea, not doubt because of its important position on roads and supply routes, its trading tradition and administrative importance,[21] was a town that rebels such as Nikephoros Botaneiates and Nikephoros Melissenos sought to control.

It was thus perhaps its relative prosperity which may have prevented Nicaea from enjoying a more stable tenor of life during these centuries. The conditions that would account for the innovative artistic endeavour that is represented by the well-head, bearing as it does a Christian symbol, would seem to have been lacking. Wells may have been dug during the siege of 1097, for example, but they would surely only have been completed with the most functional of well-heads.

If we are seeking unusual circumstances as a context for an unusual and relatively expensive work, a period that offers itself as combining these needs is that when Iznik, as Nicaea, was the capital of the Byzantine empire. A member of the Laskarid court, which was installed there from 1206 until 1261,[22] or perhaps a senior member of the patriarchate,[23] becomes, for historical reasons, the most likely originator of the well-head that was recently discovered in the city. It could be mentioned that the provision of a water supply that was independent of any external problems or constraints would also be consistent with the known policies of the Nicene emperor John III Vatatzes, who was anxious to encourage self-sufficiency and sound domestic management within the city.[24] Even if an aqueduct was still in operation outside the city walls, the first action of a besieging force would have been to sever it. This brings us to a date somewhere towards the mid-13th century, and the likelihood that the patron was a relatively rich and prominent member of the court or patriarchate; he (or the sculptor) may have consciously or unconsciously adapted a design reminiscent of Western practice to a fine piece of Proconnesian marble. The sculptor may thus have been drawing on the decorative language of two traditions: if the overall concept of a running band of interlace may be found to be ultimately more reminiscent of Venetian decorative practice, for the individual motifs that it encloses he returned to a fully Byzantine tradition that was current some two centuries earlier.[25] Even if the Western association is not accepted, the Iznik

[19] L. Schopen (Ed.) Anna Comnena, Alexiad, 2 vols., Bonn 1839—78 (CSHB), Bk. III, ch. 11, vol. I, 177—179; also Janin, *loc. cit.* Nicaea thus became the first Turkish capital to exist in Asia Minor.

[20] The Turks were devastating the countryside round Nicaea; see Anna Comnena, Alexiad, *ed. cit.,* Bk. VI, ch. 9, vol. I, 298—303.

[21] J. Sölch, Historisch-geographische Studien über bithynische Siedlungen. Nikomedia, Nikäa, Prusa. Byzant.-neugr. Jahrb., 1 (1920) 263—295, esp. 286-7.

[22] M. Angold, A Byzantine Government in Exile. Government and Society under the Laskarids of Nicaea (1204—1261) (Oxford 1975).

[23] For the status of the patriarchate at Nicaea, see Angold, *op. cit.,* p. 47 ff. and Sölch, *op. cit.,* 280 and 288.

[24] Angold, *op. cit.,* 116—117.

[25] It could be suggested that the well-head had been brought to Nicaea from Constantinople in its present state, and if so it could more readily be seen as a work of the 10th—11th centuries; it does, however, seem highly unlikely that the conditions under which the Byzantines left Constantinople in 1204 would have permitted them to be encumbered with such an object.

476

well-head may still be seen to take its place as minor evidence of the artistic taste that developed in the Laskarid capital while the city served as the seat of the patriarchate and the effective capital of the Byzantine Empire.[26]

[26] For a discussion of the possible location of a 13th century school of manuscript illumination at Nicaea, see among recent literature, H. Buchthal, Studies in Byzantine illumination of the thirteenth century, *Jahrb. der Berliner Museen*, 25 (1983) 27–102, esp. 94–102, and A. W. Carr, Byzantine Illumination 1150–1250; the study of a provincial tradition (Chicago/London 1987). Although there were certainly other art forms practised at Nicaea during the period in question, it did not seem appropriate to associate them with the well-head.

Fig 1. Iznik, Museum: well-head, Inv. no. 1625

Fig 2. Iznik, Museum: well-head, showing decoration and cross

ADDENDA

I. Byzantine *cloisonné* enamel: production, survival and loss

This article was already in the press when the completely unknown triptych discussed in Study XIII was made known by its current owner. While the listing of all currently known enamels, which is attempted here, is acknowledged to be always subject to an upward adjustment, it could not have been foreseen that it would be so soon increased by the six plaques of this outstanding work. The article of Titos Papamastorakis, 'Re-deconstructing the Khakhuli Triptych', *Deltion tis Christianikis Archaiologikis Etaireias*, 23 (2002), pp. 225–254 was not available to me before this article was completed, but its many original and perceptive observations are in keeping with the approach expressed here.

IV. La couronne grecque de la Sainte Couronne de Hongrie

This article should be seen in the context of the other papers read at the Colloque, "La Sainte Couronne de Hongrie" held at the Institut Hongrois de Paris in November 2001.

V. Byzantine and Russian enamels in the treasury of Hagia Sophia in the late fourteenth Century

I omitted any discussion of the identities of the three individuals who compiled the inventory which formed the basis of this article, but I think that a summary would be helpful here in evaluating their text. The known details are given here, with information from J. Trapp: *Prosopographisches Lexikon der Palaiologenzeit* (Vienna, 1976–91). The authors were: kyr Aléxios Tzamplákonas tou Kaballariou, Philanthropinós kyrou Andrónikou and kyr Apokaùkos tou Melissinoù. The first named was probably the senior member of the trio, and when he died at some point before 1414 he had been attached to the imperial court at some level for nearly 40 years. The second was senator from 1397 to 1409 and from that year was *oikeios* in the household of Manuel II; he became a monk in Vatopedi on Mount Athos,

but died shortly after his arrival there in 1414. The third, beside his senatorship, was also an *oikeios* of Manuel II and was probably the youngest of the three. They were thus all three members of a distinct political, secular elite, all at one time or another were named as members of the imperial household (two as *oikeioi*) and all were recorded as senators in the year 1397. Their opinions should thus be regarded as those of able, educated and cultured laymen.

VI. Byzantine enamels on a Venetian book-cover

Studying this book-cover in 1976–77 I was obliged to follow (pp. 123–127) previous writers in regarding it as having arrived, with the other relics in the 1359 purchase, from Constantinople; this meant that, having decided that it was made in Venice, it must have been returned to the capital, from whence it came back to the west. Given access to the documents in 1982 (I had been told in 1976 that they were not available in the Siena archives) it was clear that the book-cover was not among the purchases made in Pera; the proposition that it was indeed made in Venice was thus vindicated. See also G.Derenzini, 'Esame palaeografico del codice X.IV. I della Biblioteca Comunale degli Intronati, e Contributo Documentale alla Storia del "Tesoro" dello Spedale di Santa Maria della Scala', *Annali della Facoltá di Lettere e Filosofia dell' Università di Siena*, VIII (1987), 41–76, with *idem*, 'Il Codice X.IV.1 della Biblioteca Comunale degli Intronati di Siena', *Milion* 1 (1988), pp. 307–325, and Robert S. Nelson, 'The Italian Appreciation and Appropriation of Illuminated Byzantine Manuscripts, ca. 1200–1450', *Dumbarton Oaks Papers*, 49 (1993), pp. 209–235, esp. p. 216 and n. 38.

VII. A purchase of Byzantine relics and reliquaries in fourteenth-century Venice

Since this article appeared the richly documented contents of the treasury of the Ospedale di Santa Maria della Scala have become much more widely known. It was already in the press when the comments of M. Bonfioli, *Recuperi bizantini in Italia: Siena* were published in the *Akten der XVI. Internationaler Byzantinistenkongress*, Vienna, 1981 (in *Jahrbuch der Österreichischen Byzantinistik* XXXII/5, 1982, 281–289). However, the exhibition from December 1996–February 1997, which displayed the treasure, also included the book cover analysed in Study VI, and was accompanied by a finely produced catalogue: *L'Oro di Siena. Il Tesoro di Santa Maria della Scala*, edited by Luciano Bellosi (Skira, Milan, 1996); this, with its full commentary and bibliography, brought up to date all the materials on this uniquely well-documented group of works, with their demonstrable origins in the imperial palace.

XVI. The Cross of Záviš and its Byzantine enamel

In 1994, when this article was published, the Cross of Záviš was still being kept in the treasury of St Vitus' cathedral in Prague, where it had been placed for safe keeping in 1938. Since then the cross has been returned to the monastery at Vyšši Brod, its original home.

XVII. Byzantine steatites in the possession of the Knights of Rhodes

This 'Afterword', written twenty-five years after the appearance of Study XVII, was published in the catalogue accompanying an exhibition titled *Portable Altars in Malta*, ed. J. Azzopardi, Fondazzjoni Patrimonju Malti, pp. 51–52.

XVIII. A well-head in Iznik: an example of Laskarid taste?

This article excludes any discussion of Byzantine *puteals*, as they form a separate development from that of well-heads; those that are known tend to be only a few centimetres in height, and with any decoration confined to the corners of the square plinth.

INDEX

The index is limited to the names of persons and places that occur in the articles printed in this volume. Collections, public or private, are given under the name of the city or town where they are held. Churches and monasteries are given under city or town location, not their dedication. Illustrations are printed in bold.